WILLIAM WEGMAN FUNNEY/STRANGE

WILLIAM WEGMAN
FUNNEY/STRANGE

Joan Simon

YALE UNIVERSITY PRESS New Haven and London

in association with the

ADDISON GALLERY OF AMERICAN ART Phillips Academy, Andover, Massachusetts

 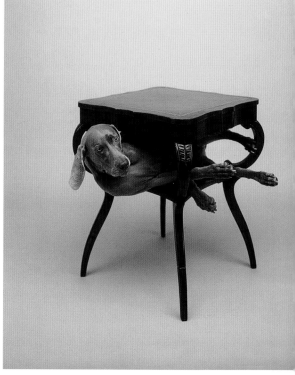

Table of Contents 1988, Polaroids, work in three parts: 24 × 20 in. (61 × 50.8 cm), each

Contents

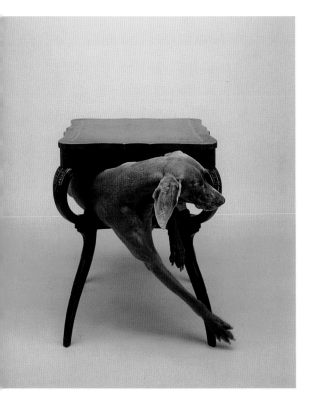

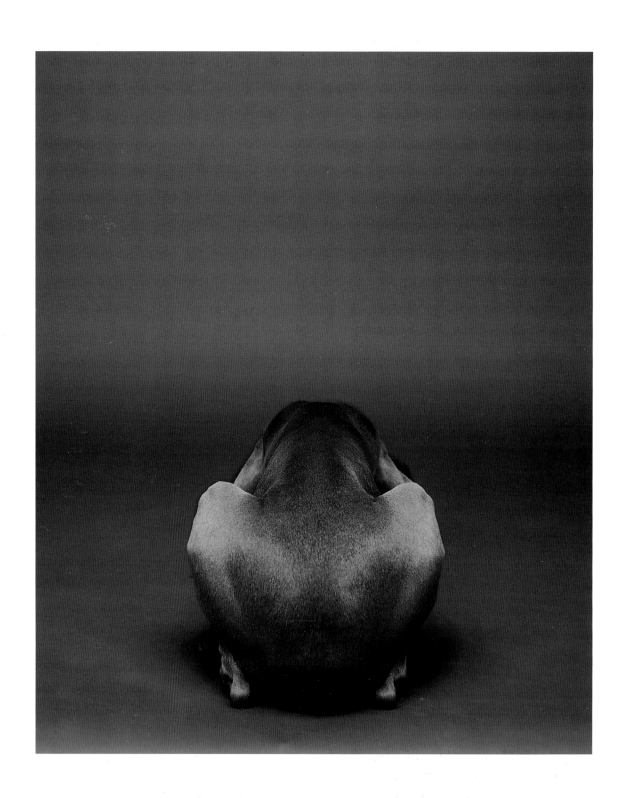

Untitled 1988, Polaroid, 24 × 20 in. (61 × 50.8 cm)

Foreword

Brian T. Allen *Mary Stripp and R. Crosby Kemper Director*

Describing William Wegman as "the man with the dogs" quickly situates him in the minds of many people, whether they be art patrons, popular culture enthusiasts, or young viewers of public television. As this remarkable exhibition and publication attest, Wegman is much more than an owner and photographer of weimaraners in the same way that his photographs of dogs are far more than canine portraits. Coming of age in the 1960s, Wegman was an early exponent of conceptual art and a pioneering maker of video. He continues to be an accomplished video artist and conceptual thinker at the same time that he is an adventurous painter, prolific writer, and masterful photographer who is able to navigate between art that amuses and surprises and art that challenges and transforms.

Wegman's career, as Joan Simon brilliantly explores herein, has never been static or predictable, yet it is woven of threads of interests that engaged him early on and have endured to this day. In casual drawings paired with deliberately misspelled words ("Funney, strange"), he has seduced us with cartoonlike images and startled us with profundity and humor. In sidesplitting videos he has challenged assumptions and exposed human foibles. In altered photographs—whether cut, marked on, or collaged—he has transformed the ordinary into the extraordinary. In carefully staged large-scale Polaroids of his beloved weimaraners, now represented by a fifth generation of the same family, he has merged performance, representation, and wit with a flawless compositional formalism. In large and ambitious paintings he has created fantasy environments of dripping and glowing color, and tour-de-force landscapes that incorporate found postcards and kitschy greeting cards and vibrant, energetic

paint into intricately mapped worlds. Nothing escapes his quiet, savvy, unnerving, yet pitch-perfect artistic grasp.

Many hands and minds have contributed to the prodigious undertaking of this publication and the accompanying exhibition. First and foremost we want to acknowledge and thank Joan Simon, who presented to the Addison's previous director Adam Weinberg the marvelous idea of an in-depth exploration of the interrelationships between William Wegman's conceptually based bodies of work in diverse media. For the Addison it was a compelling idea, since Wegman has been a part of our collection and our history for many years. We are infinitely grateful for Joan's discerning eye and impressive scholarship as well as her dedication and generosity.

We also wish to thank Trevor Fairbrother for curating this exhibition. With sensitive understanding of what he calls Wegman's "blunt yet sublime ways," his "dramatic and narrative finesse," and his "embrace of life's oddities," Trevor has crafted an eloquent exhibition that fully reveals the artist's unique and expansive talents.

The staff at the Addison has displayed its usual exemplary skill in organizing projects of amazing scope and complexity into masterful presentations of art and word. Allison Kemmerer, the Addison's curator of art after 1950, has overseen this project with great élan and ability, orchestrating the successful conclusion to this complex endeavor. She has been ably assisted by curatorial associate Juliann McDonough, who has once again spun her magic over the disparate and myriad pieces of this extensive project. Researcher extraordinaire Susan Montgomery wrestled vast

amounts of bibliographical detail into the most com-
plete and accurate recounting of Wegman's publication
and production history to date.

 In the process of our research the following
individuals and institutions have given generously
of their time and knowledge. We offer our sincere
thanks to: Ann Tootle, Albrecht-Kemper Museum of
Art, St. Joseph, Missouri; Alexandra Anderson-Spivy,
New York; Kelly Shindler, Art 21, Inc.; Nicole Kinsler,
Aspen Art Museum, Colorado; John Baldessari;
Stephanie Cannizzo, Berkeley Art Museum and Pacific
Film Archives, University of California; Robert Enright,
Border Crossings: A Magazine of the Arts, Winnipeg,
Manitoba; Jeff Sotzing, Carson Entertainment; Susan
Lawhorne, Columbus Museum, Georgia; Kimberly
Dummons, Contemporary Art Center, New Orleans;
Andrea Green, Contemporary Art Museum, St. Louis,
Missouri; Mary Dean; Patrick De Brock Gallery,
Belgium; Alexandra Novena, DeCordova Museum and
Sculpture Park, Lincoln, Massachusetts; Karen Kienzle,
de Saisset Museum, Santa Clara University, California;
David Deutsch; Laddie John Dill; Megan Lewis
and Dawn Troy, Fraenkel Gallery, San Francisco;
Galerie Juana de Aizpuru, Madrid; Marvin Heiferman;
Shaun Rance, The Kitchen, New York; Victor Kord,
New York; Chizu Morihara and Susan Trauger, Los
Angeles County Museum of Art; Kara Schneiderman,
Lowe Art Museum, University of Miami, Coral
Gables, Florida; Jeffrey A. Keough, Lisa Tung, Jim
Smith, and Paul Dobbs, Massachusetts College of Art,
Boston; John Minkowsky, Cambridge, Massachusetts;
Jayne E. Stokes, Museum of Art, Rhode Island
School of Design, Providence; Lynne Warren, Museum
of Contemporary Art, Chicago; Mary Johnson, Museum
of Contemporary Art, San Diego; Stephanie Conaway,

Museum of Contemporary Photography, Columbia
College, Chicago; Duncan Ganley, Museum of Fine
Arts, Houston; David Scarpelli, Museum of Modern
Art, San Francisco; Barbara Pope, Museum of
Photographic Arts, San Diego; Dr. Gerald O'Grady,
Cambridge, Massachusetts; Janet Lomax, Orange
County Museum of Art, Newport Beach, California;
Andrea Long, Orlando Museum of Art, Florida;
Kim Jones, Pace/Macgill Gallery, New York; Alexander
J. Kritselis, Pasadena City College Art Gallery,
California; Susan Alovisetti, Oliver Wendell Holmes
Library, and Michael J. Crouse, Polk-Lillard Center,
Phillips Academy, Andover, Massachusetts; Peter
Plagens; Steven Comba, Pomona College Museum of
Art, Claremont, California; David Platzker, Printed
Matter, Inc., New York; Robert Klein Gallery, Boston;
Ed Ruscha; Alicia Durand, Sesame Workshop;
Antonio Homen and Alma Egger, Sonnabend Gallery,
New York; Paula Owen and Kathy Armstrong-Gillis,
Southwest School of Art & Craft, San Antonio;
Angela Westwater, David Leiber, Molly Epstein, Karen
Polack, and Katharine Smyth, Sperone Westwater
Gallery, New York; Rhonda Cooper, University Art
Gallery, State University at Stony Brook, New York;
Mary Livingstone Beebe, Stuart Collection at the
University of California, San Diego; Stephen Martonis,
University of Colorado Art Museum, Boulder; Jane
Block, Ricker Library of Architecture and Art, John
Franch, University of Illinois Archives, and Pam Hohn,
College of Fine and Applied Arts, University of Illinois,
Urbana-Champaign; University of Maryland Art
Gallery, College Park; Jennifer Lind, University of
Massachusetts Gallery, Amherst; David Null, Madison
University Archives, University of Wisconsin; Anna
Vilkuna, VB-valokuvakeskus Photographic Centre,

Kuopio, Finland; Jill Vetter, Walker Art Center,
Minneapolis; Amie Scally and White Columns Gallery,
New York; and Helene Winer.

It has been a great pleasure to work with Yale
University Press on this publication. Patricia Fidler and
her staff Kate Zanzucchi, John Long, and Mary Mayer
have squired this complex project with remarkable
clarity, generosity, and skill. David Frankel revealed his
incomparable editorial mastery in his sensitive and
graceful editing of the manuscript. Graphic designer
Lorraine Ferguson has captured the spirit of Wegman's
work, both its seriousness and its joyfulness, in her
sophisticated and elegant design.

On behalf of our illustrious partners in the
presentation of the exhibition, the Brooklyn Museum,
the Smithsonian American Art Museum, and the
Norton Museum of Art, we offer our profound thanks
to all those lenders who have been willing to share
their works with us. Their patience, enthusiasm, and
generosity are greatly appreciated.

Last and most important, we offer our utmost
gratitude to Bill Wegman and his wife, Christine
Burgin, for their energetic championing of this project.
They have generously given of their time, attention,
and enthusiasm to assure the extraordinary quality and
comprehensiveness of this exhibition and publication.
They have allowed probing of their extensive archives,
answered myriad questions, and mobilized their stellar
studio assistants Jason Burch and Andrea Beeman
on behalf of this project.

We offer this publication and exhibition in
homage to the efforts of all who have contributed
to this substantive undertaking and in tribute to the
remarkable creative genius of William Wegman.

Curator's Note

Trevor Fairbrother *Guest Curator*

It was a rare pleasure to select the works featured in this new retrospective exhibition on William Wegman. I've long enjoyed the blunt yet sublime way his art cuts to the chase, including videos with crazy truthful titles (*Tonsil Song* and *Spit Sandwich*) and paintings that are unnervingly rhapsodic or suspiciously thrift-store friendly. I'm also captivated by the curious fact that the maker of such mercurial, outlandish, and impudent creations often comes across in public as a quietly preoccupied casual guy.

In making my choices for the show and for the plates featured in discrete groupings in the following text, I tried not to favor one medium over another. I was aware that some people admire Wegman's early videos or his Polaroids so intensely that they begrudge the rest of his oeuvre. I found myself flagging works that surprised me in some way, from the whimsical to the out-and-out wayward. I focused on items that puzzled me longest and—like the drawing *X Ray of Peach in Dish* (1973; p. 10)—that stunned me with their purity and perfect strangeness.

A remark Wegman made in 1990 has helped me appreciate what I can now call his profound sensitivity to the odd. His words trace the affinity back to childhood interests and experiences: "When I was a boy, my room had pirate wallpaper, and the registration of the printing was off, so that the pirate's face wasn't in the pirate's head outline. I can still recall the hours I spent studying the problem of the pirates climbing the sky and not the ladder. My paintings are a lot like that—everything is familiar but not quite in the right place. This is often the case with my drawings and photos too."[1]

A bright kid hooked on the illustrations in popular encyclopedias and scouting manuals, Wegman

Cat's Cradle 1977, altered gelatin silver print, 14 × 11 in. (35.6 × 27.9 cm)
Collection of Martin Sklar, Courtesy Gallery Schlesinger, New York

loved to draw and was eager to learn the nuts and bolts of image making. He had a boyish love of the pirate wallpaper, but he also wanted to understand how faulty printing had changed its pictures. While musing on the factors that had caused such strange visual effects, he sensed something about the aesthetic power of accident and imperfection. His imagination raced to that realm where outlaws are climbing the sky. Such episodes nurtured innate artistic gifts, particularly his genius for unhooking a familiar scenario, then deploying its elements in ways that are piquantly amiss.

I would like to recognize the rigorous and procedural cast of Wegman's mind. In the wallpaper recollection he stressed the hours he "spent studying the problem" of the defective printing. Wegman's aptitude for pictorial delight and provocation can intoxicate, but he is more than a comic: he is an artist driven to solve a particular problem or to invent variations on given issues. The dramatic and narrative finesse of his work, and its relative accessibility, often obscure the fact that Wegman is actually running this "theater," planning and building each of his pictures as a kind of experiment in staging and presentation. He explores ways to destabilize the familiar, to question protocols, and to sidestep the predictable and ordained in deft maneuvers. Why? As corny as it sounds, I think Wegman values knowledge, understanding, and education. The best of the weimaraner choreographies for his *Sesame Street* segments fuse perception, education, pleasure, and art.

Words pursue images in Wegman's art: visual and verbal accounts endlessly aid, abet, and compete with each other. When he comes up with a title like "Foald" he may be inviting mental pictures of a folded cloth, foals and foaling, or a fold harboring a flock.

In fact his painting *Foald*, a large work from 1996 (p. 183), seems ready to entertain all of these associations. A Wegman canvas from this period usually started life on the floor, with the artist sloshing acrylic paints to improvise an irregular ground or surface. Later, using oils, he improvised on and against this abstract background and turned it into a space pulsing with all manner of pictures. In the case of *Foald*, the ground becomes a cosmos, a mist, or a map: this painted world evokes a habitat for ghostly creatures and a bestiary in the heavens.

The impact of Wegman's art on its viewers is unpredictable. And a particular work may not necessarily strike them in the same way when they revisit it. Much of his art is indeed hilariously absurd or wacky, but it also has the potential to inspire other moods and feelings. Greeting the full range and savvy voice of Wegman's production, this exhibition and book allow us an opportunity to learn from his embrace of life's essential oddity.

1. William Wegman, quoted in Ruth K. Meyer, *William Wegman: The History of Travel* (Cincinnati: Taft Museum, 1990), 10.

FUNNEY

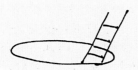

STRANGE

Funney/Strange 1982, ink on paper, 10 ¾ × 9 in. (27.3 × 22.9 cm)

FUNNY (HA HA), FUNNY (STRANGE)

An Introduction

To say that William Wegman's work is both funny and strange is to state the obvious, but no one has stated it better than the artist himself, in a series of drawings made in the early 1980s. In particular, a 1982 drawing titled *Funney/Strange* (p. xii) is distinctly summary of his enigmatic, unmasterful yet masterly way with words and images, his address of the dislocation of apparently parallel universes, and his doubling of facts and fictive voices to multiply rounds of rereadings and circuits of doubt. This simple drawing also manifests Wegman's complexity of thought, some of his recurring themes, and his informal but carefully crafted conceptual and formal concerns.

Funney/Strange shows two pairs of more or less parallel diagonal lines, each descending into its own hole. One closely spaced pair, given a slightly ovoid edge at its very top, suggests a sidelong view of a narrow column, or maybe a drinking straw, in which case the hole into which it descends might represent the circumference of a glass. The other set, open at the top, with wider-spaced parallels and runglike crosswise lines, is more evidently a ladder, most likely descending into a hole in the ground—a manhole, perhaps. Size and scale are implicitly compared and contrasted, while at the same time disjunctive questions of intimate use and public utility are implicated.

Scanning back and forth between the paired images in this drawing, one sights another pair: the word "funney" hovers above and between the images, the word "strange" below. One soon senses something "funny" about the word "funney," finding it, in fact, somewhat strange. Whatever it is, it is something requiring scrutiny, engagement, attention, but more than that: a process of buoyant looking and sorting,

a restless reverberation that is at once, and not paradoxically, both summary and summarily indeterminate. The straight-out pairing is funny but the Swiftian play on scale is strange. A straightforward reversal might lead one to think how odd it would be if the straw were in the manhole and the ladder in the drinking glass, but as a play on the illogical extremes of logical equivalents, the situation is made all the more funny and all the more strange.

A comment on the locales and subjects of artmaking may be detected as well. Artists of Wegman's generation, finding their way as the '60s became the '70s, were turning away from studio-made objects and from the related economics and politics of gallery or museum shows; they often drew on domestic, banal props, found at home or in the studio, and put them to use in everyday actions—or else they worked outdoors, making earthworks, at times on a monumental scale, and employing processes in and of the land and water. Wegman floated Styrofoam letters in the Milwaukee River for a process piece and documented this activity in photographs, for example; later, he recorded himself drinking from a glass of milk in photos and videos.

Both approaches depended on photography, film, and the newly available portable video to carry the information of such actions to a viewing public far from their locations. Until 1973, Wegman himself used these photo-based tools to document activities, situations, and processes indoors and out, keeping his facility as a draftsman at bay, just as during the same period he also abandoned his training and practice as a painter, which he had given up in 1967 and which he would take up again in 1985.

Simply drawn, naïvely posed, *Funney/Strange* in fact serves to introduce several other directions in '70s

artmaking that Wegman was signal in claiming: the insinuation of text as both pictorial device and skewed narrative; and the voice and presence of the artist directing rather than stating, so as to implicate the viewer in dynamically creating meaning from inconclusive evidence. Furthermore, Wegman laid the ground for art audiences to identify with an authorial persona who is not authoritative—an unheroic maker of mistakes as much as a shaper of ideas and forms, a maker and observer who puzzles over the obvious and calls on humor to mediate the unsettling, discomfiting realities of things that, in life and for Wegman in art, often don't add up.

From the outset, Wegman has been a contrarian and a dialectician who almost casually assumes two voices, even if—or especially when—he alone is the speaker (live, on video; in print, on the page). He readily speaks in two registers: the good and the bad, the minister and the ministered, the teacher and the student. His dual voices may be evidenced on the page or expressed by his corporal self, as when this "body artist" turns his torso into a "face" (nipples as eyes, belly button as mouth) to sing in two different voices, in an unusual call-and-response melody—puffing out his stomach to sing the higher "hoo hoo hoos" and pulling it in to sing the same in a second, lower range.

In another video Wegman does something similar through a tight framing of the zone encompassing nostrils to mouth, which he turns up, as "smile," to create one character and down to personify another. And in his work with the nobly responsive and allusively named Man Ray, the first of the weimaraners to enter his work, he is readily identified as the comic relief playing to his straight man, and doing so as fluidly as the radio-and-television team Bob (Elliott) played off Ray (Goulding) in all of their changing guises and voices. Wegman's many means of artmaking, especially his multiple voices and changing characters, offer, as Bob and Ray did, a continuing saga of the quotidian details and moral conundrums of "one fella's life" (to call on the title of one of their recurring sketches, "One Fella's Family").[1]

Like Bob and Ray—and also such predecessors as the Dada Surrealist Man Ray, as well as Wegman's onetime-fellow-California artist and first collector, Ed Ruscha—Wegman employs whatever media are suitable to the task and idea at hand. Like both the comic

duo and the transatlantic multimedia artist Man Ray, he uses storytelling, performance, role reversals, character and gender switches, and writing, especially eccentric wordplay and an affinity for puns, to elicit a public persona that exaggerates as it builds on "autobiography," drawing casually yet deliberately from fact and fiction. Like the artist Man Ray and also Ed Ruscha, Wegman is both a photographer and a painter. (Also like these two, Wegman early on made films before turning to video.) And he shares with Man Ray a fondness for found-object manipulations, sleight-of-hand revelations, and especially a practice of allusively, if also disjunctively, naming whatever is created after the fact.

Wegman, at ease with the contemporary artist's toolbox, began with a black and white "manifesto" presented as a simple mathematical sum: his art was "photography + video." To this he added text pieces (1970–71), drawing (1973), altered prints of his own photographs (late '70s), color Polaroids (1979), public sculpture (1985–88), painting (1985), artist's books and children's books (early '90s), altered vintage photos as well as found photographs by others (mid-'90s), and filmmaking (1994). He typically deploys not only the found object but also the overlooked and undervalued remnant (another echo of Man Ray, however unintended by an artist who more readily identifies with the other member of Man Ray's collaborative team, Marcel Duchamp), whether making mechanical sound-making devices for his earliest performative installations (1967–68), or deploying furniture and various other kitchen and darkroom supplies for process-oriented sculptural "arrangements" (1968–69), or using knitting-instruction books as serial units (2001), or writing one of his drawings on the cover of an actual Mead Writing Pad (1992).

Among Wegman's "perpetual motifs" and "objects of affection," to borrow phrasings from Man Ray, are pink plastic poodles, which turn up in Polaroids and in the *Sesame Street* video *Seesaw* (2002). Another is a cooking pot on a stove, boiling miniature versions of itself filled with potatoes; the pot has migrated to *Potato Pots* (1972; p. 3) from its use two years prior in one of Wegman's earliest extant videos, *I Got…* (1970), where it is initially seen bathing Wegman's feet but eventually becomes, as a longed-for swimming pool, the punchline of a shaggy dog story.

FUNNY (HA HA), FUNNY (STRANGE)

The latter video is one of Wegman's archest (and earliest) comments on human frailties, a visually understated but rhetorically powerful expression of the banality of covetousness. At the same time, the video is an acute play on scale, as in another of his funny-strange drawings in which he confounds pond and puddle with a tossed-off what's-the-difference remark: "They are all the same in the end."[2]

Wegman considered his first dog, Man Ray, a found object as well. The pet, always underfoot, roamed within the field of his still and video cameras not long after he acquired the six-week-old weimaraner puppy, in September 1970. Wegman allowed him to remain there and followed the dog's normal curiosity and habits. Thus, in one video, Man Ray gnawed on a microphone with the same relish he would a bone, resulting in a rumbling "soundtrack" that is as abstract as it is literal.

Wegman found many other ways to accommodate the dog, who was always about. He readily accessorized the fellow with domestic finds (Man Ray, as Wegman did, drank from that glass of milk), and later with thrift-shop items and trimmings. A set of costumes designed for Man Ray by the artist Robert Kushner later led to more elaborate decorations for costume dramas featuring the next generation of Wegman's theatrical cast of dogs, beginning with Fay Ray in 1987. These works included high-fashion shots, fairy tales, and the film mystery *The Hardly Boys in Hardly Gold* (1996), so named because the detective stars of this "Hardy Boys" homage are dogs and girls (specifically the weimaraners Battina and Crooky).

To his inventory of found objects Wegman has most recently added greeting cards and postcards ('90s), which function as the initial marks laid down in collaged landscape works on paper ('90s) and paintings (2003). As always, the objects that Wegman claims are distinguished not only by being readymades in a formal and tangible sense but also by their readymade content, which, in the case of the postcards, arises not only from their picturesque images but also from their history of use, an embedded tale told by stamps, postmarks, and writings on their hidden reverse faces.

Wegman moves fluidly among his drawing, painting, and photography studios, often trailed by the family of dogs who have become part of his life and

his work, and whom the general public identifies with this artist as readily as they do Campbell's soup cans with Andy Warhol. Wegman's "gray ghosts" (as weimaraners are often known) have become more and more public, and have been called on to serve as everyman on the covers of magazines as different as *The New Yorker* (in the guise of the annual appearance of "Eustace Tilley"), *George* (bedecked as George Washington), and *Tricycle* (in an Eastern robe befitting this journal of Buddhist studies). They have also

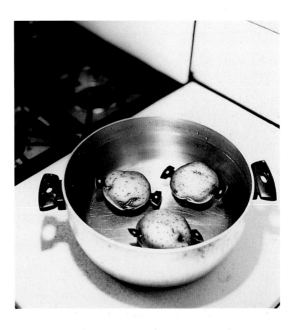

appeared with Wegman on late-night television shows and early-morning children's programming, on calendars and in books, and in print and television advertising.

Wegman has in fact seen the idealistic promise of '60s vanguard art come true, an ironic, double-edged achievement that bears critical examination and is explored later in this book. His videos reach a broad and diverse audience via broadcast; his publications do the same through mass-market circulation. At the same time, given the outsized popularity of what Wegman himself self-mockingly refers to as "Wegman, Inc.," it has been suggested that the artist has sold out.[3]

The issue is not simply that the art audiences and critics who admire Wegman's conceptual photos and videos of the '70s, and who write texts as different as Sanford Schwartz's praise in *The New York Review*

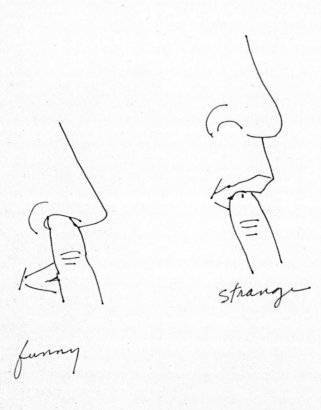

funny

strange

Funny/Strange 1982, ink on paper, 12 ¼ × 9 in. (31.1 × 22.9 cm)

of Books, Dave Hickey's astute critique in the *Los Angeles Times*, and *October* theorist Craig Owens's analysis in *Art in America*,[4] may not remember or have noticed Wegman's uncompromising appearances on late-night television, beginning with Johnny Carson's *Tonight Show* introduction of the video work in 1977 (absent the person/personality of the artist) and continuing with Jay Leno and David Letterman for twenty-plus years. Or that these audiences may not have seen either the talk show appearances or the videos watched by viewers of *Sesame Street*, or may simply be turned off by Wegman, Inc.'s many dogged offshoots, such as stationery, children's games, books—including the best-selling *Puppies* (1997), whose complex narrative belies the immediate pictorial charm of its puppy subjects—and fabric designs featuring a high-end, sophisticated kind of abstraction. More intriguing is the question of what it is about Wegman's voice that rings true to his different and for the most part separate publics.[5]

Somehow Wegman's wordplay, his plain-faced, conversational, yet carefully crafted language communicating an absurd medley of encyclopedic fact, his dislocations between shown and told, are equally recognizable and appealing to the youngest what's-wrong-with-this-picture puzzlers and to art-history students rigorously finding meaning through a compare-and-contrast methodology. Both audiences recognize the fusion of the real and the invented in a line in a postcard that Wegman continues outward beyond the card's edge by brush, then camouflages in the overall field of a collage/painting. And both see Wegman's sly hand and observant eye (no question too dumb, no siting too off-limits) in the images of another drawing titled *Funny/Strange*, also from 1982, this one without the extra "e" in "funny" (p. 4). Here two sets of nose/mouth/finger images are so posed that finger enters, in one, nose, and in the other, mouth; the word "funny" sits below the former, "strange" below the latter. One may guess that one part of Wegman's audience might laugh in recognition, another in discomfort, but on second thought (and with Wegman's works there are always second thoughts) the recognition of either would not be limited to younger or older viewers.

What is it about Wegman's canine players and their staging that touches the daily absurdities and

also the underlying pathos of the human condition, and, in doing so, touches his audiences as well? How do these images, evidencing the marks of morality tales, fit within a tradition going back to Aesop and La Fontaine, and including such twentieth-century parodists/essayists as James Thurber and E. B. White, creators of popular children's-book classics starring benignly subversive animal characters? And why is it that, despite art critics' theoretical concern with the audience and a body of writing on reception theory, an undercurrent of dismissal survives—that "popular" remains problematic in relation to "fine," outside ironic positionings or appropriations? What is it about an artist who works in the studio and whose work at times moves out into the larger world? And what is it about Wegman's career—or Man Ray's—that in its seemingly offhanded approach also reveals a persistence in exploring media different from those on which critical acclaim, not to mention commercial success and attendant celebrity, have been based?

Pioneer video-maker, wry conceptualist, performer, photographer, painter, found-object finder, draftsman, and writer, Wegman is typical of his generation in his multimedia reach but unusual in his audiences. He is not only held in critical esteem within the international art world but also beloved by the general public, often for very different works but for many of the same reasons: his smart, gently subversive humor parodies all things familiar, including conventions of artmaking. He is "the man with the dogs," whose handsome troupe of weimaraners collaborates with him in theatrical tableaux and the telling of tales.

In writing on Wegman one could in fact draw on the words used by Merry Foresta to describe the difficult critical reception of the work of the artist Man Ray—in fact, as she says, the confusion around it— as well as the clarity of his method: "In part, it was the confusion that resulted from the multifaceted activities of an artist who accomplished, with easy dexterity, so much. As a painter, a maker of objects, photographer, filmmaker, . . . Man Ray was dazzling in the multiplicity of his talents." He was an artist whose "technique was whatever he chose and he was dedicated to the creative idea rather than any particular style or medium. His themes reflected his innate curiosity and freedom."[6] Especially pertinent is Foresta's observation, "Much of Man Ray's art was deceptive in its

casualness."7 That Wegman's art is deceptive in its casualness is as noteworthy as his naming his dog, not the punning "Bauhaus," as he first considered, but "Man Ray." He has claimed that the choice was based more on the sound of the name than on any particular interest in the artist. (The comment is actually believable, given the care he takes with the sounds of words in his written texts and also with the spoken language and other sounds in his videos.)8 Once the dog was so named, however, and despite his affinity with Duchamp, Wegman felt he had to learn something about Man Ray the artist. He did his homework, and any number of his works may be cited as specifically responding to the senior artist's works, or as relating indirectly to their pictorial or narrative devices. Indeed, in looking at Wegman's various bodies of work, one recognizes a significant subset of Man Ray–inspired works within the larger cumulus of "art about art" commentaries.

This book addresses some forty years of Wegman's works in all media—conceptual and process pieces, performances, video, photography, drawing, texts, painting, public sculpture, and multimedia collage. Looking at Wegman's many bodies of work anew (or askew), the book is organized by a general but wayward chronology that follows thematic constellations within its timelines. "Eureka" (1943–1970) begins with Wegman's birth in 1943 in Holyoke, Massachusetts, and underscores the many contradictions of his upbringing as it follows his years as a talented youngster, his experiments in painting and electronic participatory environments in art school and graduate school respectively, through process and conceptual works as a young teacher and artist-in-residence. This essay culminates in Madison, Wisconsin, 1970, in the moment when pre-1970 concepts become the photographs and videos of the '70s and when related subjects, sets, and stories are seen and heard in all media. "Double Profile" (1970–1985) follows Wegman to southern California and later to New York, and shows the Wegman persona and voice developing before still and video cameras and on the page, reading and writing developing as subjects, and "reversals" evidenced in photographs printed with flipped negatives and in palindromes reading the "same" both forward and back. "Birch Bay" (1985–1996) picks up after

Wegman's dogless years (from Man Ray's death in 1982 to his acquisition of another weimaraner, Fay Ray, in 1985) during which time he continued to create color Polaroids but resisted his desire to return to painting, finally giving in in 1985, from which time he followed the landscape themes he had addressed in early earth works and process pieces and now depicted in oil on canvas and later also captured in C-prints, in an artist's book, and finally in a merging of the commercially printed and fine-art extended photo postcard collages. "Getting into *Artforum*" (1996–2005), offers Wegman's ambivalent relation to the art world and its conventions as well as to critics and fellow artists, approached as parody and at times in homage, through one of his most persistent subjects, "art about art."

At the outset of this chronicle and critical study of Wegman's work, and of the *almost* undeliberate ways he found to create it, I am reminded that while "funny" exudes a kind of confidence, "strange" implies contingency. That while "funny" may be summary and solo, "strange" is more likely determined in a social context, with shifting relations of accord or discord, of self related to or confounded by other (a dialogue just as likely to be internal within a self as external between two different parties). And above all, as Wegman's practice demonstrates in all its many forms, that while "funny (ha ha)" explodes in recognition, "funny (strange)" reverberates with uncertainty, with questions yet to be answered. Taken together, these doubled propositions offer not an "either/or" choice but the Wegmanian "both/and"—where the light humor of "funny" mediates the darker human comedy of "strange."

DRAWINGS

PRINCESS CRUISES

No ones arrived yet. Do you think we should start anyway?

I wonder if you can figure out a way to keep these pages together. My stapler is broken.

Tonights the night. How do I look?

Two small ones just came through
Get ready for a big one

Lets flush him out. You go that way and I'll go this way.

I went that way last time. This time you go that way and I'll go this way.

I'm not going in there. I got it last time. Besides...whose is it
mine or yours.

I had it right in my hands. I could shoot myself.All I had to do was
hang onto it for another 3 seconds and it would have been ours.

You are welll built and have a nice personality but unless you
have those warts removed I doubt that you will win.

Theoretically if you take all your internal organs out and
/and connected them into a straight line you would die.

You cant win. Just win your expecting it high and inside it comes to
you low and away. Win you think the heat is off you relax for for just
a second and thats win they nail you. But youre obsssed and you fight
back with all youve got because you only go around once in life and
second best is not enough.

1422 Vance Building
Seattle, Washington 98101
Telephone: (206) 624-1666

Untitled ("No-one's arrived yet…") 1970–71, typewritten text on paper, 11 x 8 ½ in. (27.9 x 21.6 cm)

Landscape Color Chart 1972, graphite on paper, 8 ¼ x 11 in. (20.8 x 27.9 cm)

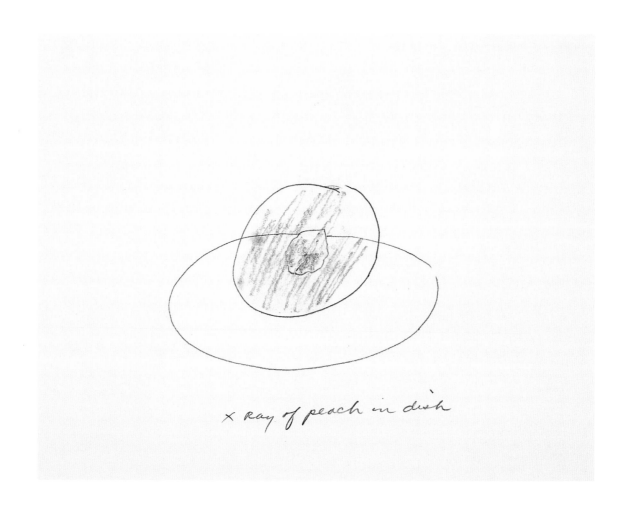

x ray of peach in dish

X Ray of Peach in Dish 1973, graphite on paper, 8 ½ x 11 in. (21.6 x 27.9 cm)

wig

dowel

detective
ENTRAPMENT

Detective Entrapment 1973, graphite on paper, 8 ½ × 11 in. (21.6 × 27.9 cm)

70 ¢

ww 73

70¢ 1973, graphite on paper, 11 x 8 ½ in. (27.9 x 21.6 cm)

big little finger

Big Little Finger 1974, graphite on paper, 11 x 8 ½ in. (27.9 x 21.6 cm)

Dramatic Scene 1974, ink on paper, 8 ½ × 11 in. (21.6 × 27.9 cm)

No Fun Sleeping Under a Picture Like This 1975, ink on paper, 8 ½ x 11 in. (21.6 x 27.9 cm)

rejected design

Rejected Design 1974, ink on paper, 8 ½ x 11 in. (21.6 x 27.9 cm)

Mixed Manimals 1976, watercolor and ink on paper, 8 ½ x 12 in. (21.6 x 30.5 cm)

DOE — BUCK

Doe-Buck 1977, ink on paper, 8 ½ x 11 in. (21.6 x 27.9 cm). Private collection

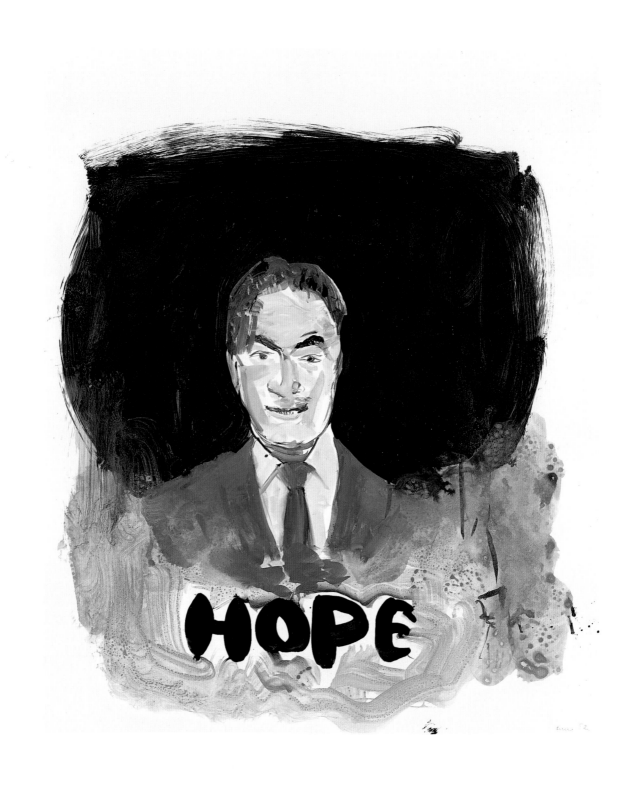

Hope 1982, gouache on paper, 17 × 14 in. (43.2 × 35.6 cm)

MARCONI

WIRELESS TELEGRARHY

GUGLIELMO MARCONI
ITALY 1874

Marconi Wireless Telegraphy 1974, ink on paper, 9 ½ × 14 in. (24.1 × 35.6 cm)

Untitled c. 1951, pastel on paper, 7 ⅝ × 7 ½ in. (19.4 × 19.1 cm). Collection of George William Wegman

EUREKA 1943–1970

Doublethink means the power of holding two
contradictory beliefs in one's mind simultaneously,
and accepting both of them.
　　　—George Orwell, *1984*

I don't need one thing, but *two* things. Two unrelated
things that I put together in order to create,
by contrast, a sort of plastic poetry.
　　　—Man Ray, c. 1970

The test of a first-rate intelligence is the ability
to hold two opposed ideas in the mind at the same
time, and still retain the ability to function.
One should, for example, be able to see that things
are hopeless and yet be determined to make
them otherwise.
　　　—F. Scott Fitzgerald, "The Crack-Up"

William Wegman was born in 1943 in Holyoke, Massachusetts, to a family that embodied many conflicting beliefs and contrary facts with grace and good humor. His mother, Eleanor Wegman (née Vezina), was a homemaker who shared her enjoyment of drawing and watercolor painting with her son from the time he was very young.[1] She was one of six children born to a Protestant mother and a Catholic father. Wegman's mother and her siblings were expected to choose their religious denomination for themselves by the age of sixteen or seventeen. They knew that having been baptized and confirmed in the Catholic Church, the process of becoming Protestant would not be simple, and would necessitate a Catholic excommunication before beginning anew. The three eldest children remained Catholic; the three youngest, Wegman's mother among them, became Protestants.

Wegman's father was also from a large family: George William was one of seven children, six of them boys.[2] "Generically Protestant" is how Wegman characterizes his father's family, whose affiliation he says depended on "whichever church happened to be in the neighborhood." George was the second youngest of the six brothers, and he was nine years old when his father died—"one of the first people ever hit by a car, after stepping off a trolley," as Wegman tells the story. The eldest brothers took responsibility for the youngest, who were children at the time, but not many years later the younger brothers were expected to work to support the family. Some took on blue-collar jobs, others more or less white-collar. The family viewed this socioeconomic divide as a matter-of-fact non-contradiction, so much so that the amiability and "sameness" among the six were later captured by the artist in a 1983 multiphoto work of his

father and uncles called *The Wegman Bros* (pp. 24–25).

The young Wegman shared a name with his father, but not exactly and not for long. The son of George William Wegman was given the name William George Wegman, but as the artist later told an interviewer,

Everyone called my father Bill until I came along. Then he became George but not by everybody. I became Billy Boy at home. Willy in art school. As an adolescent I had lots of names. Nicknames. They are often hopeful and a little sad. Especially when you move and have to introduce yourself to a new group. "Hi, my name is Billy Boy. You can call me Fubby."[3]

Or "Tubby," as the name actually was; "Fubby" was a typo in the book containing this interview. Wegman titled a 1983 drawing, his self-portrait as a young sportsman, *Tubby Wegman* (p. 27). Apparently there were other names as well, for, as Susan Morgan writes, "The high school work is signed variously Wegman, Billy Wegman, and even Billy 'Foss' Wegman; Foss, a nickname whose meaning is forgotten by even Wegman himself."[4] Years later, Wegman would draw on his inventory of nicknames for an exhibition announcement card.

The 1950s, when Wegman came of age, were the "golden age" of television, which, however, had not yet eclipsed the storytelling and imaginative space of radio. The television programming of the 1950s, especially its comedy shows, variety entertainments, quiz shows, and sales pitches—along with radio's intimate voice—would inform Wegman's later work in many ways. Listening to radio, whose sounds and voices seem to have been beamed directly from an invisible performer in some virtual space elsewhere to the conceptual, interior, heady space of the mind, is not unlike the "Live in Your Head" territory of Conceptual art, as the usually forgotten first part of the title of Harald Szeemann's benchmark 1969 show "When Attitudes Become Form" once put it—an exhibition in which Wegman, then making process sculptures, participated.[5]

Underlying Wegman's practice is an influential radio voice, in fact two, those of Bob and Ray—the team of Bob Elliott and Ray Goulding (and the many

The Wegman Bros 1983, gelatin silver prints, work in seven parts: 14 × 11 in. (35.6 × 27.9 cm), each

characters each played). Bob and Ray's back-and-forth banter of quotidian observations and mocking ads would echo in many ways in Wegman's works, especially their riffs on a "Wonderland of Knowledge," "little-known though interesting facts to help you lead a fuller, more knowledgeable life," and "knowledge that will make you pause." The Bob and Ray invention the Pittmans and their "Braid and Tassel Company, maker of doodads to dress up your crummy sofa," echo in Wegman's thrift-shop finds for set and costume designs, and his videos show traces of their "Mr. Science" and of their skewed ads for such well-known commodities as Cheerios and Piels beer. Even when performing a monologue, he often uses two voices in dialogue, especially to offer disjunctive information and to push the real to its extreme bounds. Wegman himself cites as particularly influential the Bob and Ray sketches starring "Mary Backstayge" (full title "Mary Backstayge, Noble Wife, the star of an American family of the footlights and their fight for security and happiness against the concrete heart of Broadway").[6] In one of his favorite episodes, as he recalls, Mary and cohorts "end up boarding the *Constitution* in Boston in a dinghy and get blown out to sea and end up in Africa. The story keeps morphing. It seems to go on forever."

Bob and Ray were also favorites of Wegman's colleagues, including Ed Ruscha, David Deutsch, and Laddie John Dill, whom he came to know beginning in 1970, when he moved to southern California. Crucial also to his developing sensibility during his California years were Conceptualists John Baldessari,

Allen Ruppersberg, and Bruce Nauman, all of whom employed commonplace materials and local observations, set isolated words or longer texts in counterpoint to images and objects, made artist's books, and handled photography as matter-of-factly as any of their other media. Equally important, they treated themselves as subjects and objects with detachment, sometimes comically so. In California Wegman met a number of artists through Helene Winer, then the director of the Pomona College Art Gallery, and organizer of concurrent solo exhibitions by him and Jack Goldstein there in 1971. Later he came to know others through an informal basketball game played between artists who lived and worked in Pasadena and those in and around Santa Monica. It was during his almost three years in southern California that he would find his "voice," and also his signature media: photos, videos, texts, and, at first, a single dog, the weimaraner that (or whom, so humanlike was the fellow) he named Man Ray.

In hindsight the moment when Man Ray entered Wegman's world was something of a turning point, if not an immediately evident "eureka." Naming the puppy after the Dada/Surrealist painter-photographer-writer (who always, he said, did two things at once, to poetic plastic effect), and invoking that artist's many talents (including tale-spinning), enigmatic text/object juxtapositions, and spirit, Wegman conflated material and muse, present and past, historical import and banal observations. He also claimed the dog as something other than simply canine: among his tellings, including to this writer,

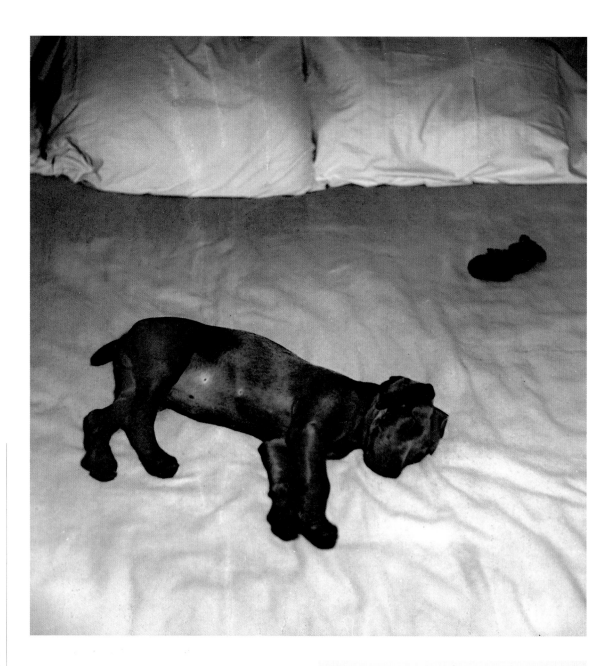

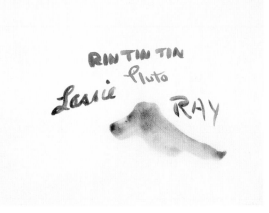

is the fact that to Wegman "he looked like a little man" and "rays of light were beaming on him." There are many other variants giving additional twists to the story.[7]

 The naming story may be somewhat apocryphal; implying levels of reading from the descriptive to the spiritual, from companionable fellowship to beatific transfiguration, it has been told differently at different times. Both the story and the name itself, however, invoke the duality of the permission that Man Ray the man offered several generations of artists: a style

Man Ray with Sock 1970, gelatin silver print, 14 × 11 in. (35.6 × 29.9 cm)
Famous Dogs 1985, watercolor on paper, 12 × 18 in. (30.4 × 45.5 cm). Collection of Gian Enzo Sperone, Courtesy Sperone Westwater, New York

and substance linguistically and visually offhanded, apparently, yet decidedly well crafted—whether an idea, an object, or a contrapuntal text or title added later to further spark the interplay of made and said. Chief among the precedents in Man Ray's art for Wegman was his way of working with serendipitous discoveries, albeit then diligently, repeatedly revising them. One of Wegman's earliest finds is retold within another of the naming stories:

We chose our six-week-old weimaraner puppy from a litter in Long Beach, California. Sitting there in the dining room in a ray of light, he looked like a little old man. Except for a big case of chewy-itis, there was nothing puppylike about him. So I named him Man Ray.

The first thing I did when I got Man Ray home was to take his picture: on the bed, deep asleep, a sock on the bed near him [1970; p. 26]. There was a similarity between this sock and Man Ray. Man Ray looked like the sock. The sock looked like Man Ray. Man Ray looked like many things. This idea grew on me.[8]

Wegman's naming of his dog "Man Ray" also recalls the Surrealists' method of giving human attributes to nonhuman or inanimate things, rather as Man Ray himself gave his name to a butane cigarette lighter, engraving the two words on one of his "objects of my affection." Wegman, too, often incorporates his own name, or the names of his many dogs, into his work. He has also invoked the names of '50s television stars, especially in drawings: in *Famous Dogs* (1985;

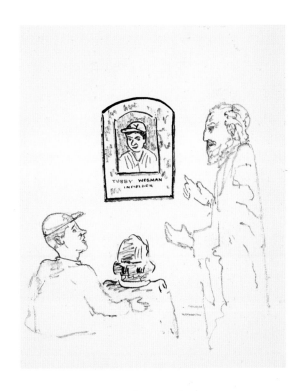

p. 26) he links the names of Rin Tin Tin, Lassie, and Pluto with that of his own canine celebrity, here called "Ray"—short for "Man Ray" but also sounding like the Ray of Bob and Ray. In another drawing he writes "Hope," the surname of the film, radio, and television comedian Bob, to accompany a rendering of this legendarily deadpan performer's portrait, but also uses the word in isolation as an optimistic, even idealistic sign of the post–World War II period (1982; p. 20), something he does even more explicitly in giving the name to one of his first paintings in 1985 where he acknowledges such subject matter (p. 147).[9]

In several drawings, including *Tubby Wegman*, Wegman plays with his name, in others his initials. In a 1997 alteration piece resembling a solarization in the style of Man Ray, for example, he has penned "Retouched by WW" at the lower left (p. 218). His signature too has been a perpetual motif. In a portrait of a blond fellow shown in the style of a "Breck Girl"— heroine of the hand-illustrated shampoo ads that constituted one of America's longest-running advertise-ment campaigns, beginning in 1936—he has a bit grandly signed "bill wegman" at the lower right with a lowercase modern signature (1981). (Wegman had copied the Breck ads as a teenager: "Back then I

W 1985, watercolor on paper, 9 × 12 in. (22.9 × 30.5 cm). Collection of Gian Enzo Sperone, Courtesy Sperone Westwater, New York

Tubby Wegman 1983, ink on paper, 14 × 11 in. (35.6 × 27.9 cm). Collection of Eve Darcy Burhenne

Truman Capote

Gore Vidal

Tht Pynchon

Norman Mailer

John Updike

Joseph Heller

Saul Bellow

William -- Wegman --

Truman Capote, Gore Vidal, Norman Mailer … William Wegman 1985, graphite on paper, 8 ½ × 11 in. (21.6 × 27.9 cm)

dreamed of one day having the job of illustrating the Breck Girl as seen in almost every magazine ad in the '50s. She was so beautiful that only the best artist would get to paint her, I was sure. I had made more than one pencil sketch of her when I was fifteen or sixteen.")[10] In one of the few drawings that acknowledge his practice as a writer, he relates his signature to those of Joseph Heller, Thomas Pynchon, and Norman Mailer (1985; p. 28). Each of these novelists has a distinct public persona as well as a singular voice in print, and Wegman—like a student conscientiously practicing different hands—also imagines elaborate personifications through their "signatures": tiny, cramped, pinched lettering, say, for the notoriously retiring Pynchon. The drawing also includes "signatures" for Truman Capote, Gore Vidal, John Updike, and Saul Bellow, and the name "William Wegman," in coming last, at lower right, bespeaks a number of ambiguities: does it draw his name into the orbit of the others? Do their names simply trail off with his? Or, having made a "picture" of their names, has Wegman put his name in the traditional painterly space for a signature? Wegman says, "I've always thought it funny to play with signatures. When I was a teenager, I used to draw my name with a dragon out of the 'g.' By the time you're an artist, having an elaborate signature is very uncool. Whistler escaped from that: he had a fancy signature and was a good artist."

When Wegman was eight or nine, he drew a pastel self-portrait (c. 1951; p. 22) depicting himself from the back, a sophisticated idea given the impossibility of gaining that view unassisted. Whether he drew from imagination or remembered either the mirror arrangement typical of 1950s barbershops or, as Wegman recalls, "the three-sided mirror when you tried on a suit," he came upon a psychologically complex posture that had been a key stance in the work of Caspar David Friedrich, and was also used by artists as different from one another as Norman Rockwell, Philip Guston, and Bruce Nauman. Explaining why he chose this vantage point, Wegman offers, typically, "Maybe because the front is too hard—the nose, the mouth. From the back is just easier," but follows up immediately with "Maybe that's how my mother would see me, looking at the back yard." Wegman's small square drawing depicts a young fellow, ax over his shoulder, accompanied by his dog, Wags, whom he had

found in his Christmas stocking that year.

In addition to drawing with his mother, Wegman would draw with his uncle Everett, "a brilliant engineer," according to Wegman's father George. Everett worked at Westinghouse and invented items as different as "the machine that dispenses cups for Coca-Cola and the clothes dryer, though he never got credit for it." Working with Everett, George recalls, young Bill would "do wild horses, cowboys, self-portraits, portraits of his mother, or scenes just out the window." Wegman's affinity for science books, technical manuals, and data may have grown from his exchanges with his scientist uncle. In his later paintings, drawings, and videos, he incorporates esoteric facts, sometimes in intimately didactic "how to" projects, or in detailed descriptions of the way things are made.

After high school, Wegman moved to Boston to study at the Massachusetts College of Art (MassArt). He recalls that at that age he "was struck hard by an urge to become 'deep.'" He contemplated "the Void" and painted "Existentialist-Abstract-Expressionist Triptychs."[11] As Michael Gross writes, "Wegman spent his first two years [at MassArt] under the sway of two much older roommates [Charles DiMascola and Robert Hubbard], both devout Roman Catholics."[12] The two introduced Wegman to classical music and to what he calls "the mysteries" of their faith's ritual.[13] (Like his father, he had been brought up Lutheran.) "We would go to four or five churches every Sunday," he told Gross. "My first work had a lot of gold leaf in it. They kept me from being too normal."[14] "In my junior year," he told this writer, "I decided not to become a Catholic. (In my sophomore year I was studying to be a Catholic.) I still wanted to hear the music, though."

Critic Peter Schjeldahl writes of Wegman, "He is the only artist I know who, like me, was raised a religious Lutheran (and who, like me, flipped from fervent belief into atheism at the onset of sexuality)." Schjeldahl continues,

Lutheranism is a pitilessly self-conscious faith. "Every man his own priest," Martin Luther enjoined—meaning that a state of grace with God, which alone promises salvation, is knowable strictly in each individual's secret heart. Lifelong anxiety

is assured. Any experience of being "in the wrong," no matter how trivial its circumstance, is apt to shake the very foundations of self-confidence. There is a compensatory gravitation, in fantasy, of remembered experiences of grace, when one had a sense of virtuous union with divine purpose. (I am speaking of a psychological condition now, having nothing to do with actual belief.)[15]

Wegman somewhat deflects the fervor that Schjeldahl accords his early beliefs, while also confirming it in his own way: in sixth grade, he offers, he "got an A on a paper about Martin Luther" and had been "trying to convert all my Catholic friends and one Jewish one. I would point to the Catholic Church, and its incense, and say they had been burning money in there." At the same time, he notes his persistent attendance at catechism class. In fact Wegman has taken teaching and preaching as subjects throughout his career, addressing them both directly and curiously sideways. In videos in the 1970s, for example, he tries to teach Man Ray both how to spell (1973–74; p. 241) and how to smoke (1976–77)—which the dog assiduously shuns, despite his master's entreaties; in the video *Minister* (1999; p. 245), Wegman, dressed in a clerical collar, retells the nursery song "Johnny's not home from the fair," but presents it as a parable.

By his third year at MassArt, as Wegman told Gross, "I was Willy Wegman—as I was called—the artist. I wasn't lost anymore. I was interested in philosophy, music, literature, and art in an incredibly, overbearingly serious way." He was enamored of what he calls "manifesto" art and art movements like Dada, Surrealism, and Constructivism: "'Every kid that painted had a little surrealist tear coming out of an eye,' he says, chortling."[16] Wegman, although then still a painter, was identifying himself with Man Ray in this reference to the artist's startling and well-known photograph from 1930–33 of a face (cropped variously in different prints) marked with glimmering, isolated tears—large, jewel-like, almost realer-than-real tears that were in fact beads of glass. Wegman would later make many references, both incidental and direct, to Man Ray in works in different media, photographs among them: the rayograph-like *Photogram* (1973), the "solarization" *Screen Puree* (1975; p. 220), and the twenty-by-twenty-four-inch Polaroid *Handy* (1984;

p. 221), which juxtaposes tiny porcelain doll hands with a face as Man Ray did in the 1936 portrait *Dora Maar* and in various self-portraits. Wegman's videos, in particular *Man Ray Man Ray* (1978), merge dog and Man as one, playing on the doubled name for the different characters. Here Wegman seamlessly keeps the narrative moving while also intercutting the two biographies in counterpoint to images showing the "switched" identities.

Wegman's work of this period was importantly informed by "the John Singer Sargent portraits, the Copleys, . . . the Chinese landscape paintings," and the Chinese-landscape-painting-inspired Japanese scrolls he saw at Boston's Museum of Fine Arts. "I was attracted to two very opposite kinds of art. Later I realized that when I was doing Polaroids I was doing Copleys and Sargents, and when I was painting it was Chinese landscapes. Sargent's great painting of four daughters mesmerized me." John Singleton Copley's painting of a boy with a squirrel was also a key image for him, and in both portraits one can see a formal contrast, a pairing of human and nonhuman, rather as Wegman doubled his subjects in his Polaroids. In Sargent's *The Daughters of Edward Darley Boit* (1882; p. 31) the scale of the "adult-size," almost figurative urns contrasts with the young pinafore-wearing daughters; in Copley's *Henry Pelham (Boy with a Squirrel)* (1765; p. 31) the almost ventriloquist-to-puppet relation between boy and squirrel is similarly notable. Also important to Wegman was a thirteenth-century Japanese handscroll at the museum, *Night Attack on the Sanjo Palace* (p. 31). The work depicts the bloody civil wars in twelfth-century Japan, and the burning flames of the palace are forcefully dominant elements.

Wegman himself later drew and painted various fires and gave his landscapes the flatness and the orientation of elements he saw in works at the Museum of Fine Arts, including especially a mid-fifteenth-century Japanese scroll by the Zen Buddhist artist/monk Bunsei, who continued the Chinese tradition of monochrome landscape painting. One sees echoes of this influence in Wegman works such as *Commas* (also called *250-foot Styrofoam Chain*, May 1969), a photo document of a conceptual piece in which he floated Styrofoam letters and punctuation marks down the Milwaukee River. Where the

John Singer Sargent (1856–1925)
The Daughters of Edward Darley Boit 1882
Oil on canvas, 87 ⅜ × 87 ⅝ in. (221.9 × 222.6 cm)
Museum of Fine Arts, Boston
Gift of Mary Louisa Boit, Julia Overing Boit, Jane Hubbard Boit,
and Florence D. Boit in memory of their father, Edward Darley Boit,
1919 (19.124)

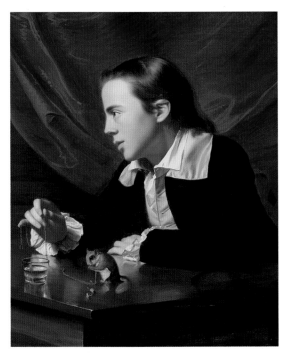

John Singleton Copley (1738–1815)
Henry Pelham (Boy with a Squirrel) 1765
Oil on canvas, 30 ⅜ × 25 ⅛ in. (77.2 × 63.8 cm)
Museum of Fine Arts, Boston
Gift of the artist's great granddaughter, 1978 (78.297)

Styrofoam elements floated up on shore, massing and
linking together, they created a continuous white
edge that is read as a sensual line across the visual field.
The Japanese scroll influence also manifests, if very
differently, in Wegman's landscape Polaroids, and most
recently in his scenic souvenir-postcard collages.

In Boston Wegman lived near the Isabella
Stewart Gardner Museum and visited often "to see the
Vermeers, Rembrandts, Titians, and to hear music."
By this time he was critically influenced by the pianist
Glenn Gould, whose controversial Bach recordings he
heard on the radio—introduced, he recalls, by an
announcer simply saying "Glenn Gould." He began to
follow Gould's recordings and went to hear him lecture
at the Gardner: "I thought of course I discovered him."

What was important for Wegman—and for
many others—was Gould's decision to give up public
concerts. For Wegman, Gould's resistance to playing
to the balcony, his choice to forgo the ingratiating
performing persona in favor of developing his music in
private and in the recording studio, was critical.
Wegman likens this move to his own decision to turn
away from making big, important public statements—
the "big piece," such as the earthworks of the '60s,
when, he notes, everyone was "making a piece." Instead
he leaned to more modest works, internal, technical,
and informal experiments that were in some ways
private. (As Wegman recalls of Gould, "He died the
same year as Man Ray died, and I had to look elsewhere
for muses.") Wegman followed closely the two
divergent strands of contemporary artmaking: the

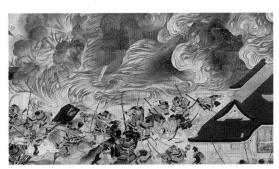

Night Attack on the Sanjo Palace (detail)
Japan, Kamakura period, second half of the 13th century
Handscroll, ink and color on paper
16 ¼ × 275 ½ in. (41.3 × 699.7 cm)
Museum of Fine Arts, Boston
Fenollosa-Weld Collection, 1911 (11.4)

"manifesto" art, as he called it, of Minimalism and Conceptualism, to which he was drawn, and the vernacular references to everyday culture in Pop art, which would inform his later work. "I was in the class right before every student had to choose sides, deciding whether to be Pop or Minimal."[17]

In the fall of 1965, Wegman began graduate studies at the University of Illinois, Urbana-Champaign, along with fellow MassArt student Robert Cumming. They had known each other at MassArt but now became close friends.[18]

By 1966, as an MFA candidate, Wegman had given up painting hard-edged abstractions for experiments in all sorts of media and processes and would soon make his first film. He spent a considerable amount of time in the University of Illinois's electrical-engineering department, where he made kinetic contraptions and such things as inflatable plastic sculptures (p. 33). He had a scholarship from the university, an assistant-ship with the painting department, and a fellowship through Heinz Von Foerster, head of the biological computer lab at the department of electrical engineering. "Illinois was known as a 'potent music' school," Wegman recalls, and had fostered composers such as Lejaren Hiller, who became legendary as the first person to compose music with a computer, writing the *ILLIAC Suite* in 1957 (the work is now called String Quartet No. 4, having lost the name of the computer with which it was created). Here Wegman also met the composer Salvatore Martirano,[19] the filmmaker Ronald Nameth, and the engineer Paul Weston. Nameth and Weston helped Wegman with his first film while he was a graduate student; later, Nameth and Wegman would present their work at the Electric Circus, the New York club where Andy Warhol was an impresario of sorts, producing the "Exploding Plastic Inevitable," a combination of music, dancing, light shows, and performances by, among others, the Velvet Underground.[20] (It was Nameth, in fact, who made the 1966 black and white film *Andy Warhol's Exploding Plastic Inevitable*.)

Wegman sometimes showed his inflatable sculptures independently or in groups, sometimes with sound machines, light works, and kinetic pieces in what he called "interactive environments." Years later he would note, "It just seemed to make sense to align

yourself with the forefront of thinking—information theory.... It seemed like a copout to be a potter."[21] In 1967 in Illinois, Wegman filled a room with one of his inflatables for a twenty-four-hour John Cage performance, which, he recalls, was closed down by the local fire department.[22] Wegman also included an inflatable as part of "Famous Powder Dance," a performance/light show at the Electric Circus in 1968.

In 1967, for his MFA thesis, Wegman devised an interactive entity called *BODOH*—three inflatable tents, one black, one translucent, one black and translucent, and a twenty-foot-long polyethelene entry tunnel, each with hatchlike doors leading into a central core. Under the floor in each space were microswitches triggered by visitors' footsteps to set off lights, sounds, and the actions of various devices, not necessarily in predictable sequences. One tent held a cup-dropping machine (perhaps owing something to the inventions of Uncle Everett) that, Wegman recalls, "made an unbelievable din"; another contained, among other things, helium-filled weather balloons with battery-powered lights, while in the third Wegman's first film (also titled *BODOH*) was projected on "air driven" floats, some of them illuminated by ultraviolet.[23] As a totality the work was a cybernetic art machine, a participatory, unpredictably responsive kinetic environment that grunted, flapped metal wings, and flashed lights. The project was accepted as Wegman's thesis, but, he recalls, "I was getting an MFA in painting and they wanted to see some paintings. So I stayed back that summer and made paintings. They looked like glow-in-the-dark Frank Stellas— Stellas from the early black period."

The crosscurrents of art and technology were much in evidence during these years, whether in the "Experiments in Art and Technology" (E.A.T.) performances in New York or in the work of such artists as Jean Tinguely and Otto Piene in Europe. Many artists were exploring the possibilities of inflated sculptures, sometimes called "air art," and Warhol, as usual, had some of the best: he called his helium-filled silver-floating pillow forms "clouds." Wegman's ambitious *BODOH* project was, typically for him, both in the scene and out of the loop, an individual endeavor that was off by itself in approach and thinking, if not in overt stylistic results.[24]

After receiving his MFA in 1967, Wegman worked as an artist and teacher for three years in Wisconsin.[25] Here he experimented with elements and procedures that would reappear in later works: "found objects" (including himself), mesh screen, and fabrics, which he would work procedurally and then let gravity take its course (as Robert Morris and Richard Serra were doing with felt and rubber), suspending "bat wings" made of cloth from the ceiling, or coiling or curling them on the floor. Beginning in 1968 he worked for two years on what he called "screen pieces," most often made of window screening on which he performed simple maneuvers (or gave instructions for same, so that the works could be made and shown in his absence).

Wegman suspended his screen pieces from the ceiling, hung them on walls, and set them out on the floor. He considered them installations but not site-specific ones, so he could hang them on the wall in his apartment or send them to appear in group shows. He submitted one, for example, to Szeemann's exhibition "Live in Your Head: When Attitudes Become Form" (Bern, March 1969), and two more to an exhibition organized by Samuel Wagstaff at the Detroit Institute of Arts (September 1969).

Wegman always worked with inexpensive objects and materials, which often had a history of use: furniture, radios, foodstuffs (including grains and carrots), shoes, gunpowder, pots and pans, Styrofoam, or window screening. He used them for temporal and changeable sculptures, for staged tableaux, and sometimes for process works that by attrition or desiccation changed form. These might be considered low-tech cause-and-effect art machines, or, seen another way, as performative sculptures. Wegman also did performances, actions improvised both indoors and out. There were also more theatrical if also improvisational pieces that he called "Arrangements," which included the movement of materials (all the furniture from the college art department, for example) from indoors to out (p. 34). Photographs of these events survive to document them, but at this point Wegman had little interest in the photograph itself. Who actually worked the camera made no difference to him, and it was usually turned over to others— students or colleagues, including his friend Cumming. In graduate school Cumming had studied photography

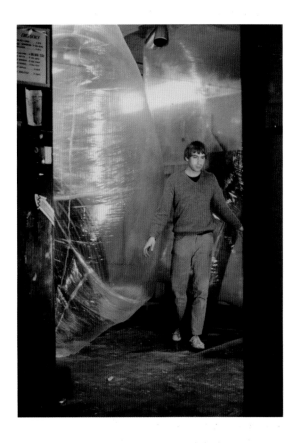

Inflatable sculptures 1967

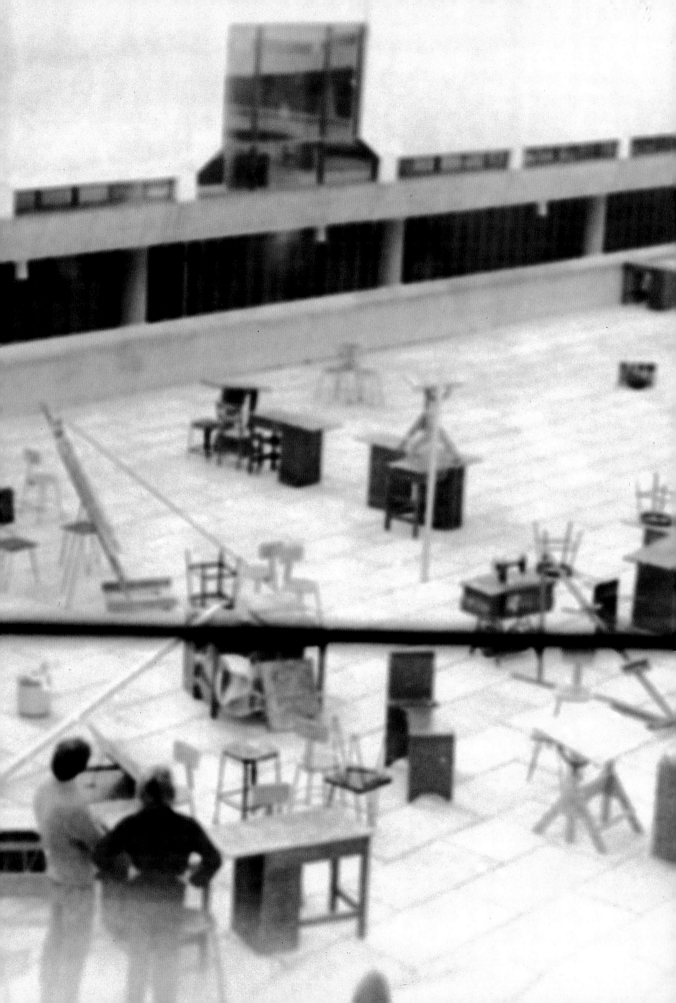

with the documentary photographer Art Sinsabaugh. (He also began to make sculpture, and as an undergraduate he had studied painting and printmaking.) Just as he had followed the same path as Wegman from MassArt to the University of Illinois, he too, like Wegman, had moved to Wisconsin in 1967. Back in Illinois, Cumming had begun to photograph his own work. In Wisconsin he eventually suggested that Wegman should do the same. (Cumming did not want to do it anymore, according to Wegman.) Wegman's students taught him how to use the darkroom to make his own prints.

By 1969, Wegman's outdoor works were beginning to get him included in such earth art shows as Willoughby Sharp's "Place and Process," at the Edmonton Art Gallery in September 1969, and he would soon appear in other shows and events organized by Sharp ("Body Works" in San Francisco in 1970; "Pier 18" in New York in 1971). He was also featured in *Avalanche,* the magazine Sharp founded in 1970 and edited with Liza Béar. His outdoor works might incorporate language, such as the Styrofoam letters accumulating along the shore of the Milwaukee River that he photographed from a bridge, having run up there after setting the letters afloat. In other works of this period Wegman formed words in colored aluminum shavings on fields of grass—the word "VIOLET" (1969; p. 35), for example, in the hue named, or the word "WILLOUGHBY," which was recorded in a small color snapshot (c. 1970), like a postcard or simply a report from the field. These works resemble Wegman's piece for the "Place and Process" show, which is documented in an article Sharp wrote for *Artforum,* where the entries give a sense of the concept and practice of process art by offering two paragraphs per work: one paragraph on the "Proposal" and another on the "Actual Work" executed. The entry on Wegman reproduces three photographs, with the caption "William Wegman, OR, Stages 1, 2, and 8. (Photo: the Artist.)" The text reads,

Proposal: Exhibit the currency from the sale of catalogs during the exhibition on the floor in a line beginning at a wall in the/a gallery/room. (Set up reasonable deposit times, e. g., twice a day. It may resemble a fund drive.) The work is for sale at a price exceeding the total by 20%.

Actual work: Wegman submitted a large number of works executed in the normal course of his artistic activities within the general time span of the exhibition. OR was selected. OR consists of masonite dust distributed by the artist at sites along the coast of Maine from 10:45 A.M. to 12:20 P.M. on August 28, 1969. The artist took photographs of each of the nine stages of work.[26]

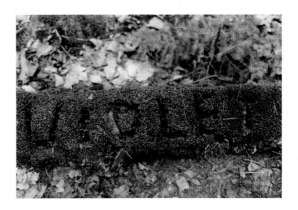

In other installations Wegman used language as elemental structure and as image. A particularly curious work involved setting out the letters S, T, V, D, Y, lit by a student desk lamp, in the vast plane of a plaza in the art school. At this point Wegman's photographs were to his mind merely secondary evidence of primary, temporal events. The photographs of STVDY (1969; p. 36), though, reflecting the drama of the siting, seem more self-conscious—carefully framed and shot. Wegman himself took these photographs, and he recognizes them as a "third" type of work: documentary in purpose, like his other late-'60s photographs, and so not considered a work of art by the artist, yet sharing visual characteristics with the staged photographs that he does consider part of his oeuvre, introduced by the eureka moment he would find in his tabletop black and white photograph *Cotto,* from 1970 (p. 45).

This ambiguous photograph type was a liaison, a bridge, in fact, between the actual documentary photograph and the "made," document-like photograph. As documents of a theatrical staging that is itself the artwork, the photographs of STVDY could confound the uninformed viewer, who might easily believe them to be fine art photographs themselves—

opposite: **Furniture Arrangement** 1969

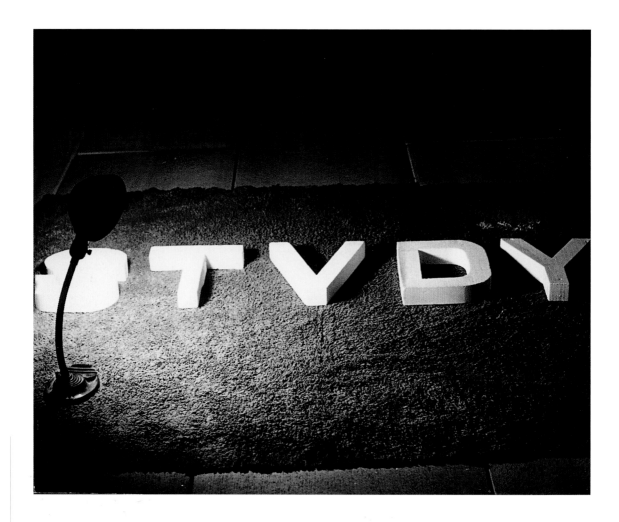

images set up expressly for the camera. This ambiguity of how to read the photograph, and what function it serves within Wegman's bodies of work, at this point becomes a critical and problematic issue. The question "Is it a document of an installation or is it a photo piece?" is often posed by curators looking at these early Wegman photographs, and not just the more "crafted"-looking ones; especially, in fact, the photographs that look like offhanded documentation.[27] At this moment in artmaking, when photographic media were entering the practice of so many artists, the very irresolution of these issues was the crux of some of the most important critical questions. If photographs were to be used, how so, and even more fundamentally, why?

Wegman soon began to incorporate photographs into his practice in more active, participatory ways, still ostensibly as documentary traces of temporal, improvisatory events, yet bordering on performance themselves. One piece from 1969, for example, involved flinging pieces of plywood into the air while arranging photographers—friends, students, amateurs, professionals—in a circle to shoot the event, and consequently each other (p. 37). (The plain facts make it sound like large-scale skeet-shooting, though without live ammunition.) Other photographs documented sequential or procedural happenings, such as the melting of a plank of Styrofoam by setting it in a tub of acetone, causing the plank, pierced at the top with two pencils, to draw a pair of lines down the wall as it disintegrated (1969; p. 38). The sequential photographs of this dissolution are noted like the proto-cinematic serial shots of Eadweard Muybridge. In another piece, based on the desiccation of a carrot, which Wegman photographed, he hooked the carrot to a string, so that when it shriveled it tripped a filament, which, being attached to a book, snapped the book shut.

Other works of this period involved shifting

STVDY 1969, gelatin silver print, 7 ¾ x 9 ½ in. (19.7 x 22.9 cm)

certain configurations within a room and taking paired photographs of them. Some involved bits of hair, mounted and labeled (1969) or absurdly blowing, apparently by a wall-mounted hand dryer gone awry. Another hair work shows Gayle Wegman speaking into a telephone receiver that seems to be shooting gales of wind upward so that her hair stands on end. A disjunction between cause and effect is a concern of Wegman's from this time forward in his use of doubling, comparisons, differences, and dislocations of what seems to be and what actually is happening.

Wegman's photographs gradually turned into the main event: photographs resembling documents of activities were in fact only "decisive" of a moment staged expressly for the camera and were shot by Wegman himself. He also used photographs as elements in other works—sculptures, process works, or wall-mounted reliefs. In a work from 1968–69, for example, eight-by-ten-inch photographs of pages of a phone book were shown unframed, curling at the edges, and affixed to wooden lattices on the wall, disposed in a way that was for Wegman like diagramming sentences.[28] He also printed photographs in different sizes to make comparison pieces. In one, from about 1969, six-foot-high photos of Wegman and colleagues are scaled so that each person, whatever his real height, becomes six feet tall (pp. 40–41). For another work using the same principle, alternately called *Fingers* or *Index* (1973; pp. 38–39), Wegman scales photographs of his fingers so that all are the length of his index finger, the finger sometimes called the "pointer." Wegman later returned to the idea in a pencil sketch, scaling thumb to doorway height. Scale comparisons appear in a number of his early-'70s photographs.

One critical variation on Wegman's formal, visual, and linguistic interplay in photo works appears in a set of photographs he used in sculptural configurations in 1968. He began by writing the letters W, O, U, N, and D on his face with Band-Aids, one letter at a time, then shooting images of his face showing each letter in turn (p. 42). In one installation variation he made eight-by-ten-inch prints of these photos and affixed them to wooden lattices on the wall. He later took four-by-five-inch photographs of this installation, along with reprints of the original photos also at four-by-five-inch size, and tucked them into

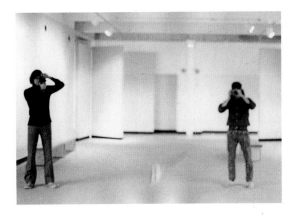

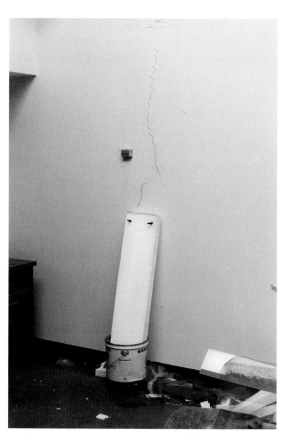

"Drawing made by dissolving a Styrofoam plank" 1969

a large pile of grain on the ground, along with a tripod, the odd sneaker, a cooking pot, etc. (1968; p. 42). Such objects also showed up in Wegman's early videos.

By 1969 Wegman had begun to experiment with 8mm film and with video, borrowing Craig video equipment for the latter from the University of Wisconsin education department—"separate components of camera, recorder, monitor and microphone" that "had to be hooked up properly to work." And it was in video, he wrote, that he found to a certain extent a solution to logistical problems he had been having with scale: "Video offered a way for my work to acquire uniformity. I was particularly perplexed by the scale problem. Big is good but hard to store. Small, nobody gets to see. Video exploded the whole issue of size and scale."29

Wegman taught at the University of Wisconsin, Madison, for the 1969–70 school year. As a sculptor he was both teacher and visiting artist, and there he met faculty artists such as Victor Kord and visiting artists Robert Morris, John Chamberlain, Richard Artschwager, Malcolm Morley, and Tony Shafrazi, among others. In the late 1960s the Madison campus was the site of many antiwar protests, some of which the authorities met by use of force. Opposition to the Vietnam War was strong on American college campuses, protesting the actions of both the U.S. government and private companies assisting the war effort. During this time, Wegman says, he was "a card-carrying member of the piece movement,"

a sardonic pun on his own artmaking and on the antiwar effort. William Severini Kowinski writes of Wegman's reaction to the large and tumultuous scene in Madison:

Wegman responded to the frenetic activity—and against the overstimulation. "I felt I was an isolated figure in an enormously uncontrollable but exciting environment. I never thought about this or said this before, but that's maybe why I turned to video, because it provided me with a sanctuary of being able to work inside a closed room without anyone else around. It was returning to a narrower little screen, but it also appealed to me because it was very big—you could broadcast it, it had the potential of reaching an enormous audience."30

Perhaps the key event in Wegman's artistic life in 1970 was a moment he later described in a text called "Eureka," a day's events that led him to start to stage scenarios for the camera so that the photographs would become the work rather than a document of it.31 According to the now-well-known story, one day, before attending a party, he drew on his hand some circles that "parodied the shapes" of the stones of his ring. As this was 1970, a touch of body painting and a ring worn on the index finger were not out of the ordinary. Later, at the party, he recognized a similarity between the circles on his hand and some slices of Cotto salami, where peppercorns in the

Index 1973, gelatin silver prints, work in five parts: 13 ½ × 10 ¾ in. (34.3 × 27.3 cm), each. Collection of Ed Ruscha, Los Angeles

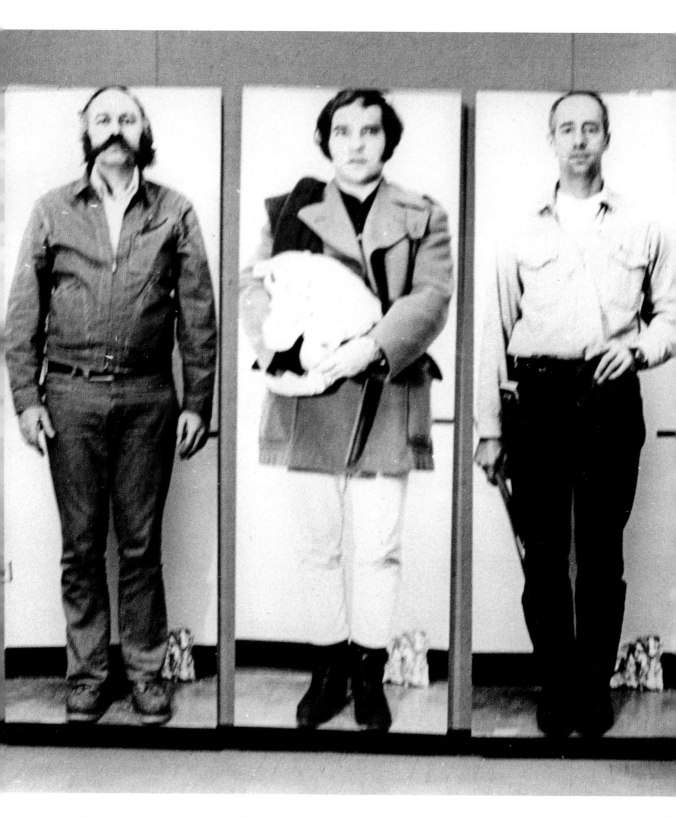

"Five figures printed at six feet" c. 1969 (from left to right: Wayne Taylor, Richard Reese, Robert Morris, Victor Kord, and William Wegman)
Installation view with Robert Cumming, foreground

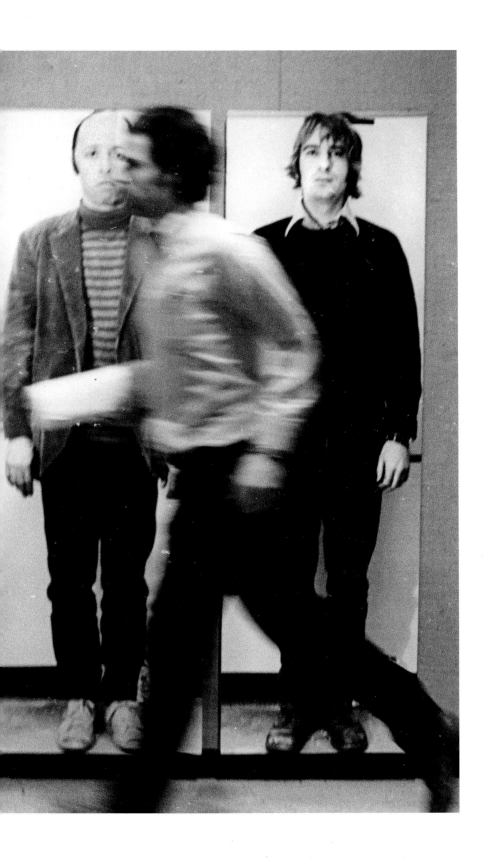

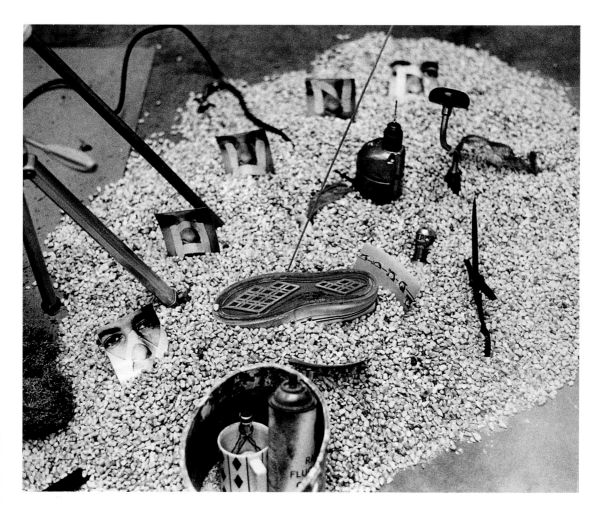

WOUND 1968, gelatin silver print, installation view, 7 ⅛ × 9 ⅝ in. (20.2 × 24.4 cm). Private collection

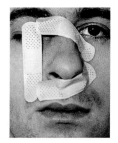

WOUND 1968, gelatin silver prints, work in five parts: 4 ½ × 3 ½ in. (11.4 × 8.9 cm). each. Private collection

meat showed the same pattern of black-circumference-around-light-center. "It was eerie. The salami looked like my hand." Wegman writes that he "rushed home from the party, bought a new package of salami from the market and set up the picture." The resulting photograph (p. 45) is an artful arrangement of overlapping circles of salami, set off by the white of the circular plate, which itself rests on the dark speckled ground of the table. The long ancestry of tabletop photography was irrelevant to Wegman at the time, as he had no background in photographic history.

This self-described "'60s minimalist-conceptualist," as he called himself in the "Eureka" text, had been trying to work himself out of "a tough corner of what to do next (that would be new and different) not painting—not sculpture not too much like Sol Lewitt [sic], Carl Andre, Robert Smithson etc." In the staged photograph *Cotto* he discovered what had been missing from his related found-object installations, through which he had "hoped to find a way out" but that, as he wrote in "Eureka," were "interesting but lacked something. Reason and clarity—clear departure points, beginnings and ends which I felt uneasy about not having." For Wegman, the setup picture "proved to be the answer and the way out."

Although Wegman had already done a few photographs he considered fully realized, *Cotto* provided a key staging. Also, not unimportantly, it had a good story. The other photographs, such as *Faculty Lounge* (also 1970 but earlier than *Cotto*; p. 43), lacked such a tale. The inclusion of at least a fragment of

narrative would soon become a critical element in Wegman's work, as it had been in another of the pre-*Cotto* photographs he had considered fully realized, the 1969 *Shower* (p. 48), in which he had placed a short paragraph encapsulating a story on the print's back (it is sometimes published as a kind of subtitle). To a take on the shower locale of the indelible murder scene in Alfred Hitchcock's *Psycho* (1960) he had added the conceptual artist's instructions, scripted actions, and immediately present narrator/persona, who is nevertheless out of the frame, hidden from view: "Turn on the shower, leave the room, close the door, leave the house, return to be frightened. The photo is of my shower and I am by the door."[32]

Whether used as instructions for conceptual and "idea art" shows or written in letters across his face or on the back of a photo, text was a pressing issue in Wegman's work. A particularly curious marker of the period is "Lunar Landing Concert (information and tasks)," a set of performance instructions conflated with a bit of mail art for the University of Illinois, Urbana, and "Program for a concert co-incident with the moon landing July 20–21, U. of Ill Champain [sic]."[33] The much anticipated lunar landing—the culmination of a Kennedy-era vision and a collective national ritual act of television-watching—turned out to be perhaps the performance of the century. The

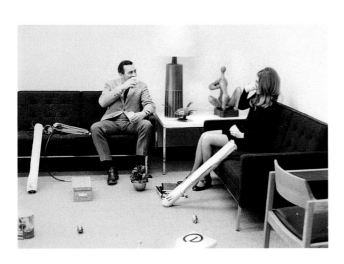
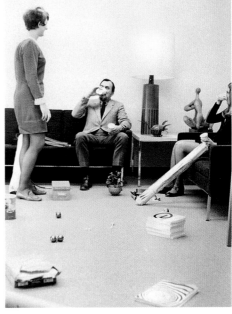

Faculty Lounge 1970, gelatin silver prints, work in two parts: 9 ¾ × 7 ½ in. (24.8 × 19 cm), each

experience of seeing the helmeted and space-suited
astronaut walking, or rather bounding, on the moon,
and of hearing, as if in a voiceover accompanying live
footage, the apparently offhanded but possibly
prescripted or premeditated remark "One small step for
man, one giant leap for mankind," related to a number
of contemporary art ideas: performance, of course,
but also the focus on video surveillance as a distinct
feature of that new medium, just as the earlier space
shots of earth from afar seemed a few degrees more
surreal than art's contemporaneous fabricated, fictional
documents in the form of still photos. Wegman's piece,
somehow conflating the ceremonies of a Red Sox
game (at its opening) and the famous rocket piercing
the eye of the man in the moon in Georges Méliès's
Trip to the Moon of 1902 (in its closing), goes as follows:

```
TASKS
concert time/hour: minute

0:30 - Applaud for 30 seconds inhaling and exhaling vigorously

1:00 - Remain still and silent for one and one-half minutes.

1:10 - Focus on a point furthest from your position.
Upon exiting, note whether you move towards or away from this point.

1:20-1:21 [handwritten] - Retain the sounds heard during this segment and sing them
when man first touches the moon. We may call it the "Moon Glowed Banner" and use
it before sporting events up there.

Distribute the elements in the pack/a pack with bird seed & confetti
[handwritten]/along the sidewalk on Green Street near Sixth.
Meaning expires July 28, 1969.

If you like, detach and fill in the form/send to Willoughby — [handwritten] for
free show.

- - - - - - - - - - - - - - - - - - - - - - - - - - - - - - - - - - - - - - - -

Fill in and send to: Willoughby Sharp, Director, Kineticism Press,
200 Park Avenue, New York, New York 10017

Dear Mr. Sharp:
Whenever I _____, I get this _____ burning sensation
near / in / on / my _____.
It feels like _____.
For relief I _____.

Signature

_____

optional adddress [sic]

William Wegman / bg / 7/20/69
```

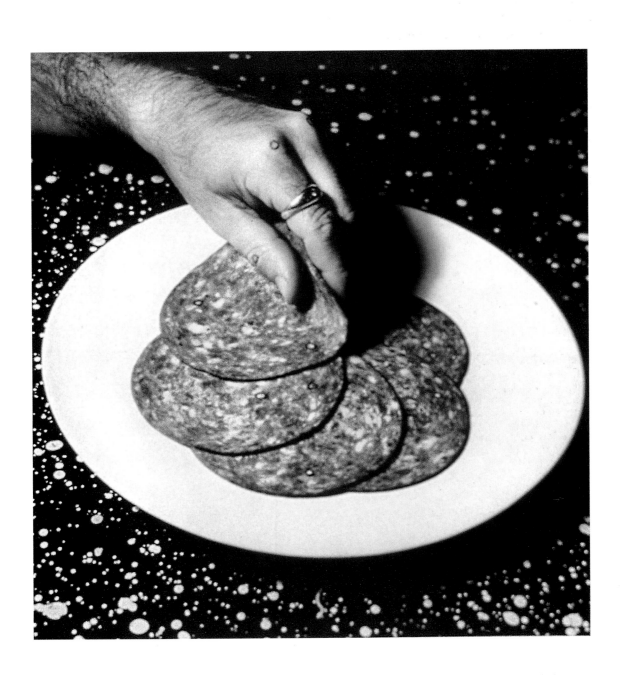

Cotto 1970, gelatin silver print, 10 ½ × 10 ¾ in. (26.7 × 27.3 cm). Collection of Ed Ruscha, Los Angeles

Wegman and Robert Cumming corresponded with each other after graduate school, and their cards and letters are full of jokes, fictive stories, and invented names, including Cumming's references to Wegman as "Wegs," "Franz," and "hot shot." Cumming's photocards are handsome and witty, often conveying verbal and visual puns. The two artists had the first of three two-person shows in 1969, while both were living in Wisconsin, and in 1970 both moved to southern California.[34] Of his friend's move Wegman wrote, "I'll be teaching life painting and drawing at Cal. State–Long Beach. No joke. Cumming is going."[35] They became known for a time as young California artists. Cumming's postcards to Wegman are classic examples of mail art, inexpensive and even less object-like than artist's books, to which they are related.

In the late '60s Wegman's attitude toward photography was indifferent; his address of the medium ran almost directly counter to that of Cumming, who was an admirer of a "broad spectrum [of photography's traditions] from [Jacques-Henri] Lartigue, [Robert] Frank and [Diane] Arbus to [Edward] Weston, [Frederick] Sommer and [Darius] Kinsey," as Cumming would tell an interviewer. "The conceptualists generally rejected this kind of history. I always found it extremely interesting."[36] Wegman, by comparison, has said, "I was so against photography. I used to argue that it wasn't art. I used to put dust in my photographs to make them look crappy. I was pretty arrogant about it."

BLACK AND WHITE PHOTOGRAPHS
AND
ALTERED WORKS

Shower "Turn on the shower, leave the room, close the door, leave the house, return to be frightened.
The photo is of my shower and I am by the door." 1969, gelatin silver print, 7 ½ × 7 ½ in. (19.1 × 19.1 cm)

Untitled (leaves on/leaves off) 1969, gelatin silver prints, work in two parts: 4 ¾ × 3 ¾ in. (12.1 × 9.5 cm), each
Collection of Christine Burgin

Stutter 1970, gelatin silver print, 7 × 7 in. (17.8 × 17.8 cm)

Shaking Hands 1972, gelatin silver print, 10 ½ × 13 ¼ in. (26.7 × 33.7 cm)

Hems 1971, gelatin silver prints, work in four parts: 13 × 10 ¾ in. (32.6 × 27.3 cm), each
Collection of Anita and Horace Solomon, New York

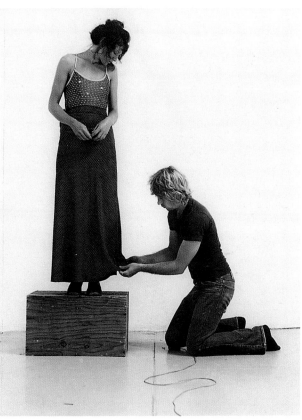

BEFORE LEARNING TO WRITE WITH HIS SWEATER
HE LEARNED TO WRITE WITH HIS HAND

Sweater Writing 1972, gelatin silver print, 14 × 11 in. (35.6 × 27.9 cm). Collection of Ed Ruscha, Los Angeles

LEARN TO DANCE WITH MODERN ELECTRONIC EQUIPMENT

Learn to Dance with Modern Electronic Equipment 1973, gelatin silver print, 14 × 11 in. (35.6 × 27.9 cm)

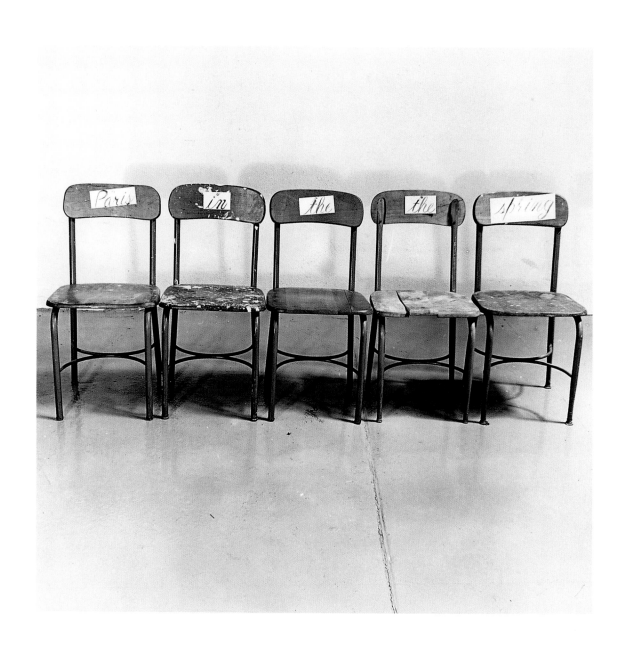

Paris in the Spring 1971, gelatin silver print, 14 × 11 in. (35.6 × 27.9 cm). Collection of Shashi Caudill and Alan Cravitz

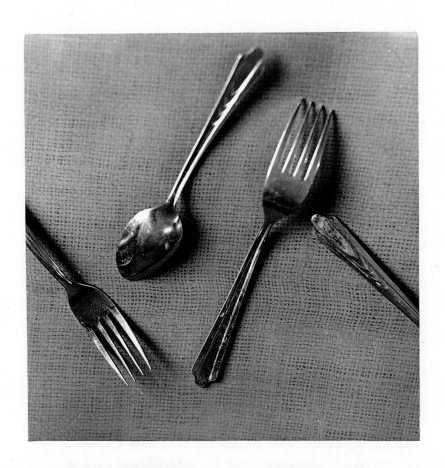

ONE OR TWO SPOONS , TWO OR THREE FORKS

One or Two Spoons, Two or Three Forks 1972, gelatin silver print, 14 × 11 in. (35.6 × 27.9 cm)

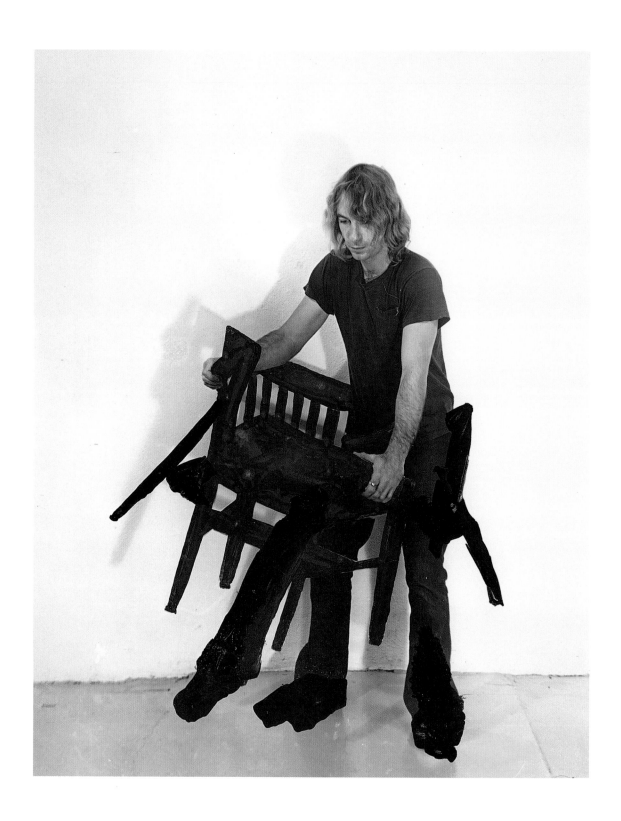

Leggy 1973–77, gouache on gelatin silver print, 13 ¼ × 10 ½ in. (33.7 × 26.7 cm)

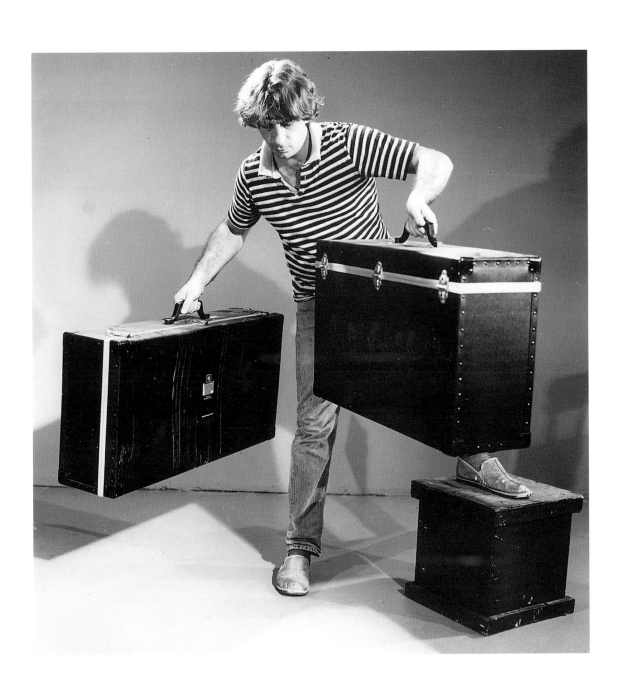

Cases: Heavy/Light 1979, gelatin silver print, 11 × 10 ½ in. (27.9 × 26.7 cm)

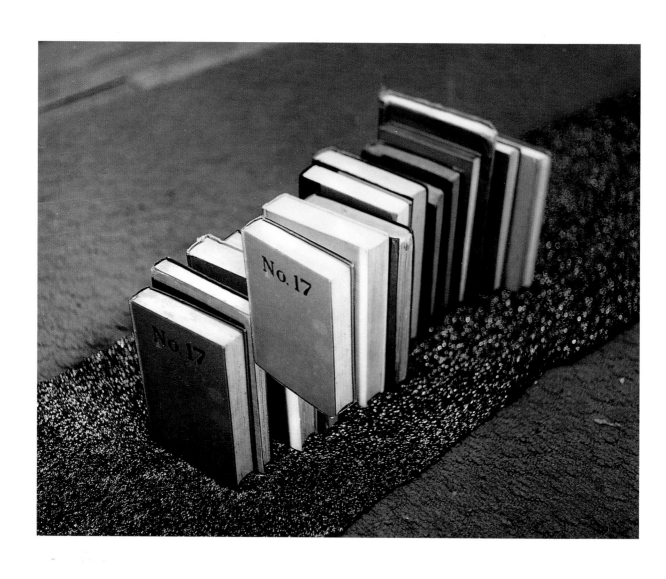

No. 17 1976, collaged gelatin silver prints, 10 ½ × 13 ¼ in. (26.7 × 33.7 cm). Collection of Christine Burgin

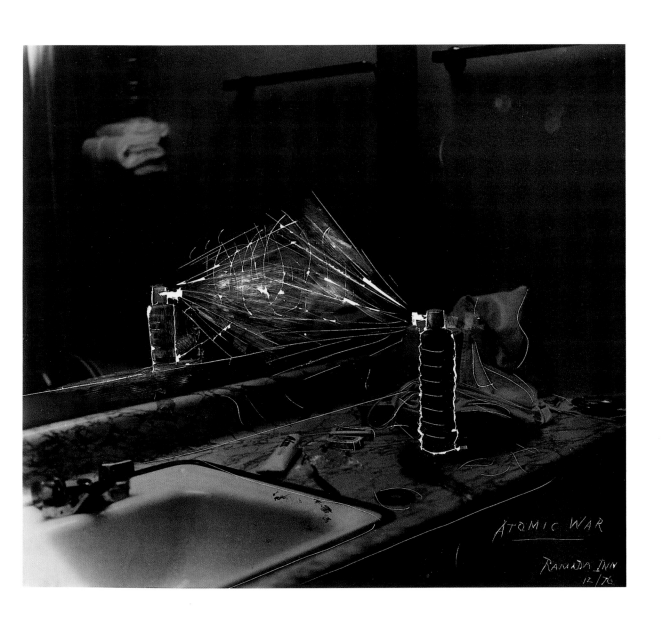

Atomic War: Ramada Inn 1976, cut gelatin silver print, 19 ¾ × 16 in. (50.2 × 40.6 cm)

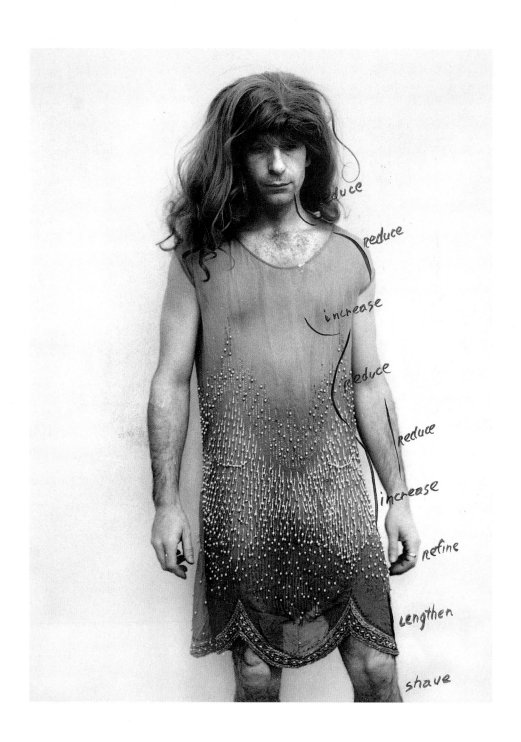

Reduce/Increase 1977, ink on gelatin silver print, 13 ¾ × 10 ¾ in. (34.9 × 27.3 cm)

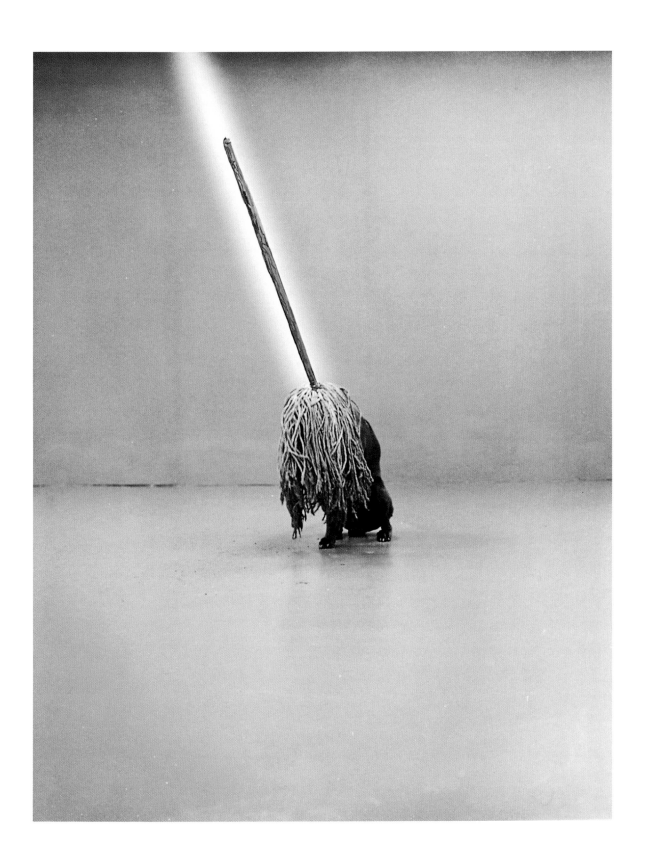

Messiah 1978, gouache on gelatin silver print, 20 × 16 in. (50.8 × 40.6 cm) 63

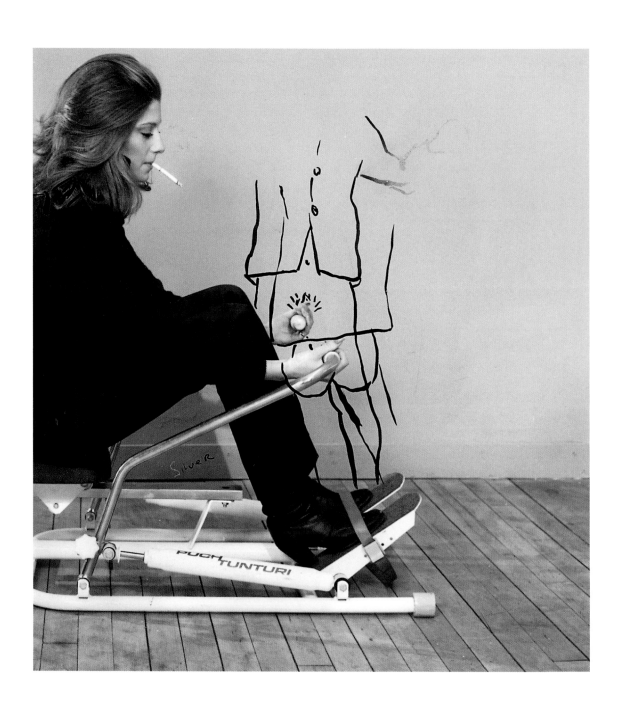

Exercise 1980, ink on gelatin silver print, 16 ¾ × 14 in. (42.6 × 35.6 cm)

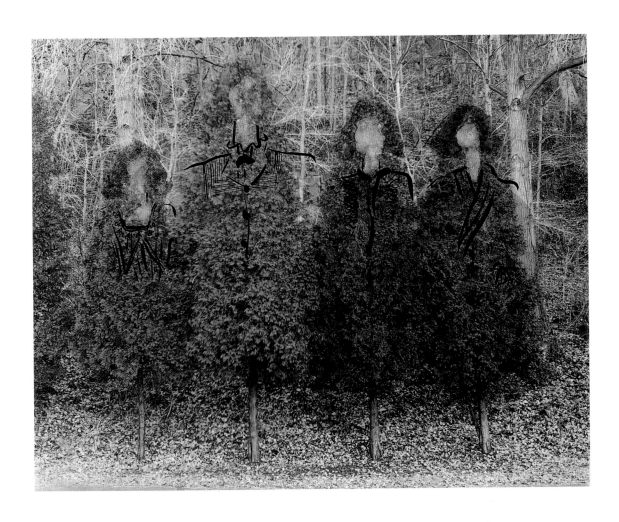

4 Trees with Coats 1982, ink on gelatin silver print, 14 × 11 in. (35.6 × 27.9 cm)

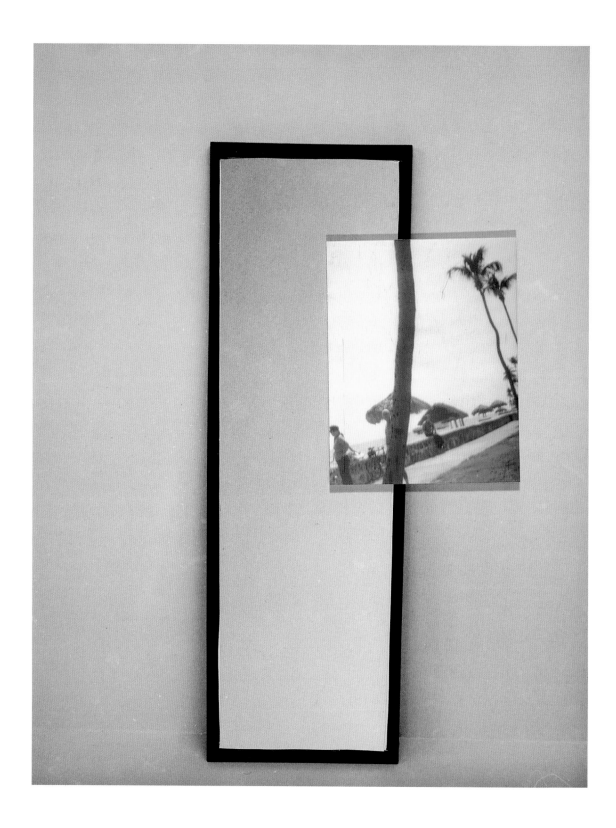

Window 1982, collaged gelatin silver prints with 3D postcard, 13 ¾ × 10 ¾ in. (34.9 × 27.3 cm)

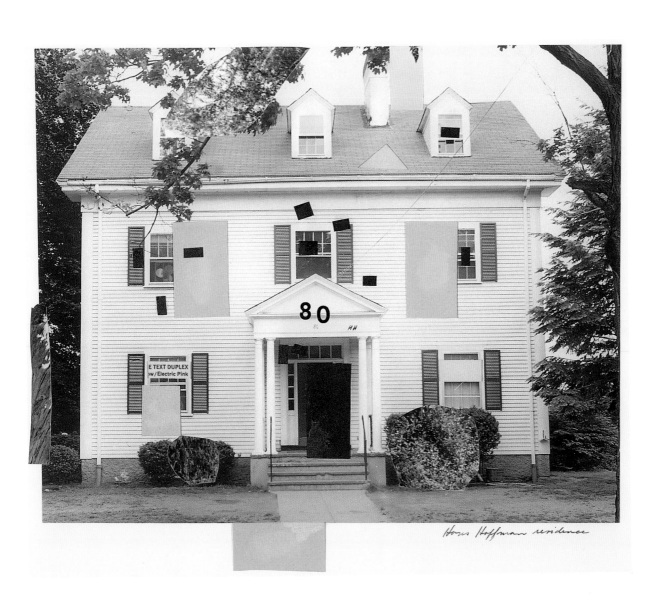

Hous Hoffman residence

Hofmann Residence 1981, ink and colored paper on gelatin silver print, 26 × 23 ¼ in. (66.1 × 59.1 cm)

Ray on the Rocks 1978, gouache on gelatin silver print, 21 × 19 ⅞ in. (53.3 × 50.5 cm)

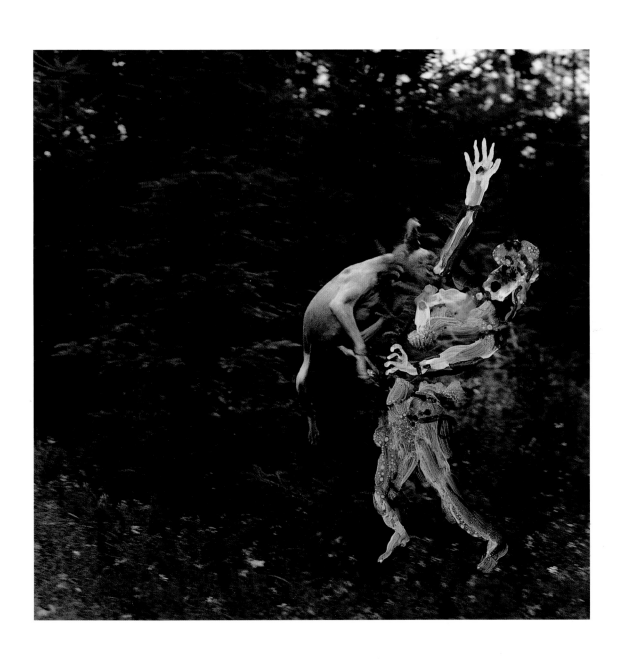

Attack Dog 1996, gouache on gelatin silver print, 10 ³⁄₈ × 10 ³⁄₈ in. (26.4 × 26.4 cm)

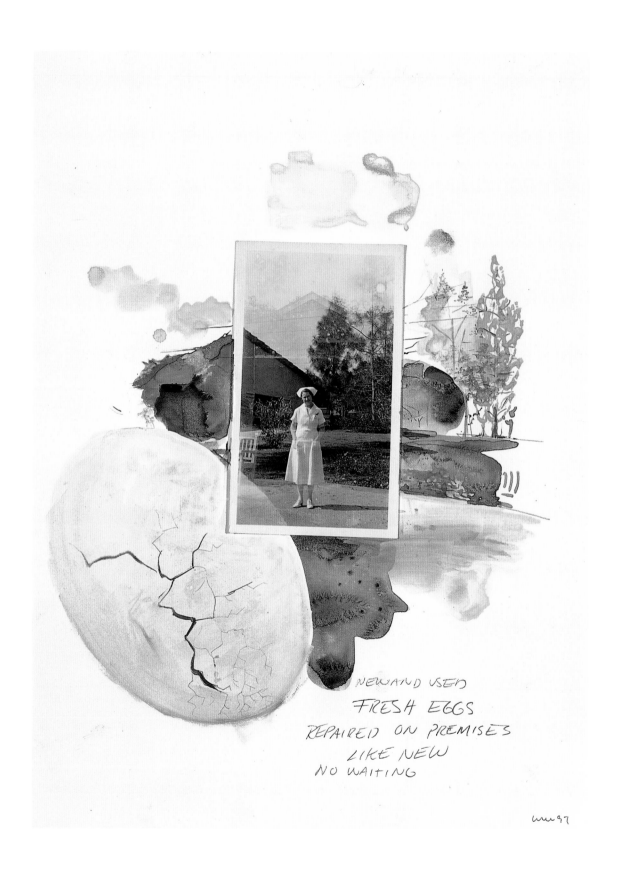

NEW AND USED

FRESH EGGS

REPAIRED ON PREMISES

LIKE NEW

NO WAITING

Egg Nurse 1997, ink, gouache, and found photograph on paper, 16 × 12 in. (40.6 × 30.5 cm)

2 DOGS DRESSED UP TO LOOK
LIKE CHILDREN

THEY WERE GIVEN IDENTICAL
SETS OF CLOTHING AND WERE
INSTRUCTED TO DRESS ANY
WAY THEY WANTED TO.

THE TWO DOGS WERE UNRELATED
IN ANY WAY SHAPE OR FORM
TO THE CHILDREN THEY
WERE ASKED TO PORTRAY

2 Dogs Dressed Up to Look Like Children 1997, gouache and found photograph on paper, 14 ½ × 11 ½ in. (36.8 × 29.2 cm)

Flight Confirmation 1997, watercolor and greeting card on paper, 15 × 22 in. (38.1 × 55.9 cm)

opposite: **Workbasket Work** 2001, detail of four of sixteen *Workbasket* magazine covers with gouache, 7 ⅞ × 5 ¼ in. (20.1 × 13.3 cm), each

THE WORKBASKET and HOME ARTS MAGAZINE

October, 1976 493

50c

The **WORKBASKET** ®
and HOME ARTS MAGAZINE

Number 12 • Volume 31 • September, 1966 372

25c

The **WORKBASKET** ®
and HOME ARTS MAGAZINE

Number 10 • Volume 37 • July, 1972 442

25c

The **WORKBASKET** ®
and HOME ARTS MAGAZINE

Number 1 • Volume 32 • October, 1966 373

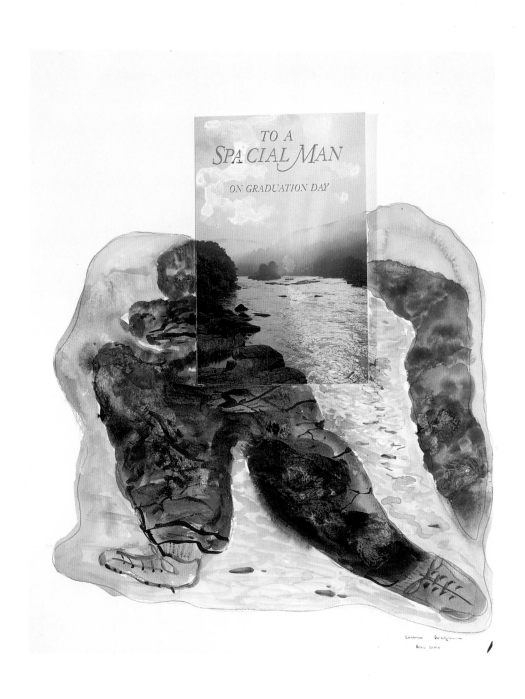

To a Spacial Man 2000, watercolor and greeting card on paper, 17 ¾ × 14 in. (45.1 × 35.6 cm)

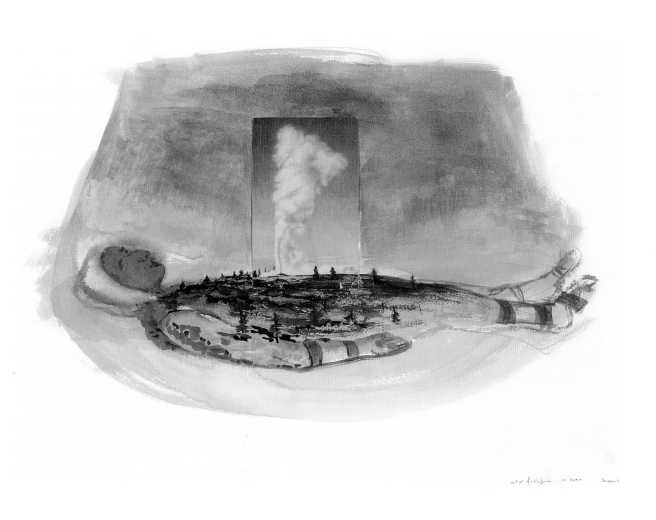

Old Faithful 2000, watercolor, gouache, and postcard on paper, 15 × 22 ½ in. (38.1 × 57.2 cm). Courtesy of Texas Gallery

Last Poker and Supper 2000, ink, gouache, and postcard on paper, 15 × 22 ½ in. (38.1 × 57.2 cm)
Courtesy Sperone Westwater, New York

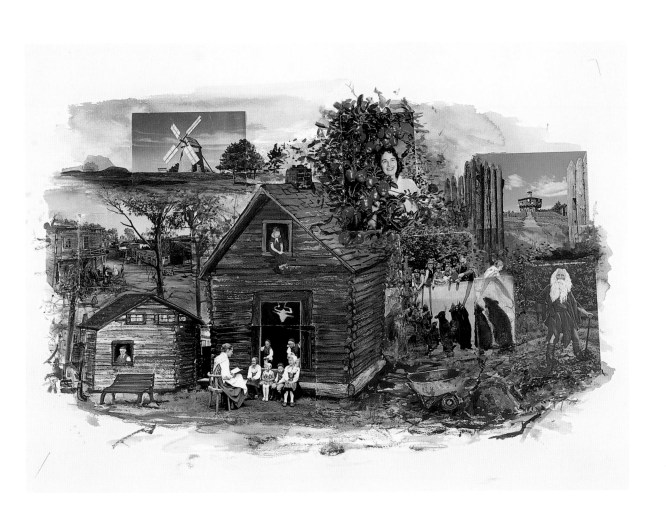

Cinema 2001, gouache, casein, and postcards on paper, 22 ½ × 30 in. (57.2 × 76.2 cm)
Collection of Gian Enzo Sperone, Courtesy Sperone Westwater, New York

Wearing Alhambras 2002, graphite, gouache, and postcards on paper, 23 × 29 ¾ in. (58.4 × 75.6 cm)

What Did You Say? 2000, ink, watercolor, and greeting card on paper, 17 × 19 ½ in. (43.2 × 49.5 cm)

Flying Water 2002, casein, gouache, and postcards on paper, 22 ¼ × 30 ¾ in. (56.5 × 78.3 cm)
Collection of Jessica Pell

The Architects 2003, gouache and postcards on paper, 22 ½ × 30 in. (57.2 × 76.2 cm)

Private collection

Tour Group 1977, ink on gelatin silver print, 10 ½ × 13 ½ in. (26.7 × 34.3 cm)

Walls 2002, gouache and postcards on paper, 22 ¼ × 29 ¾ in. (56.5 × 75.7 cm). Private collection, Houston

Bob and Ray 1996, gouache and greeting card on paper, 12 × 16 in. (30.5 × 40.6 cm)

Ozzie and Harriet 2004, watercolor, gouache, and postcards on paper, 22 ½ × 30 in. (57.2 × 76.2 cm). Private collection

he always said he wished to be an Indian*."

* "Souix, I think!"

Sioux 1970, gelatin silver print with collaged typewritten text, 6 ¼ × 6 ½ in. (15.8 × 16.5 cm)

DOUBLE PROFILE 1970–1985

On Sunday, January 10 1970, William Wegman sat in his Madison, Wisconsin studio and stuck toothpicks into his gums. Eleven photographs, each with a typewritten inscription, became *Eleven Toothpick Expressions* (… "He was an unusually quiet child.")

 —Willoughby Sharp, "Body Works"

Willoughby Sharp began his article "Body Works," in the inaugural issue of *Avalanche* (fall 1970), with a column of paragraphs each devoted to a single work by one of nine artists. "These nine works share a common characteristic," Sharp wrote, "the use of the artist's own body as sculptural material. Variously called actions, events, performances, pieces, things, the works present physical activities, ordinary bodily functions and other usual and unusual manifestations of physicality."[1]

 Were it not for this mention in *Avalanche*, and other notes, interviews, and photographs from the same magazine, we might have no record of a number of Wegman's temporal and performance works, particularly during the critical transitional year of 1970. The fragmentary nature of the reporting matched the method of these events, and this glimpse into Wegman's studio at the very outset of that year includes enough information for a further reconstruction of the piece, giving context to one of the surviving "tooth-pick expressions," *Sioux* (1970; p. 86), in which a legend typed on a piece of paper in front of Wegman's face seems to fill in another aspect of a child's biography: "he always said he wished to be an Indian. Souix [*sic*], I think."

 In addition to performing this particular action for his still camera, according to Wegman, he also executed it before his Super 8 film camera. For this version (whereabouts presently unknown) he set the toothpicks on fire: "I put them in between my teeth and lit them like a birthday cake."

 The same issue of *Avalanche* included another Wegman mention in its "Rumbles" section, this time charting his work in May of 1970, describing his earlier practice and exhibition history, and also capturing

his own cheeky commentary:

William Wegman performed *Three Speeds, Three Temperatures* ... this May in the faculty men's room at the University of Wisconsin, Madison, where he taught last year. Since his participation in *When Attitudes Become Form* at Bern [1969], Wegman has executed an unusual range of works including outdoor projects, floor arrangements, punning sculpture, body works, and a piece involving a sleeping girl and a dog. "They're always asking me what my work stands for and I always tell them it doesn't stand, it sits."[2]

Like Wegman's "toothpick expressions," *Three Speeds, Three Temperatures* (p. 88) was an event staged for the camera: three variations on the same occurrence, water flowing from a tap. As the title states, the photographs address time and heat, speed and change, through a sequential setup recalling Eadweard Muybridge. But where Muybridge tried to show something imperceptible to the eye (in, for example, his famous photographic experiment to determine whether all four hooves of a galloping horse leave the ground), Wegman's camera records the intangible through

something quite evident: visible forms in space— thicker or thinner columns of water in three separate streams—serve to indicate time and flow, for the wider the column, the faster the speed. To document temperature is something else again, out of the photograph's range—except, perhaps, that a close reading of the virtually identical taps reveals different degrees of rotation, settings for different water temperatures. In bespeaking the visual content of the pictures but not their literal subject, Wegman's title shows up the disjunction between text and action, action and document, and a viewer's assessment of how they fit together. Knowing that he performed this "water-work" in the men's room of the faculty lounge at the University of Wisconsin, Madison, suggests how he used his surroundings as a found object whose contents he could manipulate.

Three Speeds, Three Temperatures provides a context for several photographs that Wegman would set up after moving to California in the summer of 1970, including *Dishes ... Falling Glass* (1970; p. 89), which also displays a running faucet; *Photo Under Faucet*; and *Photo Under Water* (1971; p. 90). In the latter two works Wegman plays with the duality of image and self (both include the same self-portrait) and also with

Three Speeds, Three Temperatures 1970, gelatin silver print, 7 ¾ × 9 ⅝ in. (19.7 × 24.4 cm)
Collection of Shashi Caudill and Alan Cravitz

different ways to handle the existing photograph. In *Photo Under Faucet*, a diptych, the print at left is a shot of a stream of water falling from an unseen faucet into Wegman's mouth, while the print at right shows a similarly cropped open-mouthed Wegman in a photograph in which ripples over its surface indicate it is submerged in water. The photograph seen on the left in *Photo Under Faucet* reappears in *Photo Under Water*, but here a print of it—this time full frame, not cropped—has been laid in a photographer's shallow developing tray and the tray has been set in a sink under a running faucet. A photograph of this new arrangement—the faucet again outside the frame—constitutes the finished work. Like a play within a play, *Photo Under Water* complicates real and illusion, mischievously taking a Wegman work as a ready-made.

These Wegman under-water and under-faucet photographs seem to play with and against an admired if barely "elder" artist, Bruce Nauman, calling to mind his famous black and white and color photographs of himself as a "fountain" spewing water from his mouth (p. 89). Between 1960 and 1964 Nauman had been an undergraduate at the University of Wisconsin, Madison, where Wegman had later taught, and by the fall of 1970 both men were living in southern California. Coming to know each other by playing in the same basketball game, they shared a love of music, a philosophical bent, an affinity for word games, and a sense of the moral intensity of the work done by artists and teachers at Madison.

Nauman's *Self-Portrait as a Fountain* (1966) and *The Artist as a Fountain* (1966–67; p. 89) are in one sense commentaries on '60s body art. They comment still more on the state of both contemporary and classical public sculpture at the time, as well as on

Bruce Nauman
The Artist as a Fountain
1966–67
Gelatin silver print
8 x 10 in. (20.3 x 24.5 cm)
Collection of the artist
Courtesy Sperone Westwater, New York. © 2005 Bruce Nauman/Artists Rights Society (ARS), New York

contemporary figurative sculpture, including such abstracted figures as those of Henry Moore, which Nauman felt were too easily dismissed by his artist contemporaries. Wegman's water/faucet works also parody body art, and the documentation of it, but serve perhaps more sharply as a statement about the creation not only of photographs but also of identity itself. Showing himself in these works as a self literally being developed, Wegman distinguishes himself from Nauman in the fountain photographs: in a way both subtle and slightly slapstick, he isolates the idea that an artist, in taking photographs (here actual self-portraits), processing the negatives, and developing the prints, is self-evidently and self-reflexively creating a public self. He shows an image of himself in the process of becoming visible—and at the same time jokes, not spouting water like Nauman, but taking it in.

In the '60s and '70s the principle of the photographer printing his or her own work, and being responsible for its physical qualities—its perfection of surface, its tonal gradations—was in decline for some artists involved with the medium. Early in his own career, Wegman has said, he was uninterested in photographic processes and their histories (even as he learned from his students how to print his own photos). His curiosity about them during the period of

Dishes ... Falling Glass 1970, gelatin silver prints, work in three parts: 7 ⅝ x 7 ⅝ in. (19.3 x 19.3 cm), each

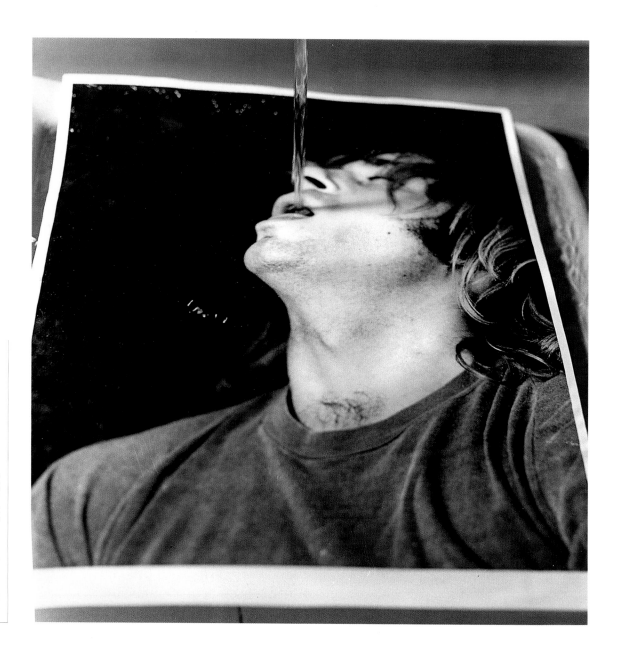

Photo Under Water 1971, gelatin silver print, 10 ¼ × 10 ⅜ in. (26 × 26.4 cm)

the water/faucet works came with an ironic distance, and he had no concern with the making of fine-quality photographic prints. He was interested, on the other hand, in fooling with the *conventions* of photography.

But the fountain and water/faucet works signal something about the artists' different approaches: where Nauman actively reanimates the fountain and offers himself as "sculpture" (no matter how absurd the gesture seems), Wegman treats himself as a passive receiver. If Nauman parodies heroic sculpture and the figurative fountain, Wegman is an average, unheroic sort to whom things happen and who makes mistakes or is caught in misunderstandings or improbable situations.[3] It was Craig Owens, writing in 1983, who recognized how fundamental this persona is to Wegman's work:

> In our culture, achievements are invariably teleo-logical and always comport some more or less explicit idea of mastery; whereas Wegman's work—if the plurality of his works can indeed be reduced to the singularity of an oeuvre—has been characterized from the very beginning by a deliberate refusal of mastery.
>
> Until recently, Wegman worked almost exclusively in video, drawing, and black-and-white photography; his works in these mediums are distinguished by their informality, artlessness, even vulnerability. Still, his refusal of mastery is not simply a matter of technique; rather it is often the explicit theme of his works, which speak of failure more often than success, of intention thwarted rather than realized, of falling short of rather than hitting the mark.[4]

Wegman also makes us aware that we are seeing a picture of a picture of him performing—the self at several removes. As Jean-François Chevrier writes, "Through this dialectic of difference and repeti-tion (articulated around reproduction), with its gaps and reversals, we are led back to the crux of the debates about art around 1970: the general question of identity. And of the identity of art itself."[5] In many ways a paradigm for the changing notions of artworks at that time, and for the changing function of photography in relation to artmaking, Wegman's art of 1970 also illuminates the different roles the artist was coming to play, including the different ways in which the artist's

identity could be called on, evidenced, or invented. Wegman's "Wegman" persona, like Jorge Luis Borges's "Borges" or the performance artist Spalding Gray's "Spalding Gray" (to cite another storyteller who was a closer contemporary of Wegman's), was both real and fictive, with the plausibly true and possibly not-true taking up the same imaginative space.

The year 1970 was not only the one in which Wegman moved to California and in which he acquired his first weimaraner; it was also the year that Sharp, as publish-er, and Liza Béar, as editor, began to publish *Avalanche* and that A. D. Coleman began to write photography criticism for the *New York Times*.[6] The last two items appear in this discussion in the former case because it reflects the emergence of a style of art-writing whose authors and editors were on common ground with the artists making the new Conceptual work (itself a radical change from earlier critical hierarchies of the '60s), and in which the makers of these time-based and photo-recorded works could speak for themselves. As for the *Times*, the newspaper of record's hiring of a photography critic signaled its perception of a new audience large enough to be interested in such special-ized coverage.

The first black and white works that Wegman made in California provoke discoveries of same and different—sometimes almost imperceptibly different, as in the diptych *Light Off/Light On* (1970; p. 92), where what distinguishes the two photographs is the tiny detail of a light switch in the up or down position. As a minimal statement of nonaction and action, this is perhaps the simplest form of narrative, not unlike Lumière's famous, far more active—and obviously visi-ble—slapstick early film "narrative" in which the story turns on a garden hose being off, then on. Wegman shot these pictures in his home on Centre Street in San Pedro, a set he also used for the video *The Door* (1970), the first in which we see him paired with his dog Man Ray: leaving the room and reentering separately or together, man and dog play out permutations.

Also shot here was the black and white diptych *Milk/Floor* (1970; p. 92), in which Man Ray laps milk from the floor. In one photograph the floorboards run crosswise; in the other they splay downward, as wayward "vertical" elements. Wegman's practice of using his domestic setting as backdrop, and his motif

Light Off / Light On 1970, gelatin silver prints, work in two parts: 8 ½ × 7 ¾ in. (21.6 × 19.7 cm), each

Milk / Floor 1970, gelatin silver prints, work in two parts: 9 ½ × 7 in. (24.1 × 19.1 cm), each
Collection of Ed Ruscha, Los Angeles

of doubling by moving backward and forward in a scene or space (or going in and out of it), or by substituting one figure or object going out for another coming in, reappear in several videos from this period. In *Milk/Floor* (1970–71) Wegman begins on all fours, and so close to the camera that our point of view is under his torso and through his legs. He crawls backward out of the room, spitting milk onto the floor; as he exits and disappears at the back, Man Ray assumes his place, entering from the same position and moving toward the camera, lapping up the line of milk as he goes. Finally the dog, concentrating on his milk-drinking, comes so close to the video camera that he bumps into it, and with that sound and close-up the piece ends.

Backwards and *Studio Work* appear on Wegman's first surviving compilation reel of videos, *Spit Sandwich* (1970), which also deals with a host of other pairings—whether twins, or two voices, or two body parts, or two characters from a classic fable. In *Twins* we see what seems to be a single woman, in profile, and her mirror image, but as one leans away from the other we understand that they are identical twins. As soon as we recognize this, though, Wegman has them begin to perform the same gesture, subtly closing their eyes and opening them in sync with each other. Again, as soon as this pattern of identicality is clear, Wegman recomplicates the situation: now he combines the out-of-sync body movement with the in-sync eye-closing. If Wegman's use of twins offers a perceptual problem, in

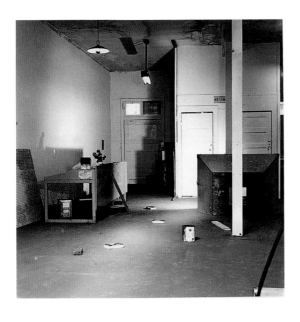

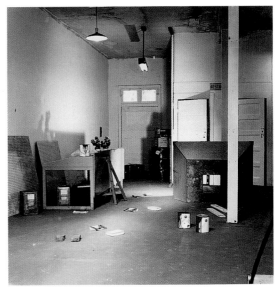

Wegman also set up and photographed situations for comparison in his studio, a former warehouse. Here he shot the diptych *Single and Double Studio* (1970; p. 93), in which the left-hand panel shows single items, such as a paint can, while in the right-hand panel each "event" or "item" is doubled. A pair of videos shot here works similarly: in *Backwards* (1970) Wegman walks backward, cradling his arms as if rocking an invisible baby, until a post falls over and the video ends with the crash, while in *Studio Work* (1970) he rolls a table backward away from the camera, then, in a reverse gesture, rolls something forward— a tire, wrapped in a cloth that it sheds as it moves.

Alex, Bart and Bill he compounds a perceptual scale shift within a theatrical frame. Two characters, Alex and Bart, both unseen, are looking for a third, Bill. In this wry twist on two characters in search of an author, Bill Wegman reads both parts in voiceover, giving the name of each character before each line of dialogue. The scene is what we assume to be the missing Bill's kitchen, represented only by a covered crock, where the character "Bill" is presumed to be hiding.

Wegman would explore such permutations of unidentical pairings for over three years, sometimes employing subtle perceptual distinctions, sometimes far more overt ones. The 1973 black and white

Single and Double Studio 1970, gelatin silver prints, work in two parts: 11 × 11 in. (27.9 × 27.9 cm), each
Courtesy Sonnabend Gallery, New York

93

UNTIED ON TIED OFF

Untied On Tied Off 1973, gelatin silver print, 14 × 11 in. (35.6 × 27.9 cm)

photograph *Untied On Tied Off*, for example, is a
Beckettian vaudeville, in which Wegman offers a pair of
boots in relation to a pair of black-socked feet seen
at the end of hairy legs. One untied boot is seen on his
left foot, the other is tied to his right shin by its laces
and dangles at his side (p. 94). Other comparison
works of the period include some employing his
students at California State, Long Beach, notably Tim
Owens, who resembled him but was larger. In the
photograph *Big/Little* (1971; p. 95) Wegman and
Owens hold tools correspondingly scaled to their sizes.
It was through Owens that Wegman found a pair of
identical twins—Owens's wife, Lynn, and her sister,
Terry—for the compare-and-contrast analyses in
several photographs. In *Terry/Lynn-Terry/Lynn* (1971;
p. 96) he merges the two women into a "third," invent-
ed sister by combining two negatives to make the third
panel of a triptych, and in *Twins with Differences* (1970)
and *Lynn's Marks Mapped on Terry* (1970; p. 96), two
diptychs, he compares their birthmarks by writing on
the prints to point up and frame their differences.

That same year, Wegman had his first solo exhi-
bition, at the gallery of Pomona College, Claremont,
from January 7 to 31, 1971. Organized by Helene Winer,
the show was one of two simultaneous one-person
exhibitions, the other artist being Jack Goldstein.[7]
Exhibited in the Pomona show was *Ostrich* (1970),
a photograph of a man upside down, his head so to
speak in the sand. For another photo piece in the show,
a diptych, Wegman photographed a selection of
his own photographs as "found objects" strewn on the
same black and white-speckled tabletop on which he
photographed the plate of salami for *Cotto*. Among the
images seen here are *Ostrich* (again), variants of
Scar (1970), and *Tools-Stools- Men's Room* (1970). The
same-and-different contrast in the two panels of this
diptych is that while the "same" pictures may appear in
both, in one of the panels the "found" images are
"flopped"—that is, the negative has been printed from
behind, to turn the image's left side into its right.
This pertains as well to a sheet of paper with the letter-
head of California State, Long Beach, reading left to
right in the left panel and reversed in the right panel,
which is shuffled among the photographs. However,
further confounding the systematic unidentical
twinnings in the diptych and unsettling the sense of
one set of images being a mirror image of the other,

Big/Little 1971, gelatin silver print, 11 × 10 ½ in. (27.9 × 26.7 cm)
Collection of F.R.A.C. Limousin, France

95

Terry/Lynn-Terry/Lynn 1971, gelatin silver prints, work in three parts: 14 × 10 ½ in. (35.6 × 26.7 cm), each

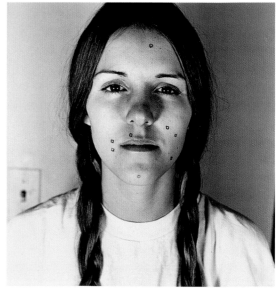

Lynn's Marks Mapped on Terry 1970, gelatin silver prints, work in two parts: 10 ¼ × 10 ¼ in. (26 × 26 cm), each

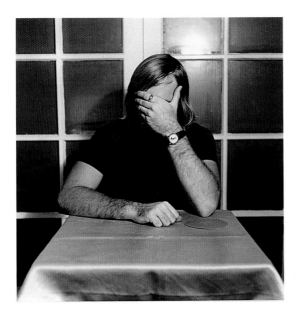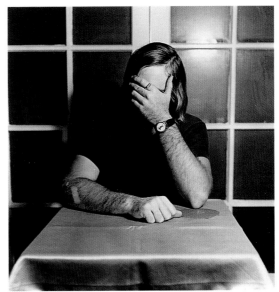

the word PHOTOS appears reading left to right on both pieces of stationery.

A last comparison piece closes the Pomona catalogue. It is different from the others and in many ways signals Wegman works to come. A huge hand descends into and almost fills the picture space. Behind it a sheet of paper emerges from a typewriter, displaying the typed words I SPIT, an equivalent of—and in some way a caption for—the gob seen in Wegman's hand. Wegman's contemporaneous video *Spit Sandwich* (1970), enacting its title, is also the last video on what is now Wegman's earliest extant video compilation reel, to which it gives its title.

Wegman's relationship to language, and to language games, puns, and palindromes, had become evident in his work by 1970. In the diptych *Madam I'm Adam* from that year (p. 97), the ability to read the title phrase both forward and backward is created by "flopping." Here Wegman photographed himself with his left hand against his forehead, his hair parted on the left, and a ring on his left index finger; then he reversed his gestures and hairstyle and took the photograph again. Finally he flopped one of the negatives in the darkroom to print them so that both pictures at first appear the same. The only element unsettling this "perfect" pair is wrong-facing numbers and hands on the face of his watch. Wegman has written of *Madam I'm Adam*, "as in

all the paired works, the differences are more fundamental than they are made to appear. There is a jump beyond looking which lets one stop totaling differences and realize the plan."[8]

By 1970–71, Wegman was not only regularly including printed words in his photographs but also allowing these micronarratives to leave photo paper for the typewritten page (p. 8). In his typewritten stories, the shortest of short stories, he often includes an autobiographical figure to whom things happen. The events are quotidian, the place may be the author's own backyard, but the incidents are weird or end with an odd twist. In his use of bits of his own biography and of himself as a character, and in the talking mode itself, he shares techniques with his generation of performers and their public chat, whether the theater-based monologues of Spalding Gray or the show-and-tell multimedia events of Laurie Anderson. His fragmentary daily observations, and his love of puns and palindromes, also recall the novelist Georges Perec and the sentence-long "I Remember" writings of the artist Joe Brainard from the early '70s.

In a letter of 1971 to Jan van der Marck, then director of the Museum of Contemporary Art, Chicago, Wegman reported the events of the day (including Robert Cumming's moving to California) in a form resembling the short texts he began to type as independent works that year:

Madam I'm Adam 1970, gelatin silver prints, work in two parts: 8 × 8 in. (20.3 × 20.3 cm), each
Courtesy of Sonnabend Gallery, New York

WEGMAN: "Ho hum. Cumming is here again. Can't seem to shake him."

CUMMING: "HO HUM. WEGMAN is here again, and he refuses to be shaken."

JVDM: "Ho hum. I refuse to be here again even though I'm shaking."

CHICAGO: HO HUM [9]

Ed Ruscha
Boss 1961
Oil on canvas
72 × 67 in. (182.9 × 170.2 cm)
The Eli and Edythe L.
Broad Collection

Other artists, to be sure—and notably in and around Los Angeles—had been and were using words. John Baldessari was isolating actions and instructions in conceptual works that concretely posed his thoughts, and was using a sign painter to execute them in the form of paintings. Nauman worked words in titles, puns, anagrams, and rebuses, sometimes also using them as images (as in the 1967 photographs *Waxing Hot*, which shows him hand-waxing the three red freestanding letters H, O, and T, and *Eating My Words*, in which the letters W, O, R, D, and S, cut out of bread, lie on a plate before him while he spreads them with jam). Also relevant here are Barry LeVa, Allen Ruppersberg, Robert Cumming, and, not least, Ed Ruscha, who was using iconic typefaces and odd materials to isolate words in paintings and drawings, applying them to their grounds with "cotton puffs and Q-Tips" to achieve a "smoke and mirrors" effect.[10] But Ruscha's use of words was tied to an idea of imagery, as he has said, rather than an idea of narrative. He explains,

When I began painting all my paintings were of words which were guttural utterances like *Smash*, *Boss*, and *Eat*. I didn't see that as literature, because it didn't complete thoughts. Those words were like flowers in a vase; I just happened to paint words like

someone else paints flowers. The words have these abstract shapes, they live in a world of no size: you can make them any size, and what's the real size? Nobody knows.[11]

If Ruscha used words to solve the scale problem, what Wegman contributed to artmaking with words, and with other meaningful readymade objects, was story. He added the narrative fragment (and later the somewhat longer text). His timing was as precise as that of any stand-up comic. As Ruscha recalls of Wegman's early work, "The pictures were like worlds unto themselves and somtimes involved ideas and texts, whereas conventional photographers were freezing a moment. And he was, yes, he was freezing a moment, but it also came with another story."[12]

In a series that began in Minneapolis in June 1970, the sentence "He tripped on her books spilling his rocks" and its inversion, "She tripped on his rocks spilling her books," are inscribed into a freshly poured concrete sidewalk. Embedded in the concrete as if strewn about the walk are actual books and rocks illustrating the act (p. 98). Soon after Wegman moved to California in the fall of 1970, he photographed two adolescent schoolchildren carrying the corresponding book and rock (p. 99). Wegman printed the image of each child on a separate panel, flipping the "girl" negative so that the boy and girl appear to be facing one another. These images appeared in Wegman's installation for "24 Young Los Angeles Artists" at the

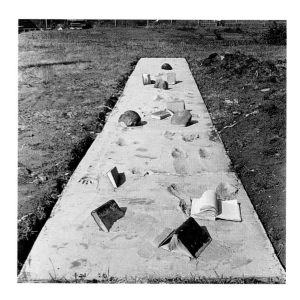

He Tripped on Her Book…(A) 1970, gelatin silver print, 7 ⅝ × 8 ⅛ in. (19.4 × 20.6 cm)

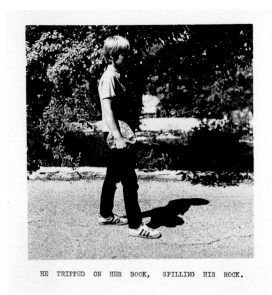

HE TRIPPED ON HER BOOK, SPILLING HIS ROCK.

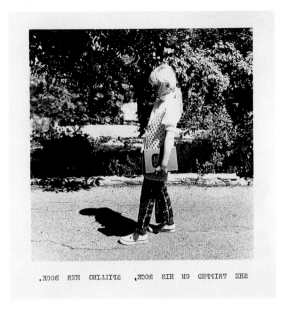

SHE TRIPPED ON HIS ROCK, SPILLING HER BOOK.

Los Angeles County Museum of Art in 1971. Wegman mounted the photos to a wall with the girl and boy opposing one another and wrote out the text using standard cardboard display letters. The actual book and rock depicted in the photos were placed on the floor of the gallery beneath the mounted display. Later that year Wegman decided that the installation aspects of the work were unnecessary and presented the piece simply as two photos with the corresponding typewritten sentences rephotographed and printed on the same sheet as the image. In the "girl" panel of the work, the text is printed in reverse. This final stage in the evolution of Book/Rock was the most satisfying to Wegman and from that point forward no further installation elements appear in his photo pieces.

A number of Wegman's works address books—and, relatedly, the reading and writing of them. This recurring motif is best exemplified in the video *Speed Reading* (1972) and in the Magrittean photograph *Reading Two Books* (1971; p. 100), in which the Wegman character accomplishes this feat by splaying his eyes outward, directing a different gaze toward books held respectively in his right and left hands. With each eye appearing stuck at the outermost edge of its socket, "normal" binocular vision, with two eyes working in concert, becomes a bilateral, disjunctive offering—yet each eye concentrates quite logically, if not perceptually functionally (an image composited from two negatives), on its book.

Wegman's typewriter turns up in works both early and late, from the photo work *I Spit* to the video *Typist* (1997–98; p. 217). In the latter, Wegman sits working at a typewriter, the sounds of its clacking keys taking up the soundtrack. He occasionally sips from a bottle beside him on the table. The scene is veiled behind a scrim but for a narrow strip at right, where the "real" slips beyond the edge of the abstracted. Here is Wegman the wordsmith (if temporarily wordless) but more than that the image-builder, making parts into a whole. This veiled image of him typing is summary of his approach, for his language is always in a sense behind the scenes, even though it is part of the critical ballast of his images—whether as typed words montaged into photographs or as written words penned on photographic prints; as the scripts and plans for early setup black and white photographs or for the illusion of an "instant" moment in the Polaroid tableaux; as the conversational riffs in his earliest videos; or as the more complete narratives in such later pieces as *Stagehand*, *What's the Story?* and *And Car Wouldn't Start* (all three 1997–98), all performed by the same solo figure on the same bare stage. Here is the "I" of Wegman's videos—the figure seen in *Typist*, the player and "voice" of the photographs and written stories.

The invented character "Wegman" shares many of the artist's attributes and concerns, not to mention a name and a constant costume (the sneakers, jeans, and T-shirt or overshirt of the ever-young college

He Tripped on Her Book … (B) 1970, gelatin silver prints, work in two parts: 12 × 12 in. (30.5 × 30.5 cm), each

Reading Two Books 1971, gelatin silver print, 14 ¼ × 10 ½ in. (36.2 × 26.7 cm)
Collection of Robert and Gayle Greenhill

student). Wegman uses himself and his name in his fictions rather as did Borges, one of his favorite writers. He is fascinated by Borges's doubled persona, as artist and as real if also invented presence, and by what he calls Borges's circular storytelling. Wegman began to work in video the same year he heard Borges lecture in Madison—1969—and Borges's method infused his work. As Peter Schjeldahl writes,

> Working alone, Wegman put himself in front of the camera and improvised small performances partly inspired by "little stories by Jorge Luis Borges— Borges's parables of circular time.... I decided that the trick of video was how to get into and then get out of the frame." Wegman's devising of organic length, shape, and closure for units of video was a small but all-important achievement. Among other things, it drew the first distinct frontiers of "William Wegman."[13]

Not just inspired by Borges, Wegman's video *Anet and Abtu* (1970–71) draws its text from Borges's *Book of Imaginary Beings*. Here, years before a big-mouthed bass singing "Take Me to the River" became a popular novelty item, Wegman has a fish serve as a mouthpiece for Borges's book (the author's photograph visible on the jacket), just as a ventriloquist's dummy gives voice to its human partner. At the core of the work is Wegman's paradigm of paired equivalents, with Wegman's (or perhaps, we're to believe, Borges's) fish mouthing Borges's words: "As all Egyptians knew, Abtu and Anet were two life-sized fishes, identical and holy, that swam on the lookout for danger before the prow of the sun god's ship. Their course was endless; by day the craft sailed the sky from east to west, from dawn to dusk, and by night made its way underground in the opposite direction."[14]

Wegman the storyteller is engaging as much for the tenor of his voice, his fluid phrasing, as for what he has to say, and for how, once he begins a story, it may take off in any direction, usually several degrees skewed from the starting place. He is somewhat shy and retiring yet still forthright, and his hesitations within a sentence as he speaks make us listen harder even as they put us at ease.

When Wegman began to tell stories on video, he was speaking to neither an audience nor even the camera but rather to a video monitor, and he spoke in a way that he has characterized as somewhere between talking to someone and just talking. He worked as the early, tripartite setup of video required: a camera, a monitor, and a tape deck were separately disposed, and he directed his attention toward his own image on the monitor. That made him both subject and object, performer and audience, at the same time. The instant feedback of video turned monologue into dialogue. His conversation with himself on the monitor may also account somewhat for the slight lag between phrases as he talks: looking at the monitor, he sometimes seems to listen to himself before "responding."

Since Wegman's first reel of videos made in 1970 in California is lost, having been inadvertently erased after the Pomona show closed, and since the videos recorded in Madison in 1969–70 are unread-able, the works on *Spit Sandwich* are Wegman's earliest surviving videos. With the exception of the opening work, *I Got...*, all are short, some no longer than fifteen seconds, and their images and subjects parallel those in the first photo works. The props named in the title of *Chair/Lamp/Suitcase* also show up in the photograph *Portable TV* (1971), for example, and the room in the video *Door* reappears in *Light Off/Light On* and in many other photo works. At the same time, the reel isolates the performer "Wegman"—his persona and distinct voice.

The reel opens with the longest video, *I Got...*, the proverbial shaggy-dog story. Throughout it we see Wegman's feet, splashing in the water in a large cook pot, as though he were soaking them after a hard day. Then we start to think they're making swimminglike moves, flutter kicks becoming more and more believ-able. Meanwhile we hear Wegman reel off a list of his possessions. Eventually Wegman's feet turn over, as if switching from a backstroke to a crawl, and we watch

Two Supporters of Illinois 1970, gelatin silver prints, work in two parts: 10 ¾ × 10 ½ in. (27.3 × 26.7 cm), each
Courtesy of Sonnabend Gallery, New York

him from behind (somehow holding himself erect while his feet are suspended in the water), keeping up his swim. To get the joke we might turn to Winer's astute observation, "As in much of Wegman's still photographic series, the first changes that take place [in the videos] are often missed, though they are reconstructed once the pattern or intent is realized." And indeed, the list of material possessions that Wegman recites as he "swims" ends with "swimming pool," the one thing he hasn't "got." With this knowledge we can view the piece again, this time fully savoring Wegman's setup, send-up, and intent.

Ill (1970; p. 239), the last video on *Spit Sandwich*, shares its subject with the diptych *Two Supporters of Illinois* (1970; p. 101).[15] Comparison shows the differences between "edits" of the same found text. *Two Supporters of Illinois* shows two fellows (apparently the same people, but actually different) wearing "Illinois" T-shirts, each bending one arm as if supporting the words on the shirt. *Ill* begins with a man (Wegman) retching, then holding his hand before his shirt so as to mask everything in the word "Illinois" but the first three letters, "Ill."

Spit Sandwich is followed by the compilation *Selected Works: Reel 1* (1970–71), which begins with works made in San Pedro and continues with those made after Wegman moved to Santa Monica in 1971. Man Ray, Wegman's dog, begins to turn up more in the works on *Reel 1* (he has had prior walk-ons), which notably opens with him chewing on a microphone as if it were a bone. Plays on body art appear in several of the videos on this reel. *Elbows* (1970–71), for example, opens with a shot of what seems to be a woman in a sarong. The shot is framed to let us see that she is naked from the waist up, and has pendulous breasts—which, however, turn out to be Wegman's elbows.

Elbows, in fact, offers many of Wegman's recurrent themes in one work: comparison of similarities and differences; an exploitation of the human tendency to draw quick conclusions from ambiguous information, although a correct observation can often lead to a wrong conclusion; and, in particular, an interest in selves and others. Here Wegman is Wegman and also someone else—himself as a woman, a transformation effected merely by a wrap of cloth, a show of pointy elbows, and careful framing. When the camera goes off frame to reveal the rest of the artist's crooked arms,

it is as if a magician, deliberately and only for a moment, had emphasized the illusion by allowing a touch of reality to slip into the act.

Wegman also often plays with two voices, as when, in *Stomach Song*, he engages in dialogue with his belly. The same kind of doubling, this time with his face, appears in *Contract*, where he creates two characters simply by different curvatures of his mouth and by speaking in two voices. One can even see this play of self and other in Wegman's pairing of himself with Man Ray—prop, accomplice, partner, straight "man"—in many videos. (Actually, as Wegman notes, the dog appeared in only about 10 percent of the early videos, even if in the public imagination he starred in most of them.) Especially in his first years working with the dog, he used Man Ray in just the way he used himself to explain situations or do certain tasks, whether drinking milk or reading newspapers.

As we have seen, Wegman has often discussed Man Ray's entrance in the work. Here is another variation: "I just loved the way he looked. This neutral gray, it was almost like a charcoal drawing. And I could use him in photography and video, and I liked hanging out with him anyway, so better to use him than not. He had an intense way of telling me that he wanted to be included. I remember on several occasions trying to work with other things to keep him out of it, and he'd keep dumping stuff over onto the set."[16] What Wegman is describing here is actually a weimaraner character trait, as Virginia Alexander and Jackie Isabell (authors of the authoritative book on the breed) write:

Weimaraners are a breed for those who enjoy a dog that is intensely devoted and responsive to attention—they demand attention. They follow owners from room to room, usually lying down with body contact when owners sit down. People who are distressed when their dog shoves open the bathroom door to stay near will not enjoy life with Weimaraners. This is a breed for those with a good sense of humor and the willingness to invest the time and effort needed to teach active, imaginative puppies the good manners needed by every family companion.[17]

Wegman, then, was in fact responding to the qualities and history of this "found object" as much as

16 E's and 16 L's 1973, ink on paper, 11 × 8 ½ in. (27.9 × 21.6 cm)

he had to any of the others he pulled into his art:

> Only in the studio, when I let him work with me, was Man Ray well behaved. No high-pitched whining there. He was calm and attentive while posing for pictures and performing in live video pieces. There was something reassuring to Man Ray about the ordeal of setting up the recording sessions with the video camera and the tape deck. I had a hard time getting things to work. Those early machines were much more clunky and demanding than current models. Setting up lights, props, and the stage, as well as the serious tone and the focus of it all, contributed to the high-mindedness of the endeavor. This stuff must be important to Bill, thought Man Ray. Ray changed the way I thought about my work. I became more and more attached to him.[18]

Curiously, although he has been identified as an L.A. artist, Wegman lived there for less than three years. In 1972, he and his friend and fellow artist David Deutsch decided to go to New York to take advantage of a three-month sublet available there. The sublet did not work out but Wegman stayed. He continued to make videotapes and to shoot photographs, but in 1973 he also began to draw, using the most basic elements he could find—No. 2 pencils and standard 8 ½-by-11-inch typing paper.

These works are as much written as drawn. They are economical in material and in thought. Among the first of them is one entitled *16 E's and 16 L's* (1973; p. 103), in which Wegman compares these almost identical cursive forms, differentiating them by size and therefore by meaning. A similar reading/ misreading, if one in more formal terms, appears in another drawing done the same day, *Gulls and Waves*: here marks that look like the French circumflex accent represent the caps of waves, and the same marks upside down create the sense of birds in flight.

Wegman claims to have made approximately forty of these drawings on the day he began making them. At first he thought he would exhibit all of them as a singular modular piece, but instead he kept going and made hundreds of drawings, casual in appearance and, when they were shown, in exhibition style. Maintaining his work's nonprecious status (though he would not have put it in those terms then or now), he left the drawings unframed, simply pinning them to the gallery walls. He showed his early photographs the same way, either pinned or taped to the wall— an attempt to retain the immediacy of making and showing without the intervention of the formal and literal framing devices of the exhibition setting. Wegman discusses this method of exhibiting in a conversation with David Ross, which well evokes the earlier time and place:

> *Ross:* I remember the first time I saw them exhibited the room looked so beautiful and formal.... What you saw were simply rows of small white rectangles tacked to the wall.
> *Wegman:* Tacked but not brutally tacked.
> *Ross:* Just elegantly.
> *Wegman:* Not even elegantly.
> *Ross:* Just …
> *Wegman:* … routinely.
> *Ross:* But not industrially.
> *Wegman:* No.[19]

Wegman also described his drawings' subjects to Ross: "The theme in my drawings keeps changing in the way that I do. Those first drawings were more about form—lists and statistical info. How to dot i's. Then later how to gouge them out with a bird beak."[20]

In New York, Wegman met a number of down-town artists living in the SoHo and TriBeCa of the '70s and also in Chinatown. Many of them were associated with the loft space at 98 Greene Street run by Holly and Horace Solomon, who had discovered his work as collectors through his exhibitions at the Sonnabend Gallery. Among this group were Neil Jenney and John Duff, with whom Wegman shared a dry humor and sources in post-Minimal sculpture, if all in different ways. (Jenney had been a fellow student of Wegman's at MassArt in Boston.) He also frequented the alternative space 112 Greene Street, founded by Jeffrey Lew, where Gordon Matta-Clark, Susan Rothenberg, George Trakas, Tina Girouard, Suzanne Harris, Bill Beckley, Laurie Anderson, and many other artists exhibited their work, musicians such as Philip Glass and Richard Landry played, and dancers such as the Grand Union, among them Trisha Brown, Yvonne Rainer, and Douglas Dunn, performed.

Contrary to the practice of many Manhattanites with country homes, Wegman spent his weekends in Manhattan and his weekdays on Long Island. He made his videos in a studio he shared with David Deutsch in East Hampton, his drawings in a New York sublet. He has said of the drawings, "I really was relieved not to have to drag something in front of the camera. I could use a pencil and paper. A regular pencil and typing paper. That appealed to me."[21] Still, the drawings did not displace the camera-based work, and Wegman's videos were included in the 1973 Whitney Biennial—the first year the Biennial included that medium, even if as something of a side event. Wegman made *Reel 4* (1973–74) after moving to New York. In a summary of reels 2, 3, and 4 he notes that they are "more audio oriented than the earlier works, given somewhat to a fascination with narrative."[22]

By 1974 Wegman had moved to a loft on Crosby Street in SoHo, where he lived for the next two years. In some ways his tools—camera, video camera, drawing implements—were suited to an itinerant life. Wegman had worked with domestic items found at home in Wisconsin and California. In SoHo, dumpsters provided fodder for his imagination and materials for his art. In 1974, near his loft on Crosby Street, he discovered a dumpster filled with books, which he took home and sorted with the artist and writer Jennifer Bartlett. One of them was about the performance and elocution exercises of François Delsarte, a Frenchman, born in the early nineteenth century, who became famous, especially in America, for teaching actors and dancers. Wegman used sample texts from this book in performance ("Pathetic Readings" at 112 Greene Street, 1974), in an artist's book (*$19.84*), and in drawings (*5¢ more*). (He also intercut melodramatic stories about Delsarte with his own biography in the character of sickly Joey in "Pathetic Readings," and he touched on the same character and method when he told Ross, "I was born on a tiny cot in southwestern Massachusetts during World War II. A sickly child, I turned to photography to overcome my loneliness and isolation.")[23] Wegman used some books in the lot—which included nineteenth-century manuals and how-to books—as reference and source material (see p. 60).

Early in 1974, Wegman participated in the month-long group exhibition "Video/Performance" at 112 Greene

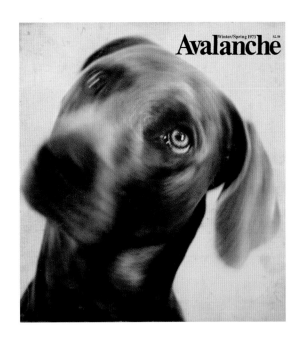

Street, a series of evenings of works by different artists. Wegman's contribution was the audiotape and video *j. J—Jacobean: The Adventures of Jack: A Play with the j words on page 538 of Webster's Collegiate Dictionary (fifth edition). First Presentation on January 14, 1974 at 112 Greene Street.*[24] The following year, in the video *Copyright 1936*, Wegman read the information on a dictionary's copyright page as if a conversation between two people.

In 1975, Wegman acquired a color VHS camera and recorder. Although his video work had been critically successful, he felt himself approaching the medium's limits: "With each replacement new possibilities were opened but others were shut down. I think I'm a very tech-sensitive artist in that I don't overreach the media. In fact, I revel in the limits. With color and higher resolution I found it hard not to look like low-budget imitation Saturday Night Live stuff. You know, bad network television."[25] More than video, what held Wegman's interest at this point was the accumulation of black and white photographs he had taken in Lower Manhattan. By writing, painting, or drawing on them he could reuse individual shots he liked, and even those he did not: being a frugal sort, he enjoyed having a purpose for photos that were not intrinsically of interest to him. The idea of treating an object with two different surfaces appealed to him, he has said, perhaps because to use those two surfaces the way he did was to tell two different stories at the same time.

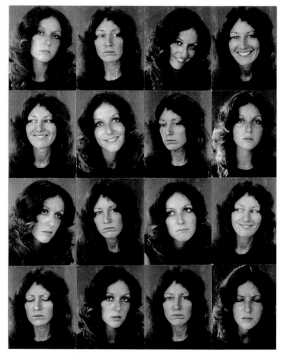

In the mid-1970s Wegman also began to reuse his own earlier photographs in other ways. *Blondes and Brunettes* (1974; p. 106) reworks pictures he had taken in California in 1971–72: a two-panel piece, sixteen photographs with two blondes in one panel and sixteen photographs with two brunettes in the other. It organizes these pairs of women by alternating one of each pair within each row and each column, the way a chess- or checkerboard alternates white and black squares. Viewing the grid of photos from a distance, members of the habitual art-viewing public especially might most readily see in this work the grid of Minimalism, and might therefore assume that the repeated units were identical. Yet Wegman had asked his models to express a range of emotions confounding a purely minimal reading of the work.

In 1975, Wegman completed *Reel 5*, which according to the artist, "is dark and obtuse. It was made on a Panasonic deck in New York in my studio on Crosby Street. I had been experimenting with … the concept of dumbness; convoluted, fractured monologues; and a little bit of camera movement. It has the aura of cabin fever about it."[26] By 1976 Wegman had moved again, this time to a loft on Thames Street in Lower Manhattan. While living there

he photographed many streetscapes, including the World Trade Center (p. 82) and a few remaining older buildings bordering the temporary "beach" at the western edge of Manhattan—landfill that extended the island farther into the Hudson River and is now the site of Battery Park City. The video works of *Reel 6* (1975–76) show themes going back to Wegman's earliest videos, but changes too. He made the reel at the WGBH workshop in Watertown, Massachusetts, as well as on Thames Street, and at WGBH he experimented with colorizing images and electronically matting and masking (as in *Furniture*).

Also on *Reel 6* is *Dog Duet* (also known as *Two Dogs*), one of Wegman's most subtle and transfixing videos. Like earlier work, it plays on similarity and difference and on the obedience and concentration of weimaraners. Two dogs (Man Ray and a German short-haired pointer), though different, perform a synchronized ballet, looking up, around, turning, until they finally do the "same" action, turning in opposite directions, like mirror images of each other. At the end of the piece, a give-away shot shows what generated their movements: the tennis ball that Wegman has been manipulating, and that they have been watching intently, comes into view.

Blondes and Brunettes 1974, gelatin silver prints, work in thirty-two parts: 10 × 8 in. (25.4 × 20.3 cm), each
Collection of Horace and Anita Solomon, New York

By this time Wegman's video work had considerably changed. He had made *Gray Hairs* (1976) at WGBH, Boston, working with a professional cinematographer and editor on two-inch video equipment. *Gray Hairs*, he notes, is "a series of long, slow pans over the contours of Man Ray. These takes are overlaid in editing, creating pulsating moiré patterns and syncopated breathing sounds."[27] *Gray Hairs* suggests a formalist exploration of black and white, of surface, of a kind of topography that is geological as much as anatomical, with sound that is initially as abstract as the image. Only at the end of the video do we realize that the camera is panning Man Ray, and that the sound we are hearing is his breathing. Shot by a professional cameraman, *Gray Hairs* is technically more sophisticated than Wegman's earlier videos; the two-inch tape's sharpness of detail allowed him to explore the subtleties of black and white in a way he had not done before, in the guise of scrutinizing the patterns in the coat of a recumbent, thoroughly abstracted Man Ray. The point of view is also new: the close-up, so close that the dog's coat becomes the fine detail of an overall field.

Wegman gave up making videos on his return from a 1978 teaching trip, where he had shot *Accident* (completed in 1979) with his students at Wright State. Among the reasons were changes in the standard video setup: the black and white videotape of the late '60s and early '70s had been replaced by color, which required intense, hot lights (Lowell lights). Wegman was no longer comfortable with the equipment or the atmosphere, which had become more like a professional studio film set: "Between the light and the heat I couldn't have eye contact with the dog."

In the summer of 1978, Wegman was one of a number of artists who received invitations from the Polaroid Corporation to use their new twenty-by-twenty-four-inch camera in Cambridge, Massachusetts. He had little interest in working with Polaroid and less in the possibilities of color, which contradicted his manifesto of black and white photography; reluctantly, though, he had already slid a bit, using color in his video work of the past two years. (He had had little choice; color had become the standard stock.) In any case, he went to the Polaroid studio in 1979.

At the Polaroid studio, Wegman was struck by how differently each artist used the same large format. He also noticed how much the apparatus resembled a nineteenth-century camera in its scale and weight, even while it used modern film instead of the old glass plate. Installed in the machine on a roll, this film produced a photo sheet twenty-four inches high and twenty inches wide—the same size as the film. A "skin" covered the film, functioning as a one-time negative. There could be "no revision, no cropping," Wegman notes, and if there was "a decisive moment, it would be through a setup awaiting a surprise accident."

Wegman's first Polaroids were of Man Ray. At first he tried to stick to his manifesto of using black and white, with its sense of unmediated, uncommercial, documentary style. There was also the question of placing the dog within the vertical format imposed by the camera. Wegman's solution was to dress or otherwise

Black Triptych 1979, Polaroids, work in three parts: 24 × 20 in. (61 × 50.8 cm), each

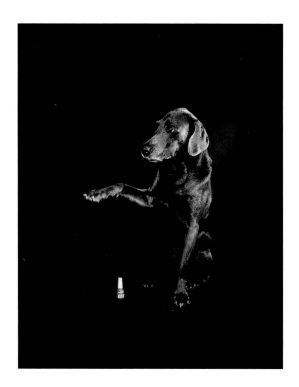

camouflage Man Ray. (He also claimed another reason: "When I went to the Polaroid studio in 1979 for the first time," he told an interviewer, "Man Ray was nine years old. He didn't look like the ideal thoroughbred dog any more. It was sort of sad, and I started to drape him to cover him.") The first coverings were consistently in a palette on the gray scale, as in *Black Triptych* (1979; p. 107), in which Wegman shot the dog under a black blanket and against a black background, producing a shadowy form. As Wegman's first work in Polaroid "color," this black-on-black study was rather perverse. The second photograph only minimally added color through red nail polish applied to the dog's toes. The bottle of Revlon is visible to the side, as if to indicate the reality of the palette—the absence of illusion at play. Wegman titled this work *Fey Ray* (p. 108), punning on the idea of the manicured Man while also alluding to the movie actress who famously played King Kong's love interest. Over the next three years Wegman would photograph Man Ray in many guises—wrapped in tinsel as an *Airedale* (1981), shot with a long sock to create a trunk for *Elephant* (1979; p. 109), apparently floating on his back near the ceiling in *Ray Bat* (1980; p. 109). This latter work depends "simply" on

one of Wegman's inversion procedures: he turned the image upside down.

In the course of working with the Polaroid, Wegman found the territory that would become definitively known as his. At the outset he could not have imagined that he would use this then-new medium for the next twenty-five-plus years, or that he would work with other dogs after Man Ray. As in his early videos, Wegman remained director and writer in the Polaroids but now worked with the Polaroid technicians and was in charge of a larger crew. The actual working process, though, was as simple as ever. Starting with an idea, a dog, and a prop, Wegman improvised. For the first Polaroids he knew his actor, Man Ray, intimately, as he would the several generations of weimaraners he would work with in the coming years. Despite the preparation, the more complex setups, and the additional staff, the speed of actually taking the photograph (as compared to the final steps of video production) brought the Polaroids back to the more comfortable, faster clock of Wegman's drawings and to the immediate feedback he had had with the early videos.

In 1980, after Man Ray had appeared with

Fey Ray 1979, Polaroid, 24 × 20 in. (61 × 50.8 cm). Private collection
Bad Dog 1981, Polaroid, 24 × 20 in. (61 × 50.8 cm). Collection of Brooklyn Museum, Frank L. Babbott Fund, 85.55.2

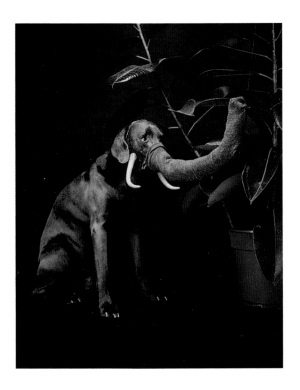
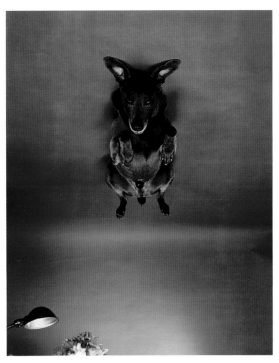

Wegman in many photographs and videos, he began to be paired with others. Among them was Hester Laddy, a performance artist who had been a student in Wegman's 1978 class at Cal State Long Beach. In *Double Profile* (1980; p. 112), the dog is aligned with Laddy and looks over her shoulder. Wegman thought of the image as manifesto-wrecking, so beautiful that it embarrassed him. Not only do the two share a physical language but Laddy's porcelain skin, and the supple folds of her sheer blouse, are a graceful contrast to the dark velvety figure of Man Ray, who seems at once to recede into a deeper plane and to advance into one closer to us. He is both behind Laddy and also coming forward, looking over her shoulder; they are almost one, so deeply felt is the connection. The angle of his dark gray head plays against the contiguous blushed color defining her cheekbone, while his white whiskers, which contrast with his dark coat, echo in the play of feathery floral lines on the glimmering field of her blouse. In many ways this is the most Sargent-like of Wegman's Polaroids to date, recalling the calm setting, contrasts of dark and light, and attention to details of fabric in the Sargent painting *The Daughters of Edward Darley Boit* (1882; see p. 31), which Wegman had seen at

the Museum of Fine Arts in Boston when he was a student at MassArt.

A later Polaroid with a different dog, Fay Ray, and a different woman, Andrea Beeman, Wegman's studio assistant since 1986, would capture a different sort of intimate connection. In *Fay and Andrea* (1987; p. 113) Beeman did not capture the dog's physical language as Laddy had, but the two share side-by-side, similarly bright eyes and intersecting gazes, as well as other complementary paired details (the light falling brightly on Beeman's left shoulder, for example, and on Fay's "mirror image" shoulder, equally glowing). For Wegman, Beeman "and Fay had a similar look— they were two young and pretty girls. Looking at the pictures of Fay and Andrea, I see an innocence and bright sweetness very different from Hester and Ray's dark romanticism."[28] Also in 1987, Wegman paired Fay and Ed Ruscha for the diptych *Fay/Ruscha* (pp. 110–11), titling the work with their respective, rhyming first name and last name and posing them, like Fay and Andrea, as equals. They appear to be placed in the same field; a kind of low horizon appears behind each figure and "connects" the two separate Polaroid images. Their heads are cocked at complementary angles, looking

Elephant 1979, Polaroid, 24 × 20 in. (61 × 50.8 cm). Private collection

Ray Bat 1980, Polaroid, 24 × 20 in. (61 × 50.8 cm). Private collection

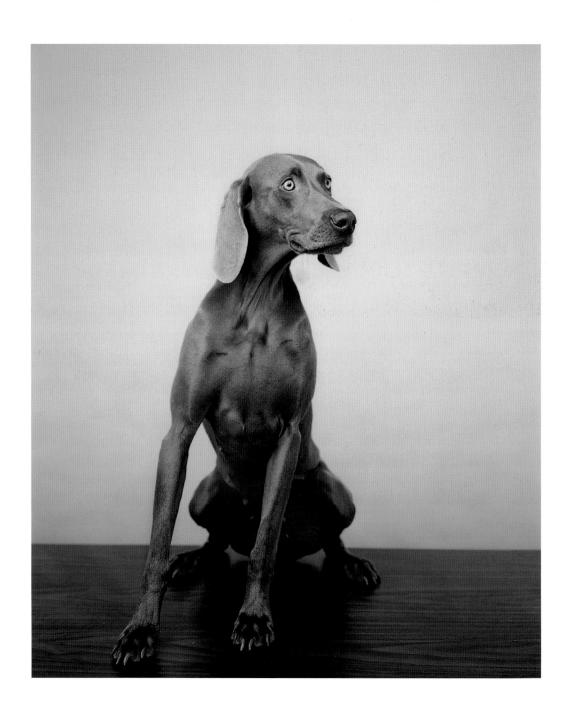

Fay/Ruscha 1987, Polaroids, work in two parts: 24 × 20 in. (61 × 50.8 cm), each
The Museum of Modern Art, New York, Gift of the Contemporary Arts Council in honor of Mrs. Ronald S. Lauder

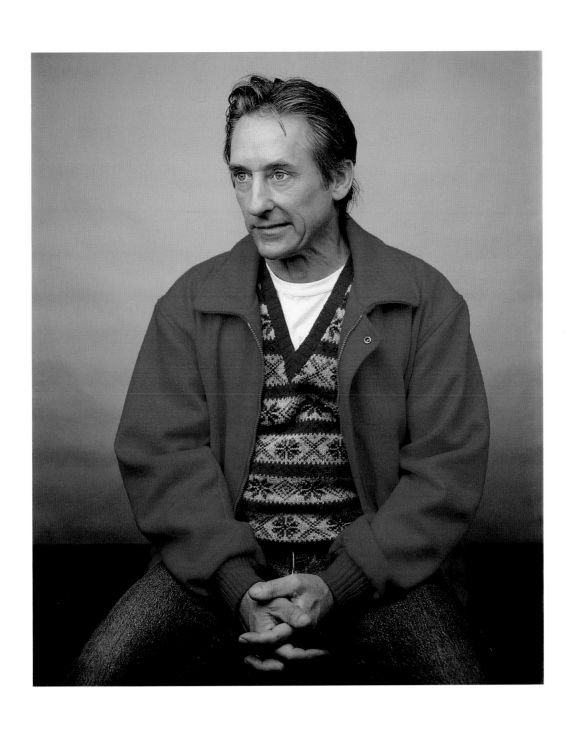

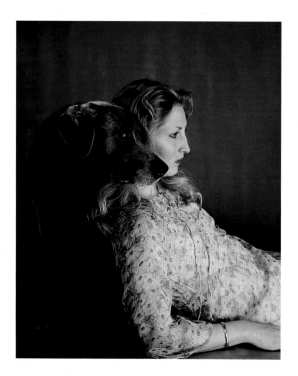

toward each other but also up and away, as if looking at the kind of out-of-frame tennis ball that Wegman used to direct the gazes of his paired dogs in *Dog Duet*.

"Whitney Biennial includes photographs for the first time!" wrote Carrie Rickey in 1981, in her arch critique of the show in *Artforum*, under the sub-heading "Starting Today, Painting Is Dead Award."[29] That year's Biennial included photo works by Duane Michals, Sandy Skoglund, Richard Misrach, Robert Mapplethorpe, and Wegman: *Double Profile* was in the show, and appeared on *Artforum*'s cover. Video (including work by Wegman) had first been included in the 1973 Biennial.[30] As Wegman's reason for photographing was leaving him (Man Ray was dying), photography was coming to prominence, a medium equal to painting and sculpture as never before.

Wegman has often described the sensuous nature of working with the eighty-pound Man Ray, how malleable he was, and how easily he responded to the work at hand. Man Ray had been subject and star of Wegman's Polaroids to such an extent that after he died, in 1982, *The Village Voice* put him on the cover as "Man of the Year."

Knowing in 1981–82 that Man Ray was aging and ill, Wegman photographed his companion and model "imagining a kind of last picture."[31] In the last year of Man Ray's life in particular he approached his subject differently: "I worked with a lot of energy.... I felt compelled to photograph Man Ray in the last year of his life to just get one more ... picture of him."[32]

During these last years Wegman photographed the dog in an Indian headdress sitting in a canoe on Kennebago Lake in Maine, in bed in a Maine cabin with companion weimaraner Liebe (*Man Ray and Mrs. Lubner in Bed Watching TV*, 1981), and in the double exposure *Bad Dog* (1981; p. 108), in which he appears, as Wegman has said, as a "devil dog burning within the cozy chamber of my brick fireplace."[33] Later shots, in fact among the last ones, include *Dusted* (1982; p. 114)—the iconic image of Man Ray dusted in flour, as if in another, already far-off realm—and the less-well-known diptych *Garden* (1982; p. 116), of Man Ray in a bath of fake flowers, as if in a shallow, flower-covered grave. There are also many close-ups of the dog's face, sometimes shaded with red, gold, or silver hairspray (p. 115), memorializing him like a commemo-rative coin: "I envisioned a portrait of Man Ray in red

Double Profile 1980, Polaroid, 24 × 20 in. (61 × 50.8 cm). University Gallery, Fine Arts Center, University of Massachusetts, Amherst, Purchased in memory of Dawn Colleary

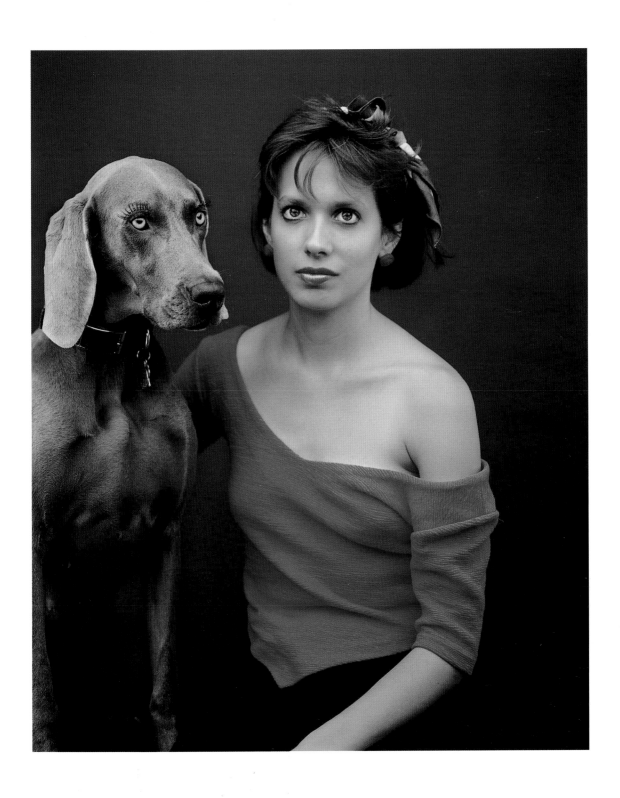

Fay and Andrea 1987, Polaroid, 24 × 20 in. (61 × 50.8 cm)

Collection of Robert and Gayle Greenhill

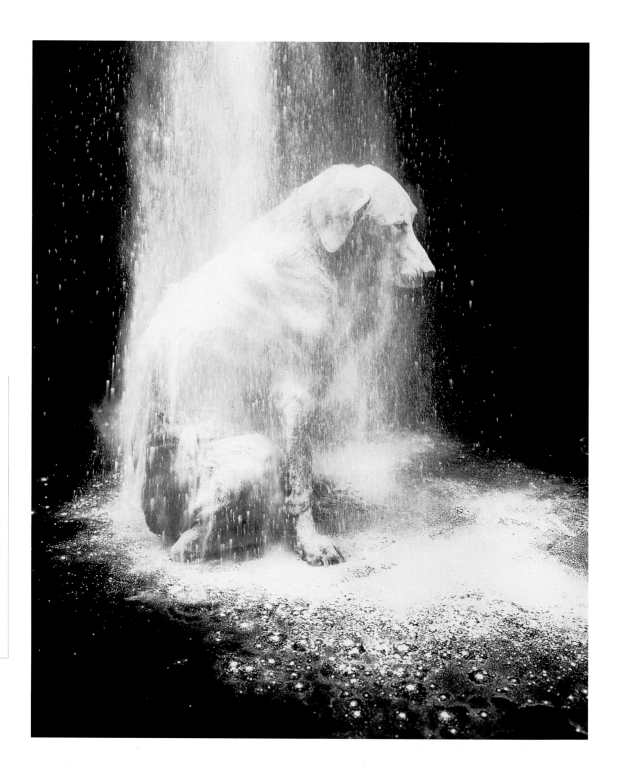

Dusted 1982, Polaroid, 24 × 20 in. (61 × 50.8 cm). Collection of Gifford Myers/OYO Studio

against black with his eyes open, but it never happened. His eyes remained shut. After a few attempts I gave up. One of the exposures was hauntingly beautiful and reverent, reminding me of Rothko. This proved to be the very last 20 × 24 of Man Ray."[34] Here even more than in the comic, vaudeville dress-ups the viewer senses a deep affection and ongoing curiosity about a long-scrutinized model and loved one—the way Henri Matisse revisited Madame Matisse, Picasso his many muse mistresses, and the artist Man Ray himself the lips of his beloved, afloat in many of his works.

Man Ray died of cancer on March 27, 1982. Also that year, Wegman lost another muse, the pianist Glenn Gould, who died on October 4 after suffering a stroke. After Man Ray's death, Wegman published *Man's Best Friend: Photographs and Drawings by William Wegman*, cowritten with Laurance Wieder. In 1983 Sanford Schwartz would write of this work in *The New York Review of Books*,

Man's Best Friend may be the most original book of photographs since Robert Frank's *The Americans* (1959). Like *The Americans*, it is a rarity in photography, a true book—an arrangement of

individual shots that, taken together, enrich each other and leave a distinct—large, impression. Frank's realist photos, the product of a road trip through the country, have everything—every mood and time of day and type of person—all seen through disgruntled and sorrowful eyes. Wegman's pictures have a more inward kind of everything. Simultaneously lush and surrealistic, silly and fairy-tale-like, they contain as many different moods and pictures as a good variety show on a night when it surpasses itself. The images go from being brilliantly weird (with an undertone of something serene) to being unexpectedly romantic (with an undertone of something insane).[35]

After Man Ray's death, Wegman returned to the photo studio, working without a dog. He photographed pairs of people or paired individuals and inanimate objects. He played with fabrics to camouflage figures or used the textiles alone to create characters (and was so skillful at this that John Reuter of the Polaroid studio dubbed Wegman "the Fabric King," a label the artist proudly wore). He also returned to some of the ideas used in his earliest black and white photographs,

Silver and Gold 1982, Polaroids, work in two parts: 24 × 20 in. (61 × 50.8 cm), each

readdressing them in color, and offered at times specifically new "takes" on some of his earlier subjects and images.

In Wegman's rephotographed version of *Cotto*, his "Eureka moment" of 1970, we see once again the rounds of salami on a plate, Wegman's hand entering the field. However, in the new version, a glistening red cloth takes the place of black and white speckled tabletop; Wegman's hand is notable for its glitter as well as for the ring he wears. The new staged event, still a still-life set-up of sorts, no longer highlights the formal repetitions of the multiple black and white circular forms but rather the realities and theatricalities of his new "red" palette and his new staging. Here is the actual color of the salami, as well as the addition of an aerosol can of Fiery Red Fluorescent Hair Color (this bit of "real-life" color functions not unlike the bottle of red nail polish in *Fey Ray* [p. 108]). In making these changes, Wegman has rewritten the photographic ironies: he exchanges the simulation of a "document" of an event or situation, traditionally in black and white, with the simulations of the products of the commercial photography studio, traditionally in color, with their often fictive "improvements" of the real to

heighten the seductions of its subjects, whether food, folks, or fashion.

In 1985, three years after Man Ray's death, Wegman acquired another weimaraner, Fay Ray. Though she would later figure importantly in his work, Fay Ray was not photographed by Wegman professionally until 1987, ending a five-year period in which Wegman worked without a dog. He photographed Fay in these first shots in a "Wonder Woman" costume and in a work titled *Rising* (pp. 118–19), showing her arising from the heap of artificial flowers that had covered Man Ray in one of Wegman's last shots of him, the Polaroid *Garden* (1982; p. 116).

Three other events marked 1985. Wegman received a National Endowment for the Arts fellowship; with video/performance artist Michael Smith, he cowrote *The World of Photography*, a video first aired that year on the PBS show *Alive from Off-Center*. Also in that year, Wegman returned to painting, while spending the summer in Maine: "Every night I would close my eyes and imagine what the paintings would look like, and I had to do it."

20 x 24 POLAROIDS

Rising 1987, Polaroids, work in two parts: 24 × 20 in. (61 × 50.8 cm), each

Transmission 1992, Polaroid, 24 × 20 in. (61 × 50.8 cm)

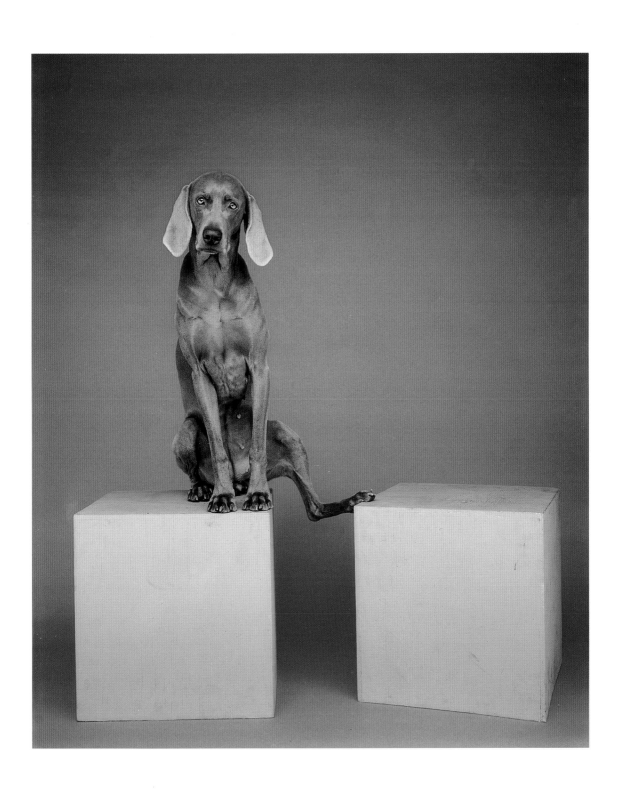

Connector 1994, Polaroid, 24 × 20 in. (61 × 50.8 cm)

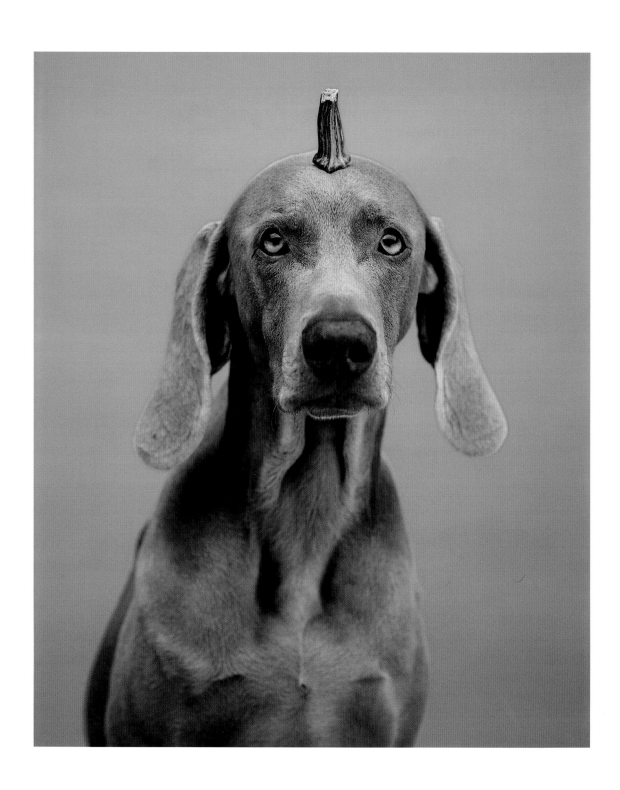

Pumpkin 1997, Polaroid, 24 × 20 in. (61 × 50.8 cm)

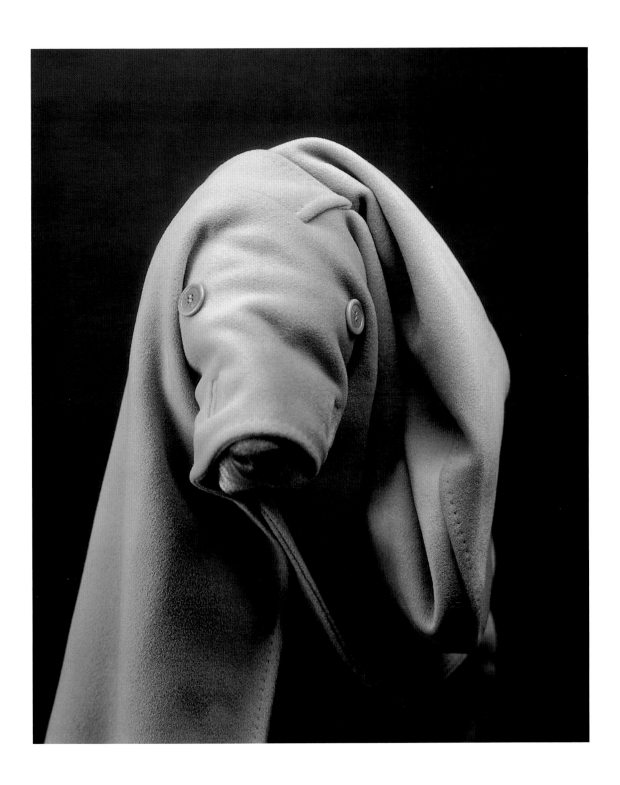

Mammal 2001, Polaroid, 24 × 20 in. (61 × 50.8 cm). Collection of Giorgio Guidotti, Italy

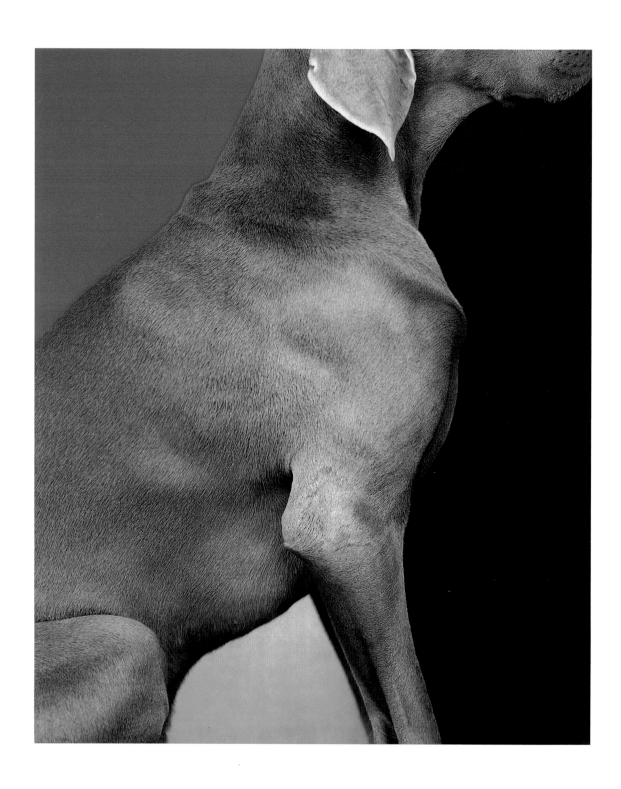

Leger 1998, Polaroid, 24 × 20 in. (61 × 50.8 cm)

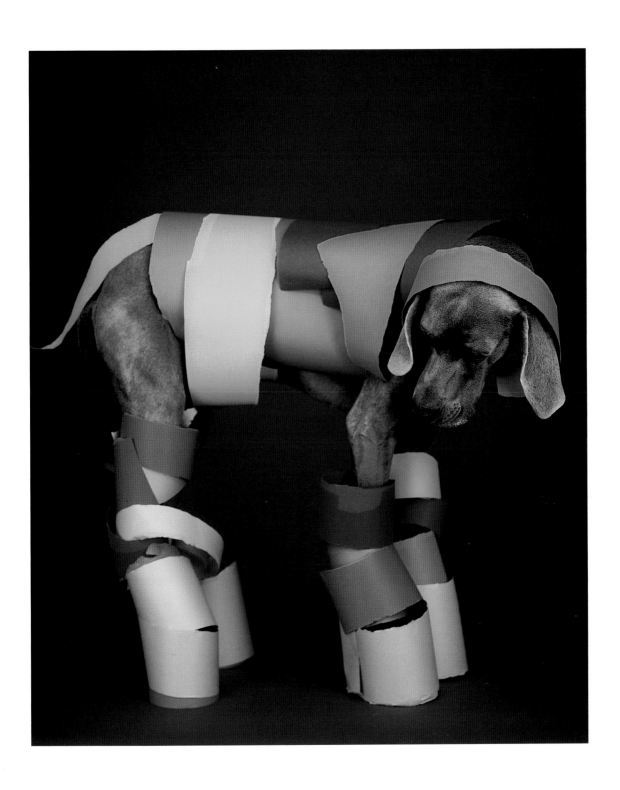

Strippy 2001, Polaroid, 24 × 20 in. (61 × 50.8 cm)

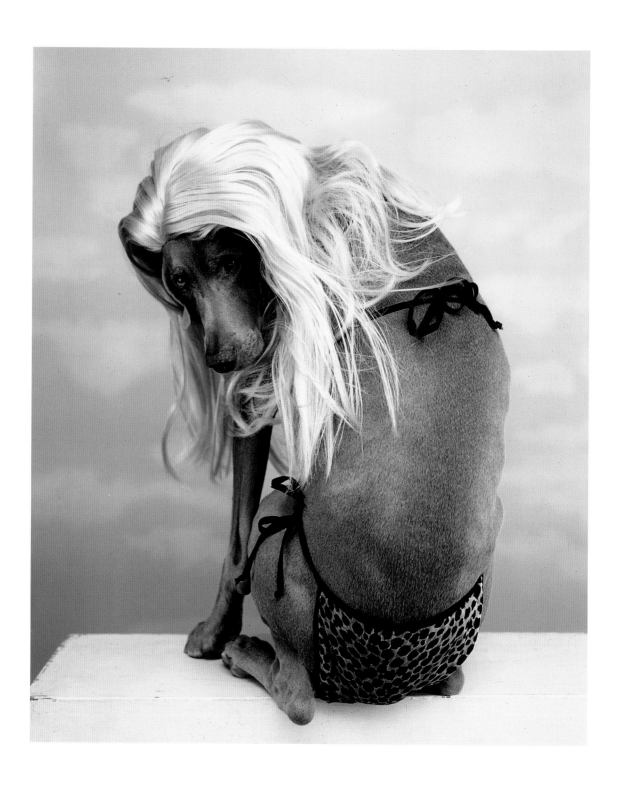

Bikini 1999, Polaroid, 24 × 20 in. (61 × 50.8 cm)

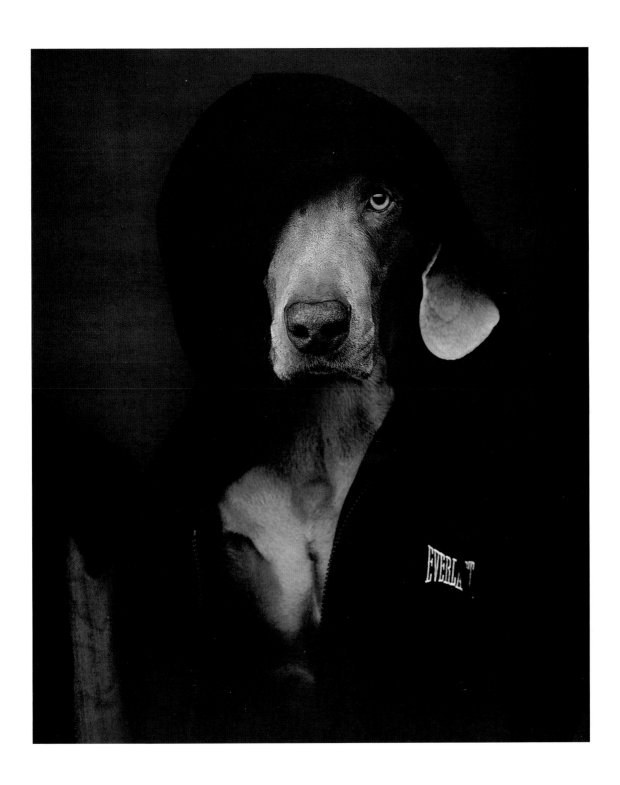

Boxer 2001, Polaroid, 24 × 20 in. (61 × 50.8 cm)

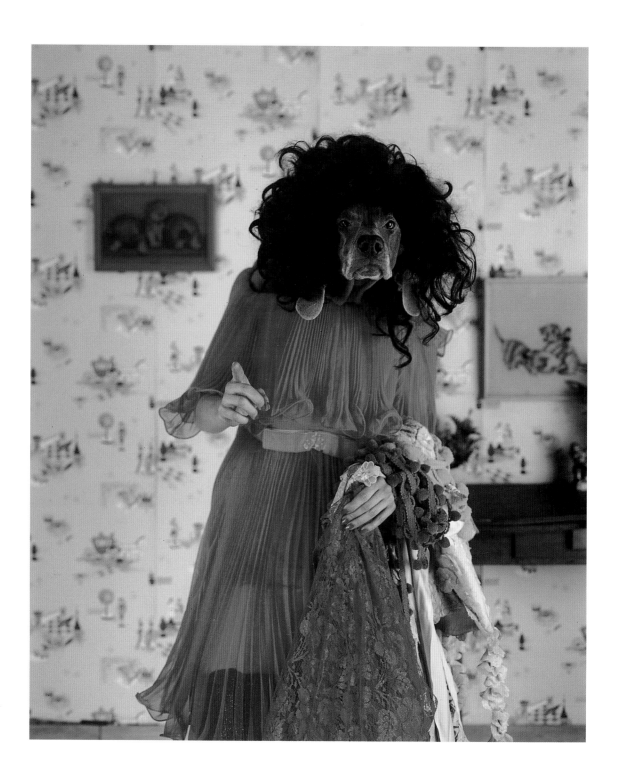

Evil Stepmother 1991, Polaroid, 24 × 20 in. (61 × 50.8 cm)

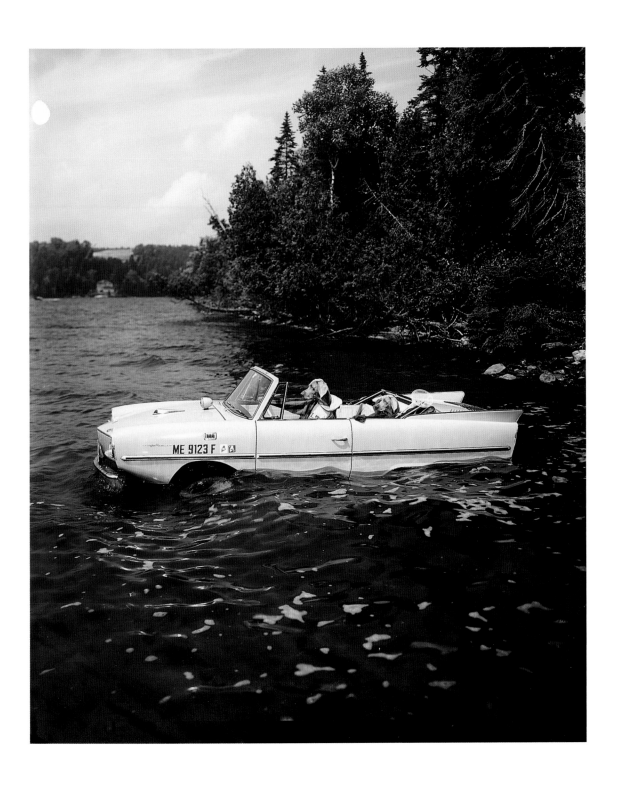

Rescue 1993, Polariod, 24 × 20 in. (61 × 50.8 cm)

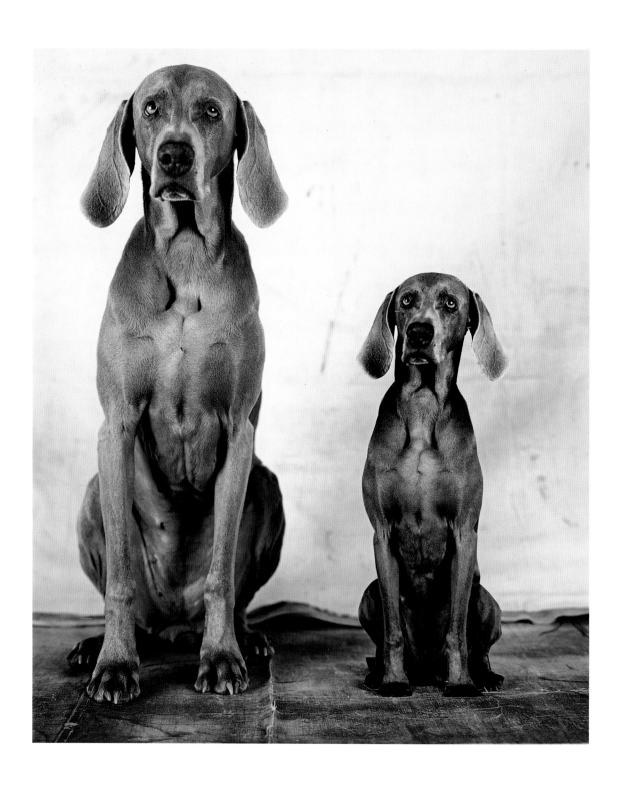

Stand In 1998, Polaroid, 24 × 20 in. (61 × 50.8 cm). Collection of Allison Salke

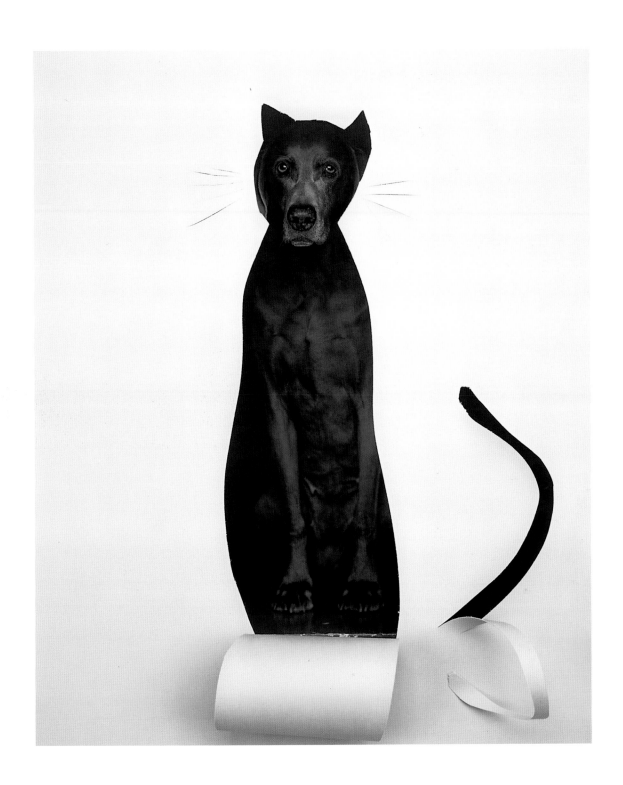

Catty 2000, Polaroid, 24 × 20 in. (61 × 50.8 cm). Private collection

Deposition 1997, Polaroids, work in five parts: 24 × 20 in. (61 × 50.8 cm), each

Breakers 1999, Polaroids, work in three parts: 24 × 20 in. (61 × 50.8 cm), each. Private collection

Armored 2005, Polaroids, work in two parts: 24 × 20 in. (61 × 50.8 cm), each

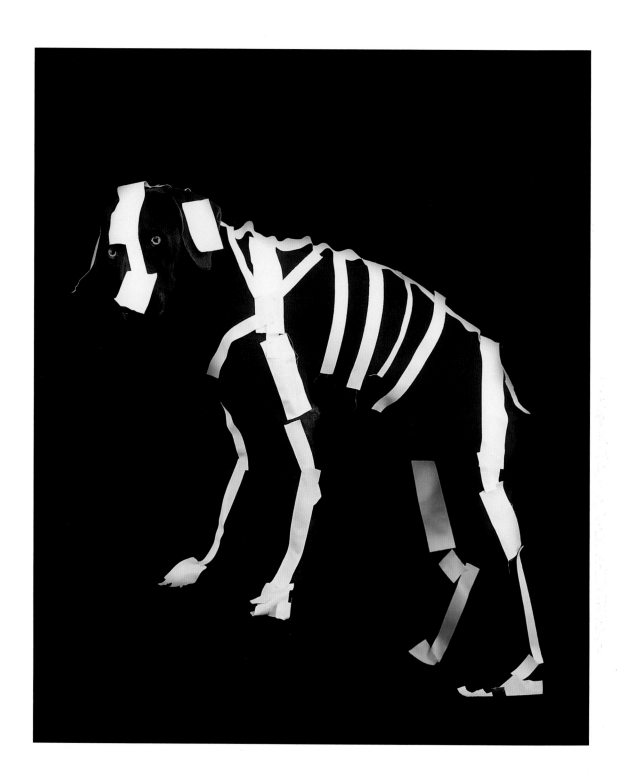

Skelly 2005, Polaroid, 24 × 20 in. (61 × 50.8 cm)

Eyes 2005, Polaroid, 24 × 20 in. (61 × 50.8 cm)

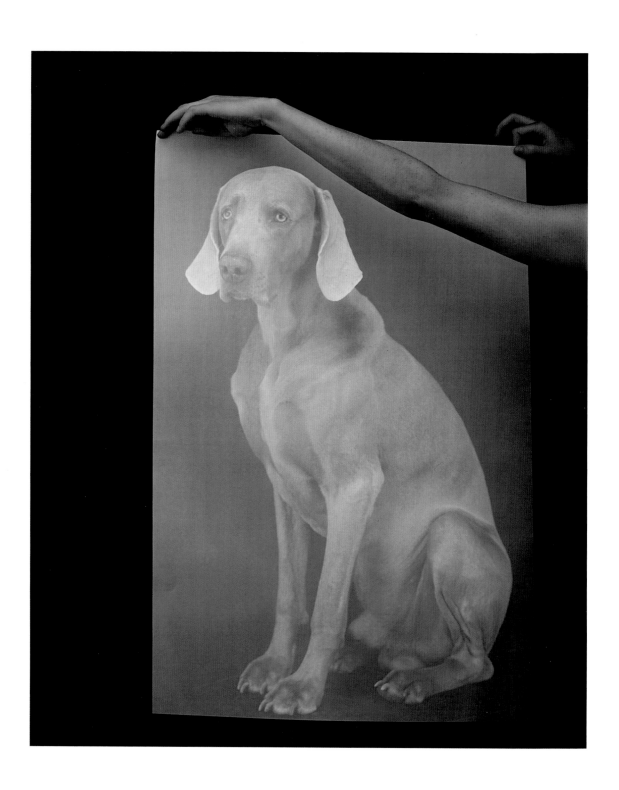

X-ray Double Exposure 2005, Polaroid, 24 x 20 in. (61 x 50.8 cm)

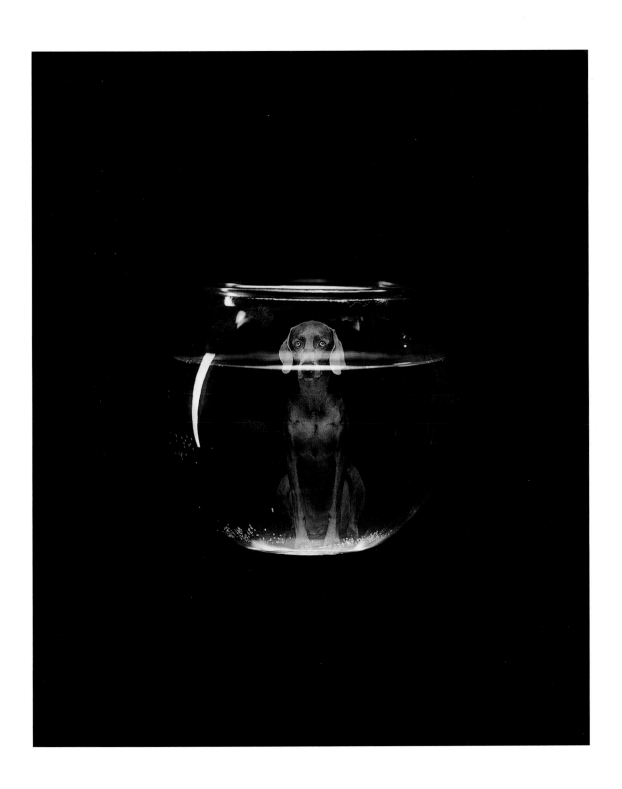

Dog Bowl 2005, Polaroid, 24 × 20 in. (61 × 50.8 cm)

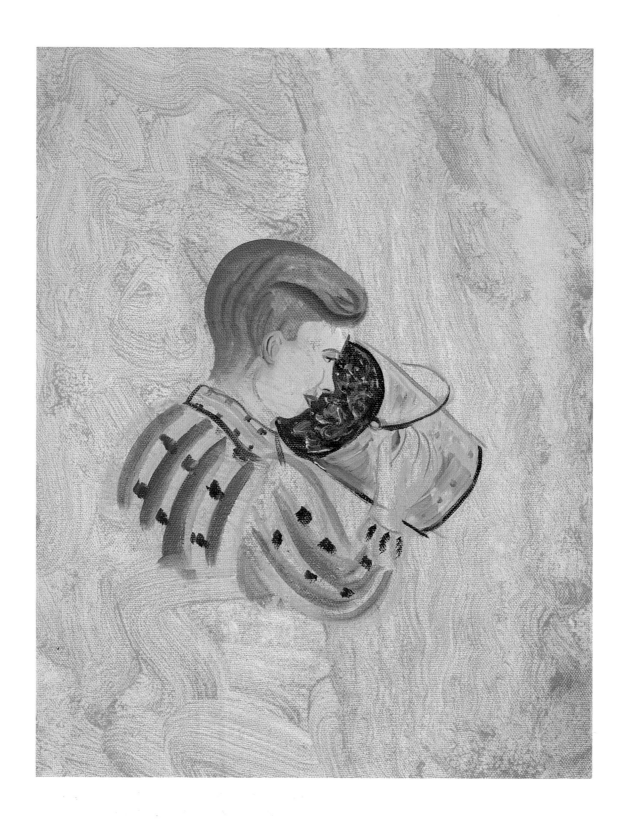

What Is Sound? 1985, oil on canvas, 14 × 10 ⅞ in. (35.6 × 27.6 cm)

BIRCH BAY 1985–1996

Q. Why did the conceptual artist take up painting?
A. It was a good idea.
 —John Baldessari, 1981

[*David*] *Ross:* And what about the return to painting. Who can we thank for those?

[*William*] *Wegman:* Well, we could start with David Davis. The New York City art store where I buy my painting supplies.

Taking up painting again was curious and contrarian, in relation both to Wegman's practice as an artist for the previous fifteen years and to the international context of artmaking in 1985. Although Wegman had been thinking about painting for some time, he had resisted the idea during the first half of the '80s, when the medium had defined the zeitgeist. The "New Spirit in Painting" exhibition in London in 1981 had heralded the "return" of painting, and had included abstraction as well as diverse strands of Expressionism, which had been developing in the 1970s in Germany ("Neo-Expressionism"), Italy (the "Transavangardia"), and the United States ("New Image Painting"). Following soon after and organized by two of the three "New Spirit" curators, was "Zeitgeist," a similarly paradigm-shifting exhibition mounted in Berlin in 1982. And preceding both, setting out the terms of the new decade before it began, had been Barbara Rose's show "American Painting: The Eighties," in New York in 1979. In fact, well before Wegman returned to painting in oil on canvas, drawings of his had been included in Marcia Tucker's "'Bad' Painting" show in New York in 1978, which had marked a return to figuration and a consciously naïve style among diverse artists.[1] The catalogue quoted Wegman saying, "I hope that you will not overlook my section in the exhibition. They are the eight small drawings."[2]

The exploratory, conceptual, "pluralist" art of the '70s seemed in the early '80s to be narrowing down to painting. Temporal and performative practices were perceived to be losing their innovative place, along with the photography, text, video, and film work that had served to reintroduce into art not just the figure but also narrative and psychosocial, autobiographical, and political content—the very subjects of painterly Expressionism. By 1985, however, this wave of "new"

interest in painting was beginning to crest, in favor of the kind of staged photographic tableaux vivants that Wegman had been a key figure in defining, and also of a new kind of high-production-value color video, shown first as multimonitor "sculptural" or environmental installations and later as wall projections. Both the new photos and the new video were shown at the scale and with the formality of painting: in the mid-'80s, color photos such as those of Cindy Sherman were often the size of easel paintings on canvas, and by the '90s innovations in printing had allowed them to reach mural scale, in the work of artists such as Andreas Gursky and Jeff Wall. Video too embraced the mural format, being shown as literally one with the wall, and re-creating for the viewer the absorptive, participatory space of Abstract Expressionism. In addition, photography and video, unapologetically no longer "new," had begun to assume the palette, the sense of fragmentary narrative, and indeed the object status traditional to painting, while also pulling in storytelling devices drawn from film, television, and the novel as well as elements of the everyday culture of signage, billboards, advertising, and illuminated display panels.

In hindsight, one can see that even as Neo-Expressionist painting was assuming a central position in the international discourse of exhibitions and criticism, alternatives in photography and video were developing strongly and would in fact become the dominant modes of the next twenty years. By the mid-'80s, for example, Sherman had not only rendered the "photography or art" question moot in her staged, self-directed self-portraits but had also moved from the late-'70s manner of her small black and white "Film Stills" to a signature format of large color prints. Her first traveling museum retrospective was prepared in 1984.[3] By the mid-'80s, artists working in the media of the staged color photograph (James Casebere, Louise Lawler, David Levinthal, Laurie Simmons, Sandy Skoglund, and many others) and of the simultaneously pictorial and sculptural video installation (Dara Birnbaum, Mary Lucier, Bruce Nauman, and Bill Viola, to name but a few) were beginning to edge out painting once again.

It was at this juncture that Wegman wanted to paint, didn't want to paint, and finally did. "I hadn't painted since graduate school. [David] Salle, [Julian] Schnabel were painting then, in the early '80s.... It seemed like everyone was painting. And if I was to

start painting, even if I wanted to, it wasn't something I would do then. By '85, it wasn't big news. 'Well,' I just said, 'I'm middle-aged, I'm famous enough, just do it.'" Putting oil paint to canvas was not a methodical, procedural decision for Wegman, then, as his turn to staged photographs had been. It was more like the additive, exploratory, idiosyncratic process of his 1973 turn to drawing—a way to express a personal content that could not enter his work in photography or video.

Wegman's desire to paint had been expressed in other ways before it entered the formal territory of the stretched canvas: in his drawings of the early '80s he had already begun to use colored pencil, gouache, and inks on paper, among other media, as in an essentially black and white drawing called *Fun* (1983), in which a four-member family on shore watches a car being towed out of a body of water. Both water and car are but an ink wash of indigo, the only chroma in sight. Given the way the drawing is made, the commentary of the title, and the remarks drawn lightly within, one recognizes that the titular "fun" pertains to the family's pleasure in the aftermath of an accident. Seeing them from the back as they watch, we also see their comments floating near their heads, as in a cartoon: from left to right, one kid comments, "Its fun Dad"; a second says, "I'm having fun"; then Dad remarks, "It is fun." No comment from Mom, the last in the family lineup, but allowing one's eye to move from her up the page, one sees a fifth figure in the picture, the crane operator who is lowering a hook toward the car to fish it out of the water. Above the cab in which he sits floats his remark: "This is fun." Beyond all this pleasure within the picture, the title might also serve as a self-reflexive comment by Wegman, observing his own pleasure in painting the drawing, and also, as a writer, observing the scene from the vantage of a kind of omniscient narrator.

In looking at the precedents for Wegman's return to painting, one might recall that since the late '70s he had been drawing and painting on the surfaces of his photographs and on other supports as well:

I started to draw on the walls some of my overlapping images from the mid-to-late '70s. They tend to be with color, and with overlapping lines—they have a kind of Sigmar Polke look—and I was drawing on shelves, on my stairs—I did a painting on my back wall, a green painting of ladies or trees,

and then in Maine in 1985, I decided to do it. So I got some paint, and store-bought canvases, and started to make these paintings.

Which of Wegman's paintings came first? As with the staged photographs of 1970, the official "first," in that case *Cotto*, is merely the one that comes dressed with the best tale: Wegman has told different stories at different times about beginning painting in 1985, and each story, rather than recording precisely what came earlier and what later, reveals a different aspect of his practice. In one telling (to this writer in 2004), the first painting was a picture of a man looking away from the viewer and into a bucket (p. 142)—the kind of skewed point of view, one could speculate, that Wegman himself had assumed earlier when he looked not toward the video camera but toward the monitor in the tripartite setup of his earliest video equipment. Even more immediately, one might call this early painting a self-portrait of sorts, with the bucket being the sink in the artist's apartment on East 6th Street. While Wegman has often used found objects as art materials, he has also consistently used ready-mades or basic, elementary materials for the furnishings of his homes and studios. Given that Wegman does not consider the man-with-his-head-toward-a-bucket painting terribly interesting—and that he has nevertheless kept it in storage—it may be a first, incompletely realized attempt in his new medium.

"I actually painted my first painting," Wegman said in another version,

on the back of a stretcher, not on the side you're supposed to. It was up in Maine and I think it was a barn and there was a tree and a telephone pole. I remember I made the pole fall over and the wires break. I think that's because I didn't want anyone to know I was painting, so I was cutting off all communication to everybody. And by putting the image on the back I could lean it against the wall and no one would see it.[4]

The ambivalence about the return to painting apparent here is also clear in this exchange with David Ross:

Ross: Does it seem strange to be painting again?
Wegman: Funny, strange, and eerie.[5]

In his painting as in his drawing, Wegman chose a deliberately naïve style—in fact a multiplicity of styles. He acknowledges that he could not have gone back to the Frank Stella–influenced approach of his MFA work, and he also wanted to avoid the facility of his own painting in his childhood, when he was known as "Billy the artist." He does not think of himself as a photographer, he notes, even when he is taking photographs, but

when I'm painting I become a painter. I think about all the things painters worldwide think about. The upper left. Stretch a canvas. One of the great things that Frank Stella did is he avoided the problem that Hans Hofmann caused: the composition. I went back to the Hans Hofmann school of painting. There was nothing to add to the Frank Stella.

Wegman worked on the new paintings with energetic momentum, if not quite at the pace of his altered photos of the late '70s or of the drawings from early in that decade. He proceeded unmindful of a consistent style, subject, or approach but attentive to each set of images. His early paintings, as Gary Indiana wrote,

belonged less to the history of painting than to the history of Wegman's personality. This personality remains the most amiable and seductive personality in contemporary art. Wegman is one of the very few strong artists in our time who has nothing hateful or mean-spirited embedded in his work. His production hasn't been consistently "big" or invariably compelling, but the big things haven't served to bash other artists around and the fizzles haven't been failed acts of megalomania. This in itself is extraordinary.[6]

These paintings took Wegman to memories of his childhood in the late 1940s and early '50s, in the suburban but still wooded area around his home in Massachusetts, and also to images from books and other printed sources that had once served the boy painter. "The clue to these strange pictures," wrote Kay Larson,

comes from his bookshelf, where a much-thumbed copy of *Webelos*, the Cub Scout manual, tucks itself

away next to an old set of encyclopedias. Images appear out of his memory, out of what he calls "this unconscious suit of boyhood, or life before puberty and sex and high school and all those fascinations … pirates, airplanes … anything that allows me to daydream into the painting."[7]

In most of Wegman's accounts, this daydream-into-painting began in the Rangeley Lakes region of Maine, where he was spending more and more time each year. It is perhaps unsurprising, then, that many of the first paintings are landscapes and seascapes. One of these shares its conceptual starting point, subject matter, and process with the postcard/collage paintings of nearly twenty years later, a method of composing and structuring in which Wegman begins with a readymade image that he transfers to his support as a starting "mark" from which to extend the image outward. In these later pictures, however, he affixes the object itself—a postcard or greeting card—directly to the canvas; in the 1985 work *Harbor View*, he began by copying an existing painting, then developed his own image from it. The painting was a watercolor from around 1949 by an artist named Peggy Cullen, a friend of his uncle Everett. "A kind of generic New England harbor scene, of Rockport or Gloucester," recalls Wegman, it had hung over the couch in his grandmother's living room. He accordingly describes his process here as a "'Rosebud' situation." In using the Cullen as a starting point, Wegman doubled his content, as he had, for example, in his video retakes of television advertising. His approach was more affectionate than parodic, though; Lisa Lyons's description of him as an "affable subversive" captures his sense of play, in which he is both astute about and at ease with his subjects.[8] Following the Cullen-inspired canvas, Wegman made others working off various types of found objects and their subjects or motifs: "a decorative pillow, upholstery fabric," he notes, and other things.

Among the first of the paintings of 1985 was one initially exhibited under the pragmatic title *Introductory Painting* and later retitled *Hope* (p. 147). As Wegman has said of these works generally, his idea for *Hope* initially involved amateur "How to Paint" books; he eventually focused on the '50s television show in which art teacher Jon Gnagy demonstrated the techniques of drawing and painting. *Hope* brings

landscape, architecture, portrait, and written document into odd relation. In the center of the painting is a woman's profile, a hovering presence that dwarfs an architectural element below (recalling the miniature observatory below the large hovering lips afloat in the sky in Man Ray's signal painting *Observatory Time—The Lovers*, 1932–34). At right is a note card painted in trompe l'oeil, as if a separate object—a painter's note or label—had been collaged into the work, superimposed on its painterly surface. Given that this note takes up almost the full height of the painting and functions as its topmost plane—in a work already constituted of layers of washes eliciting multiple images—it reads as in some way more important than the rest. Documenting Wegman's "process," it serves as a label both explaining and critiquing his method.

Adding another level of complication, Wegman has incorporated within this note what can be read as another kind of landscape: within the white card are vertically stacked color washes inflecting each section of text with an appropriate palette, so that the phrase about the lawn—"GREEN THEN BECAME A GOOD CHOICE FOR THE LAWN COLOR"—is modulated with green, although one can't quite locate the lawn itself. Above it is an ambiguous image of either sun or flower, and we might note that Wegman chose red for this image (as well as for the girl's hair). As in his photographs that have captions at odds with their images, or in his altered photographs with their inscriptions floating like a second layer of information over their photo-processed grounds, the painting overtly displays a rhetoric of disjunctive showing and telling. Echoes of the Conceptual artist's "instructions," too, survive in the card (and in the numerals 1 to 5, painted at the bottom of the canvas). Other precedents include the words naming colors painted by Jasper Johns and Saul Steinberg (both using colors other than the color named). Wegman himself had in other works substituted word for image, as in *Landscape Color Chart* (1972; p. 9), the sign that states "WOOD" in the 1976 ink and Letraset drawing of the same name, or in the pencil drawing *19th Century American Landscape* (1973), where pictorial details—"STARRY HEAVEN," "weed," "NIAGRA FALLS"—are written as much as pictured. Finally, the notecard/sign in *Hope* serves as a recipe of sorts for making the painting. It is not Wegman's only image or text to use the recipe format, not only as a

Hope 1985, oil on canvas, 20 × 25 ¼ in. (50.8 × 64.1 cm)

structuring device but also to derive comedy from a mix of ingredients.

Wegman signed *Hope* with an "artistic" "William Wegman" signature and added to the note card a miniature self-portrait. That the "Breck Girl" was his inspiration for the painting's red-haired central figure, and his own high school–yearbook picture for the self-portrait, takes the beginning paintings of 1985 back to his teenage years, when he made pencil copies of Breck Girl portraits in magazines. As he has said, "In art school I learned not to concern myself with [the Breck Girl]. In my return to painting I thought she might be the right subject, so I painted her and included some other simple things that for me represented innocence: a log cabin, my class picture, and a letter from me describing the painting, ending with the sentence 'I am more than happy with it.'"[9] Among the work's inventory of self-consciously naïve techniques is its misspelling of "chimney" and the framing of that word within quotation marks.

As important as *Hope* in setting out Wegman's painting vocabulary that first year was the small canvas *Birch Bay* (p. 148). Like Wegman's best works in all mediums, *Birch Bay* plays in the dissonance between two different ways of telling, two different ways of showing: using his eye and touch for the correct found object, Wegman has applied curling segments of birch bark to the canvas, poetic stand-ins for birches whether painted or real. There is also a funny/strange comparison here between the "skin" constituted by paint on canvas and the paperlike skin of the tree. In her catalogue essay for the 1995 exhibition "Mainely Wegmans," Alexandra Anderson-Spivy writes,

The small canvas he made [in Rangeley], called *Birch Bay* (1985), is one of his first paintings after a hiatus from painting of almost fifteen years. The picture combines several subsequently recurring themes: the rustic hotel sign, the lake and the sailboat, the Boy Scout map with mysterious foot-

Birch Bay 1985, oil and birch bark on canvas, 18 × 23 in. (45.7 × 58.4 cm)

prints, the golf pennant. These all reappear in various guises in later Wegman photographs and videos and other paintings. The dreamy, sometimes strange *World Book* imagery that flowered in the paintings actually had some of its roots in Wegman's delicately sardonic drawings. By the mid-'70s, "Drawing became not so much a perfect conceptual complement," he says, "but a deeply important routine mode of expression for me, its range extending to my own dark corners."[10]

The painterly passages in *Birch Bay*—a house, a lake, a turtle peering through a hole in a bark overlay—counterpoint its collage elements, while painted-in verbal elements serve both as "realistic" signage and as artifice-rupturing internal captions.

Wegman's paintings initially puzzled an audience that had come to expect his black and white photographs, his videos, and his color Polaroids, especially those featuring Man Ray. Viewers had also become accustomed to Wegman's sense of humor, wry and distinctive— a kind of comedy that had in fact rerouted Conceptual art, so often characterized by sobriety. That humor was evident in the paintings, but had taken a new turn:

it was neither the deadpan of the early photos and videos nor the almost music-hall theatrics of the Polaroids, with their costumes, poses, and pairings. The paintings had a new kind of wistful irony. Alexandra Anderson captured their tone when she wrote, "Wegman's misty washes of atmospheric color are like little greeting cards from dead civilizations, ones as recent as the fifties or as distant as ancient Greece. But these memory poems are steeped in irony, not sentimentality, and they are stubbornly individual, their humor more oblique than that of the photographs."[11] Wegman himself remarks,

In the process of making a painting, the humor went. A painting should not be humorous; drawings—they're quick and don't take up material space in the same way. There were some joke paintings, but something that weighs seventy pounds and takes care to store—that shouldn't be funny. In any case, my works have never been totally about humor.

In 1985 Wegman was commissioned to make a site-specific sculpture for the Stuart Collection on the campus of the University of California, San Diego.

Museum of Beer 1985, oil on canvas, 42 × 48 in. (106.7 × 121.9 cm). Estate of Holly Solomon

After considering many different locations and ideas for outdoor sculptures (including one for a fountain with a house on fire in the middle and a surrounding circle of miniature firemen putting the "fire out with the water streams from their hoses"), Wegman decided to build the scenic overlook—one facing, however, a rather unscenic site—that he would finally title *La Jolla Vista View*.[12] The project, which he addressed in a sustained way for three years (1985–88), immediately informed his paintings, especially as he worked on the panoramic bronze depiction of the view: his paintings too became panoramic views, filled with myriad detail. He had begun painting with memories in his head of images from his childhood—the wallpaper in his bedroom, for example, on which images of pirates had been printed out of register. But he soon began to explore the kinds of combine of nature and culture—natural phenomena posed against construction sites, new architecture, and other manmade attractions and blights—that he had seen, and drawn repeatedly, at the site of *La Jolla Vista View*.

If many works fall readily under the rubric "art about art," a subset of these is art about architecture. In one of the paintings from 1985, *Dome and Cottage* (p. 149), Wegman finds similar and different forms and functions—one of his compare-and-contrast abutments—between the two structures named in the title, the one the primordial shelter, the other Buckminster Fuller's futurist permutation of the form. (There may

also be an echo here of the forts he built in the woods as a young boy, setting off to explore there with his dog Wags.) He would incorporate in the paintings many references to Le Corbusier's Ronchamp chapel (pp. 81, 227), Frank Lloyd Wright's Fallingwater (p. 151), and other architectural icons without relinquishing his fondness for vernacular buildings such as motels. Several works survey a cityscape from a bird's-eye point of view, or render its artificial peaks and valleys in schematic renderings so extreme as to become diagrammatic. In many ways Wegman's paintings take on the same kinds of subject matter found in the pictures of the noted color photographers Stephen Shore in his vista views from on high and Joel Sternfeld in the accidental surrealism of his found juxtapositions.

The paintings marry influences from the Chinese landscapes that the young Wegman had seen at the Museum of Fine Arts in Boston and from *La Jolla Vista View*, which seems to have affected them just as strongly, in terms both of the figures within them and of the composition of their fields. Among the 1985 works is *Museum of Beer* (p. 150), in which mountains have billboards and ghostly Indians float in the sky, superimposed in a kind of painterly drawing (recalling the way Wegman had earlier painted or drawn on his photographs) and oriented in a floating, vertical composition, almost a stack. A number of the paintings transpose indoors and out, or juxtapose "beautiful" landscapes with blight. Interiors are shaded with

House and Village 1989, oil and acrylic ground on canvas, 32 × 64 in. (81.3 × 162.6 cm)

FOR A MOMENT HE FORGOT WHERE HE WAS AND JUMPED INTO THE OCEAN

For a Moment He Forgot Where He Was and Jumped into the Ocean 1972, gelatin silver print, 14 × 11 in. (35.5 × 28 cm)
Collection of Gian Enzo Sperone, Courtesy Sperone Westwater, New York

incongruous objects: *Double Barreled Painting* shows oil barrels in a living room. As Roberta Smith wrote in 1992, the "clouds of red paint" in *Major Mining* "suggest pollution" (one might say the same of the gray smoke cloud in *Hope*). Smith also astutely noted the edge of commentary and illustration on which the painting *House and Village* (1989; p. 151) turns:

> In "House and Village," Frank Lloyd Wright's Fallingwater, an angular masterpiece of modern architecture, overlooks small-town America, a neatly ordered grid of white houses and steepled churches. Between them is a yellow steam shovel that may represent the villagers' anger at the lofty individuality of Wright's creation. Or perhaps the machine is the harbinger of Fallingwater: The Subdivision, row upon row of identical, radical houses.

> Either way, the painting offers a witty, subtly sinister metaphor for the rugged terrain that lies between high art and real life: a place that has been Mr. Wegman's artistic territory for the last twenty years.

As usual, Mr. Wegman leaves us smiling. But

the growing power of his recent canvases also makes us admire his painterly skills and contemplate the deepening meanings of his art.[13]

Some of Wegman's early photographs address landscape in a way that hints at both the history of painting and the earthworks of what was then the contemporary moment. In *Basic Shapes in Nature* (1970), inspired by the geometries of Cézanne, Wegman denotes a square, a triangle, and a circle within large vistas, imposing, for example, a square as the head of a tiny figure standing on a hill before a vast sky. In another photograph from the same year a circle covers the face of a figure in a wooded scene; this time the work gets the scale-shifting title *Flying Saucer* (p. 153). One might see implied here the large marks made within still larger terrains by such artists as Michael Heizer or Dennis Oppenheim (not to mention a prefiguring of the geometric blots that John Baldessari would later use to mask parts of his photo-

graphic images). Another of Wegman's conceptual landscapes both deflates and escalates the humor of Yves Klein's leap into the void, the French artist's staged dive from a second-floor window documented in a (faked) photograph of 1960: Wegman's 1972 variant depends on the "horizon" made by studio floor meeting wall, above which he is seen suspended in midair as he enacts the typed legend, "FOR A MOMENT HE FORGOT WHERE HE WAS AND JUMPED INTO THE OCEAN" (p. 152).

Wegman's interest in landscape and architecture continues from the drawings he began to make in 1973 to the paintings of a dozen years later. Verbally declarative in the drawings *19th Century American Landscape* and *WOOD*, it manifests more ambiguously but no less effectively in the painting *Thing in the River* (1990; p. 154), in which Wegman's isolated body in the water, readable as both small rock and large island, becomes a play on scale.

Another address of landscape appears in the

Thing in the River 1990, oil and acrylic on canvas, 11 × 14 in. (27.9 × 35.6 cm)
Collection of Mr. and Mrs. George W. Couch III

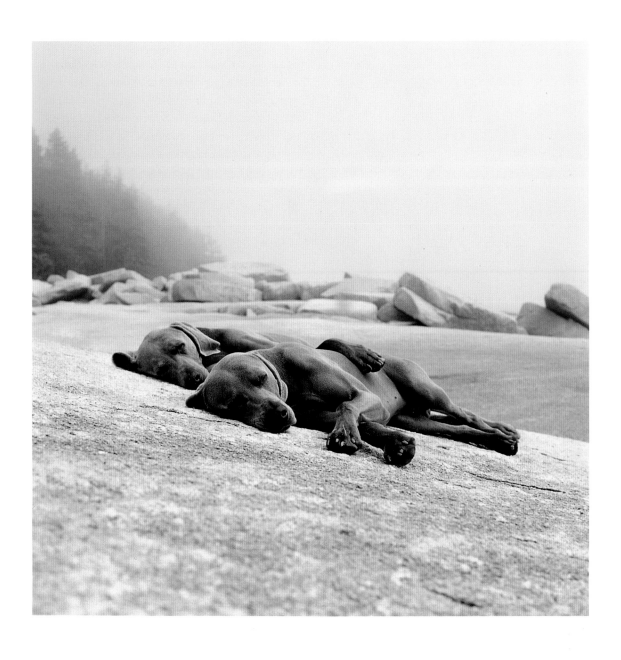

Washed Up 2002, Chromogenic print, 14 × 11 in. (35.6 × 27.9 cm)

precisely and formally composed Chromogenic prints that Wegman would begin to make in 2000. Factual, direct encounters, intimately in the moment, these works are closer to modernist "straight" photography than the Polaroids are; the point of view too is different from that of the Polaroids, largely because of the limitations of the twenty-by-twenty-four-inch Polaroid camera, with its fixed focal length. Yet here, too, Wegman retains his directorial instinct, setting the dogs into the crevices of rock formations in *Lines of Force* (2002), and along rocky shores in *Washed Up* (2002; p. 155).

Wegman usually shoots the C-prints in September, in Maine, on walks with the dogs. Using his Hasselblad double-lens 2 ¼-format camera, he works without lights, costumes, or constructed sets, and certainly without assistants—he and the dogs are often alone, or perhaps one companion comes along for the walk. The tools and advance preparation are minimal by comparison with the teams of helpers needed to set up the large-format Polaroid camera. (On occasion, however, Wegman has had that camera sent up to Maine. He used it in Rangeley for some of the last shots of Man Ray; in 1995 he used it there again to develop the scenario of his film *The Hardly Boys in Hardly Gold*.) Unlike the Polaroid, the Hasselblad allows Wegman to "move back," so to speak, exploiting its depth of focus to make shots that take in large vistas in which the dogs become integrated details. Conversely he can also come in close, as in *Ramp* (2000; p. 156), which seems at once landscape, still life, and portrait: Wegman is down on the dock at eye level with the dog, though the dog's eyes are shielded by a wood block that obviously projects toward the photographer on the ground near it, and that seems to advance into our space. Wegman rarely shows his C-prints with either his Polaroids or his earlier black and white photographs, so different are they in their intimate mood, naturalist palette, and size.

In 1988 Wegman brought the Polaroid twenty-four-by-twenty-inch camera to Maine, a trip that would be repeated annually for the next six summers. Whether he is setting it on the back of a truck to roll it out into the lake, dealing with the rural dust that mars its developing surface, or scaling rocks with it to get the shot, the difficulty of the journey (not of shooting or processing the pictures) recalls nineteenth-century

BIRCH BAY 1985–1996

Ramp 2000, Chromogenic print, 14 × 11 in. (35.6 × 27.9 cm)

Watkins 1993, oil and acrylic on canvas, 62 × 52 in. (157.5 × 132.1 cm) 157

Untitled (Fay Running, after Muybridge) 1988, gelatin silver prints, work in four parts: 8 ¼ × 8 ¼ in. (20.9 × 20.9 cm), each
Addison Gallery of American Art, Phillips Academy, Andover, Massachusetts, museum purchase, 1991.150.1-4

photographers such as Carleton Watkins, who moved through the majestic landscapes of the American West with heavy view cameras and the elaborate supplies necessary for using them. Wegman's interest in nineteenth-century photography was newly kindled by black and white Polaroid films developed in the early and mid-1990s, which reminded him of certain historical photographs and of the kinds of illusion found in them. He had long known the photographic works of Duchamp, often produced in collaboration with Man Ray, and for that matter the photography of

Man Ray himself, and of other Surrealists. Also in the mid-'90s, the San Francisco photography dealer Jeffrey Fraenkel gave Wegman some damaged nineteenth-century prints to work with—to alter as he had altered his own "vintage" prints, revealing or amplifying their internal detail with pen and ink. He found additional inspiration in a catalogue on Watkins published by the Fraenkel Gallery, to the extent that he "retook" the image on its cover: *Piwyac, Vernal Fall, 300 ft., Yosemite*, made by Watkins in 1861.[14] Wegman did not remake this work as a photograph, however, as, say, Sherrie

Stop Action 1999, Polaroids, work in five parts: 24 × 20 in. (61 × 50.8 cm), each

Levine might have done; instead he re-created it in oil
on canvas, emphasizing the luminous waterfall. In
Watkins (1993; p. 157) Wegman in a sense became
Albert Bierstadt, working in response to a majestic,
awe-inspiring view.

 Earlier, in 1988, Wegman had keyed off another
historic moment in photography when he made a serial
photographic work called *Untitled (Fay Running, after
Muybridge)* (1988; pp. 158–59), setting up a series of
four black and white shots of Fay Ray, legs bent and up,
like the horse in Eadweard Muybridge's famous experi-

ment. A decade later he reexplored the phenomenon of
running legs, this time actually off the ground, in the
black and white Polaroid *Stop Action* (1999; pp. 160–61).
In an untitled work from 1998, on the other hand, the
dog's legs are anchored like trees in a majestic sweep
of woods. For his sequential Polaroid works of the late
'90s, Wegman just as often used the dogs as near-
abstract elements, gray bundles forming the topogra-
phies of valleys, mountains, and rocky seashores.
The most "constructed" and theatrically surreal of these
images, with their complex rearrangements of multiple

dogs and their palette derived from backdrops and other paper props, include the seascape *Breakers* (1999; pp. 134–35) and *Time Garden* (2001), which has a hothouse glow.

Wegman's exploration of landscape was and continues to be far ranging. The 1982 drawing *Suburban Exploration* exoticizes a suburban street, and the visitor thereto; a "small town" is similarly treated in the painting of that title from 1986. The painting *Turner* (1989; pp. 162–63) is a luminous take on one of J.M.W. Turner's images of London's Houses of Parliament, and their reflection, which doubles the image in the field, simultaneously offers both a land and a water view. The work also reactivates Wegman's conceptual, punning play in titles: through this reflection it is literally a "turner," since turning it upside down would still provide a valid view.

By 1992, painting had run its course for Wegman, and he put it aside. After thoroughly enjoying it, he had come to a dead end, and he once again abandoned it to focus on other work—particularly the Polaroids, which had been a constant all along. Having begun to photograph Fay Ray in 1987, Wegman followed her looks and personality in new directions, in particular into fashion photography and character studies. In or out of costume, she offered a sophisticated glamour and sensuousness, especially in such shots as *Lolita* (1990; p. 164), where she lies lithely elongated, and gazing directly at her public, on a classic modern chair, or when she sets her head and neck in Audrey Hepburn-like profile under a classically elegant brimmed hat, or extends a feathered foot. The titles of many of the video segments for *Sesame Street* begin "Fay Presents," and the dog also starred in other videos for children. Eventually to become the matriarch of a theatrical canine clan, she was the first of the dogs to "get tall," filling the full frame of the large-scale Polaroid in anthropomorphic verticality—elevated on a pedestal and draped in cloth, or, later, wearing long gowns and other costumes. These shots would develop into a number of hybrid human/animal characters, human hands gesturing from dog's bodies. In a gambit typical of him, Wegman shows in certain works how his illusions are accomplished: in the triptych *Becoming* (1990; p. 165), for example, dog and woman appear side by side and separate in panel one, then have

Turner 1989, oil and acrylic on canvas, 57 ⅜ × 67 ⅛ in. (145.8 × 170.6 cm)

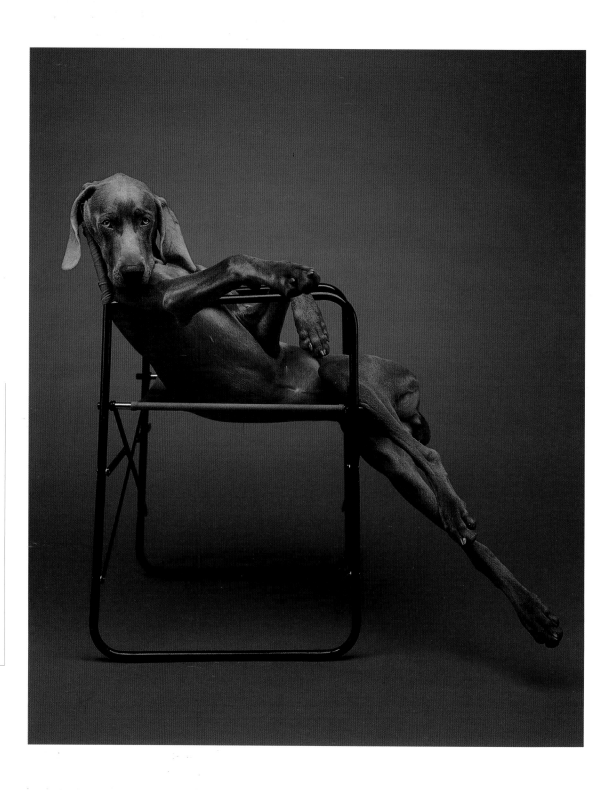

Lolita 1990, Polaroid, 24 × 20 in. (61 × 50.8 cm). Private collection

merged into one character by panel three. The single-panel *Frontal Façade* (1993) summarizes the artist's sleight of hand: we see the façade of full-length dress beneath dog head, but the dog's body is also visible in a shadowy side view.

A widespread impulse toward narrative and cinema emerged in the art of the '90s, and was expressed in a spate of video and film installations in international exhibitions. In Wegman's work it took the form of children's videos and of the longer (if not quite feature-length) 35mm film *The Hardly Boys in Hardly Gold*, which was shown at several film festivals, including Sundance. The film was inspired by the

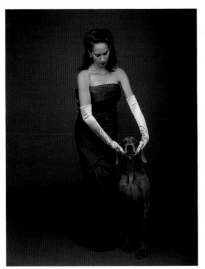
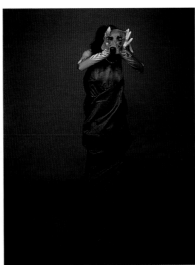
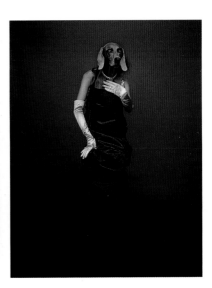

Hardy Boys books—favorites of Wegman's as a boy growing up in the 1940s and '50s—featuring the young amateur sleuths Frank and Joe Hardy, sons of the much-acclaimed detective Fenton Hardy. Before beginning his version, Wegman reread every Hardy Boy story from *The Missing Chums* to *The Sinister Sign Post*. He originally planned a book of his own, for which he started to take Polaroid photographs in the summer of 1993, but by the following summer he had decided that film was the right form. Casting his female dogs Batty and Crooky as the two young detectives allowed him to add a twist to the story: "Hardly boys, they were girls and dogs." The use of weimaraners as detectives

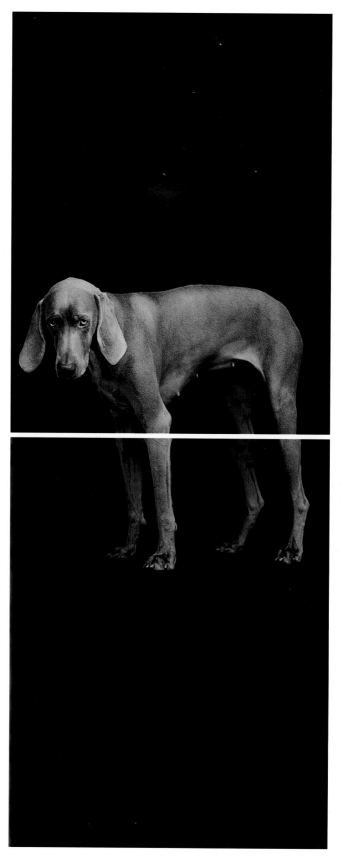

Legs with Feet 1994, Polaroids, work in two parts: 24 × 20 in. (61 × 50.8 cm), each. Private collection

seemed logical to Wegman, since they are hunting dogs—detectives by nature, tracking and sniffing for clues. He also considered the personalities and appearances of other dogs in developing other characters: Batty and Crooky's brother Chundo in the role of their father, Fenwick Hardly, and other male parts; and Fay as their mother, Laurel Hardly, as the villainous Psychotic Nurse, and as Aunt Gladiola Mason, the elderly lady in distress. Set at a summer camp, the Hardly Inn, the film includes various other family members playing sports, including tennis, croquet, and canoeing, and soon finds its plot moving to an old garnet mine, the town's sewer treatment plant, and an abandoned military training site.

The idea of time-based art came through elsewhere, as Wegman multiplied the number of panels in his Polaroid works (as he had in his black and white prints of the early '70s). His serial arrangements of Polaroids were cinematic in effect, recomplicating his imagery, the temporal quality of the works' making, and their sense of speed and time. Another level of narration emerged in both the images and their captions. Wegman might also assemble these juxtaposed Polaroid prints vertically as well as horizontally, as in the diptych *Legs with Feet* (1994; p. 166)—the over, under, and on-top-of positionings becoming a new way to find permutations of meaning.

At a time when others were moving to very large-size photographs, Wegman, in another contrarian turn, went small. In the early '90s he worked with an adapted, small-format Polaroid camera, using the body of one with the better lens of another, to make little Polaroids—intimate studies, almost sepia in tonality, with the feeling of nineteenth-century photographs or even sometimes illustrated calling cards (pp. 167–69). Setting the dogs against stark backgrounds and following them through shadows and twisting trees, these Polaroids are among the most formal of Wegman's photographs.

Wegman's works using the damaged vintage photographs given to him by Fraenkel are also necessarily small format. If one precedent for them is his translation and extension of an amateur watercolor in his *Harbor View* painting of 1985, another appears in his artist's book *Field Guide to North America and to Other Regions*, published in 1993 by Lapis Press. Both *Harbor View* and the book show him testing out and

developing the ways in which he would later collage greeting cards and postcards into drawings and paintings. *Field Guide*, as Wegman notes, "combined stories with funny drawings and C-prints. Each book was almost like a handmade catalogue of a grouping of work. There were postcards, collage material, birch bark and magazine photos ripped out and extended." Perhaps as important in his exploration of these new methods of recombining the found and the invented were the working possibilities afforded Wegman by Lapis publisher Robert Shapazian: lush papers (especially compared to the plain bond paper, scraps, or found materials such as Princess Line stationery that he had earlier used for drawing and for typing his "Tales") and an extended time frame.

Displacing the immediacy—one thought per sheet—of the early drawings, the pages of *Field Guide* were carefully considered and reworked. Some should be thought of as combines, as pages within a page or assemblages of individual pages, for which Wegman drew on magazine reproductions, postcards, his own writings, and found nineteenth-century texts. He also manipulated the formal qualities of the photograph album, mounting photographs on black pages annotated with writing in white ink. The final book is an assortment of diverse sheets, each bundled in an "endpaper" wrapping of checked wool shirting and each presented in a specially designed plywood box. As Wegman explains,

Robert Shapazian of Lapis Press approached me about making a special-edition book with him. He's a weird genius so I thought "great." My first idea was to make a parody of a fashion book with my dog cast but then I came up with a better idea: the *Field Guide*. I have always been interested in nature and nature writings in particular, especially when it comes to clashing concepts of nature— American transcendentalism, the Boy Scouts, *Field and Stream* magazine, new age musings, nature scrapbooks, etc.

On working on Fraenkel's vintage photographs Wegman notes,

It took a lot of nerve to do it, because it was potentially disrespectful. I had no problem altering

Untitled 1993, Polaroid, 4 ¼ × 3 ⅓ in. (11 × 8.5 cm)

Untitled 1993, Polaroid, 4 ¼ × 3 ⅓ in. (11 × 8.5 cm)
Untitled 1993, Polaroid, 4 ¼ × 3 ⅓ in. (11 × 8.5 cm)

Man in Moccasins 1996, gouache and found photograph on paper, 22 ½ × 15 in. (57.2 × 38.1 cm)

Birthday Greetings
TO MY WIFE

It's days
like this
I know
for sure
That I'm
A LUCKY
FELLA
For getting
these
terrific things
all under ONE
UMBRELLA

CARE
DEVOTION
CONCERN
LOYALTY
SWEETNESS

LOVE

HATE
MISER
IMPOTENCE
SMELLINESS
CARELESSNESS
TEPID
SOUR

my own photos—leftovers to begin with—it is
ok to alter things that are yours. These were different.
I started to select ... [from] these pictures Jeffrey
sent me in a bunch. And I started to work with them
in a different way: instead of an exact counterpoint,
I started to work within them in a chameleon style.
I painted them in the style of these photo processes,

and then it was fun to do the Watkins painting.
Both ways of working are twists. One is a twist on
photorealism; the other, taking a given historical
situation and turning it around.

Among the vintage photographs Wegman chose
were portraits to which he gave new attributes: a young

man wearing a mortarboard, for example, acquires webbed feet (*Graduate*, 1996), while a sober business-man gains not only arms, hands, suit jacket, and pants but also a pair of moccasins (*Man in Moccasins*, 1996; p. 170). Another work, *Mountain View* (1996; p. 172), began with a small mountain landscape, which, however, is almost completely camouflaged: extending lines out from and around the mountain, Wegman turned it into a dog's hindquarters, then set this close-up dog within another landscape, mountains to the rear and the side. So fully integrated are the old mountain and the new dog that the image plays almost like figure/ground perception tests: the one and the other merge almost seamlessly, but for the photograph's ever present signifying white edge.

Wegman had made the first of his "extension" works by reclaiming a found watercolor, the Peggy Cullen image he had known for so many years. His alterations of vintage photographs, greeting cards,

magazine covers, and postcards, especially in the collage paintings he began making in 2003 such as *The Tilted Chair* (pp. 184–85), have a commonality with his treatment of that painting: as he notes of the extension works, "They are not parodies per se" but proceed by "pulling up systems as a given, and then trying to wiggle around in to subvert and invert them, to play with them." One might trace Wegman's interest in altering cards and photographs back to his pleasure in copying pictures from magazines and books as a youngster, or to his penchant for collecting all kinds of stuff—'50s illustrations, encyclopedias, how-to books, costumes, furnishings. In many ways a working of the found against the invented, the commercial style against the artist's use of it, has been one of the most consistent parts of his practice, through many stylistically differing results.

BIRCH BAY 1985–1996

Mountain View 1996, ink and found photograph on paper, 14 × 18 in. (35.6 × 45.7 cm). Private collection

PAINTINGS

Interior Adobe 1985, oil on canvas, 36 × 48 in. (91.4 × 121.9 cm). Private collection

Axis Sculpture 1985, oil on canvas, 22 ¾ × 20 in. (57.8 × 50.8 cm)

Furniture 1985, oil on canvas, 38 × 38 in. (96.5 × 96.5 cm)

Sunken Impression 1988, oil on canvas, 20 × 25 in. (50.8 × 63.5 cm)

Bobby Pin 1985, oil on canvas, 20 x 24 ¾ in. (50.8 x 62.9 cm)

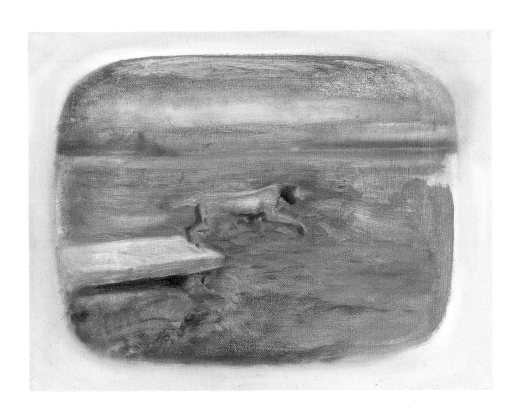

Dock 1986, oil on canvas, 12 × 16 in. (30.5 × 40.6 cm)

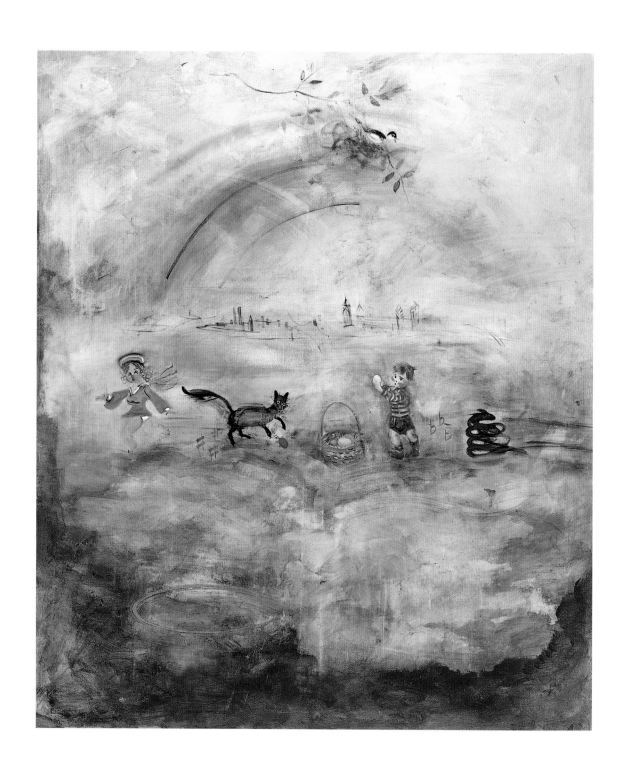

Hallmark 1987, oil and acrylic on canvas, 80 × 68 in. (203.2 × 172.7 cm)

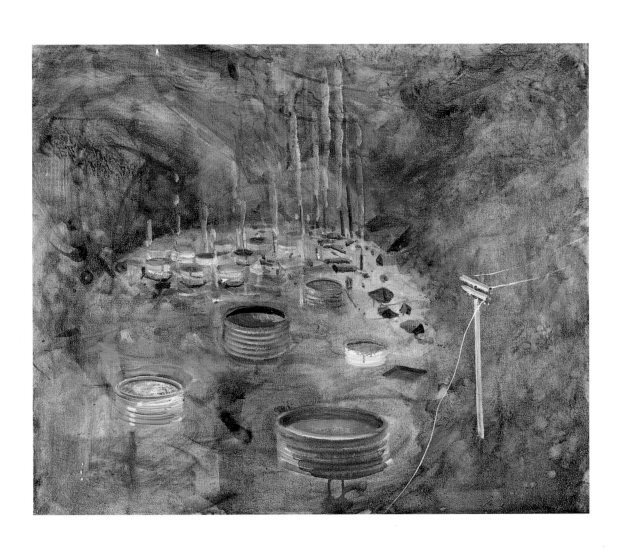

Chemical Soup 1988, oil and acrylic on canvas, 22 × 27 in. (55.9 × 68.6 cm)

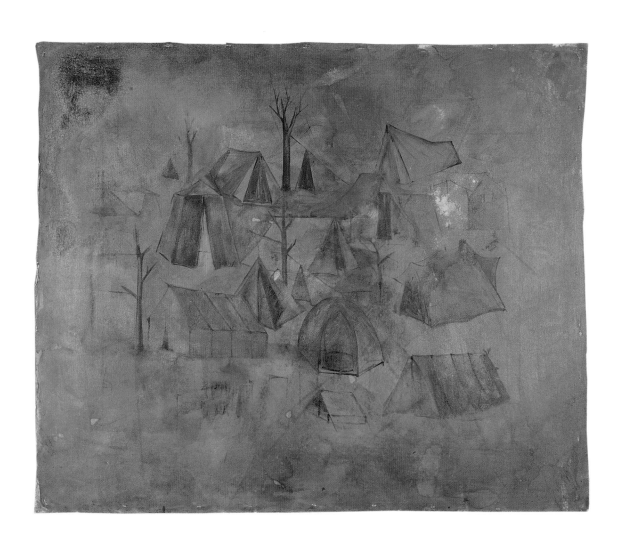

Tents 1996, oil and acrylic on canvas, 61 × 77 in. (154.9 × 195.6 cm)

Foald 1996, oil and acrylic on canvas, 79 × 65 ½ in. (200.7 × 166.4 cm)

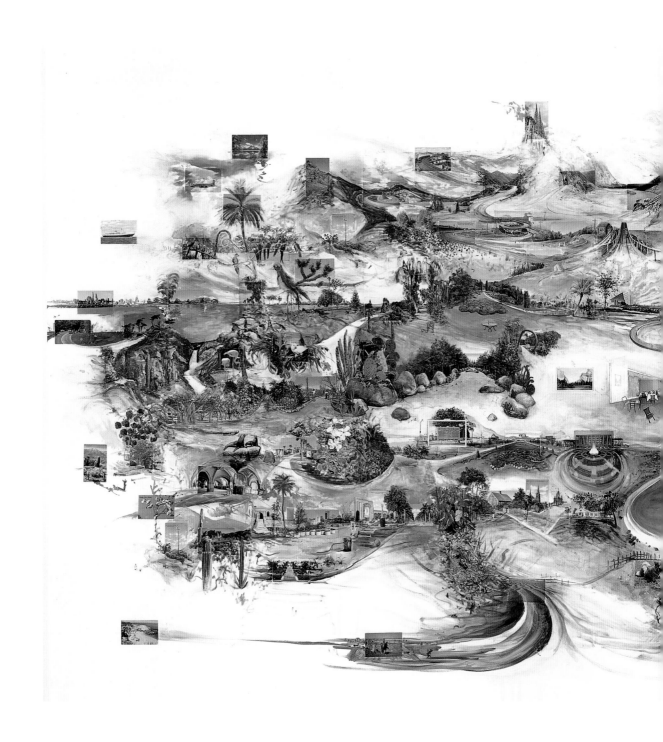

The Tilted Chair 2003, oil and postcards on wood panels, 96 × 192 × 2 in. (24.8 × 487.7 × 5.1 cm)
Columbus Museum of Art, Ohio, Museum Purchase, Derby Fund

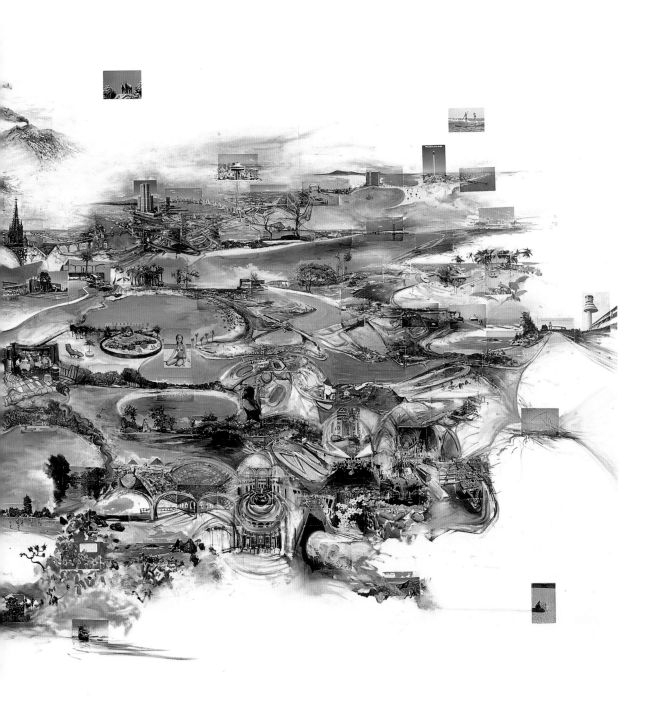

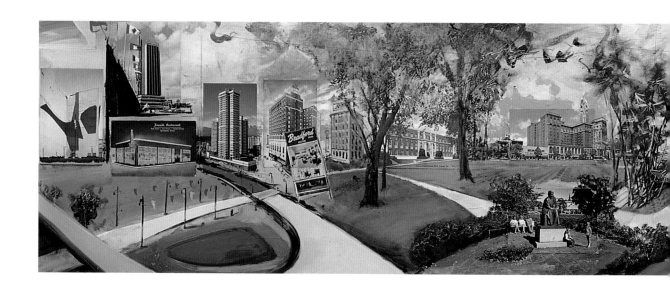

Urban Renewal 2004, oil and postcards on wood panel, 16 × 84 in. (40.6 × 213.4 cm)

Collection of Leisa and David Austin, Imago Galleries

New York Over Underground 2004, oil and postcards on wood panel, 24 × 36 in. (61 × 91.4 cm)
Collection of Dr. Dana Beth Ardi

Scenic Sets 2005, oil and postcards on wood panel, 30 × 46 in. (76.2 × 116.8 cm)
Collection of George and Linda Kelly

Pier 2005, oil and postcard on wood panel, 36 × 72 in. (91.4 × 182.9 cm)

Cat on a Rock 2005, oil and postcards on wood panel, 42 × 66 in. (106.7 × 167.6 cm). Private collection

Museum 2005, oil and postcards on wood panel, 60 × 84 in. (152.4 × 213.4 cm). Collection of Emily Leland Todd

Getting into Artforum 1970, gelatin silver print, 14 × 11 in. (35.6 × 27.9 cm)

GETTING INTO *ARTFORUM* 1996-2005

In art school you're required to study other art.
If you spend six years there, you're just sort
of set up to do battle, in some way. Even if you didn't
want to. I had always thought it was important
not to have art references in my work, because it
would limit the audience.

 —William Wegman, 2004

There has to be something bittersweet for William
Wegman about the schizophrenic nature of
his impact on our culture. He could claim, for instance,
with some justification, to be spiritual father to
some of America's "most serious new art."
And he could claim, as well, with equal justification,
to be the spiritual father of *America's Funniest
Home Videos*.

 —Dave Hickey, 1990

In the late sixties *Artforum* became the most
prestigious art mag to us recent postgraduates.
If I could only be in it I would be known, important,
a made guy. Every once in a while someone
I knew would "get into" *Artforum* and I guess I
couldn't wait any longer.

 —William Wegman, 2004

O f all the themes in Wegman's work, none is more
comprehensive or curious than that of art about art.
Here all of Wegman's media and methods come
into play, as his works do battle, whether overtly or
incidentally, with other art both past and present, by
both revered predecessors and controversial colleagues.
Here, too, there manifests Wegman's most persistent,
long-term exploration of the identity of "an" or "any"
artist, as well as that of "the" artist, that is, himself.

 In Wegman's case "the artist" is many artists.
In 1996, when he moved from his home in a former
synagogue/social hall in the East Village into another
such find—a former school in Chelsea—he created
working spaces reflecting his multiple identities:
separate painting and drawing studios, a video editing
room, a photo studio ready for the arrival of the
Polaroid twenty-by-twenty-four-inch camera when
hired, and an office to field the many requests he
receives for photos, commissions, exhibitions, book
projects, book signings, and other such requests,
and through which he, trailed by dogs, may wander to
work, or in which children may play. (Wegman and
wife Christine Burgin's son Atlas—named after the
sonogram machine on which he was first pictured—
had been born in 1994, and would be followed in 1998
by Lola Byrd Wegman, whose middle name was
selected after the sixteenth-century composer William
Byrd, one of her father's favorites.)

 Within a year of moving into his new work-
places, Wegman would begin to make videos in
his studio again. He had in any case been making short
video subjects for *Sesame Street* since 1988, and these
in many ways share the themes of his videos of
the '70s, and are as conceptually provocative. Some are
demonstrations of counting, with Wegman's video
"reverse"-showing tennis balls being subtracted (or

added) by a weimaraner assistant; others focus on such themes as in-and-out, near-and-far, the alphabet (spelled out in configurations of dogs), and a host of how-tos (pottery, painting, cooking).

Wegman would also readdress his weimaraners, this time of a younger generation, in a book called *Puppies* (1997), which begins with photos of Fay's 1989 litter. Perhaps counter to expectations (in a book that became a best-seller), the story begins with a graphic, detailed retelling of the birth of the pups, which shows the newborn whelps as "more alien than cute" (though cute comes into play later).[1] As in classic fables and fairy tales, Wegman follows a cycle of life, death, and renewal, going on to show the pups in their "grown-up" roles as performers in his works and gradually ending his tale on the one hand with the birth of more pups, in 1995, and on the other with Fay's diagnosis of fatal leukemia three weeks later—only to follow that ending with the story of how Fay's daughter Batty came to inhabit the places of her mother, and, as in many fairy tales, with the death of the mother herself. The book finally ends with the beginning of another cycle: the photographer Wegman working with a young dog, unlike the others in that he is unknown to and unengaged with the artist (and vice versa). Wegman finishes his story, "I will have to find new methods to get his attention. Right now he just sits there gazing out beyond the lens of the big camera in sublime non-anticipation."

Exactly when Wegman decided to take the subject of "getting into *Artforum*" (p. 196) literally into his own hands isn't precisely known, although he shot the photo in 1970 before the same glass-paned doors that show up in pictures such as *Madam I'm Adam* (see p. 97) and videos such as *Tortoise and the Hare* and we can safely assume that it was shot at his home in San Pedro, California, sometime in 1970. (He is also wearing the same "costume"—undressed but for briefs, black socks, and sneakers—that he wore for the video *Pocketbook Man* of 1970–71; p. 239.) What we do know is that over the course of his career, Wegman has been in the magazine many times. He was covered first in 1969, in Willoughby Sharp's article "Place and Process," and he would subsequently reappear steadily, whether in articles or in reviews covering his solo and group exhibitions. That he did literally stomp into the

magazine in the 1970 photograph (stepping on a "bubble cord," he recalls, to trigger the shutter by remote) tells much about both "Wegman" the character—vulnerable and also forthright, getting down to business—and Wegman the artist, who naturally assumes the role of the clown or fool, giving voice to difficult subjects that others shun. The photograph shows him standing, knees bent, looking down, pulling a ripped issue of *Artforum* up around his body to his loins, as if he were slipping on a second pair of briefs. The gesture is as banal as the equalizing idiom that everyone puts their pants on one leg at a time, yet is sharpened by the notion of the equivalence of art magazine and underwear. The *Artforum* in shreds here represents a veneer shattered, a boundary transgressed, while the image is at the same time distinguished by its combination of literalness and poignant futility.

In the critique that works like these established in contemporary art discourse, they recall James Wood's study *The Irresponsible Self*, a critical study of laughter in the novel. Wood discusses a kind of joke that for him is paradigmatic in positing an engagement with a non-normative norm, a persona with whom we may identify, and a familiar situation or context that allows us to read the performer's actions as tragicomedy. He writes of a joke that is "mildly rebellious" and at the same time "also oddly forgiving," because its key figure "offers himself as the weary, downtrodden example of what living in this alternative community will do to you, and offers the alternative community as the *real* normative one. The beauty of the quip is that it seems at first to assert a superiority, only, on closer inspection, to offer a helpless commonality."[2]

In *Lecture* (1999), "Wegman" gives a slide talk about his work and also calls on an expert to amplify the subject—one "Sidney Bernstein," who is also played by Wegman. (Wegman switches roles by stepping away from and back up to the lectern, changing neither his costume nor his voice.) Always literal, Wegman shows his slides by holding them up to our eyes—or rather toward the camera's lens—and illuminating them from behind with a flashlight.[3] We are not exactly blinded by the light because the slide looms so large in our field of view that it screens our vision, becoming an ironic barrier between artist and audience. The joke continues as "Bernstein" works

On Photography 1986, oil and acrylic on canvas, 24 × 18 in. (60.9 × 45.7 cm)

Collection of Ed Ruscha, Los Angeles

that other classic art-school tool, the opaque projector, this time "projecting" an actual opaque item that we are to believe is a Wegman sculpture. This object, like the slides, appears in the space between us and the artist, so that it hides him for the most part, though his hands sometimes reach up around the edges, or his head surfaces over the barrier's top.

Precise language ("First slide please"), opening credits ("Atkinson Visiting Artists Lecture Series/ March 23, 1999"), and closing remarks ("Thank you students, faculty, Professor Atkinson, for inviting me here. I'm going to be hanging around a couple of weeks if anyone wants to meet me, I'm staying at the Charles River Motel") leads one to believe that Wegman had staged a parodic performance in place of a slide talk he had actually been invited to give. In fact there is no Atkinson Visiting Artists Lecture series and no Professor Atkinson; disbelief has been suspended so easily and totally as to produce complete credibility.

In the slide lecture, whether it takes place at a school, a museum, or some other educational outlet, the persona of the artist is often a bigger draw than the art itself. The comments of "Wegman" to his fictional audience will be excruciatingly familiar to anyone who has seen an artist lecture:

By switching to a transparent media I was able to achieve more vibrant effects using the new medium that the company came out with last year. It helped me with my glazings....

I really had a lot of help in this one. Because it was so darn heavy, I needed to get a lot of people to help me with this.... It's an old wax process from the Renaissance but with some new technology applied in, which I think is really good for art students to learn now because you don't need a big foundry, you only just need lots of wax.

The ways in which we respond to *Lecture*, and decipher the clues that prompt our various stages of disbelief and belief, result from the fact that, as Wood notes of his own examples, the joke "arises gently from its context, out of a natural exchange, and in so doing offers us access, albeit fleeting, to the character of the man who made it. It is unflashy; it is not an obviously great or crushing *mot*."[4] Wood continues,

The implicit and not always explicit subject—is a kind of tragicomic stoicism which might best be called the comedy of forgiveness. This comedy can be distinguished—if a little roughly—from the comedy of correction. The latter is a way of laughing at; the former a way of laughing with. Or put it like this: at one extreme of comedy there is Momus, the ancient personification of faultfinding, reprehension, and correction, who appears in Hesiod and Lucian. And at the other extreme of comedy, in the area now called tragicomedy, is the "irresponsible self."[5]

What we see throughout Wegman's many bodies of work, and specifically in his art about art, is what Wood would call the comedy of forgiveness.

Lecture is one of several Wegman videos that take on a convention of the public presentation of art. The biographical mode of educational television, for example, is one of the relatively few places where artists appear with any regularity on television and serves as the model for *Man Ray Man Ray* (1978—the work is one of the exceptions in this medium from the period 1977–97, when according to Wegman he expressly gave up making studio videos as artworks). Artists show up more rarely on late-night network broadcasts, but Wegman's work was seen on Johnny Carson's *Tonight Show* as early as 1977 and has reappeared since, along with himself and often his dogs, on the shows of those who have followed in Carson's footsteps—Jay Leno, David Letterman, and Conan O'Brien, as well as *Saturday Night Live*. And this manner too has become a subject for Wegman, whose video *Late Night* (1997–98) intercuts his actual appearances on Letterman's show in the past with a staged, fictional appearance in the present, spiraling along the way into a rewriting of his own biography and new takes on some of his earlier works.

Wegman's art about art also extends to painting, as in *Watkins* (see p. 157), which, as we have seen, is an oil-on-canvas work based on a Carleton Watkins photograph. Contrary as it may seem to use painting to address photographic history, Wegman uses a similar strategy in *On Photography* (1986; p. 199), a moody nighttime cityscape. Looking down on a pair of buildings, we see an ovoid, vaguely highlighted area, almost a mist of light bridging the two structures and the

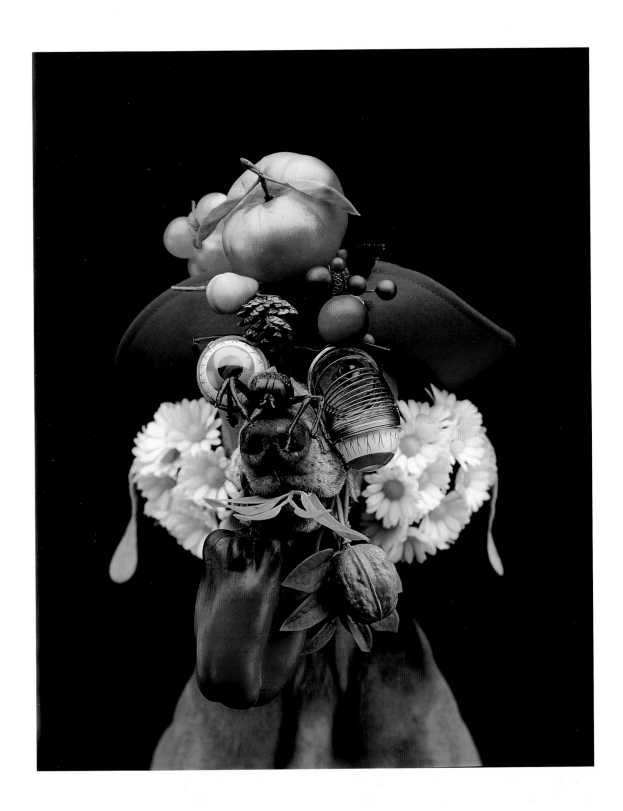

Arcimboldo 1994, Polaroid, 24 × 20 in. (61 × 50.8 cm)

Noland Olitski … art nature 1976, graphite and crayon on paper, 8 ½ × 11 in. (21.6 × 27.9 cm)

street between them. On one of the rooftops (distinguished from the other by its barrel-like water tower, a reclamation of a signal New York landmark) is a ghostly woman dangling a little girl over the edge; on the other is a photographer (sex indeterminable) shooting the scene. The work borrows its title from Susan Sontag's well-known book of 1977, of course, and like that study it constitutes a rather ambivalent comment on the nature of photography—its voyeurism and arguably inherent insensitivity, as when photo-journalists visually document someone's suffering instead of offering more direct and immediate help. One source of the painting was an image in a how-to photography manual—photographic, then, in the most literal sense—showing a man kneeling to shoot his photo of a woman holding a child. All are comfort-ably on the ground; as Wegman says, "It was an inversion; they had been in a safe environment." He also drew upon painting for this painting, specifically that of Giorgio di Chirico: "I was thinking of how di Chiricos usually take place between buildings, but I elevated his ground-level view."

In a rogues' gallery of Polaroids, drawings, and text-based works, Wegman addresses a number of artists of different kinds: Arcimboldo, Joseph Beuys, Max Bill, Chardin, Gilbert and George, Pablo Picasso. As a list, this mixed bag seems arbitrary to say the least, but its arbitrariness is part of its content. As Wegman notes,

> As a shortcut some art teachers offer names rather than ideas to students. It's much easier to say Picasso rather than Synthetic Cubism, Rose and Blue period. If I say the name Chardin or Ryder, an educated art student will know what I'm looking at when I see his or her work. As a lecturer I have to know my audience. Sometimes when I mention Judd, LeWitt, Andre I get a blank look from the face field below the podium.

Arcimboldo (1994; p. 201) stars Fay, bedecked in red felt hat, faux fruit, and novelty eyeglasses with bulging eyes, one of which shoots out and down, dangling from its Slinky-like coil. The pileup signaled to Wegman one of the sixteenth-century Italian painter Arcimboldo's well-known faces constructed of an assemblage of fruits or vegetables, and hence the work's

title. (Like many of Wegman's Polaroids, *Arcimboldo* is part of a series developed out of a single idea—in this case the premise of one-element-perched-on-dog's head, turning pup into pedestal for, once again, an address of art about art. The series began with an untitled 1994 Polaroid in which a single red pepper balances on Fay's head.) Other Polaroids and writings/drawings can be read simultaneously as homages and pointed critiques. If the Polaroids have taken on subjects as different as the Starn Twins and Picasso, the drawings are similarly eclectic, calling on, in one work, Noland, Olitski, Stella, Johns, Andre, and Judd, these names being outlined like abstracted clouds in the sky above a flowering plant bracketed on one side by the word "art" and the other "nature"—the last serving to refocus attention on the abstracted phallus form around Johns and the abstracted breasts surrounding Andre (1976; p. 202). In the 1986 draw-ing *Faculty Show* for the Cranbrook Academy of Art, Wegman's "Musée de Modern Arte" replaces the names of blue-chip artists with those of baseball Hall of Famers Connie Mack, Branch Rickey, and others.

Matisse and Joseph Beuys get their due in individual drawings, as do Max Bill and the English artist-pair Gilbert and George. Wegman deconstructs Gilbert and George's practice with a simple transposition of conjunctions: as he recently put it,

Blue Period 1981, Polaroid, 24 × 20 in. (61 × 50.8 cm)
Collection of Anita and Horace Solomon, New York

203

"What about Gilbert *or* George. That was my idea....
It's worth a drawing I thought."

Picasso, too, gets his due. Wegman wrote in
Polaroids why he made his color Polaroid *Blue Period*
(1981; p. 203):

> In my own work I have visited many art movements,
> but none more often than Cubism the epitome
> of modern art. As a student of art history, my mind
> is filled with names and dates and art-historical
> facts. In *Blue Period*, I combined Picasso's Cubist and
> Blue Period styles. The shallow depth of field of
> the large-format Polaroid camera requires a
> cramming of subject figures into a rather shallow
> space. Add a guitar to the equation and you get
> Cubism. I came by the little framed reproduction of
> Picasso's *Guitar Player* in a Goodwill shop. Man Ray
> is blue thanks to Zauder's liquid makeup. Picasso's
> Blue Period is moodier than his Cubist period.

My Blue Period lasted one afternoon.[6]

Wegman's take on the *Guitar Player* is well described
by the art historian Robert Rosenblum:

> Here, the ever-patient Man Ray re-creates, with
> variations, one of modern art's most famous icons of
> ascetic solitude, Picasso's very old and very blue
> guitarist of 1903, which is presented as a reproduc-
> tion in a dime-store frame. The guitar itself springs
> to life as Man Ray's major accessory, but the
> old musician's almost skeletal crossed legs are also
> transformed into a single blue bone that wittily
> suggests both mortality and dinner. And as a final
> appropriation on this all-blue ground, the guitarist's
> melancholy face, modeled in ghostly blue, is
> mimicked by Man Ray, who affects emotions so
> deeply depressing that the pervasive blue mood can
> actually be seen as a specter on his muzzle.[7]

Honor Dignity Justice (Drawing photographed with Basketball to Enhance Value)
1974, gelatin silver print, 10 ¾ × 13 ½ in. (27.3 × 34.3 cm)

Rosenblum also places Wegman's response to Picasso in the context of recent art:

> Wegman's borrowings from other works of art, past and present … were symptoms of a pervasive condition in the art of the 1970s and 80s that, for want of a better word, we call Post-Modernism. On this level and on far more pretentious ones, the ghost of the art-historical past looms larger and larger as artists, like the rest of us, realize that the progressive, optimistic thrust of Modernism has long ago expired, and that it is far easier now to face backward than forward to what hardly looks any longer like the Utopian future once envisioned by Modernist generations. The key prefixes these days seem to be "neo" and "retro," historicizing attitudes that have been creating the most diverse anthology of Post-Modern dogs.[8]

Logically enough, then, Rosenblum sees the Man Ray of this picture as a culmination of the dog's many roles after 1979, roles "paralleling the photographic self-portraits by Cindy Sherman in which she plays one stereotyped role after another in a complete fiction that includes clothing, wig, makeup, and set change."[9] That Wegman used the dog Man Ray as a conscious parallel to the artist Man Ray bears mention in this context, as does his own parallel use of roles in which he cast first the dog, then himself, as when he assumed the place of the dusted dog from one of his most famous works.

"Neo" and "retro" have long been part of Wegman's vocabulary, especially in his reuse of 1940s and '50s thrift-shop and yard-sale finds, including encyclopedias and other publications. Revision and appropriation were also his lingua franca both before and since the '80s, which produced a concentration of artists working with this kind of reclamation. Wegman is not one to shy away from found objects, whether they be the covers of knitting books (p. 73), a Mead Writing Tablet, or photographs of himself or of other people. In this he is working in a long-established modernist tradition: his inscription in a line down his nose on one photograph (see p. ii), or his addition of "reduce" and "increase" notations to another picture of himself gender-switched by a costume of wig and flapper dress (p. 62), for example, may be placed in the

A SELECTION OF PIPES

lineage of Marcel Duchamp adding a mustache to a found-object postcard of the Mona Lisa, or seen as a nod to Duchamp's Rrose Sélavy persona. As Wegman describes his own practice,

> I swoop down in a way that is not premeditated, like a gull, and then explore an image somehow, whether it's picking things out of it or following a shape. The early ones are more like a lightning bolt, or the light bulb over a head, although sometimes they also meander a little. That's the difference between the paintings and the drawings that begin with postcards or other found images: the paintings dream on and on, and get involved with piddling paint around.

The altered vintage photograph *A Selection of Pipes* (1997; p. 205) shows the swooping, spontaneous quality of Wegman's hand and eye, which made a connection between a group of pipe-smoking fishermen and their eccentrically long, pipelike fishing gear. The image reflects Wegman's recurring practice of comparing and contrasting images that look similar to him, whether he changes their relation by scale or puts the same image in a different context. To make a photograph of 1974, the artist descended on one of his own images, reusing a drawing in a new, ostensibly more marketable context: he posed the drawing *Honor Dignity Justice* on a basketball and photographed the result (p. 204). Seen as a drawing, *Honor Dignity Justice*

A Selection of Pipes 1997, ink on found photograph, 5 × 5 in. (12.7 × 12.7 cm)

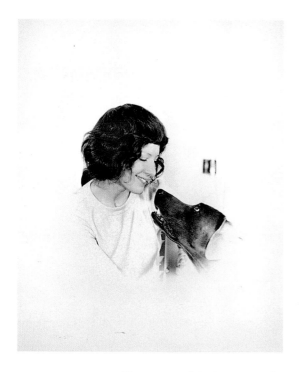

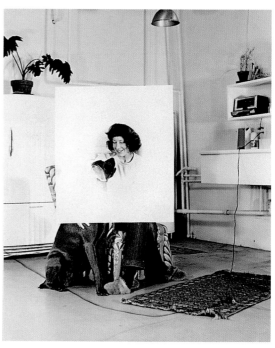

Vignette 1971, gelatin silver prints, work in two parts: 12 ⅜ × 10 ⅜ in. (31.4 × 26.4 cm), each
Collection of Gian Enzo Sperone, Courtesy of Sperone Westwater, New York

is dominated by writing. A low, horizontal building—a motel on a highway strip—has tall signs outside it, signage to flag passing motorists; somewhat incongruously, each sign bears one of the three words of the drawing's title. The title of the later photograph is self-explanatory: *Honor Dignity Justice* (*Drawing photo-graphed with Basketball to Enhance Value*). (This from an artist who almost didn't go to MassArt because it lacked team sports.) Looking at this image today, and recognizing that one's perception of any artwork is informed by what other art one has seen, one might immediately think of such early Koons works as *Three*

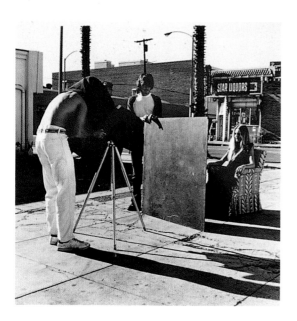

X Ray Photography 1971, gelatin silver prints, work in two parts: 14 × 11 in. (35.6 × 27.9 cm), each

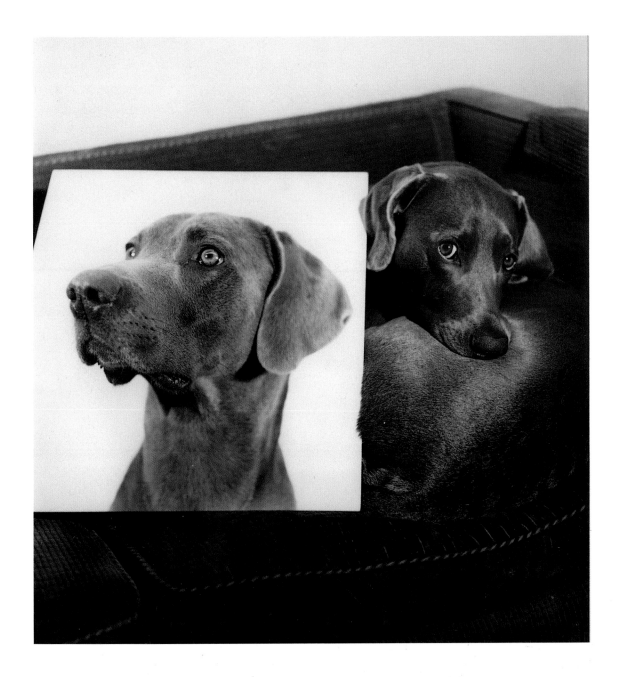

Ball 50/50 Tank, which float basketballs in Plexiglas tanks—but Koons's basketball works date from 1985, a decade after Wegman's photograph. The comparison, though, is still useful, reminding one of the conceptual propositions embedded in Wegman's compare-and-contrast method.

Commercial and practical uses of photography are a recurring interest of Wegman's, whether he is focusing on the professional portrait studio or on scientific applications of photography such as the X ray. The diptych *Vignette* (1971; p. 206) shows in its left panel the kind of sentimental, haloed oval portrait that is standard operating procedure for the average photo studio, the subjects in this case being Wegman's then wife, Gayle, looking down and almost nose-to-nose at Man Ray. This image reappears in the diptych's right-hand panel, a domestic scene showing a woman (we assume) seated in a chair, a dog at her feet looking up at her. She holds the oval portrait in her lap, where it hides most of her body and the head of the dog at her feet—which, however, is correctly proportioned and

Framed Portrait 2003, Polaroid, 24 × 20 in. (61 × 50.8 cm)

aligned with the head of the dog in the reused photo. By implication, the blue-jeaned legs of the woman in the chair are probably, if ambiguously, those of the woman in the vignette photo. In this superimposition of one photo on another to show continuities between the two, Wegman anticipates his later appropriation works using photographs, greeting cards, and scenic postcards, works in which the invented follows in a continuous line from the real. Adding confusion to this internal compare-and-contrast setup, however, Wegman "flops" the two vignette photographs in relation to each other.

Wegman offers a related comment on the subjects of this work in two other photo diptychs, *X Ray Photography* (1971; p. 206) and *Portraiture/Portrait* (1971), which also offer general ideas about portraiture, its processes and products. In the left panel of *Portraiture/Portrait* we see the artist under black cloth, as if working with a nineteenth-century view camera, photographing a seated woman; on the right we see the same woman in close-up. Incorporated into each print is a word typed in capital letters: PORTRAITURE on the left, PORTRAIT on the right. In *X Ray Photography* Wegman poses again with the same old-fashioned equipment as in *Portraiture/Portrait*, and with the same woman seated in the same chair used in that diptych. At first glance the woman in both of these diptychs seems to be Gayle; it is actually her sister, Judy. (As Wegman says, he usually chose his sitters by virtue of their being right next to him. He didn't cast so much as say "Go sit down." The chair is the same in all three works.) This time the scene is outdoors, and what looks like one of Richard Serra's signature steel plates stands between the photographer and his subject. Obviously Wegman's X ray view cannot penetrate this surface, for the photograph on the right, though still a portrait, describes not the person in the chair but the steel plate. Here Wegman foregoes the words montaged into the panels, adding his fragmentary narrative by virtue of the title only.

Portraiture, clearly, is an ongoing subject in Wegman's work, one of a number of photographic genres on which he steadily generates "takes." In the simultaneously elegant and straightforward *Framed Portrait* (2003; p. 208), a dog's head is tightly cropped within a picture frame. Wegman has used picture frames as devices often over the years (and also their

correlate, the window frame); they are almost as consistent a prop as the cube, which as an art-about-art reference echoes both the pedestal of traditional sculpture and the Euclidean geometry of Minimalism (which, of course, actually did away with the pedestal of traditional sculpture). The cube also, Wegman notes, is one of the most readily available on-set items in the studios of commercial photographers.

Framed pictures-within-pictures are a recurring part of Wegman's contrapuntal method, and they are sometimes used to add an everyday touch. The "Picasso" at Man Ray's side in *Blue Period* is a framed

thrift-store find; in the 1987 Polaroid *Charlie* (p. 209) —a work made toward the end of the artist's five-year weimaranerless period—a framed found photograph, county-fair kitsch in style, showing a big-eyed dog with eye-patch-like markings, appears next to the dog's real-life look-alike, the pet of a former assistant of Wegman's, Randy Johnsen. That dog, Charlie, appears in a number of Wegman projects, including *Dog Baseball*, a 35mm film commissioned by *Saturday Night Live* in 1986. "Man Ray didn't want Charlie in any of the pictures," Wegman remembers, "so Charlie had to wait. I thought of Charlie as a kind of everydog to Man Ray's everyman. In *Charlie*, I was thinking about the derelict and the leftover,"[10] and also, as he

Charlie 1987, Polaroid, 24 x 20 in. (61 x 50.8 cm)

amplified later, "of course, of the maudlin Keane paintings."

In *Contemplating Art, Life, and Photography* (1979; p. 211), Wegman alters one of his most iconic images of Man Ray, *Of the Lake* (printed and dated 1976, though shot in 1975). There he had cropped the photograph closely in on the dog, who seems to sit on the surface of the lake and to be continuous with it; in the later work he uses a larger part of the same image, centering the dog in the vertical format. Meanwhile, the white,

If Wegman was confused about photography both early on and, especially, after the death of Man Ray, he became over the years more and more confident in the genres he drew from—whether commercial portraiture, nature studies, or advertising photos—and particularly in his uses of particular moments in photography's history. In his retakes, curiously, he came to battle less with his photographic sources and in some ways to compliment them more directly. Wegman notes, "Photography as a subject is a good one. Its

reflective passages in the water become the grounds for written notes in cartoonlike speech frames. The words are sometimes broken into parts, with fragments appearing on separate areas of white, so that the word "photography" itself, for example, must be perceptually reconstituted from a curving set of minipages: P-HOTOGR-APHY. Accordingly, although we may "know" the work from its title, *Contemplating Art, Life, and Photography*, what we read in the image itself is inconclusive, fragmented, and searching. Reading closely, we can decipher the sentence "I GET SO CONFUSED ABOUT LIFE PHOTOGRAPHY ART" and—over Man Ray's head—"IDEALISM."[11]

history is only about 150 years.... You only have to know about twenty-five or thirty names and that's it. All you need. In painting there are more than 1,000."

Wegman had referred to historical photography in other pictures, titling one four-panel work *Untitled (Fay Running, after Muybridge)* (1988; pp. 158–59) and another, also Muybridgean work *Stop Action* (1999; pp. 160–61). An even earlier play on Muybridge appears in *Folly, Souci, Man Ray* (1973; pp. 212–13), which intercuts three different dogs along a consistent "horizon" where floor meets wall. *Untitled* (1998), a magnificent sweep of "trees" in the form of isolated and massed dog legs, spanning seven panels and

Stand In 1979, gelatin silver prints, work in two parts: 14 × 11 in. (35.6 × 27.9 cm), each

Contemplating Art, Life, and Photography 1979, ink on gelatin silver print, 19 × 13 ¾ in. (48.3 × 34.9 cm)

over fourteen feet, extends this scrutiny of time and movement, and further abstracts the dogs Wegman studies so closely. It also uses what was then a new black and white film from Polaroid to stop motion in a way not possible with color Polaroids.

Despite early disclaimers of interest in the surface and stature of the photographic print, Wegman has nevertheless revealed an eye for the formal qualities of black and white. In *Stand In*, a diptych of 1979 (p. 210), for example, showing in one panel Man Ray heaped in a chair and in its pair a mass of steel wool spilling from the same seat, Wegman juxtaposes the way light moves differently over each of these found objects, revealing their textured surfaces in a multitude of fine, black, but also reflective, lines. The video *Gray Hairs* (1976) addresses a similar find: shooting the topography of Man Ray's coat—working with a professional cameraman and with two-inch tape—Wegman elicits a shifting formal abstraction that remains visually arresting, and something of a mystery, until the tape's end. Similarly, choosing images for recent works applying digital processing to Polaroids, Wegman picked one that examines the swirling hairs in a dog's coat; as is indicated by the resulting pigment print's title, *Chest of Drawers* (2003), the hair "draws" complex patterns on the dog's chest.

Wegman's exploration of the qualities of black and white Polaroid brought new images out of old methods. Shot with this film, the inverted dog's body, seen earlier in the Polaroid *Ray Bat* (1980; see p. 109)

and in an untitled silver gelatin print triptych of 1971, has the glimmer of stone and is therefore titled *Gargoyle* (see *Gargoyle III*, 2000; p. 214). These black and white Polaroids, from *Times Square* (1995; p. 215), in which a fabric remnant masks a dog whose feet show below, to several others made almost a decade later, examine a set of issues related to veiling and the illusions of identity, abstraction, the tactility of fabrics, and the visual blurring of smoke, mist, fog, scrim, and shadow. *Smoke* (2001; p. 216), for example, shows the silhouette of a serpentine figure subject to this kind of veiling. In a series of videos made in 1997–98, noirish in their storytelling, Wegman similarly uses scrim to veil his subjects, both revealing and concealing them at the same time, offering them as shadows and abstractions as he seems to be telling a tale spontaneously.

One of these videos, *Typist* (1997–98; p. 217), summarizes both Wegman's gift as an image-builder and his distinct way of embedding narrative in his works. It shows a man sitting on the other side of a scrim, typing on a manual typewriter. The story is shot as a continuous scene, albeit with the classic three-part structure of beginning, middle, and end: man puts paper into typewriter and cranks the roller to set the paper in place (we hear the sounds on the soundtrack), types (and we hear the clacking of the keys), then cranks out the paper and reads it (silence). Were this all there was, it might be enough, but Wegman also creates tension by letting life slip into this supposedly "real" picture: next to his artful construction, in a

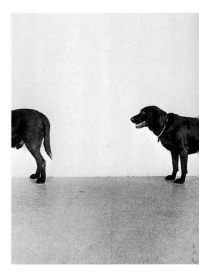

Folly, Souci, Man Ray 1973, gelatin silver prints, work in six parts: 13 ½ × 10 ½ in. (34.3 × 26.7 cm), each
Collection of David Deutsch

vertical slice at the far right edge of the screen, a slice of the typist's chair shows beyond the scrim. The scrim also serves as a "noirish" device, alluding to 1940s Hollywood movies, with their reporters (and relatedly often drinkers), and also to theatrical illusions ranging from *ombres Chinoises* to the soft, almost filmy quality of early black and white television. These various references to visual culture relate this work to Wegman's many art-about-art pieces.

Wegman plays with this veiling device in three other videos of 1997–98, *Stagehand, Car Wouldn't Start*, and *What's the Story?* The quality of the narrative here, and the precisely choreographed movements within the minimal sets, are so taut yet complicated that one feels one is watching a short story. All three begin with Wegman behind a scrim. Wegman starts his story, picking up a glove to literalize what he is saying about being the stagehand responsible for everything going on backstage. The scene thus set, he drops the glove, then advances past the scrim to come into full view, moving stage right to make his first, Shakespearian point, then so far left to make his second that he is partly lost to the camera. Completing this movement, he exits left, then circuits backstage to reenter from between the curtains. Just before he does, we see a second figure in shadow behind the scrim—a "not Wegman" (the artist's assistant Jason Burch) performing as a stagehand, confusing the whole scenario. The "Wegman" stagehand then reenters from between the curtains to say his last lines and exit forward into the audience space. The text accordingly runs,

> As a stagehand—oh look, someone left a glove down here. Hmm see—I'm responsible for everything that goes on backstage. Those little marks at the front of the stage that the actors are supposed to step on, to make sure that those things aren't lifted up. Cause if an actor who's playing Hamlet comes out and says "et tu Brutus" [moves far left] and he's standing over here and says "Romeo Romeo wherefore art thou," it's my fault.
>
> And I don't like being yelled at.
>
> All the time, a lot of times, things are all screwed up backstage.

As in Wegman's earliest videos, the audience here is ambiguous: to whom is the character talking—himself? An empty house? An unseen audience in the house? Or us viewers of the video? Shakespearian in its explicit allusions as well as in its use not only of a play-within-a-play structure but also of a character both commenting on the drama and performing in it, the story undercuts that classic echo by its slightness and circularity—the latter quality being emphasized by the stagehand's movement onto the stage, off it, and around the set to backstage, as if exiting through the wings to return to his correct reentry mark at center. Wegman's improvisational talk directly to the audience may also be his intuitive version of the Brechtian breaking of the fourth wall—a reference, then, to a

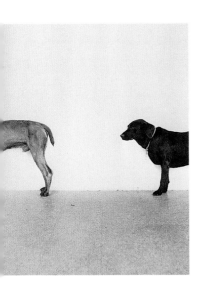
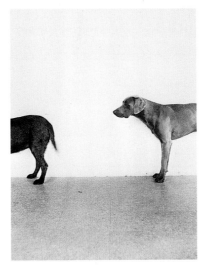
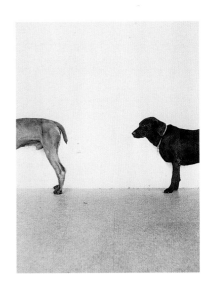

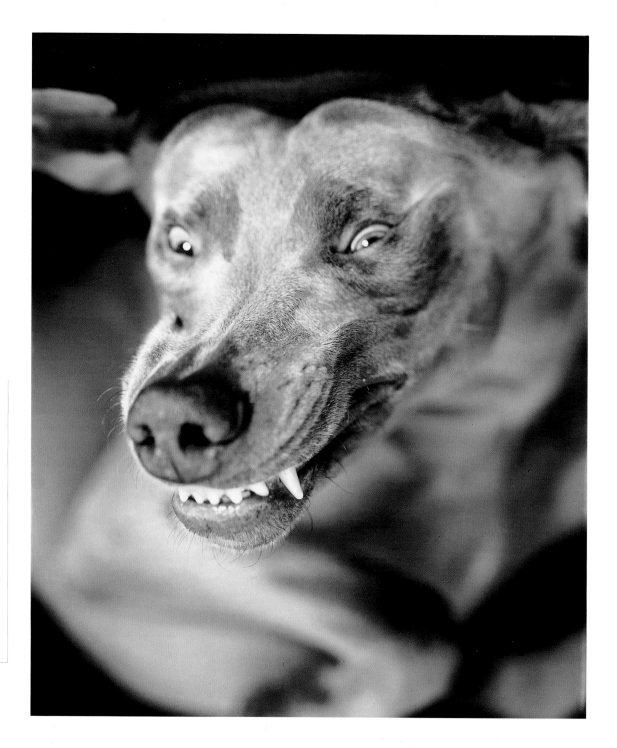

Gargoyle III 2000, Polaroid, 24 × 20 in. (61 × 50.8 cm)

familiar modernist (and postmodernist) theatrical technique. At the same time, it also recalls television commentators' direct address of the audience. Wegman's theatrical references are especially keyed to his timing, which stands comparison to that of the driest of standup comedians, particularly his signature several-beat pause between penultimate and ultimate lines.

The "Wegman" character in the Sisyphean *Car Wouldn't Start*—in some ways the simplest of these story videos—remains there for the length of the telling, walking off into real space only at the end. Here his pantomimed gestures (putting a key in the ignition, opening a desk drawer, walking by marching in place, changing direction by pivoting 90 degrees) are accompanied by emblematic sounds: footsteps and vocal mimicry of the car's motor and of the sliding of the drawer. Meanwhile, though his gestures are in sync with his story, the story itself slips in and out of sync in its internal logic. The whole—the tale of a worker constantly on the move, appropriate to Wegman's life—is maintained by a rhythm and an overriding repeat:

Got out of work. Went down to my car. Got out my key. Put the key in the ignition. Turned it. Rrrr rrrr rrrr. Car wouldn't start. Tried it again. Rrr. Rrr. Dead battery. What am I gonna do? Live a long way from home. Guess I gotta walk. Over 200 blocks 192 190 180 50 20. Here we are. Got my key out. Opened the door. I forgot my keys! Go back to the office. Go into the office. Looked in the drawer. Shhh. Got out my keys. Went back. Started the car. Brr mmm. Drove home. Brr. Car wouldn't start. Got out of the car. Back to the office. Called the repairman. He came. Started the car. Brrr. Got back in the car. Went home. I forgot my keys! Went back to the office. Got out of the car. Walked all the way home.

The most noir of this group is *What's the Story?* which offers two personas in profile, the narrator in the foreground and the silent double sitting typing behind the scrim, just as Wegman had done in *Typist*. Except for the replacement of the noirish bottle with a coffee cup, the setup is virtually the same as in *Typist*,

but this time the typist is played by Burch, a longtime member of Wegman's studio team.

This time around, Wegman adds to the traditional three-act play a fourth act, which ends, as so often, with that wry pause in delivery between the last sentence but one and the very last—here, literally enough, the phrase "End of story." He has also collaged together scenes from different acts or chapters, assembling them into a coherent, even suspenseful play. (One can find an analogy between this narrative

method and the recent collage paintings that construct an overall landscape, if summary and sometimes dissonant, out of individual postcards and their painted extensions.) And finally he has called on the twinning devices that he has used from the outset, syncopating his words and the actions of the double behind the scrim. The story:

So. What's the story. Once, once, there was a time that I was going down the ... no, no. That's not it. The other time that I spent going out with friends of mine, going to the local restaurant, the mystery happened that, in chapter 1, which is this chapter I will be telling you about, the food never came and that was only the beginning. This gorgeous blonde came in, and I don't remember anything else.

Act II: Me and the gorgeous blonde were upstairs

Smoke 2001, Polaroid, 24 × 20 in. (61 × 50.8 cm)

in this garret I'm show'n her some old clothes I have from the old days. Try this on, I said, as I took a sip from my coffee cup. As I took a sip from my coffee cup. I took a break from typing and took a sip of coffee from my coffee cup. Where was I, I said to her. Sit down be comfortable, I said in my story. Be comfortable on this chair here. Relax. And I'll try some things on. See what you like. You like this? She fell asleep. The narcotic was taking effect. I sipped from my coffee cup again. I picked up my coffee and sipped.

Act III, Scene II: Back at the restaurant. No specials today. Nothing whatsoever.

The mystery was darkening. I left the restaurant in a huff. I forgot my raincoat. I had to go back to the restaurant. My raincoat wasn't there.

Act IV, Scene II. The blonde wasn't there. I went home in a cab. Jazz music played. End of story.

Wegman's ease at moving between photography and video, painting and drawing, is notable less for its production of variety than for the different ways he is able to draw on the same themes and cast of characters, applying to each one an economy, a way of voicing ideas, proper to the medium. He is always drawing on familiar language in a new way, and with a kind of sensuousness—in these videos, for example, with a rhetoric of repetitions and hesitations, and a play between action and sound, that both partake of his method of collage and capture a content of hope versus loss, persistence versus frustration. In what is again a Shakespearean device, the stage is set up as a stage, a real space of illusion calling for no suspension of disbelief. The result is an almost magical kind of reality, both conveying the stuff of daily life and manipulated by an illusionist choosing elements that are as poetic as they are actual.

In his essay "Deceiving Appearances," of 1926, Man Ray wrote,

I have tried to capture those visions that twilight or too much light, or their own fleetingness, or the slowness of our ocular apparatus rob our senses of. I have always been surprised, often charmed, sometimes literally "enraptured."

Typist 1997–98, video still

Retouched by William Wegman 1997, gouache on photographic negative, 10 × 8 in. (25.4 × 20.3 cm)

Photography, and its brother, the cinema, join painting as it is perceived by any spirit conscious of the moral needs of the modern world.[12]

It is logical that Man Ray should turn up as a reference in Wegman's art about art, and this not only because his presence hovers in all the photos and videos of his weimaraner namesake. There is Wegman's version of a solarization, for example, and the variants on rayograms such as *Screen Puree* (1975; p. 220),

whose illuminated kitchen strainer is very much in the spirit of Man Ray's found objects. *Photogram* (1973) features the kind of found metal item with holes (albeit overscaled in Wegman's version) that in some of Man Ray's works generates an interesting pattern or image directly on the photographic paper. In the 1984 Polaroid *Handy* (p. 221), tiny porcelain doll hands lie on Wegman's face, a strategy used by Man Ray in both portraits and self-portraits. And in an untitled altered photograph (c. 1981; p. 219), Wegman lays claim to the

Untitled c. 1981, ink on gelatin silver print, 8 × 10 in. (20.3 × 25.4 cm)

iconic lover's lips (actually those of the photographer Lee Miller) that Man Ray painted, photographed, and drew many times: observing the bow shape of the upper of these famous lips, he contributes the logical (for him) addition of Cupid's arrow (see also *Bob and Ray*, 1996; p. 84).

The 1978 video *Man Ray Man Ray* confronts and conflates the life histories of two figures with key positions in Wegman's work, the dog and man who in his world share the same name.[13] This documentary-like video mimics the form of the public-television biography, in which an expert invests the story with both the charm of an Alistair Cooke and the quiet authority of an art history professor, but sound and image are desynchronized; the biography of the one is attached to images of the other. Adding to the faux-reality quality, the narrator is Russell Connor, artist and host of a well-known art program made by WGBH television in Boston. As Wegman recalls, "Part of the reason I thought up the piece was to use him—it was like using an anchorman as an anchorman."

Wegman does something similar in *Late Night* (1997–98), intercutting his own biography—footage of earlier appearances on the Letterman show—with an invented talk-show setup, and answering questions in the invented section that Letterman had posed in the actual. Wegman has long drawn from television genres for his videos, from late-night lumberyard ads and other sales pitches to Bob and Ray's spoofs of same. His works of this kind include *Deodorant* (1972–73; p. 241), *Management Fidelity Risk* (1999; p. 245), and *New and Used Car Salesman* (1973–74); a pitch for denatured alcohol—more artist-ready than the usual stuff of the networks—is included as a "commercial break" in *Late Night*: "E-Z Denatured Solvent Alcohol can be used in a number of interesting ways. But make sure you read the manufacturer's caution. It can be used to thin and cut shellac.... Use your imagination."

Late Night begins in the green room with a hairdresser (played by Burch) readying a nervous Wegman, wearing a Letterman T-shirt, to go onstage. The Letterman theme song comes up and the video cuts to the show's actual introductory shots. Then we see Wegman on a black leather couch, one dog peering from behind the couch over his shoulder, two more dogs stretched out to either side of him. Above the couch is a large yellow rectangle, a minimal abstract

Screen Puree 1975, gelatin silver print, 14 × 11 in. (35.6 × 27.9 cm)
Collection of Liliane and Michel Durand-Dessert

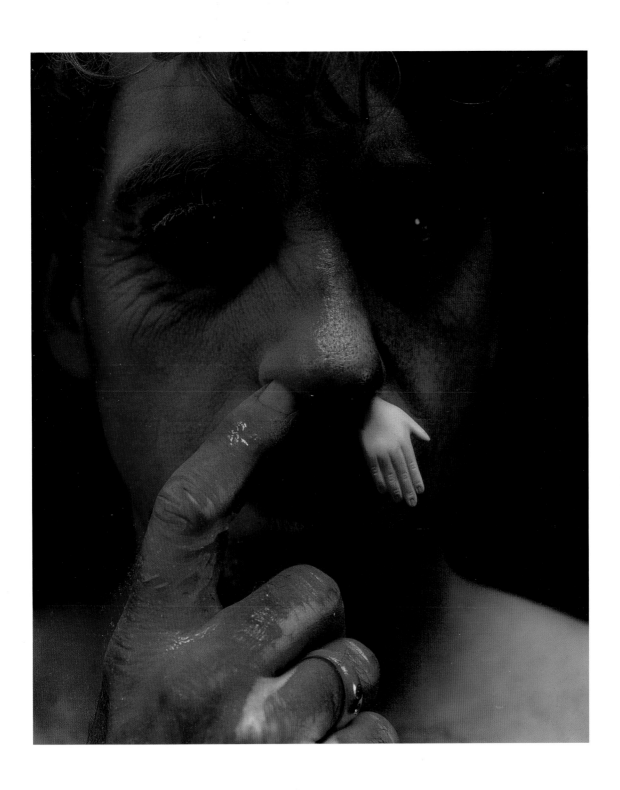

Handy 1984, Polaroid, 24 × 20 in. (61 × 50.8 cm)
Collection of Mr. and Mrs. Jerry Spiegel

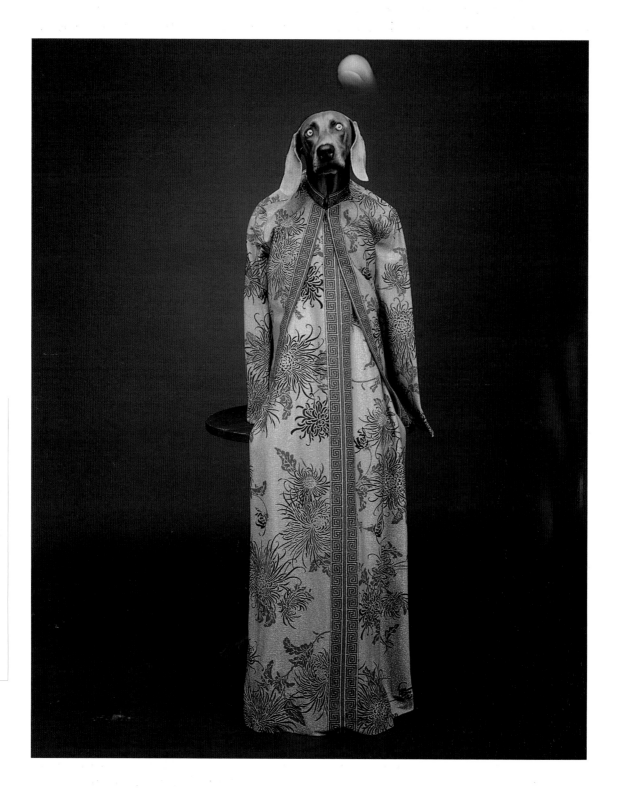

Dressed for Ball 1988, Polaroid, 24 × 20 in. (61 × 50.8 cm)
Victoria & Albert Museum, London

field in a high-keyed Wegman palette. From here on, shots of Wegman in his own studio are intercut with shots from his past appearances in the broadcast studio. The comedy arises from this combination of fake context and evidently real clips.

At every turn of the invention, Wegman has the late-night show down pat: he talks about his last appearance, mentions the things he has to pitch, and introduces both a musical interlude and a commercial break. He has his pet trick ready, and moves the conversation from life to art, from the studio air-conditioning to a museum show:

> *Wegman:* I have a book coming out, still making those videos and stuff.
> *Letterman:* How are things?
> *Wegman:* I still have these dogs, three, I used to have four. One died....
> *Letterman:* You have a major exhibition at Pompidou?
> *Wegman:* Yes, right around the corner there. Paintings, drawing, some sculpture too. I sculpt....
> I did bring a clip. Do you want to do a trick with the dogs? I could do that.

The trick involves two dogs perching on Letterman's desk to drink from respective glasses of milk in a race to see who finishes first. It is a feat we've seen in early Wegman videos.

Perhaps the most subtle and stark move in *Late Night* is Wegman's addition of narration to his own classic video *Two Dogs* of 1975–76, when he talks over a clip from it to introduce it. In essence, he answers the question viewers often wonder about when first watching that piece—what exactly the two dogs are watching, what keeps them so rapt and moving so elegantly together. (What he says, however, is false; the real trick, involving tennis balls, is revealed at the end of the original video, though not in the clip shown in *Late Night*.) At the same time, he perfectly parodies the way actors introduce film clips on late-night talk shows:

> *Wegman:* I have a couple anecdotes I could tell about the dogs. Funny things that happened while we were on a shoot.
> Well roll the clip then.
> You want me to talk over?

Well the two dogs were up on a cliff and they were look'n for a lost ball. One of the dogs had dropped the ball, and it fell down the hole there, and the funny thing is one of the dogs doesn't know it's right there and it's right next to him. And the other one has to go around and try to find it. That's me up in the tree there, I'm actually directing and some friends of mine are doing the sound and lights and everything.

Wegman had early on made a video (*Come In*, 1970–71) in which he plays a film director who suggests, on the return of a husband after years away, that the wife might welcome him by simply juggling some balls. This may have been a reference to his directing of dogs

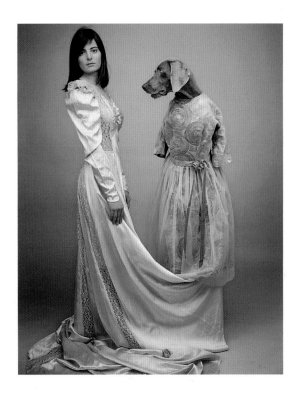

with tennis balls, as is seen in the last shots of *Two Dogs*. The self-consciousness of directing is part of the subject of *Late Night*.

In 1989, Fay had puppies, and Wegman discovered a new cast of characters in her and in this litter. Chundo, Crooky, and Battina became part of his theatrical troupe. By this time he had amassed wardrobes full of costumes, from thrift stores, yard sales, and leftovers

Arm Envy 1989, Polaroid, 24 × 20 in. (61 × 50.8 cm)
Collection of Gilles Fuchs, Paris

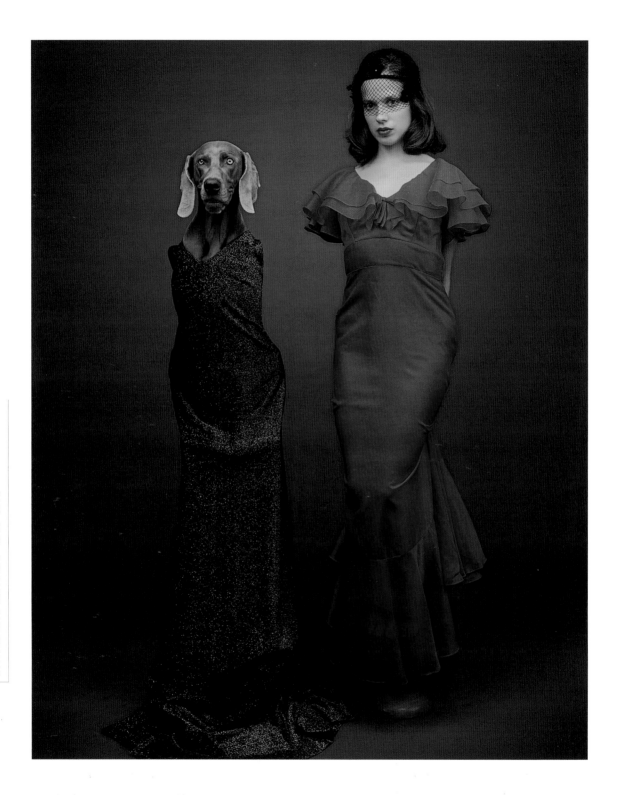

Models 1989, Polaroid, 24 × 20 in. (61 × 50.8 cm)
Collection of Leonard Rosenberg, New York

from his commercial shoots. It was around this time that he began to set Fay up on a pedestal, photographing her in a gown in *Dressed for Ball* (1988; p. 222), which catches the decisive moment between dog baseball and the Cinderella-to-be. Experimenting with putting her in sleeveless dresses, he found, in some shots, that she had the appearance of an amputee; both *Arm Envy* (1989; p. 223) and *Models* (1989; p. 224) play on this quality. Soon, however, noticing assistant Andrea Beeman's arm coming from behind Fay to adjust one of her dresses, Wegman became fascinated by the idea of a human hand as an extension of the dog, and began to take first Fay, then the other weimaraners, into the half-human, half-animal realm of fairy tales, fables, and children's books.

Wegman set up several Polaroids revealing the making of the illusion of arms. In the triptych *Becoming* (1990; p. 165), for example, one sees, in the left panel, Fay on the ground at Andrea's side, the woman's satin-gloved hands holding the dog's head; in the center panel, Fay is upright and Andrea is behind her, now leaning her arms around Fay's head; and on the right, the transformation complete, Andrea has vanished and Fay has gained her arms and a new character. (This setup was actually part of a commercial shoot for the London *Sunday Times* and involved millions of dollars worth of diamond and emerald jewelry, "an interesting change," Wegman notes, "from my usual yard sale, flea market fare."

Office Sculpture 1978, gelatin silver print, 12 ½ × 11 in. (31.8 × 27.9 cm)

Wegman's art-about-art works often explore how to make art and how to show it. School is one theme here, as in the "How to Draw Drawings" of 1983, which are supplied with pedagogic commentaries: "Very weak ... might I suggest you try a 'conte' crayon?" "Very Good ... I WAS IMPRESSED WITH YOUR SUGGESTIVE RATHER THAN EXPLICIT USE OF THE CONTE CRAYON." "Excellent ... nothing wasted in your bold strokes with the conte crayon." Post–art school issues turn up as well, as in an untitled, undated drawing that depicts a woman addressing an audience of four in the language of Wegman's video *Lecture*. (Her talk begins, "MY SLIDES GOT STOLEN. ...") In the color Polaroid *Sculpture* of 1990, a summary statement on that medium, a dog's rounded haunches are seen as the model for

a massive lump of clay; the image may be compared to the desktop figurative model in the black and white photograph *Office Sculpture* (1978; p. 225). Studies of the exhibition of art include *Early Venice Biennale Painting* (1990; p. 226) and *Museum* (2005; pp. 194–95), as well as a selection dealing with design and architecture: *House and Hut* (2002; pp. 228–29), *G. Wegman Designer* (1985), and *Ronchamp Addition* (1990; p. 227). The wimplelike roof of Le Corbusier's Ronchamp chapel recurs in many of Wegman's works of this period. As Wegman explains,

Ronchamp, again, and again. ... Not every Ronchamp. Only the Ronchamp taken from below where Corbusier has sited her in the shade of a

Early Venice Biennale Painting 1990, oil and acrylic on canvas, 44 ½ × 54 in. (113 × 137.2 cm)

Ronchamp Addition 1990, oil on canvas, 14 × 11 in. (35.6 × 27.9 cm)

House and Hut 2002, oil and postcards on wood panel, 24 × 48 in. (61 × 121.9 cm)
Private collection

cement nun's hat. Next to Corbu comes Frank Lloyd Wright, particularly Wright of Fallingwater, ruined for me some years ago by my actual visit to the masterpiece. The house is much larger than you can imagine from the photo on the World Book Encyclopedia page. The house is too big and just too great for use in a painting; the Fallingwater on a page, though....

If Wegman had found a proto-cinematic sweep in triptychs like *Becoming*, he also found, in some of his recent *Sesame Street* videos, a way to use still photos in animated films. Filmed stills of two dogs track invisible jumps from seat to seat to find the best view in *Theater: Near/Far* (2001), while also testing arrangements near and far from each other. The final image shows the two dogs nestled in the same chair, with the last word being "Cosy." Similarly, in *Wegman Partitioning 4* (2001), four dogs are moved about the set using stills recombining them in various mathematical

BOX FOR

permutations. Destined to become a Wegman classic is *Wegman Pool In/Out*, on the 2001 *Sesame Street* reel, in which the filmed-stills technique jumps dogs in and out of an inflatable backyard kiddy pool, with Wegman singing, "They're in the pool, they're out of the pool." Many of these videos echo Wegman's earliest concerns, previously exercised in multipanel photos—the permutations of being in and out of a box, for example. *Wegman 2 Dogs* (2001) in particular returns to an all-time Wegman favorite, *Two Dogs*, though his animated stills now look like the stop-action of strobe-lit dancers rather than the continuous balletic synchronization of the pair in the early video.

Wegman Stop & Go (2001), also made for *Sesame Street*, is truly Muybridgean. This time Wegman doesn't use stills but freezes frames to arrest the action of the racing dogs: we can observe, for a few moments, how many of their feet might hit the ground as they run. He also plays with the footage, running it in forward and in reverse (when he says "Go back"). The

Box For 1974, crayon on paper, 9 × 12 in. (22.9 × 30.5 cm)

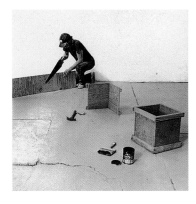 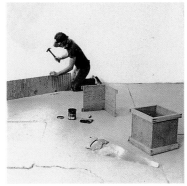 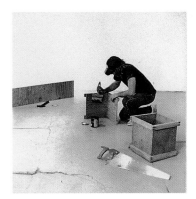

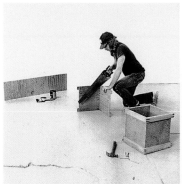 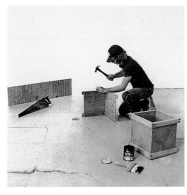 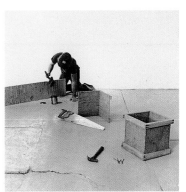

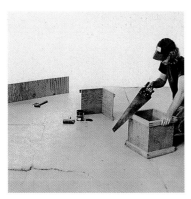

video's tag line is one of Wegman's best: "And the winner is [pause] one of the dogs." In *Museum* (2000), Wegman takes a walk-through of the Brooklyn Museum from the low vantage of a dog trot. One of his most recent videos, *Space Capsule* (2004), takes one of his work's strangest points of view: the architecture framing a view of his studio is the inside of a shell, which creates the feeling of a voyeuristic peephole into a private world. The simplicity of means here is typical of the new short videos, lyrical statements that

Wegman himself calls "video poems." (This almost goes without saying, but, in another example of his offbeat timing, he has once again picked up a medium at the time when the international art world appears to be sated with it.)

A video of 2004 remanifests Wegman's affection for shadow plays: we see the shadow of a house and of a squirrel, which runs up the edge of the roof and back again. Like a puppeteer, Wegman shows himself as the magic-maker and transformer

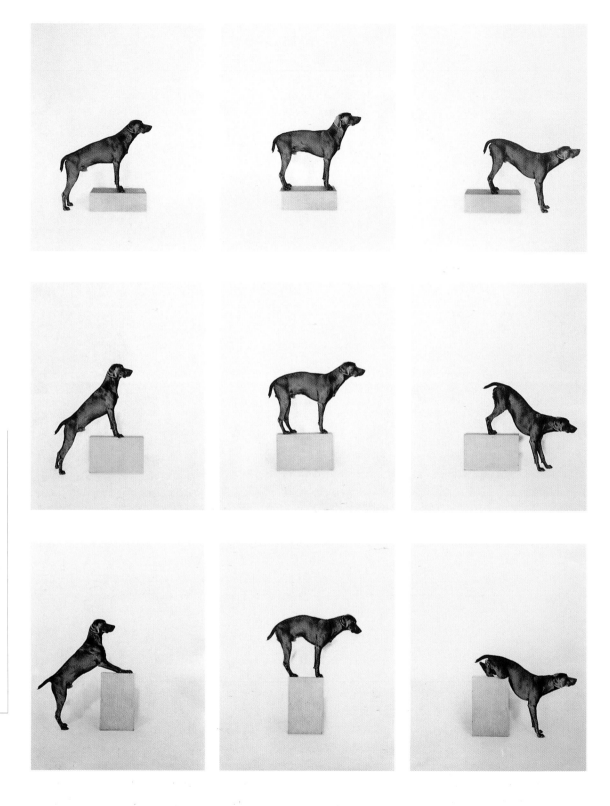

Stormy Night 1972, gelatin silver prints, work in nine parts: 14 × 10 ¾ in. (35.6 × 27.3 cm), each
Kemper Museum of Contemporary Art, Bebe and Crosby Kemper Collection, Gift of the William T. Kemper Charitable Trust

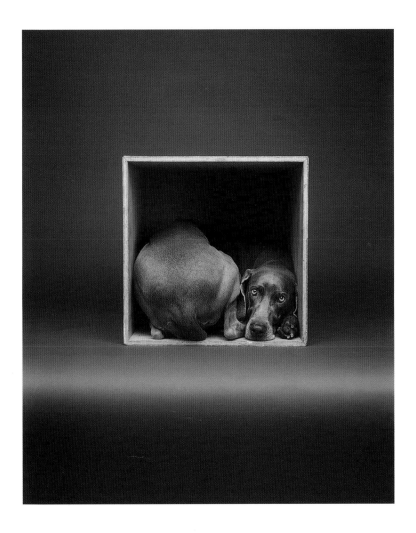

who also reveals his tricks. Here, using shadows, he plays with reality and illusion as simply as he had in the early black and white *Duck/Crow*, where a crow improbably but actually casts the shadow of a duck.

 The most telling and consistent of Wegman's art historical wanderings may be his many variations on the cube, whether in direct references to Minimalism or in the use of a cubic box as a pedestrian stand or pedestal. (Then, too, Wegman has acknowledged Cubism as the movement he has returned to again and

again.) One thinks, for example, of the drawing *Box For* (1974; p. 230), the "process" recorded in the multi-panel *Building a Box* (1971; p. 231), the perceptual tests within the different panels of *Stormy Night* (1972; p. 232) and *Before/On/After: Permutations* (1972; pp. 234–35), and the magical illusions seen in the 1989 Polaroid *Back, Front, Top* (p. 233). In this latter work, the hind quarters of one dog, at left, and the head of another, at right, are apparently seen within an open-fronted box—but actually the lithe Fay, curved amazingly within,

Back, Front, Top 1989, Polaroid, 24 × 20 in. (61 × 50.8 cm) 233

Philadelphia Museum of Art, Purchased for the Hunt Manufacturing Co. Arts Collection Program, 1990

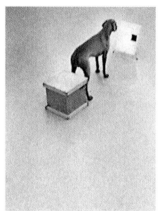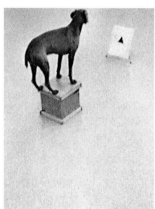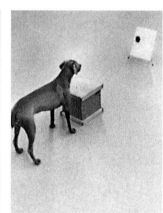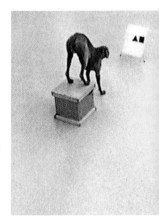

Before/On/After: Permutations 1972, gelatin silver prints, work in seven parts: 13 ⅝ × 10 ⅝ in. (34.5 × 26.9 cm), each
Private collection

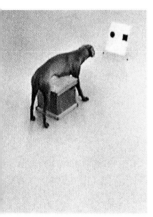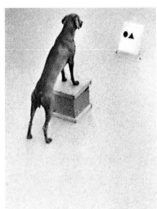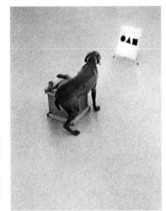

is the only dog in the shot. The black and white triptych *Surround Sound* (2003; pp. 236–37) offers three views of a box: a corner shot, as if two parallelograms flanged from the edge; a simple white rectangle on a black field; and a third that mysteriously locates a dog behind a translucent scrim, like a specter barely anchored there—a haunting image of a shadow within a shadow, created by Wegman's new method of making double exposures on the same sheet of Polaroid film. Like the earlier Polaroid *Houdini,* in which a tipped block has a small paw reaching out from under it,

Surround Sound again shows Wegman the illusionist transfiguring a vocabulary that is sure and well known to him but is still subject to new provocations.

Two works bring this book full circle. One is *Transmission* (1992; p. 120), in which a formalist torquing and stacking of two cubes produces a hyper-real extension of one (or more?) dogs, whose bodies extend from behind it at its upper left and lower right edges. *Connector* (1994; p. 121) is the other. Lacking any sense of trick photography, it focuses on the straight-forward gaze of a single dog, balancing delicately

Surround Sound 2003, Polaroids, work in three parts: 24 × 20 in. (61 × 50.8 cm), each

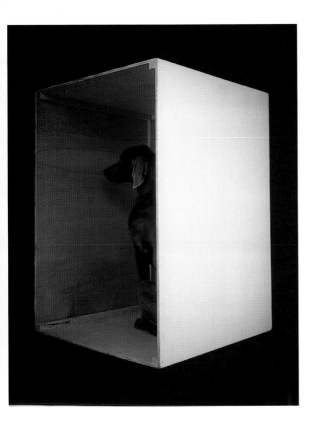

yet daringly between two cubes. *Connector* may be read as a metaphor for Wegman's work as a whole: it stands for his straddling of two worlds, his place in the tantalizing, unstable zone between known places. With daring reach and seemingly also an almost impossible sense of ease, Wegman (and in this Polaroid, the dog) puts parallel universes into relation. One finds in his work not a synthetic merging of different parts or dissonant voices but rather an analytic, accepting assemblage of facets and facts, both visual and verbal. If one presence in *Connector* is the white cube, symbol of both the modernist room and the Minimalist's rigor, another is the anima, which Wegman has charged his works with since 1970: the gray (canine) ghost, both raw material and raw energy.

Wegman continues to work in his different media, each body of work independent of the others but related in voice and in gesture, each stoically stubborn in its way, yet also intimately, independently accessible. He continues to subvert, to reveal "irresponsible" selves, to say what others would not, and in a voice as quiet as it is sometimes outrageous. And he continues to take new directions, to which Borges and baseball apply equally: here the "garden of forking paths," there, in the words of Yogi Berra, "If you see a fork in the road, take it." In choosing which way to go at the fork, Wegman follows his own imperative. His productivity may be necessary to keep his restless hand and curious eye and mind in gear and at attention.

In his person and personas, Wegman is the artist who takes familiar things into new territories of content and meaning, through relentless work, a good bit of dreaming, and some strange and contrarian reversals. Like his heroes Bob and Ray, he works between daily pragmatic realities and out-of-time reveries that come from the most unexpected places. It seems appropriate, then, to end with the radio pair's signoff, which could just as well be Wegman's: "Call if you get work. Always hang by your thumbs."[14]

VIDEOS

ILL

1970 Spit Sandwich

POCKETBOOK MAN

1970–71 Reel 1

PART ONE
Boy #1: Oh Mom! The Pocketbook Man is here!

PART TWO
Boy #2: Hey Mom! Dad's home!

Pocketbook Man: Oh wow, what a day.
Help me get these things off, Johnny. Oh well,
I didn't sell anything. What's for dinner?
Oh, great. This is really too much. Oooh, man.
How'd you do? Oh yeah? Let's see. Oh my
[I'm] bushed.

239

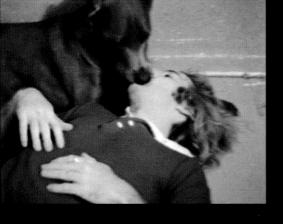

THE KISS

1972 Reel 2

MASSAGE CHAIR

1972–73 Reel 3

I thought perhaps you'd like to see a demonstration
of the new massage chair that we just got in.
It—the reason for its—it looks revolutionary, it doesn't
look really like a typical massage chair, and
that's because I think Mies van der Rohe had a part,
or at least he was a consultant, to the firm that
designed this. Notice the all steel construction and
the kind of simple back, it's not real flashy like
the kinds that you see usually advertised on
TV. The principle—there's really a good reason for
this metal construction—it works on the same
principle as a tuning fork. They give you this striker
when you buy the chair and when you strike it,
it sends pleasurable waves up and down your whole
body, which relaxes you. These waves last any-
where from five to ten seconds, depending
on whether you get the short leg or the long legged
chair. So I guess the only real drawback is you
have to, you have to hit it quite often to experience
the lasting pleasure sensation. You find your
own, what speed you like best. If you like a lot
of waves, then you strike it quite frequently.

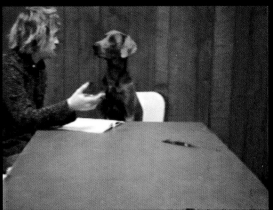

DEODORANT

1972–73 Reel 3

Of all the deodorants, this is the one that
I enjoy using the most. It feels real nice going
on, and smells good, and keeps me dry all
day. I don't have to worry about it cutting out
in clutch moments. All the other ones are just,
oh, I don't know, they just never seem to
hold up under pressure for me.
I can put this on once during the day, and for
the rest of the day I'm fine. I'm all set up;
I don't have to worry about, you know, social
nervousness or anything. It's just . . . it keeps
me feeling good and fresh. I love the smell.
I don't think there's any deodorant that comes
close to this one.

SPELLING LESSON

1973–74 Reel 4

You got . . . P-A-R-K was spelled correctly,
and that was good. Wait! And you spelled O-U-T
right. But when it came to "beach" you
spelt it B-E-*E*-C-H, which is like the, uh, well
there's a gum called beech-nut gum, but the
correct spelling is—we meant "beach" like the sand,
so it should have been like the ocean, B-E-*A*-C-H.
(Man Ray whines.) See, that's the difference.
Well, OK, I forgive you, but remember it next
time. OK, stay there—

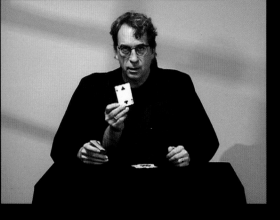

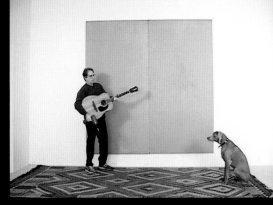

ORDINARY DECK

1997–98 Reel 8

An ordinary deck of cards. Nothing unusual about them.

INSTALLED GUITAR

1997–98 Reel 8

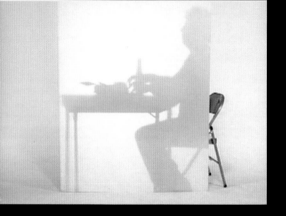

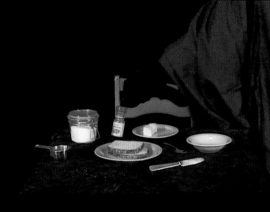

TYPIST

1997–98 Reel 8

LOG CABIN CINNAMON TOAST

1997–98 Reel 8

DENATURED ALCOHOL

1997–98 Reel 8

E-Z Denatured Alcohol can be used in a number
of ways. You can use it to thin and dilute shellac
and you can use it on appliances but make
sure you read the manufacturer's . . . um, cautions.
You cannot make—what's the problem?
That shadow?
Yeah, do you like the shadow?
E-Z Denatured Alcohol can be used in
a number of ways. E-Z Denatured Solvent
Alcohol can be used in a number of
ways. You can use it to thin and cut shellac.
Use your imagination.

TEA PARTY *

1999 Reel 9

[Excerpt]

Disson: How do you do Miss Dodd?
Please come in. Nice of you to come.
Sit down. That's right.
I've had a look at your references . . .

* From **THE LOVER, TEA PARTY, THE BASEMENT**;
adapted from Harold Pinter's *The Lover, Tea Party,
The Basement.*

MANAGEMENT FIDELITY RISK

1999 Reel 9

Hey, I'm not getting anywhere!
I'm stuck! I'm not getting into the next room!
Why can't I get anywhere, with my management
possibilities? I feel trapped by my lack of
investment opportunities.
I'm stuck! I can't get out! I'm stuck! I'm in a rut!
Looking for a window of investment
opportunity? Having trouble making your
house payments?
Then it's time to break out, break free —
Will I make my house payments?
Will I make my mortgage payments?
I'm stuck! I can't get to the next level.
I can't bring myself into the next room.
At Management Fidelity Risk, we will bring
you to the next level. And we will mangage
your portfolio so *you* can move on—
We at Fidelity Management Risk collaborate
with our inside team to maximize *your* portfolio
in a high yield risk low—

MINISTER

1999 Reel 9

Oh dear, what can the matter be? Oh dear, what can
the matter be? Oh dear, what can the matter be?
Oh dear, what can the matter be? Johnny's not home
from the fair. Where is he? Where is Johnny, if
he's not at the fair? He promised to buy you a bunch
of blue ribbons. He promised to buy me a bunch
of blue ribbons, and me, he promised a bunch of blue
ribbons, to tie up my bonnie brown hair. To tie up
your bonnie brown hair. Oh dear, what can the matter
be? Oh dear, what can the matter be? Johnny's not
home from the fair. He promised to buy me a basket
of posies, a basket of posies, a garden of lilies,
a garland of lilies, a garland of roses, to tie up that
bonnie brown hair. He promised to buy me a little
straw hat, that set off the blue ribbons that tie up my
bonnie brown hair. But Johnny, Johnny is not back
from the fair. OK. What, what does that mean?
Of course. Would it have been better for Johnny not
to make promises, to have just gone off and not
come back, to never have made promises, or is it better
that Johnny made the promises, promises that
he knew he couldn't keep, that he knew he could not
address. Time and time again, Johnny, meaning
all of us, make promises that we can't keep. But we
think it's better, we think it's better, that, knowing that
we can't keep them, we give others hope. Hope,
that's a good topic. Hope. In John 1:19 there's a
paragraph in verse form on the topic of hope.
And if you could all turn to your page where that is
in your book and read silently, that'll be good.

NOTES

FUNNY (HA HA), FUNNY (STRANGE)

1. One might cite here the words of Phillips Academy founder Samuel Phillips, Jr., who in 1778 established an academy "for the purpose of instructing Youth, not only in English and Latin Grammar, Writing, Arithmetic, and those Sciences, wherein they are commonly taught; but more especially to learn them the GREAT END AND REAL BUSINESS OF LIVING." Quoted in Susan Faxon, "Introduction: History and Change on Academy Hill," in *Academy Hill: The Andover Campus, 1778 to the Present* (Andover, Mass.: Addison Gallery of American Art, Phillips Academy, and New York: Princeton Architectural Press, 2000), xiii.

2. Frédéric Paul, a longtime William Wegman scholar and curator of several Wegman shows, notes of the funny/strange dichotomy that the two notions are frequently indistinguishable in Wegman's work. He cites Wegman's 1984 gouache *In the End*, which states, "Lake, Puddle: They are all the same in the end." Frédéric Paul, *William Wegman: Dessins/Drawings 1973–1997*, exh. cat. (Limoges: Fonds régional d'art contemporain du Limousin, 1997), 75.

3. Unless otherwise noted, all quotations of the artist are from conversations with the author.

4. See Sanford Schwartz, "The Lovers," review of *Man's Best Friend: Photographs and Drawings* by William Wegman and *Wegman's World* by Lisa Lyons and Kim Levin, *New York Review of Books* 30, no. 13 (18 August 1983): 44–45; Dave Hickey, "Wegman: Teaching Old Dogs New Tricks," *Los Angeles Times*, 11 April 1990, 1; and Craig Owens, "William Wegman's Psychoanalytic Vaudeville," *Art in America* 71, no. 3 (March 1983): 100–109.

5. Wegman has staged this question himself, if in a circular way, in a drawing of c. 1978, where the word/images "WHAT," "WHY," and "HOW" are emphasized by frames of thick, craggy black lines and are related to one another by directional arrows pointing variously toward others of the trio. One of these arrows points downward to a smaller phrase (echoing the relationship between Wegman's photographs and their accompanying typed narratives, which via separate negatives are printed on the same paper) that more quietly says, "Some Questions to Think About."

6. Merry Foresta, "Introduction," *Perpetual Motif: The Art of Man Ray* (New York: Abbeville Press, and Washington, D.C.: National Museum of American Art, Smithsonian Institution, 1988), 9.

7. Ibid., 23.

8. See, for example, Helene Winer on the audio element in one of Wegman's first videos, in "Introduction," *William Wegman: Video Tapes, Photographic Works, Arrangements*, exh. cat. (Claremont, Calif.: Pomona College Art Gallery, Montgomery Art Center, 1971), n.p.

EUREKA

1. "She was the family intellectual, artistic and also smart," Wegman remembers. "As a high school student she earned straight A's and had won a scholarship to Pratt, but her father did not allow her to take up the offer." In the three years before her marriage to George William Wegman, in 1942, she worked for a photographer hand-coloring black and white prints.

In "Pencil and Paper—Interview," in *William Wegman: Dessins/Drawings*, 100, Frédéric Paul asks Wegman about using his own name in his drawings: "I'm thinking of 'Bill,

where are you?' a watercolor drawing where your mother is calling you." Wegman replies, "In the watercolor you refer to the caption reads, 'Down here, Mom.' This is obviously not the case because you see the figure of the child on the mountaintop." Wegman amplifies the work's autobiographical import: "My mother and I always did watercolors together at the kitchen table. Then one day she put away her brush. She said that I was better than her. I was about eleven, I think. I told her she was wrong, she was a lot better at it than I was. But my mother never made another watercolor. There are a lot of times when you have to lie to your mother. My head was spinning with these memories when I made this work."

2. In fact there were nine children altogether: "Two others didn't make it past childhood," notes George William Wegman. This and other quotations from George William Wegman are from a telephone conversation with the author, January 31, 2004.

3. Wegman, quoted in Paul, "Pencil and Paper—Interview," 100. The one-letter typo here that transformed "Tubby" into "Fubby" is the kind of wordplay that Wegman relishes, and the "new" name, whose sound he liked, made him laugh aloud when reading it in print.

4. Susan Morgan, in "William Wegman as Told to Susan Morgan," *Real Life* (Winter 1981): 3.

5. Harald Szeemann, *Live in Your Head: When Attitudes Become Form* (Bern: Kunsthalle Bern, 1969).

6. *Bob & Ray: The Lost Episodes Volume V. More CBS Years, the Found LPs* (New York: Goulding-Elliott Greybar Productions RadioArt/The Radio Foundation, 2003). CD set.

7. Among the many versions of the Man Ray acquisition story is this one he told to Liza Béar: "We got a dog when we moved to California because we had a big space or we decided it wouldn't be too difficult. We picked him out of a litter in Long Beach. Compared to the other puppies in the litter he acted strange and distant. Later, we found out why—he had swallowed a beach ball. Most of it came out a couple of weeks later. We're still waiting for the rest of it. I had no idea I was going to be using him in the pieces." *Avalanche*, no. 7 (Winter/Spring 1973): 40. Another: "I didn't really want a dog. I was too busy being an artist. But my wife did, so I promised her that when we got to California we would get one. I was hoping she would forget. It was a

long drive to Los Angeles from Madison, where I had been teaching in the art department of the University of Wisconsin, but she didn't forget. When we arrived we decided to look for a dalmatian. We couldn't find one. Apparently there was a dalmatian shortage in 1970. Someone said weimaraners were good dogs. I had never heard of them." Wegman, *Puppies* (New York: Hyperion Books for Children, 1997), n.p. Or this variant: "My first response to him in my studio was to take his picture. I guess you do the same with a baby. He looked like an old man and he was sitting in a ray of light. Man Ray!" Wegman, in "William Wegman, February 25, 1993, Studio, East Village," in Judith Olch Richards, ed., *Inside the Studio: Two Decades of Talks with Artists in New York* (New York: Independent Curators International, 2004), 107.

8. Wegman, *Puppies*, n.p.

9. A Wegman oil painting of 1985 (p. 147), in which he writes as well as paints, is also called *Hope*.

10. Wegman, in "William Wegman, February 25, 1993," 109.

11. Wegman, quoted in Peter Schjeldahl, "The Faith of Daydreams," in *William Wegman*, exh. cat. (Monterrey, Mexico: Museo de Monterrey, 1993), 12. Here Wegman says that he was about fifteen at this point, but he now says it was when he was around seventeen, about the time he started art school.

12. Michael Gross, "Pup Art," *New York* 25, no. 13 (March 30, 1992): 47.

13. As Wegman told this writer, "In music class once in high school I had heard classical music, and it gave me the shivers, but I did not know what that was." Today he finds respite from work in reading *Gramophone* magazine, and in listening to CDs from his collection of thousands. In 2004, *Gramophone* commissioned Wegman to write a piece for the magazine (publication forthcoming). The manuscript opens,

> When I was four I took apart the family piano and it never got put back together again and that was the extent of my childhood music education. So when I went off to college music was waiting for me. Boston radio had great music programming back then. One day, in fall 1962, I heard something on the radio that paralyzed me. Bach Partita No. 6 by Glenn Gould.

I became a Glenn Gould convert, consuming everything in its path.

Gould was not my only inspiration. My two roommates were unusually passionate about classical music and they provided a great service in broadening my horizons. One was into the brooding heavy works of Bruckner, Mahler, Wagner. The other loved "happy" music. Vivaldi, Boccerini, early Mozart. They both had extensive record collections, which I explored thoroughly. Between them they had the 18th and 19th centuries covered. That left me with the twentieth century. Bartók became my favorite composer in those days when not under the spell of Bach.

14. Wegman, quoted in Gross, "Pup Art," 47.

15. Peter Schjeldahl, "Paintings: The New Wegman," in Martin Kunz, ed., *William Wegman: Paintings, Drawings, Photographs, Videotapes*, exh. cat. (1990; rev. ed., New York: Harry N. Abrams, 1994), 182.

16. Wegman, quoted in Gross, "Pup Art," 46–47.

17. Wegman, quoted in Schjeldahl, "The Faith of Daydreams," 12.

18. Not only were they roommates but, Wegman remembers, "We had driven together from Boston. We were both from Massachusetts, and alienated in the Midwest, and we both had teachers who disapproved of our work. Not to sound pompous, we were as close as Picasso and Braque."

19. In 1964–65 Salvatore Martirano had composed a piece called *Underworld*, scored for four actors, four percussionists, two string basses (or string bass and cello), tenor sax, and two-channel tape. It existed in two performance versions, one with actors and one in which the actors' roles were taken by the musicians. Elements for the tapes were computer generated, and the overall structure included sections called WAILING, LAUGHING, and forms of YES and NO. According to Martirano, *Underworld* "utilizes a unique combination of instruments yet deals with experience common to all. It has a NAME not a TITLE. There's a progression from tragedy to comedy to a mix of comedy and tragedy interpreted and intensified by statements of acceptance and rejection." Martirano's comments resonate interestingly with Wegman's later performative works. See the program notes for the University of Illinois Contemporary Chamber Players' performance of

Underworld at the Ravinia Festival, Illinois, conducted by Martirano on July 21, 1968, pp. 72, 75.

20. On the Electric Circus and the "Exploding Plastic Inevitable" see David Bourdon, *Andy Warhol* (New York: Harry N. Abrams, 1989), 225.

21. Wegman, quoted in Gross, "Pup Art," 48.

22. On December 3, 1967, using University of Wisconsin, Wausau, letterhead, Wegman wrote to Heinz Von Foerster, "We are hoping to see you in Champaign on or around December 16. Ron Nameth has invited us to participate in [John] Cage's event of that date and I am wondering to what extent you and Paul [Weston] are involved. Ron's letter suggested you did have something to do with it." Courtesy of the University of Illinois Archives.

23. *BODOH*, 1968, 16mm film, color, sound by Paul Weston and the computer lab of the electrical-engineering department, University of Illinois, camera and editing by Ron Nameth. Present whereabouts unknown. See "The Story of William Wegman," n.d., a four-page typescript that Wegman probably wrote in response to a request for biographical information from the secretary of Jan van der Marck, director of the Museum of Contemporary Art, Chicago, in 1969, when van der Marck was organizing the "Art by Telephone" exhibition. See Nancy R. Reinish, letter to Wegman, July 28, 1969. Archive, Museum of Contemporary Art, Chicago. See also Wegman, *A Report on a Thesis Project Entitled "Bodoh," Thesis Submitted in Partial Fulfillment of the Requirements for the Degree of Master of Fine Arts in Painting and Printmaking in the Graduate College of the University of Illinois, 1967, Urbana, Illinois*. Architecture and Art Library, University of Illinois, Urbana-Champaign. In this description Wegman mentions an 8mm film, but he elsewhere refers to a 16mm film (see, e.g., "The Story of William Wegman"), and given that *BODOH* had sound (by Weston) and was shot by Nameth, it is more likely to have been shot in 16mm, as Wegman now recalls.

24. His own description of the project is of interest not only for the ideas he would later follow but also for the way he writes about it, the images in which he speaks. He concludes *A Report on a Thesis Project Entitled "Bodoh,"*

Neither painting nor sculpture nor something in between; not architecture; not a happening, psychedelic light show or carnival of sorts; environmental but too self consciously present to be termed an environment,

"Bodoh" eludes classification. The structure, almost an object, is more like that of a big puffy dinosaur, rather clumsy and bound to extinction. Its geometric core, like an 18th century understanding of the central nervous system with its kinetic plastic extensions, can indeed, with a stretch of the cortex, suggest for those with a compulsion for simile, an ancient animal or some lost reptile. However, "Bodoh" was not intentionally anthropomorphic and it would disturb my aesthetic faction to have it so described. The electronics involved were not sufficiently advanced to be of technological interest, and nothing new was said in terms of its construction. Like all art, "Bodoh" is essentially functionless and without a purpose.

I began thinking about a project like "Bodoh" during the summer of 1966 while a research assistant with the University's Biological Computer Laboratory.

Unfortunately, all of my ideas about light and sound required an exhibition hall of considerable size. Space and money will determine any future extensions into the electronic media.

25. Wegman worked at three campuses of the University of Wisconsin: Wausau (September 1967–January 1968), Waukesha (July 1968–[month unknown] 1969), and Madison (September 1969–June 1970).

26. Willoughby Sharp, "Place and Process," *Artforum* 8, no. 3 (November 1969): 49.

27. There is a short answer to the question of how to recognize which of Wegman's photographs are documentation and which are photo pieces: those that are documentation carry no dimensions, the implication being that they were made to be reproduced, and may be reproduced in various sizes, and that the concern is the photographic image, not a photographic object. For photo pieces that are artworks, dimensions and photographic process are specified.

28. Robert Cumming later made freestanding sculptures also using the formal structure of the exercise of diagramming a sentence.

29. Wegman, "Videotapes: Seven Reels," in Kunz, *William Wegman*, 25.

30. William Severini Kowinski, "Is Wegman an Artistic Comic or a Comic Artist?" *Smithsonian* 22, no. 6 (September 1991): 47.

31. Wegman, "Eureka," in *William Wegman: Photographic Works/L'oeuvre photographique, 1969–1976*, exh. cat. (1991; reprint ed., Limoges, France: Fonds régional d'art contemporain Limousin, 1993), 9–14.

32. The text is dated 1969, but the work has been published as 1970, for example ibid., 45.

33. The title "Lunar Landing Concert..." appears on a list of performance pieces submitted as part of "The Story of William Wegman," the biographical document sent to van der Marck in 1969. Details of the program are outlined in a separate document, dated 7/20/69, also in the archive of the Museum of Contemporary Art, Chicago.

34. Cumming's and Wegman's first two-person show was "William Wegman and Robert Cumming," at the Laura Knott Gallery, Bradford Junior College, Haverhill, Massachusetts, September 10–30, 1969. They have also exhibited together in Milwaukee (1970) and Pasadena (1978).

35. Wegman, letter to van der Marck, dated May Day [1970]. William Wegman archives, New York.

36. Cumming, interviewed by Michael H. Smith, in *Robert Cumming and William Wegman*, exh. cat. (Pasadena: Baxter Art Gallery, California Institute of Technology, 1978), 154.

DOUBLE PROFILE

1. Willoughby Sharp, "Body Works," *Avalanche*, no. 1 (Fall 1970): 14.

2. Willoughby Sharp, "Rumbles," *Avalanche*, no. 1 (Fall 1970): 8.

3. In addition to his "heroic" stance as a fountain, Nauman, as Wegman later did, also sometimes pictured mistakes, as in his ceramic *Cup and Saucer Falling Over* (1965) and the photographs *Failing to Levitate in the Studio* (1966) and *Spilling Coffee Because the Cup Was Too Hot* (artist's proof, 1967, and the same image retitled *Coffee Spilled Because the Cup Was Too Hot* in the editioned portfolio *Eleven Color Photographs*, 1966–67/1970).

4. Craig Owens, "William Wegman's Psychoanalytic Vaudeville," *Art in America* 71, no. 3 (March 1983): 101.

5. Jean-François Chevrier, "The Adventures of the Picture Form in the History of Photography," in Douglas Fogle, *The Last Picture Show: Artists Using Photography 1960–1982,* exh. cat. (Minneapolis: Walker Art Center, 2003), 124. This is an abridged translation of an essay first published as "Les Aventures de la forme tableau dans l'histoire de la photographie," in *Photo-Kunst: Arbeiten aus 150 Jahren,* exh. cat. (Stuttgart: Graphische Sammlung Staatsgalerie Stuttgart, and Ostfildern: Edition Cantz, 1989), 47–81.

6. See "Timeline," in Miles Orvell, *Oxford History of Art: American Photography* (Oxford and New York: Oxford University Press, 2003), 234.

7. Skewing Wegman's pleasure at this event was a *Los Angeles Times* review, which in its opening sentence ascribed each artist's work to the other: "Two cautiously far-out young artists make a tandem debut in Pomona College's art gallery. Jack Goldstein makes photos and arrangements of books and rubbishy stuff. William Wegman stacks hewn lumber" (William Wilson, "Two Young Artists Make Tandem Debut," *Los Angeles Times,* January 12, 1971, IV:15). Each artist was correctly aligned with his work later in the article, which was especially perceptive about Wegman's work.

8. Wegman, in "Shocked and Outraged as I Was, It Was Nice Seeing You Again," *Avalanche,* no. 2 (Winter 1971): 61.

9. Wegman, letter to van der Marck, February 20, 1971. William Wegman archives, New York.

10. Margit Rowell, with an essay by Cornelia Butler, *Cotton Puffs, Q-Tips, Smoke and Mirrors: The Drawings of Ed Ruscha,* exh. cat. (New York: Whitney Museum of American Art, 2004).

11. Ed Ruscha, quoted in Fred Fehlau, "Ed Ruscha," *Flash Art,* no. 138 (January–February 1988): 70–72. Reprinted in Ruscha, *Leave Any Information at the Signal: Writings, Interviews, Bits, Pages,* ed. Alexandra Schwartz (Cambridge, Mass., and London: MIT Press, an October book, 2002), 264.

12. Ruscha, conversation with the author, August 12, 2003.

13. Peter Schjeldahl, "The Faith of Daydreams," in *William Wegman,* exh. cat. (Monterrey, Mexico: Museo de Monterrey, 1993), 12.

14. Jorge Luis Borges, with Margarita Guerrero, *The Book of Imaginary Beings,* rev., enlarged, and trans. by Norman Thomas di Giovanni (New York: E. P. Dutton & Co., Inc., 1969, second printing 1970), 23.

15. As Wegman wrote of *Two Supporters of Illinois* (1970), "When reading the surface the changes appear slight. It looks constant. The difference is behind (or inside) the surface and it is fundamental: one ring, one watch, one shirt, two bodies." Wegman, "Shocked and Outraged," 61.

16. Wegman, in a radio interview with Lynn Neary, available on the audiotape *The Best of NPR: On Creativity* (New York: National Public Radio, 1997).

17. Virginia Alexander and Jackie Isabell, *Weimaraner Ways* (Germantown, Md.: SunStar, 1993), 13.

18. Wegman, *Puppies* (New York: Hyperion Books for Children, 1997), n.p.

19. David Ross and Wegman, in Ross, "An Interview with William Wegman," in Martin Kunz, ed., *William Wegman: Paintings, Drawings, Photographs, Videotapes,* exh. cat. (New York: Harry N. Abrams, 1990), 21.

20. Ibid.

21. Ibid.

22. Wegman, "Videotapes: Seven Reels," in Kunz, *William Wegman,* 25.

23. Wegman, quoted in Ross, "An Interview with William Wegman," 13.

24. A transcript of the audiotape Wegman played at 112 Greene Street on January 14, 1974, and a description of *j. J–Jacobean…* were published as "William Wegman.......Pathetic Readings" in *Avalanche,* May/June 1974.

25. Wegman, quoted in Ross, "An Interview with William Wegman," 17.

26. Wegman, "Videotapes: Seven Reels," 25.

27. Ibid., 26.

28. Wegman, in *William Wegman Polaroids* (New York: Harry N. Abrams, 2002), 61.

29. Carrie Rickey, "Curatorial Conceptions: The Whitney's Latest Sampler," *Artforum* 19, no. 8 (April 1981): 52–57.

30. See Marita Sturken, "The Whitney Museum and the Shaping of Video Art: An Interview with John Hanhardt," *Afterimage* 10, no. 10 (May 1983): 4–8.

31. Wegman, *William Wegman Polaroids*, 34.

32. Wegman, in the radio interview with Neary.

33. Wegman, *William Wegman Polaroids,* 33.

34. Ibid., 40.

35. Sanford Schwartz, "The Lovers," review of *Man's Best Friend: Photographs and Drawings by William Wegman* and *Wegman's World* by Lisa Lyons and Kim Levin, *New York Review of Books* 30, no. 13 (18 August 1983): 44.

BIRCH BAY

1. "New Spirit in Painting" was organized by Christos M. Joachimides, Norman Rosenthal, and Nicholas Serota at the Royal Academy of Arts, London, in 1981; "Zeitgeist" by Joachimides and Rosenthal at the Martin-Gropius-Bau, Berlin, in 1982; and "American Painting: The Eighties" by Barbara Rose at the Grey Art Gallery, New York University, 1979. The Italian critic Achille Oliva Bonito explicated the "Transavangardia" in many texts and exhibitions, notably the 1980 Venice Biennale. "New Image Painting" was organized by Richard Marshall at the Whitney Museum of American Art, New York, in 1978. "'Bad' Painting" was organized by Marcia Tucker at the New Museum, New York, in 1978.

2. *"Bad" Painting* (New York: The New Museum, 1978), n.p.

3. Organized by I. Michael Danoff at the Akron Art Museum, the exhibition was accompanied by a catalogue, *Cindy Sherman*, with texts by Danoff and Peter Schjeldahl (New York: Pantheon, 1984). Schjeldahl wrote, "Since 1977 . . . Cindy Sherman has exhibited about one hundred thirty photographs of herself as art—not as 'art photogra-

phy' but as art, period. Or art, exclamation point." "Introduction: The Oracle of Images," 7.

4. Wegman, quoted in Robert Enright, "Chamelionesque: The Shape-Shifting Art of William Wegman," *Border Crossings* 22, no. 1 (February 2003): 42. Wegman often tells whole portions of stories almost identically, like a folktale told and retold, then skews them with a different detail at the end.

5. David Ross and Wegman, in Ross, "An Interview with William Wegman," in Martin Kunz, ed., *William Wegman: Paintings, Drawings, Photographs, Videotapes*, exh. cat. (New York: Harry N. Abrams, 1990), 13.

6. Gary Indiana, "Doglessness," *The Village Voice*, May 31, 1988, 94.

7. Kay Larson, "Talking to . . . Wegman," *Vogue* 178, no. 8 (August 1988): 288.

8. Lisa Lyons, "Wegman's World," in Lisa Lyons and Kim Levin, *Wegman's World* (Minneapolis: The Center, 1982), 7.

9. Wegman, in "William Wegman, February 25, 1993, Studio, East Village," in Judith Olch Richards, ed., *Inside the Studio: Two Decades of Talks with Artists in New York* (New York: Independent Curators International, 2004), 109.

10. Alexandra Anderson-Spivy, *Mainely Wegmans: An Exhibition of Work by William Wegman and Pam Wegman*, exh. cat. (Waterville, Me.: Colby College Museum of Art, 1995), n.p., quoting Wegman's "Why Draw, . . . " *William Wegman* (New York: Sperone Westwater Gallery, 1990), n.p. The exhibition was on view August 9–October 25, 1995.

11. Alexandra Anderson, "He Shoots Dogs, Doesn't He?" *Smart*, April 1990, 51.

12. See Mary Livingstone Beebe et al., *Landmarks: Sculpture Commissions for the Stuart Collection at the University of California San Diego* (New York: Rizzoli, 2001), 144; and Wegman, quoted in Simon, "William Wegman," in Beebe et al., *Landmarks*, 151.

13. Roberta Smith, "William Wegman's Versatile Humor Survives Man Ray," *New York Times*, January 24, 1992, C26.

14. Peter E. Palmquist, *Carleton E. Watkins: Photographs 1861–1874* (San Francisco: Fraenkel Gallery in association with Bedford Arts Publishers, 1989). *Piwyac, Vernal Fall, 300 ft., Yosemite* appears both on the cover and as a plate inside this unpaginated book.

GETTING INTO *ARTFORUM*

1. Wegman, *Puppies* (New York: Hyperion Books for Children, 1997), n.p.

2. James Wood, *The Irresponsible Self: On Laughter and the Novel* (New York: Farrar, Straus and Giroux, 2004), 5.

3. *Lecture* took on a new connotation in 2004, when the Kodak company announced that it would no longer manufacture the slide carousels that were once the often cranky performers in the kinds of talks satirized here. This kind of projector, of course, has been largely replaced by the more corporate, computer-generated, PowerPoint-type presentation. Wegman chooses the more low-tech system of illuminating his slides by flashlight.

 On Kodak's new direction and its implications for contemporary art and art history, see Pamela Lee, "Split Decision: Pamela Lee on the Demise of the Slide Projector," *Artforum* 43, no. 3 (November 2004): 47–48.

4. Wood, *The Irresponsible Self*, 5.

5. Ibid., 6.

6. Wegman, *William Wegman Polaroids* (New York: Harry N. Abrams, 2002), 30.

7. Robert Rosenblum, *The Dog in Art from Rococo to Post-Modernism* (New York: Harry N. Abrams, 1988), 99.

8. Ibid.

9. Ibid., 99.

10. Wegman, *William Wegman Polaroids*, 50.

11. In addition to altering *Of the Lake* into *Contemplating Art, Life, and Photography* in the *Man Ray Portfolio* (1982), Wegman had earlier transformed another image in the portfolio: in 1975, by adding a written alteration to

Modeling School (1974), he had titled the book balanced on Man Ray's head *The Joy of Cooking*.

12. Man Ray, "Deceiving Appearances," *Paris Soir*, March 23, 1926, Eng. trans. Murtha Baca in *Man Ray: The Photographic Image*, ed. Janus (Woodbury, N.Y.: Barron's, 1980), 211.

13. This is one of a handful of videos made during several years when Wegman had largely put the medium aside. The three other videos from that period are *Accident* (1979), shot with Wegman's students at Wright State; *How to Draw* (1983), a parody of Jon Gnagy's television drawing class; and *World of Photography* (1986), a collaboration with Mike Smith in which Smith plays an everyday Joe who wants to learn photography from the pro played by Wegman.

14. Bob and Ray, *Bob & Ray: The Lost Episodes*.

EXHIBITION HISTORY

An asterisk preceding an entry indicates
an accompanying catalogue or other publication.
For further information about asterisked items,
see *Selected Bibliography*.

SOLO EXHIBITIONS

1967

Excedrin: A Controversy in Art. University of Wisconsin,
Marathon County Center, Wausau. 9 November.

BODOH. M.F.A. Thesis Exhibition. University of Illinois,
Urbana.

1968

Inflatable Sculptures. Ravinia Green, Chicago. 21 July.

1970

Three Speeds, Three Temperatures. University of Wisconsin,
Madison.

1971

**William Wegman: Video Tapes, Photographic Works,
Arrangements*. Pomona College Art Gallery,
Montgomery Art Center, Claremont, California.
7–31 January.

1972

**William Wegman*. Konrad Fischer Galerie, Düsseldorf,
Germany. 14 January–10 February.

William Wegman. Situation Gallery, London. February.

**William Wegman*. Sonnabend Downtown Gallery,
New York. October.

William Wegman. Courtney Sale Gallery, Dallas. November.

William Wegman. Sonnabend Gallery, Paris.

1973

William Wegman. Texas Gallery, Houston. 13 January–
3 February.

**William Wegman*. Los Angeles County Museum of Art,
Los Angeles. 22 May–1 July.

William Wegman. Copley-Lambert Gallery, Los Angeles.
November.

1974

Sonnabend Downtown Gallery, New York. February.

1975

William Wegman: Early Work. 112 Greene Street, New York.
8–20 February.

**William Wegman: MATRIX 9*. Wadsworth Atheneum,
Hartford, Connecticut. July–August.

1976

William Wegman: Drawings and Videotapes. The Kitchen,
New York. 23 March–3 April.

1978

**MATRIX/Berkeley 6: William Wegman*. University of
California, Berkeley Art Museum and Pacific Film
Archive. 1 April–31 May.

1979

William Wegman. Holly Solomon Gallery, New York.
28 March–18 April.

William Wegman. Konrad Fischer Galerie, Düsselforf.
5–25 May.

Arnolfini Gallery, London.

1980

Improved Photographs. Neil G. Ovsey Gallery, Sherman
Oaks, California. March.

William Wegman: Selected Works 1970–1979. Colorado
University Art Museum, Boulder. 10–30 March.
Traveled to Aspen Center for the Visual Arts, Aspen.
28 May–29 June.

Holly Solomon Gallery, New York. October.

1982

Dart Gallery, Chicago. April.

Holly Solomon Gallery, New York. May.

William Wegman. Fraenkel Gallery, San Francisco.
8 September–16 October.

**William Wegman*. Southeastern Center for Contemporary
Art, Wake Forest College, and North Carolina School
for the Arts, Winston-Salem, 1 October–14 November
(simultaneous exhibition at three venues).

James Corcoran Gallery, Los Angeles. November.

Holly Solomon Gallery, New York. November.

Wegman's World. Walker Art Center, Minneapolis.
5 December 1982–16 January 1983. Traveled to Fort
Worth Art Museum, Fort Worth, Texas. 30 January–
6 March; DeCordova Museum and Sculpture Park,
Lincoln, Massachusetts. 20 March–1 May;
Contemporary Art Center, Cincinnati. 12 May–
25 June; Corcoran Gallery of Art, Washington, D.C.
10 July–28 August; Newport Harbor Art Museum,
Newport Beach, California. 28 September–
29 November.

1983

Local Boy Makes Good. University Gallery, University of
Massachusetts, Amherst. 5 February–18 March.

Real Art Ways Gallery, Hartford, Connecticut. May.

Wegman's Photographs from the Ed Ruscha Collection.
Newport Harbor Art Museum, Newport Beach,
California. 29 September–27 November.

$19.84. Center for the Exploratory and Perceptual Arts
Gallery, Buffalo, New York.

1984

Holly Solomon Gallery, New York. March.

William Wegman. Mackenzie Art Gallery, University of
Regina, Regina, Saskatchewan. 2 March–8 April.

Everyday Problems: Drawings. Holly Solomon Gallery,
New York. October.

Wegman's Instant Miami. Lowe Museum of Art, University
of Miami. 6 December 1984–13 January 1985.

1985

Holly Solomon Gallery, New York. November.

1986

Wegman Paints! Holly Solomon Gallery, New York.
8 January–1 February.

William Wegman: Improved Photographs. Daniel Wolf Gallery,
New York. 8 January–1 February.

William Wegman. Lisa Sette Gallery, Scottsdale, Arizona.
6–28 February.

Pace/MacGill Gallery, New York. December.

1987

William Wegman: Paintings Drawings Photographs.
McIntosh/Drysdale Gallery, Washington, D.C.
10 January–5 February.

William Wegman Photographs. Long Island Railroad
Concourse, Pennsylvania Station, New York.
March–June.

William Wegman. Huntington Gallery, Massachusetts
College of Art, Boston. May.

William Wegman: Photographs and Videos. Southwest Craft
Center, San Antonio. October.

Pace/MacGill Gallery, New York. December 1987–
16 January 1988.

1988

Thomas Solomon's Garage, Los Angeles. April.

William Wegman: New Paintings. Holly Solomon Gallery,
New York. April–May.

William Wegman: Man Ray Commemorative Prints. Solo
Gallery, New York. 3 May–18 June.

William Wegman: Polaroids and Videos. San Francisco
Museum of Modern Art. 12 August–16 October.

Rena Branstein Gallery, San Francisco. 27 August.

Fraenkel Gallery, San Francisco. 17 September.

William Wegman: Photographs. G. H. Dalsheimer Gallery,
Baltimore. 6–29 October.

Dart Gallery, Chicago.

La Jolla Vista View. Stuart Collection, University of
California, San Diego.

Thomas Solomon's Garage, Los Angeles. December
1988–15 January 1989.

1989

William Wegman. Maison de la culture et de la
communication de Saint-Etienne, Loire, France.
9 February–25 March.

Dart Gallery, Chicago. Spring.

Galerie Baudoin Lebon, Paris. June.

*William Wegman: Peintures, Dessins, Polaroids, Photos
Retouchées*. Galerie Liliane & Michel Durand-Dessert,
Paris. 21 October 1989–6 January 1990.

1990

Pace/MacGill Gallery, New York. February.

William Wegman: Paintings and Drawings. James Corcoran
Gallery, Santa Monica, California. March.

William Wegman. Gian Enzo Sperone, Rome. March.

William Wegman: Polaroids. Linda Cathcart Gallery,
Los Angeles. March–27 April.

William Wegman: Paintings and Polaroids. Lisa Sette Gallery,
Scottsdale, Arizona. 3–31 March.

William Wegman: Drawings. Sperone Westwater Gallery,
New York. 31 March–5 May.

William Wegman: The History of Travel. Taft Museum,
Cincinnati. 19 April–24 June. Traveled to Butler
Institute of American Art, Youngstown, Ohio.
16 September–28 October.

New Paintings and Late Man Ray Polaroids. Holly Solomon
Gallery, New York. 26 April–9 June.

William Wegman. Galerie Susan Wyss, Zurich. 3 May–
24 June.

William Wegman: Paintings, Drawings, Photographs, Videotapes.
Kunstmuseum, Lucerne, Switzerland. 5 May–17 June.
Traveled to Institute of Contemporary Arts, London.

11 July–26 August; Stedelijk Museum, Amsterdam.
14 September–5 November; Frankfurter Kunstverein,
Frankfurt. 7 December 1990–3 February 1991;
Centre Georges Pompidou, Paris. 27 February–7 April;
Neuberger Museum of Art, Purchase College, State
University of New York, Purchase. 28 April–30 June
1991; Institute of Contemporary Art, Boston.
7 August–6 October 1991; John and Mable Ringling
Museum, Sarasota, Florida. 8 November 1991–
5 January 1992; Whitney Museum of American Art,
New York. 23 January–19 April 1992; Contemporary
Arts Museum, Houston. 15 May–23 August 1992.
William Wegman. Fraenkel Gallery, San Francisco.
24 October–1 December.

1991

Paintings, Drawings, Photographs. Fay Gold Gallery, Atlanta.
11 January–7 February.

William Wegman: Outdoor Photographs. Neuberger Museum
of Art, Purchase College, State University of New
York, Purchase. 28 April–30 June.

William Wegman. Nancy Drysdale Gallery, Washington,
D.C. 19 September–21 October.

*William Wegman: Photographic Works/L'oeuvre photographique,
1969–1976.* Fonds régional d'art du Limousin,
Limoges, France. 4 October–10 November.

William Wegman: Polaroids and Prints. Gallery COA, Tokyo,
Japan. 21 October–16 November.

William Wegman: Paintings. Sperone Westwater Gallery,
New York. 9 November 1991–7 January 1992.

Outdoor Photographs. Linda Cathcart Gallery, Santa
Monica, California. 19 November–31 December.

1992

Early Black and White Photographs. Pace/MacGill Gallery,
New York. 16 January–22 February.

New Paintings, Polaroids & Drawings. Holly Solomon
Gallery, New York. 16 January–15 February.

Foto, Film, Zeichnungen. Galerie Andreas Binder, Munich.
18 January–29 February.

William Wegman: The Ghent and Puppy Portfolios. Lisa Sette
Gallery, Scottsdale, Arizona. 5–26 March.

Dogs and Other Things: Works by William Wegman. Herbert F.
Johnson Museum of Art, Cornell University, Ithaca,
New York. 7 April–10 May.

Field Guide to North America (and to other regions).
Atheneum Music and Arts Library, La Jolla, California.
28 April–6 June.

William Wegman: Paintings and Drawings. John Berggruen
Gallery, San Francisco. 13 May–6 June.

William Wegman: Recent Work and 20-Year-Old Photographs.
Fraenkel Gallery, San Francisco. 13 May–20 June.

William Wegman: New Polaroids. Texas Gallery, Houston.
16 May–27 June.

William Wegman. Gerald Peters Gallery, Dallas. 5 June–
5 July.

William Wegman: Paintings and Drawings. I Space, College
of Fine and Applied Arts, University of Illinois,
Urbana-Champaign. 11 September–10 October.

Photographs. Linda Cathcart Gallery, Santa Monica,
California. November–24 December.

Paintings. James Corcoran Gallery, Santa Monica,
California. December 1992–5 January 1993.

Gerald Peters Gallery, Dallas. 17 December 1992–
21 January 1993.

1993

William Wegman's Cinderella. Museum of Modern Art,
New York. May.

*Fay's Fairy Tales: William Wegman's "Cinderella" and "Little Red
Riding Hood."* Baltimore Museum of Art. September–
December. Traveled to Carnegie Museum of Art,
Pittsburgh. 8 January–6 March 1994; Columbus
Museum of Art, Columbus, Ohio. 29 March–5 June
1994; Modern Art Museum of Fort Worth, Fort
Worth, Texas. 26 June–4 September 1994; Ansel
Adams Center for Photography, San Francisco.
4 October–27 November 1994; Museum of
Contemporary Art, San Diego. Closed 12 February
1995.

William Wegman Photographs. Orlando Museum of Art,
Orlando, Florida. 9 October–5 December.

William Wegman. Museo de Monterrey, Mexico. 14
October 1993–2 January 1994.

Pace/MacGill Gallery, New York. November.

William Wegman: Out of Doors. Atlantic Center for the
Arts, New Smyrna Beach, Florida. 3 November–
30 December.

William Wegman: Fairy Tales. Fraenkel Gallery, San
Francisco. 18 November–30 December.

William Wegman. Robert Klein Gallery, Boston.
2 December 1993–7 January 1994.

William Wegman: Les Contes de Fay. Galerie Liliane &
Michel Durand-Dessert, Paris. 4 December 1993–
29 January 1994.

1994

William Wegman: The Fairy Tales. Lisa Sette Gallery,
Scottsdale, Arizona. 6–29 January.

William Wegman: New Polaroids. Nancy Drysdale Gallery,
Washington, D.C. 19 March–6 April.

William Wegman Photolithographs. David Adamson Gallery,
Washington, D.C. Closed 26 March.

Pasadena City College Art Gallery, Pasadena, California. 28 March–22 April.

Drawings and Altered Photographs from the 1970s. Edition Julie Sylvester, New York. April. Traveled to Hebrew Home for the Aged, Riverdale, New York. 1995.

New Photographs: William Wegman. Robert Klein Gallery, Boston. 2 December 1994–14 January 1995.

William Wegman. Klein-Becker Gallery, Miami. 10 December 1994–10 January 1995.

1995

Photographs. Galerie Bugdahn und Kaimer, Düsseldorf, Germany. 10 March–22 April.

**William Wegman: Photographs*. Aspen Art Museum, Aspen, Colorado. 8 June–23 July.

A William Wegman Primer: Shapes, Numbers and ABCs. South Gallery, George Eastman House, International Museum of Photography and Film, Rochester, New York. 17 June–10 December.

**Weimar den Weimaranern*. ACC Gallery, Weimar, Germany. 18 June–27 August.

William Wegman. Pace Wildenstein Gallery, Los Angeles. October.

William Wegman: Photographs and Lithographs. Lisa Kurtz Gallery, Memphis. October.

William Wegman: Recent Work. Gerald Peters Gallery, Dallas. 11 October–18 November.

William Wegman: Altered Photographs. Pace/MacGill Gallery, New York. 19 October–18 November.

1996

William Wegman: Photographs, Paintings, Drawings and Video. Albrecht-Kemper Museum of Art, St. Joseph, Missouri. 12 April–30 June. Traveled to Boise Art Museum, Boise, Idaho. 29 November 1996–2 February 1997; Contemporary Art Center, New Orleans. 23 March–20 April 1997; San Jose Museum of Art, San Jose, California. 17 May–24 August 1997; Arkansas Art Center, Little Rock. 18 September–14 December 1997; Austin Museum of Art–Laguna Gloria, Austin, Texas. 10 January–1 March 1998; Tennessee State Museum, Nashville. 21 March–20 May 1998; Leigh Yawkey Woodson Art Museum, Wausau, Wisconsin. 6 June–30 August 1998; Quincy Art Center, Quincy, Illinois. 12 September–23 October 1998; Art Center of Battle Creek, Battle Creek, Michigan. 21 January–21 March 1999; Orange County Museum of Art, Newport Beach, California, May–16 June 2000.

William Wegman. Jay Gorney Modern Art, New York. 26 October–30 November.

1997

William Wegman: Fay's Fairy Tales. Musée d'art contemporain, Montreal. January–16 March.

William Wegman: Time Released. Department of Art Gallery, Mississippi State University, Mississippi. 27 January–28 February.

Polaroids and Other Photographs. Galerie Bugdahn und Kaimer, Düsseldorf, Germany. 14 February–22 March.

Dogs. Vered Gallery, East Hampton, New York. May.

William Wegman (Lost and Found). Fraenkel Gallery, San Francisco. 1 May–28 June.

**William Wegman*. Isetan Museum of Art, Tokyo. 29 May–23 June. Traveled in Japan to Parco Gallery, Nagoya. 18 September–27 October; Museum EKi, Kyoto. 12–30 November.

William Wegman: Picnic. Galeria Juana de Aizpuru, Madrid. 2 October–14 December.

**William Wegman: Dessins/Drawings, 1973–1997*. Fonds régional d'art contemporain du Limousin, Limoges, France. 15 October–8 November.

William Wegman. Salle d'Armes, Pont de l'Arche, France. 7 November–7 December.

1998

William Wegman: Recent Work. Gerald Peters Gallery, Dallas. 12 February–14 March.

**William Wegman*. Rooseum, Malmö, Sweden. 7 March–10 May. Traveled to Museet for Fotokunst, Odense, Denmark. 12 June–16 August; Göteborgs Konstmuseum and Hasselblad Center, Göteborg, Sweden. 3 October–15 November; Kiasma, Nykytaiteen Museo, Helsinki, Finland. 17 April–23 May 1999.

Polaroids. Pace Wildenstein MacGill Gallery, New York. 12 March–25 April.

**Saks Fifth Avenue Project Art: William Wegman: Photos, Clothes, Videos*. Saks Fifth Avenue, New York, men's windows 10–14. 6–13 May.

Wegman for Children. New Genre Festival, Virginia. Philbrook Museum of Art, Tulsa, Oklahoma. 7 June.

**Strange But True: William Wegman*. Huntington Gallery, Massachusetts College of Art, Boston. 31 October–24 December. Traveled to George Walter Vincent Smith Museum of Art, Springfield, Massachusetts. May–20 June 1999; Colorado University Museum, Boulder. 31 August–3 November 2001.

1999

William Wegman: Recent Polaroids. SOMA Gallery, LaJolla, California. 5 March–3 April.

William Wegman: Drawing, Video, Painting, Photography.
Williams College Museum of Art, Williamstown,
Massachusetts. 3 July–6 September.

William Wegman: New Photographs. David Floria Gallery,
Aspen, Colorado. 6 August–6 September.

William Wegman. Galerie Liliane & Michel Durand-
Dessert, Paris. 11 September–16 October.

William Wegman: Fashion Photographs. Birmingham
Museum of Art, Birmingham, Alabama. 18 October
1999–8 January 2000. Traveled to Miami Art
Museum, Miami, Florida. 21 July–8 October 2000;
Fabric Workshop and Museum, Philadelphia.
16 November 2000–13 January 2001; University of
South Florida Contemporary Art Museum, Tampa.
10 February–17 March 2001; Miami Art Museum.
May 2001; Speed Art Museum, Louisville. 22 May–
12 August 2001; University of Iowa Museum of Art,
Iowa City. 25 January–14 April 2002; Art Gallery
of Ontario, Toronto. 1 May–28 July 2002.

William Wegman: Prints and Polaroids. David Adamson
Gallery, Washington, D.C. 6 November–3 December.

2000

A Project for the Learning Center: William Wegman. Katonah
Museum of Art, Katonah, New York. January.

William Wegman: Drawing, Video, Painting. McKinney Avenue
Contemporary, Dallas. April–28 May.

William Wegman: The Art of the Narrative. Pillsbury-Peters
Gallery, Dallas. 22 April–20 May.

William Wegman. Orange County Museum of Art, Newport
Beach, California. 29 April–16 July.

TV Lunch Series Video Screening: William Wegman. The
Kitchen, New York. 13 May.

William Wegman: Canis Ecclesiorum. Cathedral of St. John
the Divine, New York. September.

*Saks Fifth Avenue Project Art: William Wegman: The Night
before Christmas*. Beverly Hills, California, and Palm
Beach, Florida. November–December.

William Wegman. Patrick deBrock Gallery, Knokke,
Belgium. December.

2001

*William Wegman: Drawings, Photographs, and Videos:
1970–2000*. University of South Florida
Contemporary Art Museum, Tampa. 9 February–
17 March.

William Wegman: Selected Polaroids. Nassau County
Museum of Art, Roslyn Harbor, New York. 20 May–
5 August.

William Wegman: Serie La Iglesia. Galeria Juana de Aizpuru,
Madrid. 21 June–30 July.

William Wegman Photographs. Candace Perich Gallery,
Katonah, New York. September.

Fashion Photographs. Museum of Fine Arts, Boston.
October–January 2002.

William Wegman: Early Works. Patrick & Beatrice Haggerty
Museum, Marquette University, Milwaukee,
Wisconsin. 11 October–1 January 2002.

2002

photo + drawing + video = William Wegman. South East
Center for Contemporary Art, Winston-Salem, North
Carolina. Febuary–12 April.

*William Wegman: Early Drawings/Early Video. Recent
Drawings/Recent Video*. Gorney, Bravin & Lee, New
York. 8 February–9 March.

William Wegman. Savage, Portland, Oregon. 22 February–
6 April.

*William Wegman: Early Video/Recent Video, New
Drawings/Earlier Paintings*. Texas Gallery, Houston.
16 April–18 May.

*William Wegman: Fashion Photographs and More: Works on
Paper and Video, 1970–2001*. Art Gallery of Ontario,
Toronto. 1 May–28 July.

William Wegman. Roman Zenner, Stuttgart. 5 May–2 June.

*William Wegman: Indian in the Refrigerator and Other Printed
Works*. Printed Matter, Inc., New York. 11 October–
16 November.

*William Wegman in the 59th Minute: Video Art on the Times
Square Astrovision*. Creative Time and Panasonic, New
York. 6 November 2002–22 January 2003.

William Wegman: Works on Paper. Dunn and Brown
Contemporary, Dallas. 22 November–17 December.

2003

William Wegman: Reading Two Books. Pace/MacGill Gallery,
New York. February.

William Wegman: Paintings. Sperone Westwater Gallery,
New York. 5 March–12 April.

William Wegman: New Pigment Prints. David Adamson
Gallery, Washington, D.C. 18 March–30 April.

William Wegman: Recent Polaroids. Marc Selwyn Fine Art,
Los Angeles. May.

William Wegman. VB Photographic Centre, Kuopio,
Finland. 6 June–31 August.

William Wegman. Galleria Cardi & Co., Milan. 11 June–
25 July.

William Wegman: Little Red Riding Hood Polaroids. Neuberger
Museum of Art, Purchase College, State University of
New York, Purchase. August.

William Wegman. Winston Wächter Gallery, Seattle.
9 September–30 October.

William Wegman. Senior & Shopmaker Gallery, New York. October.

William Wegman. Centro José Guerrero, Granada, Spain. October 2003–January 2004. Traveled to Artium, Vitoria, Spain. February–April 2004.

William Wegman: Recent Polaroids. Imago Galleries, Palm Desert, California. 6 December 2003–11 January 2004.

2004

William Wegman: Recent Polaroids. Galerie Bugdahn und Kaimer, Düsseldorf, Germany. 28 February–17 April.

William Wegman: Recent Paintings. Imago Galleries, Palm Desert, California. 27 March–8 May.

William Wegman. Domaine de Kerguéhennec: Centre d'art contemporain, Centre culturel de rencontre, Bignan, France. 10 April–20 June.

William Wegman. Dunn and Brown Contemporary, Dallas. 22 May–10 July.

2005

William Wegman, Man's Best Friend: Photographs and Videos. Lisa Sette Gallery, Scottsdale, Arizona. 7 July–30 September.

GROUP EXHIBITIONS

1967

Graduate Student Exhibition. Krannert Art Museum, University of Illinois, Champaign. 28 May–2 June.

1968

1968 Biennial of Painting and Sculpture: Iowa, Minnesota, North Dakota, South Dakota, Wisconsin. Walker Art Center, Minneapolis. 8 September–13 October.

Media in a Supermarket. John Michael Kohler Arts Center, Sheboygan, Wisconsin. Fall 1968–Winter 1969.

1969

Soft Art. New Jersey State Museum, Trenton. 1 March–27 April.

Live in Your Head: When Attitudes Become Form. Kunsthalle, Bern, Switzerland. 22 March–27 April. Traveled to Museum Haus Lange, Krefeld, Germany. 9 May–15 June; Institute of Contemporary Arts, London. 28 September–27 October.

55th Annual Wisconsin Painters and Sculptors Exhibition. Milwaukee Art Center, Wisconsin. 23 March–20 April.

Place and Process. Edmonton Art Gallery, Edmonton, Alberta. 4 September–26 October. Traveled to Kineticism Press, New York. 1–28 November.

Other Ideas. Detroit Institute of Arts. 10 September–19 October.

William Wegman and Robert Cumming. Laura Knott Gallery, Bradford Junior College, Haverhill, Massachusetts.

10–30 September.

Art by Telephone. Museum of Contemporary Art, Chicago. 1 November–14 December.

Plane und Projekte als Kunst. Kunsthalle, Bern, Switzerland. 8 November–7 December.

1970

William Wegman/Robert Cumming. University of Wisconsin, Milwaukee, Art History Gallery. February.

12 x 12. Addison Gallery of American Art, Phillips Academy, Andover, Massachusetts. 6–29 March.

Art in the Mind. Allen Memorial Art Museum, Oberlin College, Oberlin, Ohio. 17 April–12 May.

9 Artists/9 Spaces: An Exhibition of Outdoor Projects. Minnesota State Arts Council, Minneapolis. 1 September–15 October.

Body Works: A Video Exhibition of Work by Acconci, Fox, Nauman, Oppenheim, Sonnier and Wegman. Museum of Conceptual Art, San Francisco. 18 October.

1971

24 Young Los Angeles Artists. Los Angeles County Museum of Art, Los Angeles. 11 May–4 July.

Projects: Pier 18. The Museum of Modern Art, New York. 18 June–2 August.

11 Los Angeles Artists. Hayward Gallery, London. 30 September–7 November. Traveled to Palais des Beaux Arts, Brussels; Akademie der Kunst, Berlin.

Installation Works by Vito Acconci, Bill Beckley, Terry Fox, and William Wegman. 93 Grand Street, New York.

Prospect '71: Projection. Städtische Kunsthalle, Düsseldorf.

1972

15 Los Angeles Artists. Pasadena Art Museum, Pasadena, California. 22 February–29 March.

Exhibition 10. Contemporary Arts Museum, Houston. 20 March–4 June.

Documenta 5. Museum Fridericianum, Kassel, Germany. 30 May–8 October.

St. Jude Invitational Exhibition of Video Art. de Saisset Gallery and Art Museum, Santa Clara University, Santa Clara, California. 3–29 October.

1973

Biennial Exhibition: Contemporary American Art. Whitney Museum of American Art, New York. 10 January–18 March.

Mixed Bag. University of Maryland Art Gallery, College Park, Maryland. 17 January–9 March.

Circuit: A Video Invitational. Concurrent exhibitions at the Everson Museum of Art, Syracuse, New York; Henry Art Gallery, University of Washington, Seattle; and Cranbrook Academy, Bloomfield Hills, Michigan. April.

Story. John Gibson Gallery, New York. 7 April–3 May.

Camera Art. Ben Shahn Art Gallery, William Paterson College, Wayne, New Jersey. 1–31 December.

Some Recent American Art. National Gallery of Victoria, Melbourne; West Australian Art Gallery, Perth; Art Gallery of New South Wales, Sydney; Art Gallery of South Australia, Adelaide; City of Auckland Art Gallery, Auckland, New Zealand.

1974

Video Performance Series. 112 Greene Street, New York. 12–22 January. (William Wegman: 14 January.)

New Learning Spaces and Places. Walker Art Center, Minneapolis. 27 January–10 March.

Idea and Image in Recent Art. Art Institute of Chicago. 23 March–5 May.

Art Now 74: A Celebration of the American Arts. John F. Kennedy Center for the Performing Arts, Washington, D.C. 30 May–16 June.

Projekt 74: Aspekte Internationaler Kunst am Anfang der 70er Jahre. Kunsthalle Köln and Kölnischen Kunstverein, Cologne, Germany. 6 July–8 August.

Projects: Video I. The Museum of Modern Art, New York. 26 August–31 October.

1975

Von Pop zum Konzept. Neue Galerie, Sammlung Ludwig, Aachen, Germany. 10 April–11 September.

Projected Video. Whitney Museum of American Art, New York. 6–18 June.

Southland Video Anthology. Long Beach Museum of Art, Long Beach, California. 8 June–7 September.

Five Artists and Their Video Work. and/or Gallery, Seattle. 3 October–30 November.

The Extended Document: An Investigation of Information and Evidence in Photographs. International Museum of Photography at George Eastman House, Rochester, New York.

1976

Video Art: An Overview. San Francisco Museum of Modern Art. 23 March–18 April.

Video Performance Series. 112 Greene Street, New York. 30 April–6 May. (William Wegman: 4 May.)

Baldessari/Wegman. Whitney Museum of American Art, New York. 3–6 June.

Sonnabend Gallery, New York. July.

1977

Whitney Biennial. Whitney Museum of American Art, New York. February.

10th Biennale de Paris. June.

Video Festival. Frances Wolfson Art Gallery, Miami, Florida. 3–23 October.

Photography Not by Photographers. Visual Arts Museum, New York. November.

Contemporary American Photographic Works. Museum of Fine Arts, Houston. 4 November–31 December.

16 Projects/4 Artists: Laurie Anderson, Dennis Oppenheim, Michelle Stuart, William Wegman. University Art Museum, California State University, Long Beach; Moore College of Art, Philadelphia; Fine Arts Gallery, Wright State University, Dayton, Ohio, and University of New Mexico, Albuquerque. November 1977– May 1978.

American Narrative/Story Art: 1967–1977. Contemporary Arts Museum, Houston. 17 December 1977– 25 February 1978.

1978

"Bad" Painting. New Museum, New York. 14 January– 28 February.

Robert Cumming and William Wegman. Baxter Art Gallery, California Institute of Technology, Pasadena. 6 April–14 May.

The Moving Image Statewide. Media Study/Buffalo, Buffalo, New York.

1979

Concept, Narrative, Document: Recent Photographs from the Morton Neumann Family Collection. Museum of Contemporary Art, Chicago. 9–20 March.

Video: A Selection in the Art Form. Firehouse Gallery, Nassau Community College, Long Island, New York. April.

The Altered Photograph. P.S. 1 Contemporary Art Center, Long Island City, New York. May.

Attitudes: Photography in the 1970s. Santa Barbara Museum of Art. 12 May–5 August.

Avec un certain sourire?/With a Certain Smile? InK, Halle für international neue Kunst, Zurich, Switzerland. 15 June–12 August.

Commissioned Video Works (1976). University of California, Berkeley Art Museum and Pacific Film Archive. 24 June.

Five Artists/First Precinct. Old Slip Gallery, New York. October–17 November.

William Lundberg/William Wegman. Otis Art Institute, Los Angeles. 27 October–2 December.

20 x 24. Light Gallery, New York.

1980

The Photograph Transformed. Touchstone Gallery, New York. February.

Invented Images. University Art Museum, University of California at Santa Barbara. 20 February–23 March. Traveled to Portland Museum of Art, Portland, Oregon. 8 April–18 May; Mary Porter Sesnon Art

Gallery, University of California, Santa Cruz. 28 May–21 June; Freidas Gallery, New York. September–11 October.

Artist and Camera. Mappin Art Gallery, Sheffield, England. 25 October–23 November.

Ils se disent peintres, ils se disent photographes. Musée d'art moderne de la ville de Paris. 22 November 1980–4 January 1981.

Islamic Allusions. Alternative Museum, New York. 20 December 1980–31 January 1981.

1981

Whitney Biennial. Whitney Museum of American Art, New York. 20 January–19 April.

Drawing Distinctions: American Drawings of the Seventies. Louisiana Museum of Modern Art, Humlebæk, Denmark. 15 August–20 September. Traveled to Kunsthalle, Basel, Switzerland; Wilhelm-Hack Museum, Ludwigshafen, Germany; Städlische Galerie im Lenbachhaus, Munich.

Art on Paper. Witherspoon Art Gallery, University of North Carolina, Greensboro. 15 November–13 December.

Not Just for Laughs: The Art of Subversion. New Museum, New York. 21 November 1981–21 January 1982.

Instant Fotografie. Stedelijk Museum, Amsterdam. 4 December 1981–17 January 1982.

1982

Beyond Photography: The Fabricated Image. Delahunty Gallery, New York. July.

Photographs By and Photographs In. Daniel Wolf Gallery, New York. Two-part exhibition. September and October.

Shift: LA/NY. Newport Harbor Art Museum, Newport Beach, California. 7 October–27 November.

In Our Time: Houston's Contemporary Arts Museum, 1948–1982. Contemporary Arts Museum, Houston. 23 October 1982–2 January 1983.

Faces Photographed. Grey Art Gallery, New York University, New York. November.

The Destroyed Print. Pratt Manhattan Center Gallery, New York. 15 November–11 December.

1983

Video/TV: Humor/Comedy. Media Study/Buffalo, Buffalo, New York. 8–23 February.

Big Pictures. Museum of Modern Art, New York. May. Queens Museum of Art, New York. June. White Columns Gallery, New York. June.

Language, Drama, Source, and Vision. New Museum, New York. 8 October–27 November.

1984

The Innovative Landscape. Holly Solomon Gallery, New York. June.

Alibis. Centre Georges Pompidou, Paris. 6 July–17 September.

Color in Summer. Brooklyn Museum of Art, New York. September.

Ten Years of Video: The Greatest Hits of the '70s. Little Center Gallery, Clark University, Worcester, Massachusetts. September.

The Dog Observed: Photographs 1844–1983. Dog Museum of America, New York. 21 September–30 November. Traveled via S.I.T.E.S. to Midland Art Council, Michigan. 9 February–10 March 1985; Presentation House Gallery, North Vancouver, British Columbia. 30 March–28 April 1985; McKissick Museum, Columbia, South Carolina. 18 May–16 June 1985; Cordova Mall, Pensacola, Florida. 6 July–4 August 1985; Fayetteville Museum of Art, North Carolina. 24 August–22 September 1985; Erie Art Museum, Pennsylvania. 30 November 1985–1 January 1986; Milwaukee Public Library, Wisconsin. 18 January–16 February 1986; Speed Museum, Louisville, Kentucky. 8 March–6 April 1986; Tarble Arts Center, Charleston, Illinois. 14 June–13 July 1986; Ruth Eckerd Hall, Clearwater, Florida. 2 August–31 August 1986; Springfield Art Museum, Missouri. 20 September–19 October 1986; Muskegon Museum of Art, Michigan. 8 November–7 December 1986; Islip Art Museum, East Islip, New York. 27 December 1986–25 January 1987; MNAH, University of Nevada, Las Vegas. 14 February–15 March 1987; Albany Museum of Art, Georgia. 4 April–3 May 1987.

1985

A New Beginning. Hudson River Museum, Yonkers, New York. March.

Innovative Still Life. Holly Solomon Gallery, New York. June.

Funny Art. Concorde Gallery, New York. June–12 July.

Self-Portrait: The Photographer's Persona, 1840–1985. The Museum of Modern Art, New York. November.

1986

Altered Egos: Samaras/Sherman/Wegman. Phoenix Art Museum, Arizona. 10 January–23 February.

The Real Big Picture. Queens Museum of Art, Flushing, New York. 17 January–19 March.

Photographic Fictions. Whitney Museum of American Art at Champion, Stamford, Connecticut. 4 April–28 May.

Art and Advertising: Commercial Photography by Artists. International Center of Photography, New York. September.

Prospect '86. Frankfurter Kunstverein, Frankfurt, Germany. 9 September–2 November.

Animals. California State University, Fullerton. 14 September–9 November.

TV: Through the Looking Glass. Art Gallery, Fine Arts Center, New York State University, Stony Brook. 10 October–5 November.

Text and Image: The Wording of American Art. Holly Solomon Gallery, New York. December.

Painting and Sculpture Today: 1986. Indianapolis Museum of Art, Indiana.

1987

The Success of Failure. Laumeier Sculpture Park and Gallery, St. Louis. 15 February–22 March. Traveled to Johnson Gallery, Middlebury College, Middlebury, Vermont. 18 October–6 December; University of Arizona Museum of Art, Tucson. 31 January–12 March 1988.

Art from Down Under: The Smorgon Family Collection of Contemporary American Art. La Jolla Museum of Contemporary Art, California. 10 April–31 May.

Photography and Art: Interactions Since 1946. Fort Lauderdale Museum of Art, Florida; Los Angeles County Museum of Art, June.

Dokumenta 8. Museum Fridericianum Veranstaltungs, Kassel, Germany. 12 June–20 September.

Early Concepts of the Last Decades. Holly Solomon Gallery, New York. September.

The Dog Show. Jan Kesner Gallery, Los Angeles. 19 November–31 December.

Legacy of Light. International Center of Photography, New York. 20 November 1987–3 January 1988. Traveled to the DeCordova Museum and Sculpture Park, Lincoln, Massachusetts. 28 May–31 July 1988.

Instant Image. Rockland Center for the Arts, West Nyack, New York. December.

The New Who's Who. Hoffman-Borman Gallery, Santa Monica, California.

Panoramas and Prospects. Holly Solomon Gallery, New York.

1988

Photographic Truth. Bruce Museum, Greenwich, Connecticut. February; Sragow Gallery, New York. May.

Land. ACA Contemporary Gallery, New York. June.

The Unnatural Landscape. Fay Gold Gallery, Atlanta. 15 July–31 August.

Prints by Solo Press. Cardozo School of Law, New York. October.

1989

Photography Now. Victoria & Albert Museum, London. 15 February–30 April.

Holly Solomon Gallery, New York. March.

560 Broadway Gallery, New York. April.

Whitney Biennial. Whitney Museum of American Art, New York. 27 April–16 July.

Focus on the Collection: Five Photographic Portfolios. Neuberger Museum of Art, Purchase College, State University of New York, Purchase. July.

Personae. Islip Art Museum, Islip, New York. October.

Image World: Art and Media Culture. Whitney Museum of American Art, New York. 8 November 1989–18 February 1990.

Painting Beyond the Death of Painting. USSR Artists' Union, Moscow.

1990

Photography until Now. The Museum of Modern Art, New York. February. Traveled to Cleveland Museum of Art, Cleveland. June.

Word as Image: American Art, 1960–1990. Milwaukee Art Museum, Wisconsin. 15 June–26 August. Traveled to Oklahoma City Art Museum. 17 November 1990–2 February 1991; Contemporary Art Museum, Houston. 23 February–12 May 1991.

Just Pathetic. Rosamund Felsen Gallery, Los Angeles. August.

Humor, Satire & Irony. Krasdale Foods Gallery, Bronx, New York. October.

Points of Departure: Origins in Video. Carnegie Museum of Art, Pittsburgh. 3 November 1990–6 January 1991.

1991

Altered Truths: Contemporary Photographers from the Michael Myers/Russell Albright Collection. New Orleans Museum of Art. 12 January–24 February.

Space Attitudes: Eggleston, Jenney, Wegman. Holly Solomon Gallery, New York. 29 January–23 February.

Photography Show for Children. James Danziger Gallery, New York. June.

How She Looks. Staley-Wise Gallery, New York. July.

The Artist's Hand: Drawings from the Bank of America Corporation Art Collection. Museum of Contemporary Art, San Diego. July.

Letters. Christine Burgin Galley, New York. August.

Blum Helman Gallery, New York. September.

Motion and Document-Sequence and Time: Eadweard Muybridge and Contemporary American Photography. Addison Gallery of American Art, Phillips Academy, Andover, Massachusetts. 18 October–12 December.

Traveled to National Museum of American Art, Smithsonian Institution, Washington, D.C. 28 June–9 September 1991; Institute of Contemporary Photography, New York. 21 February–26 April 1992; Long Beach Museum of Art, Long Beach, California. 19 July–6 September 1992; Presentation House, North Vancouver, British Columbia. 23 October–13 December 1992; Henry Art Gallery, University of Washington, Seattle. 14 January 1992–21 March 1993; Wadsworth Atheneum, Hartford, Connecticut. 9 May–8 August 1993; International Museum of Photography at George Eastman House and Visual Studies Workshop, Rochester, New York. Fall 1993.

Fourth International Video Week. Geneva, Switzerland. 4–9 November.

Los Angeles, 1970–1975. Christine Burgin Gallery, New York.

1992

Multiple Exposure: The Group Portrait in Photography. Ezra and Cecile Zilka Gallery, Wesleyan University, Middletown, Connecticut, and Zabriskie Gallery, New York. 21 January–6 March. Traveled to Bayly Art Museum, University of Virginia, Charlottesville. October 1995; Bruce Museum of Arts and Sciences, Greenwich, Connecticut.

Replay: Art that Is Serious/Playful. William E. Gahlberg Gallery, College of duPage, Glen Ellyn, Illinois. 13 March–19 April.

Sofort-Bild-Geschichten: Eileen Cowin, David Levinthal & William Wegman. Museum Moderner Kunst Stiftung Ludwig, Vienna. May–June.

More than One Photography. The Museum of Modern Art, New York. 14 May–9 August.

Black and White Exhibition. Newport Harbor Art Museum, Newport Beach, California. July.

Photo-Collage. Contemporary Arts Museum, Houston. August.

Videorama: A Celebration of International Video Art. Walter Reade Theater, New York. October.

A New American Flag. Max Protech Gallery, New York. October.

Proof: Los Angeles Art and the Photograph, 1960–1980. Laguna Art Museum, Laguna Beach, California. 31 October–17 January 1993. Traveled to DeCordova Museum and Sculpture Park, Lincoln, Massachusetts. 13 February–11 April 1993; Friends of Photography, Ansel Adams Center, San Francisco. 23 June–22 August; Montgomery Museum of Fine Arts, Montgomery, Alabama. 11 September–7 November;

Tampa Museum of Art, Florida; Des Moines Art Center, Des Moines, Iowa. 5 March–8 May 1994.

Greg Colson, Guillermo Kuitca & William Wegman. Sperone Westwater Gallery, New York. 7 November–31 December.

Fables, Fantasies, and Everyday Things: Children's Books by Artists. Whitney Museum of American Art, New York. 20 November 1992–31 January 1993. Traveled to Whitney Museum of American Art at Champion, Stamford, Connecticut. 14 October–30 December 1994.

1993

Humor and Art. José Drudes-Biada Art Gallery, Mount St. Mary's College, Los Angeles. 12 May–12 June.

42nd Street Redevelopment Project, New York. July.

Art Works: Teenagers and Artists Collaborate. International Center of Photography, New York. July.

Action/Performance and the Photograph. Jan Turner Gallery and Turner/Krull Galleries, Los Angeles. July.

SEX-MONEY-POLITICS. Nancy Drysdale Gallery, Washington, D.C. 18 September–16 October.

Image Makers. Nassau County Museum of Art, Roslyn Harbor, New York. 3 October 1993–2 January 1994.

The Return of the "Cadavre-Exquis." The Drawing Center, New York. 6 November–18 December. Traveled to Corcoran Gallery of Art, Washington, D.C. 5 February–10 April 1994; Fundacion para el Arte Contemporaneo, Mexico City; Santa Monica Museum of Art. 9 July–6 September 1994; Forum for Contemporary Art, St. Louis. 30 September–12 November 1994.

1994

Animal Farm. James Corcoran Gallery, Santa Monica, California. 15 January–26 February.

Lessons in Life: Photographic Work from the Boardman Collection. Art Institute of Chicago. March.

James River Festival of the Moving Image. Richmond, Virginia. April.

Oh Boy, It's a Girl! Kunstverein, Munich. 20 July–11 September.

The camera i: Photographic Self-Portraits from the Audrey and Sydney Irmas Collection. Los Angeles County Museum of Art, Los Angeles. 11 August–23 October.

Old Glory: The American Flag in Contemporary Art. Cleveland Center for Contemporary Art. 14 August.

Solo Impressions Inc. College of Wooster Art Museum, Wooster, Ohio. 24 August–9 October.

Wildlife. California Center for the Arts Museum, Escondido. 1 October–31 December.

Private Art/Public Art: Photographs from the Collections of Johnson & Johnson and Citibank. Tyler Fine Arts Gallery, State University of New York, Oswego. 14 October–13 November. Traveled to Schweinfurth Art Center, Auburn, New York. 4 February–16 April 1995; Montclair Art Museum, New Jersey. 8 May–26 June 1995; University Art Gallery, State University of New York, Stony Brook. 11 November–16 December 1995; Emerson Gallery, Hamilton College, Clinton, New York. 24 February–6 April 1997; Centennial Hall Gallery, Augustana College, Rock Island, Illinois.

Elvis + Marilyn: 2 x Immortal. Institute of Contemporary Art, Boston. 2 November 1994–8 January 1995. Traveled to Contemporary Arts Museum, Houston. 4 February–26 March 1995; Mint Museum of Art, Charlotte, North Carolina. 15 April–30 June 1995; Cleveland Museum of Art. 2 August–23 September 1995; Jacksonville Art Museum, Jacksonville, Florida; Portland Art Museum, Portland, Oregon; Philbrook Academy, Tulsa, Oklahoma. 13 April–3 June 1996; Columbus Museum of Art, Columbus, Ohio. 22 June–19 August 1996; Tennessee State Museum, Nashville. 7 September–3 November 1996; San Jose Museum of Art, San Jose, California. 23 November 1996–25 February 1997; Honolulu Academy of Art. 16 April–8 June 1997; Hokkaido Obihiro Museum of Art, Hokkaido, Japan; Daimaru Museum, Umeda-Osaka, Japan; Takamatsu City Museum, Takamatsu, Japan; Sogo Museum of Art, Yokohama, Japan; Mitsukoshi Museum of Art, Fukuoka, Japan.

Single Cel Creatures: Cartoons and Their Influence on Contemporary Art. Katonah Museum of Art, Katonah, New York. December.

An American Century of Photography: From Dry-Point to Digital, Selections from the Hallmark Photographic Collection. Nelson-Atkins Museum of Art, Kansas City. 17 December 1994–15 February 1995. Traveled to Mead Art Museum, Amherst College, Amherst, Massachusetts. 10 March–14 May 1995; International Center of Photography, New York. 2 June 1995–10 September 1995; Auckland City Art Gallery, New Zealand. 17 November 1995–7 February 1996; Art Gallery of New South Wales, Sydney, Australia. May–June 1996; National Gallery of Victoria, Melbourne, Australia; Museum of Photographic Arts, San Diego. 28 August–1 December 1996; Phillips Collection, Washington, D.C. 23 January–28 March 1999; Seattle Art Museum. 30 September 1999–9 January 2000; Joslyn Museum, Omaha, Nebraska;

Delaware Art Museum, Wilmington. 9 February–22 April 2001; Columbus Museum, Columbus, Georgia. 23 September 2001–6 January 2002; Denver Art Museum. 29 June–29 September 2002.

1995

Putting on the Dog: Prints and Photographs. Hartman & Company, La Jolla, California. February.

Dance Ink: Frame by Frame. Frieda and Ray Furman Gallery, Lincoln Center, New York. 3 July–31 August.

Children's Books by Artists. Printed Matter Gallery, New York. August.

Mainely Wegmans. Colby College Art Museum, Waterville, Maine. 9 August–25 October.

Dokumente 1968-1969-1971 Prospect. Galerie Bugdahn und Kaimer, Düsseldorf, Germany. 9 September–21 October.

Starbucks Invitational. Rabbet Gallery, New Brunswick, New Jersey. October.

Reconsidering the Object of Art: 1965–1975. Museum of Contemporary Art, Los Angeles. 15 October 1995–4 February 1996.

Contemporary Narrative. James Graham & Son, New York. 9 November–23 December.

It's Only Rock and Roll: Rock-and-Roll Currents in Contemporary Art. Contemporary Arts Center, Cincinnati. 17 November 1995–14 January 1996. Traveled to Lakeview Museum of Arts and Science, Peoria, Illinois. 17 February–14 April 1996; Virginia Beach Center for the Arts, Virginia Beach, Virginia. 3 May–29 June 1996; Tacoma Museum of Art, Tacoma, Washington. 12 July–8 September 1996; Jacksonville Museum of Contemporary Art, Jacksonville, Florida. 26 September–20 November 1996; Bedford Gallery, Dan Lesher Regional Center for the Arts, Walnut Creek, California. 17 December 1996–16 February 1997; Phoenix Art Museum, Phoenix. 22 March–15 June 1997; North Carolina Museum of Art, Raleigh. 27 July–16 November 1997; Lowe Art Museum, Coral Gables, Florida. 11 December 1997–8 February 1998; Milwaukee Art Museum, Wisconsin. 20 March–24 May 1998; Arkansas Art Center, Little Rock. 26 June–30 August 1998; Austin Museum of Art, Austin, Texas. 30 January–3 April 1999.

Art, Design and Barbie: The Evolution of a Cultural Icon. Liberty Street Gallery, New York. December.

1996

Altered and Irrational: Selections from the Permanent Collection. Whitney Museum of American Art, New York. January.

Preferred Seating: A Brief History of the American Chair.
Pelham Art Center, Pelham, New York. June.

**Comme une Oiseau*. Fondation Cartier pour l'art contemporain, Paris. 19 June–13 October.

**Photographing the LA Art Scene, 1955–1975*. Craig Krull Gallery, Santa Monica, California. 6 July–17 August.

**L'art au corps: le corps exposé de Man Ray à nos jours*.
MAC–Galeries contemporaines des musées de Marseilles, France. 6 July–15 October.

**The Real, the Fictional, the Virtual*. Rencontres Internationales de la Photographie, Arles, France. 6 July–18 August.

**Rules of the Game*. Davis Museum and Cultural Center, Wellesley College, Wellesley, Massachusetts. 30 July–30 September.

Summer in America. Candace Perich Gallery, Katonah, New York. August.

Harrison Celebrates Art: Tricentennial Tribute. Neuberger Museum of Art, Purchase College, State University of New York, Purchase. August.

Dogs in Form and Image. Fine Arts Gallery, Golden West College, Huntington Beach, California. November.

Passionate Pursuits. Montclair Art Museum, Montclair, New Jersey. November.

**Double vie, double vue*. Fondation Cartier pour l'art contemporain, Paris. 1 November 1996–16 March 1997.

Legacy of Light: Master Photographs from the Cleveland Museum of Art. Cleveland Museum of Art, Ohio. 24 November 1996–2 February 1997.

1997

Portraits. Marlborough Gallery, New York. February.

The Museum of Modern Art: Digital Video Wall. Underground concourse of Rockefeller Center, New York. February–May.

Wit, Whimsy and Humor. Castle Gallery, New Rochelle, New York. February.

Rooms with a View: Environments for Video. Guggenheim Museum SoHo, New York. April.

**Finders/Keepers*. Contemporary Arts Museum, Houston. 10 May–3 August.

Image. Lance Fung Gallery, New York. 18 June–25 July.

Aerial Perspective: Imagination, Reality & Abstraction. D. C. Moore Gallery, New York. 15 July–14 August.

Video Art: The First 25 Years. Art Center, College of Design, Alyce de Roulet Williamson Gallery, Pasadena, California. August–21 September.

Creature Comforts. Monmouth Museum, Lincroft, New Jersey. Fall.

History of Video Art in Boston, Part III: The 1980s. DeCordova

Museum and Sculpture Park, Lincoln, Massachusetts. 13 September–28 December.

Nam June Paik & William Wegman. Holly Solomon Gallery, New York. 26 September–mid-November.

Mother Goose. Premiere. Chicago International Children's Film Festival. 9 October.

Animal Kingdom. New Jersey Center for the Visual Arts, Summit, New Jersey. 21 November 1997–1 February 1998.

New York International Children's Film Festival. December.

Animating the Static: Experiments in Video 1965–1980. Yale University Art Gallery, New Haven, Connecticut. 16 December 1997–1 February 1998.

1998

**The Pictures of Texas Monthly: Twenty-five Years*. Lyndon Baines Johnson Library, Austin, Texas. February. Traveled to McKinney Avenue Contemporary, Dallas. 29 March; Houston Center for Photography; Fort Worth Modern Art Museum, Fort Worth; San Antonio; El Paso; National Arts Club, New York; Los Angeles 1999; Museum of Fine Arts, Houston. 28 October 2000-28 January 2001; Houston Public Library. February 2001.

International Children's Film Festival. Berkeley Art Museum and Pacific Film Archive, University of California, Berkeley. February.

UTZ: A Collected Exhibition. Lennon, Weinberg Gallery, New York. 6 February–7 March.

**MATRIX: Berkeley: 20 Years*. University of California, Berkeley Art Museum and Pacific Film Archive. 24 February–5 July.

Great Buys: Recent Acquisitions from the Permanent Collection. DeCordova Museum and Sculpture Park, Lincoln, Massachusetts. 28 March–25 May.

The Unreal Person: Portraiture in the Digital Age. Huntington Beach Art Center, Huntington Beach, California. 26 April–14 June.

Conceptual Photography from the '60s and '70s. David Zwirner Gallery, New York. May.

**Performance in the 1970s: Experiencing the Everyday*. Walker Art Center, Minneapolis. 24 May–8 November.

Mirror Images. Arts on Douglas Gallery, New Smyrna Beach, Florida. 6 June–28 July.

Remix. Holly Solomon Gallery, New York. September.

Portfolios and Suites. Greg Kucera Gallery, Seattle. 3–27 November.

**Photography's Multiple Roles: Art, Development, Market, Science*. Museum of Contemporary Photography,

Columbia College, Chicago. 14 November 1998–
9 January 1999. Traveled to Cheekwood Museum of
Art, Nashville. 2 February 2002–April 2002;
Tampa Museum of Art, Tampa, Florida. September
2002–5 January 2003.

Dessins. Galerie Liliane & Michel Durand-Dessert, Paris.
Closed 30 January 1999.

*Beginnings of Video: Nam June Paik, Martha Rosler and William
Wegman*. Video Lounge, New York.

1999

Photography Show for Children. Candace Perich Gallery,
Katonah, New York. January.

Attention. Galerie Art: Concept, Paris. January–6 March.

Transmission. Bakalar and Huntington Galleries,
Massachusetts College of Art, Boston. 25 January–
27 February.

Sesame Street's Art from the Fuzzy and Famous. Museum of
Television and Radio, New York. February.

**Radical P.A.S.T.: Contemporary Art and Music in Pasadena,
1960–1974*. Norton Simon Museum of Art, Armory
Center for the Arts, and Williamson Gallery,
College of Design, Pasadena, California. 7 February–
9 May.

**Art at Work: Forty Years of the Chase Manhattan Collection*.
Contemporary Arts Museum and Museum of Fine
Art, Houston. 3 March–2 May.

BAMkids Film Festival. Brooklyn Academy of Music,
Brooklyn, New York. 17–18 April.

100 Drawings. P.S. 1 Institute for Contemporary Art, Long
Island City, New York. 18 April–20 June.

Still Photography: Works from the Tang College. The Tang
Teaching Museum and Art Gallery at Skidmore
College, Saratoga Springs, New York. 16–26 June.

Animals in Art. Art Gallery, Staller Center, University of
New York at Stony Brook. 24 June–31 July.

Animals Are Funny People. Keith deLellis Gallery, New York.
July.

20 Years of the Grenfell Press. Paul Morris Gallery, New
York. 8 July–19 August.

**The American Century, 1950–2000*. Whitney Museum
of American Art, New York. 26 September–
13 February 2000.

Animal Artifice. Hudson River Museum, Yonkers, New
York. 8 October–9 January 2000.

2000

Here Kitty, Kitty. Atlanta Contemporary Art Center, Atlanta,
Georgia. 14 January–26 February.

Become Like Me. Stills Gallery, Edinburgh. 2 February–
5 March.

Il Contratto del Disegnatore. In Arco, Torino, Italy.
31 May–15 July.

**Photography in Boston, 1955–1985*. DeCordova Museum
and Sculpture Park, Lincoln, Massachusetts.
16 September 2000–21 January 2001.

*Photoanatomic: Photographs of the Collection of the Mütter
Museum*. Barrister's Gallery, New Orleans.
2–30 December.

Once Upon a Time: Contemporary Art for Children's Books.
Cleveland Center for Contemporary Art, Cleveland,
Ohio. 8 December 2000–16 February 2001.

2001

*Is Seeing Believing? The Real, the Surreal, the Unreal in
Contemporary Photography*. North Carolina Museum of
Art, Raleigh. 14 January–1 April.

Azerty. Centre Georges Pompidou, Paris. 17 March–
14 May.

**Summer Reading: The Re-Creation of Language in Twentieth-
Century Art*. Frances Lehman Loeb Art Center, Vassar
College, Poughkeepsie, New York. 29 June–
16 September.

Literary Dogs! Sewickley Public Library, Sewickley,
Pennsylvania. 5 July–31 August.

Bugs. Pace Prints, New York. 30 July–7 September.

A Private Reading: The Book as Image and Object. Senior &
Shopmaker Gallery, New York. 13 September–
10 November.

**In Response to Place*. Corcoran Gallery of Art, Washington,
D.C. 15 September–31 December. Traveled to Houston
Museum of Natural Sciences, Houston. 1 February–
28 April 2002; Bellevue Art Museum, Seattle.
29 June–1 September 2002; High Museum of Art,
Atlanta. 14 September 2002–4 January 2003;
Indianapolis Museum of Art, Indianapolis. 10 May–
3 August 2003; Chicago Cultural Center, Chicago.
24 January–26 March 2004; Cincinnati Museum
Center, Cincinnati. 15 April–June 2004;
Contemporary Art Center of Virginia, Virginia Beach.
1 August–19 September 2004.

It Makes Me Sick. Longwood Art Gallery, Bronx, New York.
15 September–27 October.

13th Annual Virginia Film Festival. Charlottesville, Virginia.
October.

Impakt Festival 2001. The Centraal Museum, Utrecht,
The Netherlands. 2–7 October.

World Wide Video Festival. Amsterdam, The Netherlands.
10 October–11 November.

**Televisions*. Kunsthalle Wien, Vienna. 18 October–
6 January 2002.

2002

A Thousand Hounds: A Walk with Dogs through the History of Photography. UBS Paine Webber Art Gallery, New York. 17 January–29 May. Traveled to Norton Museum of Art, West Palm Beach, June–1 September; Ross Art Museum, Ohio Wesleyan University, Delaware, Ohio and Columbus Art Museum, Columbus, Ohio. 18 October–19 December; Delaware Art Museum Downtown Gallery and First USA Riverfront Arts Center, Wilmington, Delaware. 7 March–4 May 2003; Winnipeg Art Gallery, Manitoba. 31 May–7 September 2003; Durham Western Heritage Museum, Omaha. 20 September–7 December 2003.

Outer and Inner Space: Video. Virginia Museum of Fine Arts, Richmond. 19 January–17 March.

Scratch and Twitch: Gesture and Obsession in Video. REMOTE, New York. 20 January.

Reactions. Exit Art Gallery, New York. February.

The First Decade: Video from the EAI Archives. Museum of Modern Art, New York. 26 February–17 May.

FF Video Show. The Centraal Museum, Utrecht, The Netherlands. 17 March–26 May.

Equivoques, Figures du corps en action. Grandes Galerie-Aître Saint-Maclou, Ecole Régionale des Beaux-Arts de Rouen, France. 28 March–5 October.

I-5 Resurfacing: Four Decades of Contemporary California Art. San Diego Museum of Art, San Diego. 20 April–July 28.

Fifteenth Annual Dallas Video Festival. Dallas Theater Center, Dallas. 15–19 May.

Playground. Institute of Contemporary Art, Maine College of Art, Portland. 30 May–12 June.

New Photography. Art Downtown Project, New York. June.

From Pop to Now: Selections from the Sonnabend Collection. The Tang Teaching Museum and Art Gallery at Skidmore College, Saratoga Springs, New York. 22 June–29 September. Traveled to Wexner Center for the Arts at Ohio State University, Columbus. 3 November 2002–2 February 2003.

Naked (sic) in the Landscape. Pace/MacGill Gallery, New York. 11 July–28 August.

Constellation. Center for Photography at Woodstock, New York. 10 August–20 October.

Past, Present, Future. Center for Maine Contemporary Art, Rockport. 10 August–5 October.

Art Inside Out. Children's Museum of Manhattan. October 2002–December 2003.

Fins, Fangs, and Feathers. Cumberland Gallery, Nashville. October.

Photography Past/Forward: Aperture at 50. Rockefeller Center, New York. October.

Mütter Museum Photographs. Ricco/Maresca Gallery, New York. 17 October–16 November.

Video Acts: Single Channel Works from the Collection of Pamela and Richard Kramlech and New Art Trust. P.S. 1 Contemporary Art Center, Long Island City, New York. 23 November 2002–28 April 2003. Traveled to Institute of Contemporary Arts, London, 30 July–9 November 2003.

Corps Sublimes. Galerie Liliane & Michel Durand-Dessert, Paris. 23 November–18 January 2003.

Once upon a Time: Fiction and Fantasy in Contemporary Art. Whitney Museum of Art, New York. December.

2003

A Dog's Life: Images from Dürer to Wegman. Davison Art Center, Wesleyan University, Middletown, Connecticut. 22 January–7 March.

Video Wall. Kunsthalle, Vienna. February.

On the Wall: Wallpaper by Contemporary Artists. Rhode Island School of Design Museum, Providence. 7 February–20 April. Traveled to and expanded there as *On the Wall: Wallpaper and Tableau*. Fabric Workshop and Museum, Philadelphia. 9 May–13 September.

New Artist Multiples. Fabric Workshop and Museum, Philadelphia. 10 February–19 April.

Lines of Engagement. Sperone Westwater Gallery, New York. 1 June–1 July.

Looking at Photographs: 125 Masterpieces from the Museum of Modern Art. State Hermitage Museum, St. Petersburg, Russia. 21 June–31 August.

Living with Duchamp. The Tang Teaching Museum and Art Gallery at Skidmore College, Saratoga Springs, New York. 27 June–28 September.

The Human Zoo. Hatton Gallery, University of Newcastle, Newcastle-upon-Tyne, England. 28 June–23 August.

Pour l'Amour des Chiens. Mona Bismarck Foundation, Paris. 2 July–30 August.

Stranger in the Village. Guild Hall Museum, East Hampton, New York. September.

The Last Picture Show: Artists Using Photography, 1960–1982. Walker Art Center, Minneapolis. 11 October 2003–11 January 2004. Traveled to UCLA Hammer Museum, Los Angeles. 8 February–11 May 2004; Fotomuseum, Winterthur, Switzerland. 26 November 2004–13 February 2005.

Nothing Special. FACT Centre, Liverpool. 31 October 2003–1 January 2004.

Jennifer Bartlett and William Wegman. Imago Galleries, Palm Desert, California. 6 December 2003–11 January 2004.

2004

Recent Multiples by Louise Bourgeois and William Wegman. The Fabric Workshop and Museum, Philadelphia. January–March.

**Behind the Facts: Interfunktionen, 1968–1975*. Fundació Joan Miró, Barcelona. 19 February–2 May. Traveled to Museu de Arte Contemporânea, Fundação de Serralves, Porto, Portugal. 23 July–24 October.

**100 Artists See God*. The Jewish Museum, San Francisco. 3 March–27 June. Traveled to Laguna Art Museum, Laguna Beach, California. 24 July–3 October; Contemporary Art Center of Virginia, Virginia Beach. 9 June–4 September 2005.

Animals & Us: The Animal in Contemporary Art. Galerie St. Etienne, New York. 1 April–22 May.

Semana de Cine. Medina del Campo, Spain. 16–24 April.

Evidence of Impact: Art and Photography 1963–1978. Whitney Museum of American Art, New York. 29 May–10 October.

Brainstorming: topographie de la morale. Centre d'arte contemporain de Vassiviere en Limousin, Limoges, France.

BIBLIOGRAPHY

BOOKS AND WRITINGS

A Report on a Thesis Project Entitled "Bodoh." Graduate College of the University of Illinois, Urbana. 1967.
 Unpublished typescript.

"Shocked and Outraged as I Was, It Was Nice Seeing You Again." *Avalanche*, no. 2 (Winter 1971): 58–69.

"Pathetic Readings," *Avalanche* (May/June 1974): 8–9. Transcript of audiotapes from performance at 112 Greene Street,
 New York, 14 January 1974.

Man's Best Friend: Photographs and Drawings by William Wegman. New York: Harry N. Abrams, 1982, 1999. Texts by
 William Wegman and Laurance Wieder. German-language edition: *Der Menschen Freund: Photographien von William
 Wegman*. Hamburg: Rogner & Bernhard GmbH & Co. Verlags, 1992.

Everyday Problems: William Wegman. New York: Brightwater, 1984.

$19.84. Buffalo, New York: Center for the Exploratory and Perceptual Arts, 1984.

"Album: William Wegman." *Arts Magazine* 60, no. 5 (January 1986): 116–117.

"The World of Photography." *Artforum International* 25, no. 2 (October 1986): 106–111. Texts by William Wegman
 and Michael Smith.

"Folio of Photographs." *The Company of Dogs: Twenty-One Stories by Contemporary Masters*. New York: Doubleday, 1990;
 Artisan, 1995; Galahad, 1996. Edited by Michael J. Rosen.

"Inside/Outside." *Dog People: Writers and Artists on Canine Companionship*. New York: Doubleday, 1990.
 Edited by Michael J. Rosen.

Cinderella. New York: Hyperion Books for Children, 1993, 1999; New York: Scholastic, 1996. Texts by Carole Kismaric
 and Marvin Heiferman. German-language edition: Munich: Schirmer/Mosel, 1993.

Little Red Riding Hood. New York: Hyperion Books for Children, 1993, 1999. Texts by Carole Kismaric and
 Marvin Heiferman. German-language edition: *Rotkäppchen*. Munich: Schirmer/Mosel, 1994; Spanish-language
 edition: *Caperucita Rojer*. Barcelona: Ediciones B., 2000.

Field Guide to North America and to Other Regions. Venice, California: Lapis, 1993; French-language edition: Le Havre,
 France: Editions Flux, 2004. Translation by Heather Allen and Pierre Guislain.

ABC. New York: Hyperion Books for Children, 1994.

The Making of Little Red Riding Hood. New York: Whitney Museum of American Art, 1994.

1, 2, 3. New York: Hyperion Books for Children, 1995.

Triangle, Square, Circle. New York: Hyperion Books for Children, 1995.

William Wegman's Mother Goose. New York: Hyperion Books for Children, 1996.

Puppies. New York: Hyperion Books for Children, 1997.

*William Wegman's Farm Days: or How Chip Learnt an Important Lesson on the Farm, or a Day in the Country, or Hip Chip's Trip,
 or Farmer Boy*. New York: Hyperion Books for Children, 1997; Scholastic, 1998.

A Showing of Weimaraner: Being Specimens of Letters, Numbers, and Punctuation of an Original and Extraordinary Letterform.
 New York: Thornwillow, 1998.

My Town. New York: Hyperion Books for Children, 1998; Scholastic, 1999.

Baby Book. San Francisco: Chronicle, 1999. French-language edition: *Le Livre de Bébé*. Paris: Editions Seuil Jeunesse, 1999.

Fay. New York: Hyperion, 1999.

What Do You Do? New York: Hyperion Books for Children, 1999.

William Wegman: Fashion Photographs. New York: Harry N. Abrams, 1999. Text by William Wegman and Ingrid Sischy.

William Wegman's Pups. New York: Hyperion Books for Children, 1999; London: Turnaround, 1999.

Surprise Party. New York: Hyperion Books for Children, 2000; London: Turnaround, 2001. French-language edition:
 Joyeux Anniversaire. Paris: Editions Seuil Jeunesse, 2001.

The Night Before Christmas. New York: Hyperion Books for Children, 2000; London: Turnaround, 2001.
 Text by Clement Clarke Moore.

William Wegman's Wegmanology. New York: Hyperion Books for Children, 2001; London: Turnaround, 2001.

How Do You Get to MOMAQNS? New York: Museum of Modern Art, 2002.

William Wegman: Polaroids. New York: Harry N. Abrams, 2002.

Chip Wants a Dog. New York: Hyperion Books for Children, 2003; London: Turnaround, 2003.

INTERVIEWS AND MONOGRAPHS

Béar, Liza. "Man Ray, Do You Want to ... An Interview with William Wegman." *Avalanche*, no. 7
 (Winter/Spring 1973): 40–51.

Enright, Robert. "Chameleonesque: The Shape-Shifting Art of William Wegman." *Border Crossings* 22, no. 1
 (February 2003): 30–47. Introduction by Meeka Walsh.

Kunz, Martin, ed. *William Wegman: Paintings, Drawings, Photographs, Videotapes*. New York: Harry N. Abrams, 1990.
 Texts by Martin Kunz, Alain Sayag, Peter Schjeldahl, William Wegman, Peter Weiermain, and David Ross.
 French-language edition: *William Wegman: Peintures, Dessins, Photographies, Vidéos*. Paris: Centre Georges Pompidou, 1991.

Larson, Kay. "Talking to ... William Wegman." *Vogue* 178, no. 8 (August 1988): 280, 282.

Miller, Nancy. "An Interview with William Wegman." In *William Wegman: Outdoor Photographs*. Purchase, N.Y.:
 Neuberger Museum, State University of New York, 1991. Exhibition brochure.

Montano, Linda M. "William Wegman." In *Performance Artists Talking in the Eighties*. Berkeley, Los Angeles, and London:
 University of California Press, 2000.

Morgan, Susan. "William Wegman as Told to Susan Morgan." *Real Life* (Winter 1981): 2–3.

Neary, Lynn. "Interview with William Wegman." In *The Best of NPR: On Creativity*. New York: National Public Radio,
 1997. Audiotape.

Simon, Joan. "Interview with William Wegman." In Mary Beebe et al., *Landmarks: Sculpture Commissions for the Stuart
 Collection at the University of California, San Diego*. New York: Rizzoli, 2001.

Teitelbaum, Matthew. *An Afternoon with William Wegman*. Boston: Institute of Contemporary Art, 1991. Videotape.

Wegman's World. VPRO Television, Washington, D.C.: New River Media, 1997. Videotape.

ARTICLES AND REVIEWS

Adams, Brooks. "Wegman Unleashed." *ARTnews* 89, no. 1 (January 1990): 150–155.

Anderson, Alexandra. "Vignettes: Notes from the Art World." *Portfolio* 4, no. 5 (September–October 1982): 14.

———. "He Shoots Dogs, Doesn't He?" *Smart* (April 1990): 46–51.

Anderson, Laurie. "Review." *ARTnews* 71, no. 8 (December 1972): 76.

Apple, Max. "Caring for the Older Dog." *New York Times Magazine*, 30 September 1984.

Armstrong, Richard. "Santa Barbara: Altered Photographs: UCSB Art Museum." *Artforum* 18, no. 9 (May 1980): 88.

Boice, Bruce. "Review." *Artforum* 11, no. 5 (January 1973): 88.

Boxer, Sarah. "Wegman Drops Props and Lets Dogs Lie." *New York Times*, 10 April 1998.

Calnek, Anthony. "New York." *Contemporanea* 2, no. 4 (June 1989): 30–31.

Cavaliere, Barbara. "William Wegman: The David Letterman Show." *Arts Magazine* 56 (May 1982): 29.

Collins, James. "Review." *Artforum* 12, no. 1 (September 1973): 83–85.

Constantini, Paolo. Review of *Photography Now* by Mark Haworth-Booth. *Contemporanea* 3, no. 1 (January 1990): 99.

Cork, Richard. "UK Commentary." *Studio International* 183, no. 942 (March 1972): 116–121.

Coupland, Ken. "William Wegman: Only Human." *Graphis* 50, no. 292 (July–August 1994): 60–71.

Decter, Joshua. "William Wegman." *Arts Magazine* 66, no. 6 (February 1992): 79.

Filler, Martin. "Wegman's Wildlife." *Vanity Fair* (July 1990).

Freudenheim, Susan. "Under the Singing Eucalyptus Tree." *Artforum International* 26, no. 8 (April 1988): 124–130.

Gardner, Paul. "What Artists Like About the Art They Like When They Don't Know Why." *ARTnews* 90, no. 8 (October 1991): 116–121.

Gray, Alice. "William Wegman." *ARTnews* 91, no. 5 (May 1992): 121.

Gross, Michael. "Pup Art." *New York* 25, no. 13 (30 March 1992): 44–49.

Grundberg, Andy. "'20 x 24' at Light." *Art in America* 68 (February 1980): 134.

———. "Mixing Art and Commerce." *New York Times,* 24 May 1981.

———. "Photography Has Become Part of the Practice of Art." *New York Times,* 26 December 1982.

Hagen, Charles. "William Wegman." *Artforum International* 22, no. 10 (Summer 1984): 90.

Halpern, Sue M. "In Short: Canine Camera." Review of *The Dog Observed* by Ruth Silverman. *New York Times Book Review,* 30 September 1984.

Hazelwood, Robin. "William Wegman Runs Free." *Photomarket* (August 1997): 24–27.

Heartney, Eleanor. "William Wegman." *ARTnews* 87, no. 8 (October 1988): 168.

Hempel, Amy. "William Wegman: The Artist and His Dog." *New York Times Magazine,* 29 November 1987, 9, 34.

Hickey, Dave. "Wegman: Teaching Old Dogs New Tricks." *Los Angeles Times,* 11 April 1990, F1, F6.

Hoberman, J. "Wise Guys." Review of *The Best of William Wegman, 1970–1978. Village Voice,* 11 June 1985, 51.

Indiana, Gary. "Doglessness." *Village Voice,* 31 May 1988, 94.

Jappe, Georg. "Projection: The New Trend at Prospect '71." *Studio International* 182, no. 939 (December 1971): 258–261.

Johnstone, Mark. "William Wegman Improved Photographs." *Artweek* 11, no. 11 (22 March 1980): 1, 16.

Knight, Christopher. "William Wegman Goes Back to the Future." *Los Angeles Times,* 11 April 1990.

Kowinski, William Severini. "Is Wegman an Artistic Comic or a Comic Artist?" *Smithsonian* 22, no. 6 (September 1991): 44–52.

Kurtz, Bruce. "Video Is Being Invented." *Arts Magazine* 47, no. 3 (December 1972–January 1973): 37–44.

Kuspit, Donald. "The History of Travel: Paintings by William Wegman." *Dialogue* 13, no. 5 (September–October 1990): 35.

Larson, Kay. "The Museum of Modern Art Unveils Its Treasures." *New York,* 39, no. 5 (14 May 1984).

Lavin, Maud. "Notes on William Wegman." *Artforum* 13, no. 7 (March 1975): 44–47.

Lewis, Louise. "Shared Humor and Sophistication." *Artweek* 6, no. 18 (May 1978): 5.

Marks, Ben. "William Wegman: Puttin' on the Dog." *Artspace* (July–August 1990): 54–56.

Marzorati, Gerald. "Did I Say Something Funny?" *Soho Weekly News,* 5 April 1979, 28–29.

"The Masters." *American Photo* 1, no. 1 (January–February 1990): 62–77.

McCoy, Pat. "Image World: Art and Media Culture." *Flash Art* 152 (May–June 1990): 187.

Morgan, Stuart. "Everything You Wanted to Know About William Wegman but Didn't Dare Ask." *Arnolfini Review* (May–June 1979): 4–5.

Morgan, Susan. "And That's the Way It Is: The Works of Applebroog, Diamond, and Wegman." *Artscribe* 58 (June–July 1986): 48–49.

Muchnic, Suzanne. "Conceptualism Spans the Gulf." *Los Angeles Times,* 1 May 1978.

Murray, Joan. "Man Ray and E. T." *Artweek* 13, no. 32 (2 October 1982): 11–12.

Nemser, Cindy. "Subject/Object Body Art." *Arts Magazine* 46, no. 1 (September–October 1971): 28–42.

Owens, Craig. "William Wegman's Psychoanalytic Vaudeville." *Art in America* 71, no. 3 (March 1983): 100–109.

Perrone, Jeff. "I'd Rather Be Laughing." *Artforum International* 30, no. 6 (February 1992): 102–107.

Pincus-Witten, Robert. "Anglo-American Standard Reference Works: Acute Conceptualism." *Artforum* 10, no. 2 (December 1971): 82–85.

Plagens, Peter. "The Decline and Rise of Younger Los Angeles Art." *Artforum* (May 1972): 79–81.

Pollan, Michael, with photographs by William Wegman. "An Animal's Place." *New York Times Magazine,* 10 November 2002, 58–65, 100, 110–111.

Pomeroy, Ralph. "Soft Objects at the New Jersey State Museum." *Arts Magazine* 43, no. 5 (March 1969): 46–48.

"Portfolio: William Wegman: Man Ray." *Paris Review* 25, no. 87 (Spring 1983): 133–143.

Power, Mark. "Sequential Photography: Unfolding a Visual Kaleidoscope." *Washington Post,* 15 March 1975.

"Projects: Pier 18." Press release, no. 80. New York: Museum of Modern Art, June 1971.

"Projects: William Wegman." *Artforum* 26, no. 6 (February 1980): 27–28.

Raynor, Vivien. "William Wegman: Photographer as Painter." *New York Times,* 10 January 1986.

Reust, Hans Rudolf. "William Wegman—Kunstmuseum/Mai 36." *Artscribe* 83 (September–October 1990): 95–96.

Rice, Shelley. "Image Making." *Soho Weekly News* 6, no. 34 (24 May 1970): 50.

Rickey, Carrie. "The More the Merrier." *Village Voice,* 29 October 1979, 79.

———. "Curatorial Conceptions: The Whitney's Latest Sampler." *Artforum* 19, no. 8 (April 1981): 52–57.

———. "Postmodern Pup." *Village Voice* 28, no. 1 (4 January 1983): 28–29.

Robbins, D. A. "William Wegman's Pop Gun." *Arts Magazine* 58, no. 7 (March 1984): 116–121.

Rosenblum, Robert. "William Wegman at Pace/MacGill Gallery." In *Art Today* 2, no. 3 (March 1990). Videotape.

Saltz, Jerry. "Notes on a Painting: A Blessing in Disguise: William Wegman's 'Blessing of the Field' 1986." *Arts Magazine* 62, no. 10 (Summer 1988): 15–16.

Schjeldahl, Peter. "The Hallelujah Trail." *Village Voice,* 18 March 1981, 77.

Schwartz, Sanford. "The Lovers." Review of *Man's Best Friend: Photographs and Drawings* by William Wegman and *Wegman's World* by Lisa Lyons and Kim Levin. *New York Review of Books* 30, no. 13 (18 August 1983): 44–45.

Sharp, Willoughby. "Place and Process." *Artforum* 8, no. 3 (November 1969): 46–49.

———. "Body Works." *Avalanche,* no. 1 (Fall 1970): 14–17.

———. "Rumbles." *Avalanche,* no. 1 (Fall 1970): 8–9.

Smith, Roberta. "Biennial Blues." *Art in America* 69, no. 4 (April 1981): 92–101.

———. "Bartlett's Unfamiliar Quotations." *Village Voice,* 25 May 1982, 88.

———. "From Camera to Paint: New Style for Wegman." *New York Times,* 13 May 1988.

———. "The Dog Days and Years of William Wegman." *New York Times,* 14 June 1991.

Squires, Carol. "The Monopoly of Appearances." *Flash Art* 21, no. 123 (February–March 1987): 98–100.

———. "The Tale That Wags the Dog." *Artforum International* 26, no. 1 (September 1987): 76–77.

Stevens, Mark. "From Dada to Bowwow." *Newsweek,* (3 January 1983): 64–65.

Stimson, Paul. "William Wegman at Holly Solomon." *Art in America* 67, no. 5 (September 1979): 133–134.

Stitelman, Paul. "Review." *Arts Magazine* 47, no. 3 (December 1972–January 1973): 74–75.

Straus, Marc. "Facts and Fancy." *Contemporanea* 2, no. 5 (July–August 1989): 87–89.

Stretch, Bonnie Barret. "Prints and Photographs: A Rich Mixture of Mediums." *ARTnews* 87, no. 2 (February 1988): 56, 62.

Sturken, Marita. "The Whitney Museum and the Shaping of Video Art: An Interview with John Hanhardt." *Afterimage* 10, no. 10 (May 1983): 4–8.

"The Subversive Art." Review of "Photography and the Mirror of Art" by Martin Jay in *Salmagundi* (Fall 1989). *Wilson Quarterly* 14, no. 2 (Spring 1990): 135–136.

Terbell, Melinda. "Los Angeles." *Arts Magazine* 45, no. 6 (April 1971): 74.

Thornton, Gene. "For William Wegman, Slapstick Is Serious." *New York Times,* 7 November 1982.

Trucco, Terry. "Photography: Man Ray's Best Friend." *Portfolio* 4, no. 1 (January–February 1982): 24, 26, 28.

Verzotti, Giorgio. "William Wegman: Maison de la Culture, Saint-Etienne." *Flash Art* 147 (Summer 1989): 162.

Virshup, Amy. "Picture This." *ARTnews* 87, no. 3 (March 1988): 13–14.

Walsh, Mike E. "Photography: Invented Images." *Artweek* 11, no. 18 (10 May 1980): 11.

Whelan, Richard. "Color Polaroid '20 x 24' Photographs." *ARTnews* 79, no. 4 (April 1980): 185–186, 190.

"Where Were They Then? How Some of Today's Photographic Stars Launched Their Brilliant Careers." *American Photo* 5, no. 4 (July–August 1994): 95–96, 99.

"William Wegman Altered Photographs." *Domus* 596 (July 1979): 53.

Wilson, Martha. Review of *$19.84* by William Wegman. *Artforum International* 23, no. 4 (December 1984): 2.

Wilson, William. "Two Young Artists Make Tandem Debut." *Los Angeles Times,* 12 January 1971.

Winer, Helene. "How Los Angeles Looks Today." *Studio International* 182, no. 937 (October 1971): 127–131.

———. "Scenarios/Documents/Images." *Art in America* 61 (March–April 1973): 42–47, and (May–June 1973): 69–73.

Wise, Kelly. "A Positive Month for Photo Exhibits." *Boston Globe,* 7 April 1983.

Woodward, Richard B. "The International Center of Photography Comes of Age." *ARTnews* 85, no. 2 (February 1986): 80–88.

———. "Documenting an Outbreak of Self-Representation." *New York Times,* 22 January 1989.

Yau, John. "William Wegman: Holly Solomon Gallery." *Artforum International* 27, no. 2 (October 1988): 42.

Zelevansky, Lynn. "Photography at the Whitney Biennial." *Flash Art* 103 (Summer 1981): 43.

SOLO EXHIBITION CATALOGUES

Aspen, Colorado. Aspen Art Museum. *William Wegman: Photographs.* 1995. Brochure.

Berkeley, California. University of California, Berkeley Art Museum and Pacific Film Archives. *MATRIX/Berkeley 6: William Wegman.* 1978. Brochure.

Bignan, France. Domaine de Kerguéhennec. *William Wegman.* 2004. Text by Frédéric Paul. Brochure.

Boston. Massachusetts College of Art. *Strange But True.* 1998. Texts by Jeffrey Keough and William Wegman.

Buffalo, New York. Center for the Exploratory and Perceptual Arts Gallery. *$19.84.* 1984.

Cincinnati and Youngstown, Ohio. Taft Museum and Butler Institute of American Art. *The History of Travel: William Wegman.* 1990. Texts by Ruth K. Meyer and Donald B. Kuspit.

Claremont, California. Pomona College Art Gallery, Montgomery Art Center. *William Wegman: Video Tapes, Photographic Works, Arrangements.* 1971. Text by Helene Winer.

Düsseldorf. Konrad Fischer Galerie. *William Wegman.* 1972.

Granada, Spain. Disputación Provincial de Granada. *William Wegman.* 2004. Texts by Maite Barrera, William Wegman, Robert Enright, and Meeka Walsh. Spanish, Basque, and English.

Hartford, Connecticut. Wadsworth Atheneum. *William Wegman: MATRIX 9.* 1975. Brochure.

Limoges, France. Fonds régional d'art contemporain du Limousin. *William Wegman: Dessins/Drawings, 1973–1997.* 1997. Text by Frédéric Paul.

Limoges, France. Fonds régional d'art contemporain du Limousin. *William Wegman: Photographic Works/L'oeuvre photographique: 1969–1976.* 1991; and New York, DAP/Distributed Art Publications, 1993. Text by Frédéric Paul. "Eureka" by William Wegman.

Loire, France. Maison de la Culture et de la Communication de Saint-Etienne. *William Wegman.* 1989. Texts by Yves Aupetitallot, William Wegman, Peter Schjeldahl, and Bernard Blistène.

Los Angeles. Los Angeles County Museum of Art. *William Wegman.* 1973. Text by Jane Livingston.

Malmö, Sweden. Rooseum. *William Wegman.* 1998. Texts by William Wegman, Bo Nilsson, and Staffan Schmidt. Swedish and English. Finnish-language edition: Helsinki. Nykytaiteen Museo. 1999.

Minneapolis. Walker Art Center. *Wegman's World.* 1982. Text by Lisa Lyons and Kim Levin.

Monterrey, México. Museo de Monterrey. *William Wegman.* 1993. Text by Peter Schjeldahl. Spanish and English.

New York. Holly Solomon Gallery and Pace/MacGill Gallery. *William Wegman.* 1991. Text by William Wegman.

New York. Holly Solomon Gallery. *Everyday Problems.* 1984. Text by William Wegman.

New York. Holly Solomon Gallery. *New Paintings, Polaroids, and Drawings.* 1992.

New York. Pace/MacGill Gallery. *Early Black and White Photographs.* 1992.

New York. Saks Fifth Avenue. *Saks Art Project #2: William Wegman: Photos, Clothes, Videos.* 1998. Brochure.

New York. Sonnabend Downtown Gallery. *William Wegman.* 1972.

New York. Sperone Westwater Gallery. *William Wegman: Why Draw?* 1990. Text by William Wegman.

Newport Beach, California. Newport Harbor Art Museum. *Wegman's Photographs from the Ed Ruscha Collection.* 1983. Texts by Ed Ruscha, Paul Schimmel, and William Wegman. Brochure.

Purchase, New York. Neuberger Museum of Art, State University of New York. *William Wegman: Outdoor Photographs.* 1991. Brochure.

Regina, Saskatchewan. Mackenzie Art Gallery. *William Wegman*. 1984. Text by William Wegman.

Stuttgart. Roman Zenner. *William Wegman*. 2002. Text by Curtis L. Carter.

Tokyo. APT International. *William Wegman*. 1997. Text by Mami Asano, Maki Izumikawa, and Vince Leo. English and Japanese.

Urbana-Champaign, Illinois. College of Fine and Applied Arts, University of Illinois. *William Wegman: Paintings and Drawings*. 1992. Text by Lisa Wainwright. Brochure.

Weimar, Germany. ACC Gallery. *Weimar den Weimaranern*. 1995.

Winston-Salem, North Carolina. Southeastern Center for Contemporary Art. *William Wegman*. 1982. Text by Laurance Wieder.

SELECTED GROUP EXHIBITION CATALOGUES

Aachen, Germany. Neue Galerie Sammlung Ludwig. *Von Pop zum Konzept*. 1975. Text by Wolfgang Becher. French, German, and Dutch.

Amsterdam. Stedelijk Museum. *Instant Fotografie*. 1981. Texts by Ulay, Els Barents, and Karel Schampers. Dutch.

Andover, Massachusetts. Addison Gallery of American Art, Phillips Academy. *Motion and Document—Sequence and Time: Eadweard Muybridge and Contemporary American Photography*. 1991. Texts by James Sheldon and Jock Reynolds.

Arles, France. Rencontres Internationales de la Photographie. *The Real, the Fictional, the Virtual*. 1996. Text by Joan Fontcuberta.

Austin. Texas Monthly Press. *The Pictures of* Texas Monthly: *Twenty-Five Years*. 1998. In association with Stewart, Tabori & Chang, New York. Texts by Stephen Harrigan and Anne Wilkes Tucker. Edited by D. J. Stout and Nancy McMillen.

Barcelona. Fundació Joan Miró. *Behind the Facts: Interfunktionen 1968–1975*. 2004. In association with Ediciones Polígrafa. Texts by Friedrich Heubach and Birgit Pelzer. Edited by Gloria Moure.

Berkeley. University of California, Berkeley Art Museum and Pacific Film Archive. *Commissioned Video Works, 1976*. 1979. Videocasette.

Berkeley. University of California, Berkeley Art Museum and Pacific Film Archive. *MATRIX: Berkeley: 1978–1998*. 1998.

Bern, Switzerland. Kunsthalle Bern. *Live in Your Head: When Attitudes Become Form*. 1969. Texts by Scott Burton and Grégoire Muller. English, French, German, and Italian.

Bern. Kunsthalle Bern. *Plane und Projekte als Kunst*. 1969. Text by Daniel A. Bochner. Brochure.

Boston. Institute of Contemporary Art. *Elvis + Marilyn: 2 x Immortal*. Produced by Branka Bogdanov, Wendy McDaris, and Ted Reinstein. Edited by Geri Depaoli. Videocassette. See also New York: Rizzoli.

Brooklyn. Pratt Institute. *The Destroyed Print*. 1982. Texts by Jeff, Ellen Schwartz, and Kay Larson.

Buffalo, New York. Media Study/Buffalo. *Video/TV: Humor/Comedy*. 1983. Text by John Minkowsky.

Chicago. Art Institute of Chicago. *Idea and Image in Recent Art*. 1974. Text by Anne Rorimer.

Chicago. Museum of Contemporary Art. *Art by Telephone*. 1969. LP recording.

Chicago. Museum of Contemporary Art. *Concept, Narrative, Document: Recent Photographs from the Morton Neumann Family Collection*. 1979. Text by Judith Tannenbaum.

Chicago. Museum of Contemporary Photography, Columbia College, Chicago. *Photography's Multiple Roles: Art, Development, Market, Science*. 1998. Texts by Mihaly Csikszentmihalyi, Denise Miller, Eugenia Parry, Ed Paschke, F. David Peat, Naomi Rosenblum, Franz Schulze, and Rod Slemmons.

College Park, Maryland. University of Maryland Art Gallery. *Mixed Bag*. Newspaper. 1973.

Cologne, Germany. Dokumenta GmbH. *Performance auf der Dokumenta 8, Kassel, 1987*. 1987. Edited by Elisabeth Jappe. German. Videocassette. See also Kassel: Weber & Weidemeyer.

Cologne. Kunsthalle Köln and Kölnischer Kunstverein. *Video Bänder*. 1974. Published in conjunction with the exhibition *Projekt 74: Aspecte Internationaler Kunst am Anfang der 70er Jahre*. German.

Dayton, Ohio. Wright State University. *16 Projects/4 Artists: Laurie Anderson, Dennis Oppenheim, Michelle Stuart, William Wegman*. 1977.

Detroit. Detroit Institute of Arts. *Other Ideas*. 1969. Text by Sam Wagstaff.

Düsseldorf. Städtische Kunsthalle. *Prospect '71: Projection*. 1971. Texts by Konrad Fischer, Jürgen Harten, and Hans Stretlow.

Escondido, California. California Center for the Arts Museum. *Wildlife*. 1994. Texts by Reesey Shaw and Jeff Kelly.

Flushing, New York. Queens Museum. *The Real Big Picture*. 1986. Text by Marvin Heiferman.

Fort Lauderdale, Florida. Fort Lauderdale Museum of Art and Los Angeles County Museum of Art. *Photography and Art: Interactions Since 1946*. 1987. Published in association with Abbeville Press. Texts by Andy Grundberg and Kathleen McCarthy Gauss.

Frankfurt. Frankfurter Kunstverein. *Prospect '86*. 1986. Texts by Martina Detterer and Peter Weiermair. German.

Glen Ellyn, Illinois. William E. Gahlberg Gallery. *Replay: Art That Is Serious/Playful*. 1992. Text by Kathryn Hixson.

Greensboro, North Carolina. Witherspoon Art Gallery, University of North Carolina. *Art on Paper*. 1981.

Houston. Contemporary Arts Museum. *American Narrative/Story Art: 1967–1977*. 1978. Texts by Marc Freidus, James Harithas, Paul Schimmel, and Alan Sondheim.

Houston. Contemporary Arts Museum. *Exhibition 10*. 1972. Texts by John Alberty, David Deutsch, Robert Grosvenor, Newton Harrison, Paul Sharits, Vera Simmons, Michael Snow, Richard Van Buren, Ellen Van Fleet, and William Wegman.

Houston. Contemporary Arts Museum. *Finders/Keepers*. 1997.

Houston. Contemporary Arts Museum. *In Our Time: Houston's Contemporary Arts Museum, 1948–1982*. 1982. Texts by Cheryl A. Brutvan, Marti Mayo, and Linda L. Cathcart.

Houston. Museum of Fine Arts, Houston. *Contemporary American Photographic Works*. 1977.

Houston. Museum of Fine Arts, Houston, and Contemporary Arts Museum. *Art at Work: Forty Years of the Chase Manhattan Collection*. 1999.

Humlebæk, Denmark. Louisiana Museum of Modern Art. *Drawing Distinctions: American Drawings of the Seventies*. 1981. Text by Alfred Kren.

Kassel, Germany. Weber & Weidemeyer. *Dokumenta 8*. 1987. In association with Museum Fridericianum Veranstaltungs. German. See also Cologne: Dokumenta GmbH.

Laguna Beach, California. Fellows of Contemporary Art. *Proof: Los Angeles Art and the Photograph, 1960–1980*. 1992. Text by Charles Desmarais.

Lincoln, Massachusetts. DeCordova Museum and Sculpture Park. *Photography in Boston, 1955–1985*. Texts by Rachel Rosenfield Lafo and Gillian Nagler.

London. Arts Council of Great Britain and Hayward Gallery. *11 Los Angeles Artists*. 1971. Text by Maurice Tuchman and Jane Livingston.

London. Victoria & Albert Museum. *Photography Now*. 1989. Text by Mark Haworth-Brown.

London and Sheffield, England. Arts Council of Great Britain and Mappin Art Gallery. *Artist and Camera*. 1980. Texts by Michael Regan and Joanna Henderson.

Long Beach, California. Long Beach Museum of Art. *Southland Video Anthology*. 1975.

Long Island City, New York. P.S. 1 Contemporary Art Center. *Video Acts: Single Channel Works from the Collections of Pamela and Richard Kranlich and New Art Trust*. 2002. Texts by Klaus Biesenbach, Barbara London, and Christopher Eamon.

Los Angeles. Los Angeles County Museum of Art. *24 Young Los Angeles Artists*. 1971. Text by Maurice Tuchman and Jane Livingston. Brochure.

Los Angeles. Los Angeles County Museum of Art. *The camera i: Photographic Self-Portraits from the Audrey and Sydney Irmas Collection*. 1994. In association with Harry N. Abrams, Inc., New York.

Los Angeles. Museum of Contemporary Art. *Reconsidering the Object of Art, 1965–1975*. 1995. Published in association with M.I.T. Press. Texts by Ann Goldstein and Anne Rorimer.

Los Angeles. Rosamund Felsen Gallery. *Just Pathetic*. 1990. Text by Ralph Rugoff.

Marseilles. Musées de Marseilles. *L'art au corps: le corps exposé de Man Ray à nos jours*. 1996. Text by Philippe Vergne.

Melbourne. National Gallery of Victoria. *Some Recent American Art*. 1973.

Milwaukee, Wisconsin. Milwaukee Art Center. *55th Annual Wisconsin Painters and Sculptors Exhibition*. Board of Regents of the University of Wisconsin. 1969.

Milwaukee. Milwaukee Art Museum. *Word as Image: American Art, 1960–1990*. 1990.

Minneapolis. Minneapolis State Arts Council. *9 Artists/9 Spaces: An Exhibition of Outdoor Projects*. 1970. Text by Siah Armajani.

Minneapolis. Walker Art Center. *1968 Biennial of Painting and Sculpture: Iowa, Minnesota, North Dakota, South Dakota, Wisconsin.* 1968. Text by Martin Friedman.

Minneapolis. Walker Art Center. *The Last Picture Show: Artists Using Photography, 1960–1982.* 2003. Text by Douglas Fogle.

Minneapolis. Walker Art Center. *New Learning Spaces and Places.* 1974.

Minneapolis. Walker Art Center. *Performance in the 1970s: Experiencing the Everyday.* 1974. Brochure and *Design Quarterly 90/91: 80–81.*

New Orleans. New Orleans Museum of Art. *Altered Truths: Contemporary Photography from the Michael Myers/Russell Albright Collection.* Text by Nancy Barrett. Brochure.

New York. Alternative Museum. *Islamic Allusions.* 1981. Text by April Kingsley.

New York. The Dog Museum of America. *The Dog Observed: Photographs, 1844–1983.* 1984. In association with Alfred A. Knopf. Text by Ruth Silverman.

New York. The Drawing Center. *The Return of the "Cadavre-Exquis."* 1993. Text by Jane Philbrick.

New York. Grey Art Gallery and Study Center, New York University. *Faces Photographed.* 1982. Text by Ben Lifson.

New York. Hallmark Cards, Inc. *A Century of American Photography: From Dry-Plate to Digital: The Hallmark Photographic Collection.* 1995. In association with Harry N. Abrams, Inc. Text by Keith Davis.

New York. Holly Solomon Gallery. *Space Attitudes.* 1991.

New York. Independent Curators, Inc. *Multiple Exposure: The Group Portrait in Photography.* 1995. Texts by Leslie Tonkonow and Alan Trachtenberg.

New York. Independent Curators, Inc. *The Success of Failure.* 1987. Text by Joel Fisher.

New York. Independent Curators International. *100 Artists See God.* 2004. Texts by John Baldessari, Meg Cranston, and Thomas McEvilley.

New York. International Center of Photography. *Legacy of Light.* 1987. In association with Alfred A. Knopf. Texts by Peter Schjeldahl, Gretel Ehrlich, Robert Stone, Richard Howard, and Diane Johnson.

New York. Javan Corporation. *The Smorgon Family Collection of Contemporary American Art.* 1985.

New York. Museum of Modern Art. *The First Decade: Video from the EAI Archives.* 2002. Brochure.

New York. Museum of Modern Art. *More than One Photography: Works Since 1980 from the Collection.* 1992.

New York. New Museum. *"Bad" Painting.* 1978. Text by James Albertson.

New York. New Museum. *Language, Drama, Source, and Vision.* 1983. Brochure.

New York. New Museum. *Not Just for Laughs: The Art of Subversion.* 1982. Text by Marcia Tucker.

New York. Rizzoli. *Elvis + Marilyn: 2 x Immortal.* 1994. Text by Geri DePaoli and Wendy McDaris. See also Boston: Institute of Contemporary Art.

New York. Whitney Museum of American Art. *The American Century: Art and Culture 1950–2000.* 1999. Texts by Lisa Phillips and Barbara Haskell.

New York. Whitney Museum of American Art. *Fables, Fantasies, and Everyday Things: Children's Books by Artists.* 1994. Text by May Castleberry and Eugenie Tsai.

New York. Whitney Museum of American Art. *Image World: Art and Media Culture.* 1990. Texts by Marvin Heiferman, Lisa Phillips, and John G. Hanhardt.

New York. Whitney Museum of American Art. *1973 Biennial Exhibition: Contemporary American Art.* 1973.

New York. Whitney Museum of American Art. *1981 Biennial Exhibition.* 1981.

New York. Whitney Museum of American Art. *1989 Biennial Exhibition.* 1989. Text by Richard Armstrong.

New York. Whitney Museum of American Art. *Photographic Fictions.* 1986.

New York and Cologne, Germany. Taschen. *A Thousand Hounds / Tausend Hunde / Un Millier de Chiens.* 2000. Texts by Miles Barth and Raymond Merritt. English, German, and French.

New York and Munich. Exhibition Management, Incorporated and Prestel. *It's Only Rock and Roll: Rock-and-Roll Currents in Contemporary Art.* 1995. Text by David S. Rubin.

Newcastle-upon-Tyne, England. Hatton Gallery. *The Human Zoo.* 2003. Text by Steve Baker.

Newport Beach, California. Newport Harbor Art Museum. *Shift: LA/NY.* 1982. Texts by Paul Schimmel, Marcia Tucker, Melinda Wortz, and Jane Livingston.

Notre Dame, Indiana. Moreau Gallery, Saint Mary's College, University of Notre Dame. *Sign, Signal, Symbol.* 1969. Text by R. P. Penkoff.

Oberlin, Ohio. Allen Memorial Art Museum. *Art in the Mind*. 1970. Text by Athena Spear.

Paris. Fondation Cartier pour l'art contemporain. *Comme une oiseau*. 1996. In association with Editions Gallimard/Electa. Texts by David Arasse, Hervé Chandès, Joean Dorst, Claude Lévi-Strauss, Susan Koslow, François-Bernard Mâche, Michael Onfray, José Pierre, Pierre Nicolau-Guillaumet, and Jen-Loup Rousselot.

Paris. Musée d'art moderne de la ville de Paris. *Ils se dissent peintres, ils se dissent photographes*. 1981.

Paris and Arles. Fondation Cartier pour l'art contemporain and Actes Sud. *Double view, double vue*. 1996. Text by Patrick Roegiers. French.

Pasadena, California. Baxter Art Gallery, California Institute of Technology. *Robert Cumming and William Wegman*. 1978. Text by Michael H. Smith.

Pasadena. Pasadena Art Museum. *15 Los Angeles Artists*. 1972.

Pasadena and Santa Monica, California. Armory Center for the Arts and Art Center, College of Design. *Radical P.A.S.T.: Contemporary Art and Music in Pasadena, 1960–1974*. 1999. Texts by Jay Belloli, Linda Centell, Michelle Deziel, Karen Jaconson, Suzanne Muchnic, Peter Plagens, and Jeff von der Schmidt.

Phoenix, Arizona. Phoenix Art Museum. *Altered Egos: Samaras, Sherman, Wegman*. 1986

Pittsburgh. Carnegie Museum of Art. *Points of Departure: Origins in Video*. New York: Independent Curators, Inc., 1990. Texts by Jacqueline Kain and William D. Judson.

Poughkeepsie, New York. Frances Lehman Loeb Art Center, Vassar College. *Summer Reading: The Re-Creation of Language in Twentieth-Century Art*. 2001. Brochure.

Providence. Rhode Island School of Design Museum. *On the Wall: Wallpaper by Contemporary Artists*. 2003. Brochure.

Richmond, Virginia. Virginia Museum of Fine Arts. *Outer & Inner Space: Pipilotti Rist, Shirin Neshat, Jane & Louise Wilson, and the History of Video Art*. 2002. Text by John B. Ravenal, Laura Cottingham, Eleanor Heartney, and Jonathan Knight Crary.

Rochester, New York. International Museum of Photography at George Eastman House. *The Extended Document: An Investigation of Information and Evidence in Photographs*. 1975. Text by William Jenkins.

San Francisco. San Francisco Museum of Modern Art. *Video Art: An Overview*. 1976. Brochure.

Santa Barbara, California. Santa Barbara Museum of Art. *Attitudes: Photography in the 1970s*. 1979. Text by Fred R. Parker.

Santa Barbara, California. University of California, Santa Barbara Museum. *Invented Images*. 1980. Text by Phyllis Plous and Steven Cortright.

Santa Monica, California. Craig Krull Gallery and Smart Art Press. *Photographing the L.A. Art Scene, 1955–1975*. 1996. Text by Craig Krull.

Saratoga Springs, New York. The Tang Teaching Museum and Art Gallery at Skidmore College. *From Pop to Now: Selections from the Sonnabend Collection*. 2002. Texts by Ileana Sonnabend, Margaret Sundell, and Rachel Haidu.

Saratoga Springs. The Tang Teaching Museum and Art Gallery at Skidmore College. *Living with Duchamp*. 2003. Brochure.

Seattle. and/or Gallery. *Five Artists and Their Video Work*. Atomic Press, 1975. Text by Katherine Ann Grosshans.

Sheboygan, Wisconsin. John Michael Kohler Arts Center. *Media in a Supermarket*. 1969.

Stony Brook, New York. Art Gallery, New York State University. *TV: Through the Looking Glass*. 1986. Brochure.

Tokyo. APT International. *William Wegman*. 1997. Texts by William Wegman, Kohtaro Iizawa, and Noi Sawaragi. English and Japanese.

Trenton, New Jersey. New Jersey State Museum. *Soft Art*. 1969. Text by Ralph Pomeroy.

Vienna. Kunstalle Wein. *Televisions*. 2001. Brochure.

Vienna. Österreichisches Fotoarchiv in Museum moderner Kunst. *Sofort-Bild-Geschichten/Instant-Imaging-Stories: Eileen Cowin, David Levinthal, William Wegman*. 1992. Texts by Monika Faber and Ralph Rugoff. German and English.

Washington, D.C. Artrend Foundation. *Art Now: A Celebration of the American Arts*. 1974. Text by Jocelyn Kress.

Washington, D.C. The Nature Conservancy. *In Response to Place: Last Great Places*. 2001. In association with Little, Brown & Co., Bulfinch Press, Boston. Texts by Terry Tempest Williams and Andy Grundberg.

Waterville, Maine. Colby College Museum of Art. *Mainely Wegmans*. 1995. Text by Alexandra Anderson-Spivy.

Wayne, New Jersey. Ben Shahn Art Gallery, William Paterson College. *Camera Art*. 1973. Text by Les Levine and Gregory Battock.

Weimar, Germany. ACC Galerie. *Weimar den Weimaranern*. 1995. Texts by Frank Motz and Katharina v. d. Leyen. German.

Wellesley, Massachusetts. Davis Museum and Cultural Center. *Rules of the Game: An Exhibition of 74 Photographs and Videos Examining the Nature and Underlying Intentions of Humans' Interest in Other Animals.* 1996. Texts by Marie José Burki and Lucy Flint-Gohlke.

Zurich, Switzerland. InK, Halle für international neue Kunst. *Avec un certain sourire?/With a Certain Smile?* 1979. Texts by Ida Applbroog, Ger van Elk, Georg Ettl, Bruce McLean, Sigmar Polke, Ed Ruscha, Fritz Schwegler, Boyd Webb, and William Wegman. English and German.

BOOKS AND GENERAL REFERENCE

Beebe, Mary Livingstone, James Stuart DeSilva, Robert Storr, and Joan Simon. *Landmarks: Sculpture Commissions for the Stuart Collection at the University of California, San Diego.* New York: Rizzoli, 2001.

Castelli-Sonnabend Videotapes and Films. Volume I, no. 1. New York: Castelli-Sonnbend Videotapes and Films, Inc. May 1974.

Hoy, Anne H. *Fabrications: Staged, Altered, and Appropriated Photographs.* New York: Abbeville Press, 1987.

Levine, Les. *Media: The Bio-Tech Rehearsal for Leaving the Body.* Calgary: Alberta College of Art Gallery, 1979.

Rosenblum, Robert. *The Dog in Art from Rococo to Post-Modernism.* New York: Harry N. Abrams, 1988.

FILMS AND VIDEO

Untitled (Toothpick/Fire), 1969, Super 8mm film, color, silent, 3 minutes. Whereabouts unknown.

Untitled (Bubblegum), 1970, Super 8mm film, color, silent, 3 minutes. Whereabouts unknown.

Spit Sandwich 1970, black & white, sound, 15:10 minutes: *I got…* (2:46); *Chair/Lamp/Suitcase* (0:58); *Muscles* (0:34); *Falling Milk* (0:27); *TV Plunger* (0:30); *Clamp Cut* (0:11); *Crane Art* (1:02); *Twins* (1:03); *Alex, Bart, and Bill* (0:55); *Astronaut* (1:19); *Tonsil Song* (1:04); *Tortoise and the Hare* (0:25); *Mixer* (0:22); *Backwards* (0:19); *Squirrel Around* (0:28); *Classical Ruins* (0:15); *Studio Work* (0:30); *Spit Sandwich* (0:48); *Ill* (0:15).

Selected Works: Reel 1 1970–71, black & white, sound, 30:12 minutes: *Microphone* (0:47); *Pocketbook Man* (1:19); *Anet and Abtu* (0:47); *The Ring* (1:11); *Randy's Sick* (0:16); *Milk/Floor* (1:02); *The Door* (2:06); *William Wegman in Chinese* (0:36); *Elbows* (1:46); *Dress Curtain* (0:19); *Hot Sake* (0:36); *Caspar* (0:35); *Handy* (0:09); *Out and In* (0:06); *Plunger Series* (0:33); *Nosy* (1:08); *Firechief* (0:22); *Come In* (1:40) *Hidden Utensil* (0:29); *Stomach Song* (1:20); *Happy Song* (0:17); *Contract* (1:23); *Puppet* (0:51); *Shadows* (0:18); *Ventriloquism* (2:16); *Light Trails* (2:00); *Cape On* (4:39).

Selected Works: Reel 2 1972, black & white, sound, 19:42 minutes: *Sanforized* (0:47); *Coin Toss* (2:11); *Monkey Business* (1:06); *Same Shirt* (0:32); *Diving Board* (0:47); *Straw and String* (0:51); *Product* (1:31); *In the Cup* (0:16); *The Kiss* (1:27); *Name Board* (4:41); *Peck and Chuck A* (0:34); *Treat Bottle* (4:18).

Selected Works: Reel 3 1972–73, black & white, sound, 21:41 minutes: *Stick and Tooth* (1:00); *Emperor and Dish* (1:09); *Lucky T-Shirt* (1:04); *Rage and Depression* (1:03); *Speed Reading* (1:02); *Born with No Mouth* (1:00); *Dual Function* (1:33); *Massage Chair* (1:35); *Raise Treat* (0:25); *Man Ray, Do You Want To?* (1:54); *Crooked Finger, Crooked Stick* (0:39); *Deodorant* (0:49); *Bubble Up* (0:59); *Joke Paper* (0:54); *Model Child* (2:50); *What Do You Want?* (0:39); *Paper Meaning* (0:26); *Same Old Shirt* (0:54); *47 Seconds* (1:00).

Selected Works: Reel 4 1973–74, black & white, sound, 20:33 minutes: *Wake Up* (1:33); *Trip Across Country* (0:50); *Down Time* (0:36); *Laundromat* (0:43); *Saw Movies* (1:25); *Cocktail Waiter* (0:40); *Nail Business* (0:27); *Calling Man Ray* (0:45); *New and Used Car Salesman* (1:31); *On the Ball* (1:29); *Tails* (0:43); *Radar Screen* (0:52); *Air Travel* (0:42); *Growl* (1:00); *Spelling Lesson* (0:49); *Criticize* (0:41); *Pyramids* (0:15); *Symbolize* (1:05); *The Letter* (0:59); *Mixing Bucket* (0:11); *Bug Repellant* (0:18); *Snowflakes* (2:10).

Selected Works: Reel 5 1974–75, black & white, sound, 30:20 minutes: *Nocturne* (7:49); *Stalking* (2:06); *Audio Tape and Video Tape* (2:04); *Dancing Tape* (5:27); *Hobo on Train* (0:52); *Drinking Milk* (1:55); *Copyright* (1:43); *Buying a House* (1:00); *Lerch Hairpieces* (0:19); *Tammy and Can of Plums* (0:19); *Loves Water* (0:43); *Average Guy* (0:15); *Newscast* (2:42); *Marbles* (0:23); *Ball Drop* (0:43); *Treat Table* (0:38); *Hey Roy* (0:40).

Semi-Buffet 1975, color, sound, 20:18 minutes.

Selected Works: Reel 6 1975–76, black & white and color, sound, 19:38 minutes: *Ball and Can* (6:28); *The Reel* (1:00); *Eyes of Ray* (0:34); *Dog Duet* (2:38); *Stereo System* (1:32); *Tube Talk* (1:16); *Video* (1:18); *Joke* (0:46); *Furniture* (1:42); *Moby Dick* (1:09); *Cord Walk* (0:45).

Gray Hairs 1976, color, sound, 5:10 minutes.

*World History** 1976 (audio only), 16:20 minutes.

Selected Works: Reel 7 1976–77, color, sound, 18:06 minutes: *Alarm A* (0:35); *Dr. Joke* (2:17); *Bad Movies* (0:59); *Drop It* (1:40); *Oh Boy, Fruit* (0:26); *Smoking* (1:52); *Baseball over Horseshoes* (1:16); *Fast* (0:12); *Piano Hands* (2:16); *House for Sale* (0:40); *Peck and Chuck B* (0:24); *Alphabet* (1:22); *Starter* (0:47); *Night Song* (1:37); *Alarm B* (1:03).

William Wegman: Selected Works, 1970–1978 compiled 1981, black & white and color, sound, 19:11 minutes: *Milk/Floor* (1:03); *Stomach Song* (1:19); *Randy's Sick* (0:17); *Pocketbook Man* (1:30); *Anet and Abtu* (0:52); *Out and In* (0:06); *Rage and Depression* (1:03); *Massage Chair* (1:36); *Crooked Finger/Crooked Stick* (0:39); *Deodorant* (0:50); *Growl* (1:00); *Spelling Lesson* (0:54); *Drinking Milk* (1:56); *Dog Duet* (2:29); *Starter* (0:45); *Bad Movies* (0:59); *House for Sale* (0:40); *Baseball over Horseshoes* (1:16).

** **Man Ray, Man Ray** 1978, color, sound, 5:23 minutes.

** **Accident** 1979, color, sound, 4:17 minutes.

*How to Draw** by William Wegman and Mark Magill, 1983, color, sound, 5:41 minutes.

*Dog Baseball** 1986, color, sound, 3:26 minutes. Produced for *Saturday Night Live*.

*World of Photography** by Michael Smith and William Wegman, 1986, color, sound, 24:35 minutes. Produced in association with Contemporary Art Television (CAT) Fund and KTCA.

Introductions to "Alive from Off Center." 1988.

*Music Video for New Order's Blue Monday** by William Wegman in collaboration with Robert Breer, 1988, color, sound, 4:05 minutes.

+**Sesame Street Segments, 1989** color, sound. *Fay On and Off* (0:42); *Fay On and Under Rug* (0:26); *Muybridge* (0:18); *Listening* (0:46); *4 Balls—Addition* (0:37); *4 Balls—Subtraction* (0:40); *3 Balls—Subtraction* (0:25); *3 Balls—Addition* (0:18); *Zero* (0:22); *3 Blue Balls/One White* (0:44); *Dog O'Clock* (0:13); *Guessing Game 1* (0:58); *Guessing Game 2* (1:05); *Fay On and Under Stool* (0:13).

Sesame Street Segments, 1992 color, sound. *Fay Family: One of These Things* (0:31); *Sleeping Fay Family: One of These Things* (0:32); *Fay Family: Next To* (1:00); *Fay Ball Near and Far* (0:23); *Here Comes Fay Near and Far* (0:19); *Here Comes Fay Near and Far* [Not for Air] (0:19); *Fay Family #3* (0:22); *Fay Family Counting to 3* (0:28); *Fay Bridge* (0:10); *Fay Family Sound ID* (0:38); *Chundo Day Dreams of Spain* (0:25); *Chundo Day Dreams of Italy* (0:25); *Chundo Day Dreams of India* (0:25).

Sesame Street Segments, 1993 color, sound. *McDoubles Cooperate Passing Fruit* (0:29); *McDouble Twins Count 2* (0:32); *Old McFay Subtracts 5-3-2=1* (0:41); *Old McFay 3 Is Always 3* (0:30); *Old McFay Subtracts 3-2=1* (0:23); *Old McFay Counts to 40* (1:17); *Old McFay Subtracts Lemons 6-5-4-3-2-1=0* (0:42); *Old McFay Counts 6 Lemons & Limes 25* (1:11); *Old McFay Configuration of 4* (0:52); *Old McFay Count to 10* (0:29); *Old McFay Adds 3+2=5* (0:30).

Made in Maine: Fly Fishing by William Wegman in collaboration with Betsy Connors, 1992, color, sound, 7:02 minutes.

Made in Maine: W-O-O-D by William Wegman in collaboration with Betsy Connors, 1992, color, sound, 2:18 minutes.

Henry Purcell's "Curtain Tune" from Timon of Athens 1994, color, sound, 2:30 minutes. Produced for Comedy Central.

Sesame Street Segments, 1994 color, sound. *Dog Alphabet* (1:35); *Fay Family—"GO"* (0:16); *Fay Family—"ON"* (0:10); *Goldilocks* (1:28); *Fay Dog Letter A* (0:10); *Fay Dog Letter E* (0:10); *Fay Dog Letter H* (0:10); *Fay Dog Letter J* (0:10); *Fay Dog Letter K* (0:10); *Fay Dog Letter L* (0:10); *Fay Dog Letter* (0:10); *Fay Dog Letter T* (0:10); *Fay Dog Letter W* (0:10); *Fay Dog Letter P* (0:10); *Fay Family Counts to 8* (0:55); *Fay Family Counts 1–9 and 9–0* (0:40).

Fay Presents Alphabet Soup 1995, color, sound, 26:21 minutes.

Fay Presents Fay's Twelve Days of Christmas 1995, color, sound, 25:45 minutes.

The Hardly Boys in Hardly Gold 1995, 35mm film, color, sound, 28 minutes.

Sesame Street Segments, 1995 color, sound. *Little Jack Horner* (0:32); *Little Bo Peep, Part 1* (0:24); *Little Bo Peep, Part 2* (0:12); *Little Bo Peep, Part 3* (0:13); *Jack Sprat* (0:17); *Jack and Jill* (0:52); *Pat-a-Cake* (0:42); *Little Miss Muffet* (0:37); *Old Mother Hubbard* (0:24); *Old King Cole* (1:47).

Sesame Street Segments, 1996 color, sound. *Jack-Be-Nimble* (1:09); *Cock-A-Doodle Doo* (0:58); *Jack-A-Nory* (0:28); *To Market* (1:10); *Three Men in a Tub* (0:47); *Ten O'Clock Scholar* (0:50); *Letter A/Artist/Airplane* (0:33); *Letter B/Boat* (0:24); *Fay Letter J/Jester* (0:40); *Letter K/King* (0:22); *SW Milk* (0:52); *Letter T/Train* (0:21); *Letter V/Violin* (0:45); *Letter X/X-Ray* (0:19).

Sesame Street Segments, 1997 color, sound. *Fay Family Makes Popcorn* (1:52); *Fay Family Makes Bread* (1:55); *Fay Family Makes PB&J* (1:59); *Fay Family Makes a Cake* (1:25); *Fay Family Doctor Exam* (2:22); *Fay Family Eye Exam* (1:02).

Mother Goose 1997, color, sound, 25:54 minutes. Distributed by Sony Wonder.

Selected Works: Reel 8 1997–98, color, sound, 25:52 minutes: *Ordinary Deck* (1:12); *Stagehand* (0:49); *Typist* (0:24); *Installed Guitar* (0:43); *What's the Story?* (2:50); *Denatured Alcohol* (0:53); *Car Wouldn't Start* (1:26); *Log Cabin Cinnamon Toast* (3:45); *Two Dogs* (1:30); *Living Room of the Future* (1:38); *Phone Card* (0:55); *Crossing Guard* (1:39); *Late Night* (7:05).

Sesame Street Segments, 1998 color, sound. *Fay Family: Waiter* (1:52); *Fay Family: Auto Mechanic* (1:31); *Fay Family: Truck Driver* (1:36); *Fay Family: House Painter* (1:16); *Fay Family: Hairdresser* (1:22).

Selected Works: Reel 9 1999, color, sound, 21:40 minutes: *Depressed* (1:09); *Hockey* (2:01); *Flower Catalog* (1:09); *Mixer* (0:52); *Women Artists* (0:31); *Lecture* (3:53); *Pert 2650305* (0:43); *Minister* (2:56); *Management Fidelity Risk* (1:02); *Confession* (2:11); *Running Out of Time* (0:23); *Two Hands* (0:24); *A Chorus Line* (0:40); *The Lover, Tea Party, The Basement* (2:25); *Okay, Go!* (0:12).

Sesame Street Segments, 1999 color, sound. *Fay Family: McDoubles Cooperation* (0:59); *Fay Family Fisherman* (1:15); *Fay Family: Sales Person* (1:11); *Fay Family: Ball Game* (0:22).

Sesame Street Segments, 2000 color, sound. *Wegman Dogs—Painting* (0:57); *Wegman Dogs—Conductor* (1:08); *Wegman Dogs—Batty's into Pottery* (1:05); *Wegman Dogs—Instruments* (0:44); *Museum* [segment not delivered] (1:00).

Sesame Street Segments, 2001 color, sound. *Wegman Pool In/Out* (0:20); *Wegman 2 Dogs* (0:35); *Wegman Partitioning 4* (0:30); *Wegman Building One* (0:39); *Wegman Canoe* (0:54); *Theater Near/Far* (0:33); *Wegman Stop & Go* (0:54).

Notions of Identity in collaboration with Steve Martin, 2001, color, sound, 3:03 minutes. Commissioned by "Art:21—Art in the Twenty-First Century."

Sesame Street Segments, 2002 color, sound. *Fay Family Red Ball* (1:02); *Fay Family Seesaw* (0:33); *Fay Family Croquet* (0:36); *Fay Family 4 Mud Pies* (1:04); *Fay Family 4 Glasses of Punch* (1:01); *Fay Family Red Ball 2* (0:23).

Front Porch 2002, color, silent, 0:52 minute. Presented at Creative Time's "The 59th Minute: Video Art on the Times Square Astrovision," November 6, 2002–January 22, 2003.

Created for Nokia Connect to Art and playable only on mobile devices, 2004, color, sound: *Alarm* (0:20); *Buxtehude* (0:25); *Entertainer* (0:24); *Metropolis* (0:20); *Red Ball* (0:21); *Trio* (0:22).

Space Capsule 2004, color, sound, 0:51 minute.

East Frampton 2004, color, sound, 2:09 minutes.

Squirrel 2004, color, sound, 0:45 minute.

* William Wegman's films and videotapes have been distributed in a number of ways, by organizations including Castelli-Sonnabend Tapes and Films, Electronic Arts Intermix (EAI), and Video Data Bank.

**Distributed by Electronic Arts Intermix (EAI) in a compilation *Man Ray, Man Ray; Accident; Gray Hairs*, 1976–79, color, sound, 15 minutes.

+ Distributed by Electronic Arts Intermix (EAI) as *Sesame Street Fay Ray Segments*, 1989 color, sound.

INDEX

INDEX

Exhibition

The exhibition **WILLIAM WEGMAN FUNNEY/STRANGE** was organized by the Addison Gallery of American Art, Phillips Academy, Andover, Massachusetts, with guest curator Trevor Fairbrother.

Generous support for this exhibition and publication was provided by The Henry Luce Foundation.

Exhibition dates:

Brooklyn Museum
New York
March 8–May 28, 2006

Smithsonian American Art Museum
Washington, D.C.
July 4–September 24, 2006

Norton Museum of Art
West Palm Beach, Florida
November 4, 2006–January 28, 2007

Addison Gallery of American Art
Phillips Academy, Andover, Massachusetts
April 7–July 31, 2007

Yale University Press
P.O. Box 209040
New Haven, Connecticut 06520
www.yalebooks.com

Addison Gallery of American Art
Phillips Academy
180 Main Street
Andover, Massachusetts 01810
www.addisongallery.org

Content Editor
David Frankel

Copyeditor
Linda Truilo

Research Associate
Susan J. Montgomery

Proofreader
June Cuffner

Indexer
Carol Roberts

Design and Typography
Lorraine Ferguson

Typeset in Vendetta and Solex
Printed in Italy at Mondadori
10 9 8 7 6 5 4 3 2 1

Library of Congress
Cataloging-in-Publication Data

Simon, Joan, 1949–
William Wegman : funney/strange /
Joan Simon.
 p. cm.
Catalog of an exhibition organized
by the Addison Gallery of American
Art, Phillips Academy, Andover,
Mass., to be held at the Brooklyn
Museum, New York, Mar. 8–May
28, 2006, at the Smithsonian
American Art Museum, Washington,
D.C., July 4–Sept. 24, 2006, at the
Norton Museum of Art, West Palm
Beach, Florida, Nov. 4, 2006–Jan.
28, 2007, and at the Addison
Gallery of American Art, Apr. 7–July
31, 2007.
Includes bibliographical references
and index.
ISBN 0-300-11444-3 (paperback)
1. Wegman, William— Exhibitions.
I. Title: Funney/strange.
II. Wegman, William.
III. Addison Gallery of American
Art. IV. Brooklyn Museum.
V. Norton Museum of Art.
VI. Smithsonian American Art
Museum.
VII. Title.
N6537.W345A4 2006
700'.92—dc22
2005009406

Front cover
Ramp 2000
Chromogenic print
14 × 11 in. (35.6 × 27.9 cm)

Back cover
Funney/Strange (detail) 1982
ink on paper
10 ¾ × 9 in. (27.3 x 22.9 cm)

Frontispiece
Untitled 1980
ink on gelatin silver print
10 × 8 in. (25.4 × 20.3 cm)